DEFINING MODERN ART

Selected
Writings of
Alfred H. Barr, Jr.

Harry N. Abrams, Inc.
Publishers,
New York

DEFINING MODERN ART

Selected Writings of Alfred H. Barr, Jr.

EDITED BY
IRVING SANDLER
AND AMY NEWMAN
WITH AN INTRODUCTION
BY IRVING SANDLER

EDITOR: PHYLLIS FREEMAN
DESIGNER: JUDITH HENRY

Binding stamp: Alfred Barr, drawing by Meyer Schapiro, done at a meeting of the
Advisory Council of the Museum, c. 1943, MoMA Archives: Alfred Barr Papers

Library of Congress Cataloging-in-Publication Data
Barr, Alfred Hamilton. Defining modern art.
 Bibliography: p. 274.
 Includes index.
 1. Art, Modern—20th century. I. Sandler, Irving, 1925–
II. Newman, Amy. III. Title.
N6490.B2587 1986 709'.04 86-3357
ISBN 0-8109-0715-1

For permission to reprint these writings by Alfred H. Barr, Jr., grateful acknowl-
edgment is made to the following:

"Russian Diary." From *October,* no. 7 (Winter 1978), pp. 10–50. "Nationalism in
German Films." From *The Hound & Horn,* VII, no. 2 (January/March 1934), pp.
278–83. "Art in the Third Reich—Preview, 1933." From *Magazine of Art,*
XXXVIII, no. 6 (October 1945), pp. 212–22. Courtesy of The American Federation
of Arts. "Matisse, Picasso, and the Crisis of 1907." From *Magazine of Art,* XLIV,
no. 5 (May 1951), pp. 163–70. Courtesy of The American Federation of Arts.
"Research and Publication in Art Museums." From *The Museum News,* XXIII, no.
13 (January 1, 1946), pp. 6–8. "A Symposium: The State of American Art." From
Magazine of Art, XLII, no. 3 (March 1949), p. 85. Courtesy of The American
Federation of Arts. "Is Modern Art Communistic?" From *The New York Times
Magazine,* December 14, 1952, Sect. 6, pp. 22–23, 28–30. Copyright © 1952 by
The New York Times Company. Reprinted by permission. "Artistic Freedom." From
College Art Journal, XV, no. 3 (Spring 1956), pp. 184–88. "The Museum of Modern
Art's Record on American Artists." From *Art News,* LVI, no. 5 (September 1957),
pp. 56–57. Copyright 1957 by ARTnews Associates. "Tastemaking." From *The New
York Times,* September 25, 1960, Sect. 2, p. 13. Copyright © 1960 by The New
York Times Company. Reprinted by permission. "The Pied-billed Grebe." From *Art
News,* XLVI, no. 7 (September 1947), p. 6. Copyright 1947 by ARTnews Associates.
"The Loyalty Oath." From *Princeton Alumni Weekly,* LI, no. 22 (April 13, 1951),
p. 3. "The Miracle." From *Magazine of Art,* XLIV, no. 5 (May 1951), p. 194.
Courtesy of The American Federation of Arts. "City's Resort for Wild Fowl." From
New York Herald Tribune, March 26, 1953, Sect. 1, p. 22. © I.H.T. Corporation.
Reprinted by permission. "American Conformity." From *The Hartford Courant,*
December 23, 1964, Sect. 1, p. 14.

Selections from Museum of Modern Art publications are reprinted with permission
of the publisher. All rights reserved. Full information can be found in "Alfred H.
Barr, Jr.: A Bibliography of Published Writings," pp. 274–92.

Contents

Pictures appear following pages 96 and 208

Introduction

BY IRVING SANDLER

Alfred Hamilton Barr achieved a position of such preeminence in the art world in the almost four decades he served The Museum of Modern Art that now, twenty years after his retirement in 1967, he continues to be a subject of interest. Moreover, controversies in which he was a leading protagonist continue to provoke public debate. Among the topics of ongoing argument are: the definition of modern and avant-garde art; censorship in the arts; the opposing claims of nationalism and internationalism in art; art as art or art in the service of a cause; modernism and postmodernism or antimodernism in art and architecture; formalism and antiformalism in art criticism and history. In fact, the fundamental role of a modern museum continues to be questioned: should a museum be both a repository of proved masterworks and a patron of new, problematic art; a showcase of both fine art and applied or popular art? And recently there has been heated debate over the role of the American avant-garde, The Museum of Modern Art, and Barr in the cold war of the late forties and the fifties. Yet despite all this discourse, Barr's thought is not as well known as it should be, a deficiency that the following selection of his published writings, consisting of 35 of the 339 pieces in the bibliography (pages 274–92), should help to remedy.

In 1929, "The Ladies"—Mrs. John D. Rockefeller, Jr., Miss Lillie P. Bliss, and Mrs. Cornelius J. Sullivan—met and decided to organize a new gallery or museum of modern art in New York. They enlisted A. Conger Goodyear, Frank Crowninshield, Paul J. Sachs, and Mrs. W. Murray Crane in their cause, and appointed Barr the first Director of The Museum of Modern Art—as the new institution was called—on the recommendation of Sachs, whose museum course Barr had taken at Harvard.[1]

Although Barr was only twenty-seven years old, he had already revealed his brilliance as an art historian and his knack for writing lucidly and elegantly in articles, book reviews, and letters to the editor, which he had begun to publish three years earlier. Sachs had been so impressed that he had written to the great medievalist Charles Rufus Morey, with whom Barr had studied at Princeton, to congratulate him "on the perfectly splendid student you have developed in Alfred Barr." Sachs added: "I have no hesitation in saying that he acquitted himself better than any candidate during the time that I have been here. . . . One got the impression that he had thought deeply and ranged widely over the whole field [of the history of art]."[2]

Barr's conception of modern art and culture had come to popular attention

in 1927, in "A Modern Art Questionnaire," published in *Vanity Fair,* the bellwether of the lively arts.[3] Barr had used this questionnaire as a test to determine whether undergraduates at Wellesley College possessed sufficient knowledge of contemporary culture to take his course on modern art, the first offered in America. By the mid-twenties, modern art had already become a cause in whose service Barr had enlisted.[4] Being modern, William Phillips wrote, means being "suspended between tradition and revolt, nationalism and internationalism, the aesthetic and the civic, and between belonging and alienation."[5] Barr balanced these conflicting claims with a felicitous mix of mission, imagination, scholarship, ability to communicate, and as Philip Johnson recalled, "unbridled . . . torrential passion."[6] In addition, as Barr was soon to show, he was an excellent administrator. Barr's vision and leadership built the Museum into the greatest museum of modern art in the world; its influence on public attitudes, art education, and museum practices is unequaled among institutions of its kind.

Barr's understanding of art had been shaped during his years as an undergraduate at Princeton (1918–22) by Morey. Morey's course encompassed all the arts of the Middle Ages: illumination, wall painting, sculpture and ivories, architecture, handicrafts, and folk art.[7] Later, Barr's own course in modern art at Wellesley dealt not only with twentieth-century painting and sculpture and their roots in the late nineteenth century, but with the broad spectrum of contemporary architecture, industrial design, photography, film, theater, and music as well. Barr had applied to the modern arts Morey's approach to the medieval arts. Thus, it was natural for him to conceive of the mission of a museum of modern art as a broad one, embracing not only the pioneers and the living practitioners of progressive painting and sculpture—the "high" arts—but all visual phenomena, practical and popular.

The roots of Barr's conception of a museum can be found in several contemporary movements, notably Dutch De Stijl, German Bauhaus, and Russian Constructivism.[8] He surely had these in mind as early as 1926, when he applied to Harvard for a fellowship to travel to Europe to do research for a proposed thesis on "The Machine in Modern Art." He was not awarded the fellowship but, in the following year, made the trip with four hundred dollars given him by Sachs, visiting not only museums, historic churches, and other monuments of art-historical interest but also J. J. P. Oud's modern housing for workers at the Hook of Holland and Walter Gropius's Bauhaus in Dessau, where he met and was deeply impressed by Gropius, Kandinsky, Klee, Feininger, Schlemmer, Moholy-Nagy, Albers, Breuer, Bayer—"they formed a dazzling constellation of artist-teachers such as no art school has ever known before or since."[9] "A fabulous institution," Barr summed up the Bauhaus, in which all of the arts were related and studied in a large, new, modern building.[10]

Barr's exposure to the art, architecture, design, and aesthetics of European

Constructivist movements of the twenties confirmed his belief that a museum of modern art ought to encompass within its walls the varied creations by artists and artisans of our time, paying attention without bias to a painting by Picasso or an inspired folk artist, an experimental work by a newcomer, and an ordinary steam radiator by an anonymous designer. To be sure, the "fine" arts, in which creative possibilities are unlimited, mattered more than the "applied" arts, in which the artists aim only to enhance useful objects—but both were worthy of sympathetic scrutiny.

What counted for Barr was "the conscientious, continuous, resolute distinction of quality from mediocrity."[11] Nevertheless, bringing together even the best examples of applied arts with painting, sculpture, and architecture within the walls of a museum was, at that time, a radical museological practice. And it was also political in the sense that it implied that aesthetic awareness could help improve our everyday surroundings, calling to mind Kazimir Malevich's pronouncement that art must become the content of life.

Barr's broad conception of the Museum's mission did not alone account for its greatness, of course. That was due primarily to the permanent collection of modern masterworks, unequaled in range, size, and aesthetic quality, that he amassed, his movement-by-movement installation of them, and the temporary exhibitions he organized: comprehensive surveys of Post-Impressionism (the opening exhibition: *Cézanne, Gauguin, Seurat, and Van Gogh,* 1929), *Cubism and Abstract Art* (1936), and *Fantastic Art, Dada, Surrealism* (1936), and the major retrospectives of Matisse (1931) and Picasso (1939)—each also the subject of a major book or catalogue by Barr.

In forming the permanent collection Barr was guided primarily by his superb taste and connoisseurship, and also by his art-historical knowledge. But he did not restrict his acquisitions and exhibitions to established works; he was equally committed to new and unproved art. The Museum was to be a Kunsthalle, exhibiting the latest works, as well as a Kunstmuseum, a permanent collection. This was risky, as Barr knew. But to prevent the Museum from becoming a graveyard of art, it was a risk worth taking. "Of course many mistakes are made. No one connected with the Museum pretends to infallibility. Yet, if fifty years from now our errors should seem egregious, perhaps a hundred years hence some of our judgments may be justified. In any case, it is already clear that errors of omission are by far the most serious for they are usually irrevocable."[12]

During his trip to Europe, Barr visited the Soviet Union, arriving on Christmas Day, 1927, and remaining for some two months. What struck him most was the vitality of the revolutionary film and theater that he saw. But he was also intent on discovering avant-garde painting and sculpture. This proved difficult because the visual arts were in crisis. "I must find some painters if possible," he wrote in his diary. He had met the leading avant-garde artists, El Lissitzky, Aleksandr Rodchenko and his wife, Varvara Stepanova, and they had told him painting was dead. "Rodchenko showed much satisfaction at having delivered

the death blow to painting in 1922."[13] Barr asked Lissitzky whether he still painted. "He replied that he painted only when he had nothing else to do, and as that was never, never."[14]

Barr blamed the rejection of painting by the Russian avant-garde in part for the resurgence of backward-looking figurative styles. But he was also aware of the political vulnerability of Constructivist artists. They had failed in their proclaimed mission: their aesthetically revolutionary work, which they had related to Lenin's social revolution,[15] served no practical function. Communist zeal led a number of them—Rodchenko and Stepanova, for example—who came to be called the Productivists, to take an anti-aesthetic stance and desert " 'useless' art [in order] to work on constructivist stage-settings, *photomontage*, the designing of posters, books [mainly for propaganda purposes], and furniture."[16] They tried to present their Productivism as an advance over their earlier abstract art. Barr was sympathetic to their aspirations and to those of their allies, such as the poet Vladimir Mayakovsky, the journalist Sergei Tretyakov, the theatrical director Vsevolod Meyerhold, and the filmmaker Sergei Eisenstein, who formed LEF (Left Front). But Barr distinguished between the demands of Marxism and art, taking his stand for art and looking for aesthetic quality even in propaganda, as is clear in his article on Eisenstein, written in 1928. Eisenstein's *Ten Days that Shook the World* was not a box office success. The reason, as Barr saw it, was that it was "pure *kino* of the subtlest quality" that "makes no compromise with popular taste," the kind of compromise pure propaganda would make.[17]

Barr was particularly sensitive to the growing repression of difficult art by Communist bureaucrats, who not only catered to the popular distaste for abstract art but feared the creative excursions of free artists. By 1922, the Soviet commissars had begun

> to purge "modern" art as a "bourgeois deviation" . . . [and] the best "modern" artists had left Russia or were passing into frustrated obscurity. Conservative artists . . . rapidly took command. Within a few years a banal academic realism was enforced under a dogmatic tyranny which made the old Czarist regime seem liberal indeed.[18]

While in Russia, Barr found that the Museum of Abstract Art in Moscow was padlocked.[19]

Questions regarding art's aesthetic value and social use, freedom of creation and censorship, whether totalitarian-minded politicians would allow artists to survive as artists or even to survive at all, were to engage Barr for the rest of his career. These concerns are clear in his introduction to the catalogue of *Cubism and Abstract Art* (1936), a third of which he devoted to "abstract art and politics." The artistic repression and censorship Barr encountered in the Soviet Union (reinforced by his first-hand experiences in Germany during the Nazi takeover in 1933) so troubled him that artistic freedom became a passionate,

lifelong cause, in which he frequently exhibited great courage. Indeed, both the artist's need for creative freedom and the viewer's need to be perpetually open to new experiences became decisive considerations in Barr's thinking and actions. He resisted any attempt to fetter artistic freedom whether by acts of censorship or the imposition of any preconceived or deterministic ideology— Marxist, nationalist, or avant-gardist. The only arbiter that Barr would accept was the self-determining individual genius and his or her creation. This he considered central to modernism—and possible only in a democracy.

Recognizing that new art in its pluralistic manifestations could thrive only in a free society, he acknowledged that private patronage was necessary for the health of the arts. Soviet architecture was sick, he implied in his "Russian Diary," because "the private individual who might wish to attest to his membership in the *avant-garde* by patronizing the adventurous architect does not exist in Russia." Thus, the only patrons were bureaucrats, "alas, only a little more advanced than . . . their American counterparts."[20] Independent, cultivated patrons of the arts did exist in the Western democracies, and whether or not one liked the social class to which they belonged, at least they supported genuinely creative art.

Barr's conception of modern art and its interpretation changed over the years. In the twenties, influenced by his reading of Roger Fry's *Vision and Design* and Clive Bell's *Art*—primers for his generation's art-conscious young of venturesome disposition—he was concerned mostly with formal values. Barr made that formalist inclination clear in his review of *The Art of Painting* by Albert C. Barnes, published in 1926, when Barr was twenty-four:

> The word "plastic" is the battle-cry of Mr. Barnes's challenging dialectic. "The things that a painter can work into various forms are line, color, and space: these are the plastic means." "The study of a painting consists in nothing more than the determination of how successfully the artist has integrated the plastic means to create a form which is powerful and expressive of his personality." "Relevant judgment or criticism of a picture involve[s] the ability to abstract from the appeal of subject matter and consider only the plastic means in their adequacy as constituents of plastic form." . . . He condemns "the painter who habitually accentuates those human values, religious, sentimental, dramatic, in terms not purely plastic."

Barr agreed:

> Mr. Barnes will find many, especially among those whom Aldous Huxley terms "the absurd young," who are more or less in sympathy with his position. Among them is the reviewer who has frequently found himself

formalism as optical cognition —
to vstand a new place, one
understands it formally first then
"content".

engaged in a long analysis of a painting without the slightest consciousness
of subject matter until some philistine undergraduate brings the discussion
to earth by asking why the madonna has such a funny chin. The undergradu-
ate's impatience is pardonable. His aesthetic illiteracy is shared by all but
a few who find pictures interesting.

But even as he acknowledged the persuasiveness of Barnes's arguments for
formalism, Barr remained open to other possibilities. He added prophetically
that formalist analysis might be merely a temporary canon, a matter of fashion.
"If by the literary canons of the last century he seems to over-emphasize the
rhetoric of painting, by canons of music he is merely revealing essentials. In the
light of history and experience neither fashion is final, though at present the
latter is crescent."

Barr was troubled by the question: what price plastic values? Were they
worth the reduction of "Titian's noble tragedy"? He concluded: "Mr. Barnes
will yet drive us to re-reading Ruskin, and to the tearful contemplation of those
'positively saint-like' animals of Sir Edwin Landseer, R.A."[21] Thus, from the
beginning of his career, while formulating his view of modernism, Barr had
already anticipated the post-modernist reaction, which would commence about
the time of his retirement four decades later.[22]

ms args that AHB wrote t swch formalism t surrealism.

Within three years of his review of Barnes's book, Barr had reacted against
formalist analysis and that art in which formal concerns were primary, acclaim-
ing a number of European and American painters who were venturing in other
directions—among them Picasso, Dix, Grosz, Severini, de Chirico, Hopper,
Burchfield, and Sheeler.[23] Barr also began to champion Surrealism, which led
him to deny that the integration of spaces, colors, and forms was the primary
purpose of art. And Barr would remain antiformalist. In 1949, for example,
defending Oskar Kokoschka against the art critic Ralph Pearson's contention
that he was not experimental enough, Barr accused Pearson of holding up as
standards the formal Cézanne-Cubist tradition and the " 'plastic value' esthetics
of 1920."

Kokoschka early produced a number of portraits which are important not
for their form, which is adequate, but for their extraordinary psychological
subtlety. Later, before 1920, he painted figure compositions, the best of
them unsurpassed in their time for their magnificent passion and rapture
expressed not through balanced formal organization, but through vehement
drawing and volcanic color. . . . [What] painter alive has surpassed or even
attempted anything comparable to his wonderful panoramic cityscapes of the
late 1920's; and who today can approach the exciting, lyrical virtuosity of
his recent mountain pictures or his views of Florence? They do not always
hold up structurally, but they reveal a mastery of color and electric drawing,
and a direct, vivid, emotional response to the visual world. These are "mod-
ern" values, too.[24]

Barr not only rejected formalism as *the* modernist approach, but by 1929 had already come to the conclusion that modern art had ventured to its outer limits.

By 1912 the ideal of *pure spontaneity* in painting had passed through varieties of expressionism to the ultimately amorphous *Improvisations* of Kandinsky. By 1920, the ideal of *pure design* in painting had passed through cubism to Piet Mondriaan's rectangles drawn with a ruler and painted red, yellow, and blue, or to Alexander Rodchenko's circles drawn with a compass, black on black. Romantic "spontaneity" was realized variously in dadaism, *Merzismus,* sur-réalisme, while classical emphasis on design was carried to the extremes of *Kompressionismus,* neoplasticism, suprematism, *purisme.* [25]

It seems extraordinary that by the age of twenty-seven, Barr should have so assimilated the major modern "isms"—grasped their central impulses and envisioned their ultimate manifestations. Thus, he could conceive of them as sufficiently formulated to be dealt with from an art-historical point of view. This prompted him to praise history-minded contemporary artists whose works referred directly to past styles—the Realist Otto Dix, for example—and were consequently considered retrograde in avant-garde circles. In looking back twenty years later, Barr remarked that his stance had been "reactionary."[26] But he did not again accept the claim that to be interesting modern art had to jump to new extremes. There were other criteria and options for modern artists. He granted that at any moment, one style did seem more interesting than others, but *relatively* more interesting, not *absolutely.* And no such style made the past obsolete. Very early in his career Barr rejected the vanguardist notion that art was progressing in one direction—the claim Clement Greenberg would later make. For avant-gardism, Barr substituted the conception of the history of art as a vast storehouse of ideas that living artists could use for new departures, depending on their vision, energy, and independence.

Barr responded to the pull both of tradition and of modern innovation, which seemed to subvert it: he was attracted to masterpieces with art-historical pedigrees and to lively new works with none, and even to movies, snapshots, and mass-produced artifacts, whose very status as art was questionable. He chose to be open to every pressure, committing himself only to "the discovery and proclamation of excellence."[27]

Not only was the entire history of art available to the contemporary artist, but "much scientific and psychological knowledge. . . . He picks and chooses whatever he wishes."[28] As he summed it up later: "Modern art is almost as varied and complex as modern life."[29] By 1934 Barr questioned every definition of what makes art modern: "The truth is that modern art cannot be defined with any degree of finality either in time or in character and any attempt to do so implies a blind faith, insufficient knowledge, or an academic lack of realism."[30] Certainly from this time on, Barr would regard modern art as too elastic, broad, and complex for a narrow, programmatic approach, although he did believe that

within its diversity, certain tendencies at any moment seemed *relatively* "more challenging, original and not yet accepted."[31] And because difficult art was attacked by those of conventional taste, "modern" remained a fighting word. Barr summed up his disposition toward problematic art in a letter to Mrs. John D. Rockefeller in 1947:

> Some kinds of art should be restful and easy—as Matisse said, like a good armchair. Other kinds, like Picasso's, challenge and stimulate us. They are often hard to understand at first but, like our minds and muscles, our artistic sensibilities are strengthened by exercise and hard work. I have never thought of art as something primarily pleasant—but as something which stirs us to a fresh awareness and understanding of life—even of the difficulties, confusions and tragedies of life as well as its joys.[32]

Barr's reluctance to define modern art stemmed in part from his recognition that preconceptions would curb receptivity to new experiences. Moreover, implicit in any definition was a restriction of the artist's freedom of creation or what it was permissible for a "modern" artist to create. Any such limitation or even its suggestion was intolerable to Barr. Only free artists could determine what art would be; curators, critics, viewers had to remain perpetually open to the new visions of artists.

Although Barr was reserved and scholarly, he was engaged in one widely publicized controversy after another throughout his career, as I have remarked. When there was an attack on modern art, particularly if directed at the Museum, Barr was quick to jump to its defense, but he ignored personal attacks. Perhaps what accounted for his combativeness was his moral conviction, the legacy of his father, a Presbyterian minister.[33] Barr also recognized that it was in controversy that his ideas could best be disseminated to a broad public. People could not help taking notice of a fight.

Barr stirred up his first controversy inadvertently in 1926, when there appeared in the *Harvard Crimson* an article titled " 'Boston Is Modern Art Pauper'—Barr."[34] Among other criticisms of Boston, Barr made or was alleged to have made, since he was badly misquoted,[35] was that "It is actually impossible . . . to study in any of these great galleries [the Museum of Fine Arts, Fenway Court, the Fogg], a single painting by Cézanne, Van Gogh, Seurat, Gauguin, masters who are honored the world over . . . but not in Boston."[36] The local newspapers picked up the story. The *Boston Evening Globe* and the *Boston Evening Transcript* ran it as a news item; the latter also published a temperate editorial.[37] But the art critic of the *Boston Herald* used Barr's remarks to savage the Post-Impressionists:

> Cezanne was a poor painter, one with bad eyesight. . . . Van Gogh was a crazy galoot, who cut off his ear to spite a woman and who painted for years

in an insane asylum at Arles. . . . At their worst [his paintings] resemble the crude, elemental "expressions" which nit-wits affix to sidewalks, fences, barn doors and elsewhere—especially elsewhere.[38]

And so on to Gauguin and Seurat. It was this kind of know-nothing "art criticism" that modern artists and their supporters were up against, not only in 1926 but in sophisticated art circles as late as the fifties and among the general public to this day. Even in art-historical circles ignorance was rife; Barr reckoned that between 1925 and 1930, only four articles on modern art had been published in the two leading professional journals.[39]

Forbes Watson used the controversy as the subject of an editorial in *The Arts.* He attacked the *Boston Herald* art critic for his "ignorant bigotry, blind irritation or some similar motivating force that leads a partisan reactionary to attack great painters in the language of appalling vulgarity." Watson concluded that the *Herald* review supported "the contention of Professor Barr that Boston is a pauper in modern art."[40] Fortunately, Watson, who happened to be conservative in his taste, was not alone in his open-mindedness. Beginning in the twenties, there was a growing audience for modern art, composed of educated, relatively affluent individuals who looked to art for stimulating experiences and even more, for self-liberation, exaltation, and renewal. Barr spoke to this new urbane public.

During its first season the Museum followed an even-handed exhibition policy, alternating between European and American artists; its second show was *Paintings by Nineteen Living Americans,* followed a year later by another American show.[41] Yet Barr and the Museum came under continual criticism for favoring foreign artists and neglecting Americans. Because this charge was "the greatest single source of animosity toward the Museum,"[42] Barr spent considerable time and energy refuting it. In 1940, he proposed to set the record straight in an issue of the Museum's *Bulletin* on the occasion of American Art Week, November 25–December 2.[43] In a memorandum of October 10 he wrote that "some such statement as we hope to make has been long overdue." He went on to say:

This is the background of our problem:
 The Museum was founded for the presentation and study of the modern arts without any nationalistic bias or prejudices. It was an implicit part of our policy to choose the best from all over the world. This did not mean, of course, that our own product was unimportant. I think that statistics will show that we have been more concerned with American art than with the art of all foreign countries combined. In spite of this fact there has certainly been some feeling, especially on the part of certain American artists and dealers, that the Museum was primarily concerned with "foreign art." This impression has been caused in part by the character and reputation of the

Trustees' collections, partly by the success of certain foreign exhibitions, and partly by the fact that in New York of the three principal museums concerned with modern art only the Museum of Modern Art deals with foreign art, whereas the Whitney and Metropolitan confine themselves in the 20th century exclusively to American art.

Still another important factor is the tendency on the part of the public to identify art with painting and sculpture—two fields in which America is not yet, I am afraid, quite the equal of France; but in other fields—the film, architecture and photography, for instance, the United States would seem to be the equal or superior of any other country.

If, then, we can in this Bulletin assemble our record in American art in all fields I am convinced that we will have a very strong case for no other Museum in the country has done as much to further the interest of American photography, American films, American architecture and American industrial design—nor when the facts are in do I think that painting and sculpture will be far behind.[44]

Before the coming of age of American art in the forties, Barr did favor French over American art because, as he gently suggested, there was simply no parity between the two. He was too politic to say that modern European art was in every way superior to its American derivations. Thus, as Barr said, the Museum was required to be internationalist in its acquisition and exhibition policies. But it was also nationalist because it had amassed and shown more works by American than by foreign artists. That, however, did not appease partisans of the American Scene. The issue for them was that the Museum's primary emphasis was on European masters and not on the *direct support* of native artists. This was largely responsible for "The Degradation of Art in America," the title of an essay Thomas Craven, the most prominent spokesman for Regionalism, wrote in 1948. It best exemplifies the Regionalist position. Craven had looked forward to "an art that truthfully reflects the native spirit of America and organizes our ways and experiences in form[s] at once beautiful and enduring." Such an art had not emerged, despite the efforts of John Steuart Curry, Thomas Hart Benton, Grant Wood, Charles Burchfield, and Reginald Marsh. Quite the contrary; even the "immense publicity accorded to their contributions" (in *Life* magazine, for example) had not prevented the waning, indeed, demise, of their influence. Instead, there was nationwide an "obsessive absorption in abstract drivel" imported from abroad and created by American artists who looked to European modernism for inspiration.

As Craven viewed it, blame for the abortion of an "American" art lay with a "clique" at the Museum,

a Rockefeller plant riddled by cultural sicknesses. Its top intellectual, Alfred Barr, master of a style that is one part mock-erudition and nine parts pure drivel, writes books on Picasso, the Red idol deified by the Parisian Bohemia

which he rules, and on other such deadly phenomena. His museum is a glittering depot of exotic importations and the claptrap of a few culled Americans who have nothing American about them.[45]

Curiously, the Regionalist position was close to the pro-Soviet position. In a widely discussed article entitled "Abstract Art Today: Doodles, Dollars and Death," 1952, in the left-wing publication *Masses & Mainstream,* Sidney Finkelstein condemned abstract art as the creation of The Museum of Modern Art. This decadent movement had denied art that was related to the artists' "own nation and people." But Finkelstein was more hopeful than was Craven. Russia was providing a model that "is healthy, depicts people as human beings, deals with real subject-matter and even history." Young American artists were turning to Socialist Realism, or in Communist jargon, were "seeking ways to make their art a force in the struggle for peace and democracy, for life against death."[46]

It is clear in retrospect that the Museum and its Regionalist critics were engaging each other at cross purposes, and there was no bridging their positions. The Regionalists condemned the Museum for not fostering a nationalist art. The Museum insisted that that was never its purpose and pointed with pride to its record in exhibiting and collecting American art as part of its internationalist mission. Ironically, the works by American artists that Barr did show and acquire were primarily figurative, not abstract, the evidence of which is the exhibitions *Americans 1942, Romantic Painting in America* (1943), and *American Realists and Magic Realists* (1943). These shows provoked criticism from internationalists in the American Abstract Artists and the Federation of Modern Painters and Sculptors. James Thrall Soby, Director of Paintings and Sculpture, defended the Museum against the latter's claims by denying that to be modern art had to disregard factual and romantic representation and follow Expressionist or abstract lines. As he saw it, these lines had been "established thirty to fifty years ago. Of course that is what *some* of modern art is and will continue to be, but not all of it. . . . [It is] precisely because the Museum has refused to accept so narrow and *final* a definition of modern art, it has been attacked time and again and will go on being attacked."[47]

In 1930, shortly after he had become the Museum's director, Barr "began to plot the overthrow of the reigning order of American architecture."[48] His first move was to ask Henry-Russell Hitchcock, an architectural historian he had met at Harvard, and Philip Johnson, later to be appointed head of the Museum's Department of Architecture, to organize an exhibition of modern architecture.[49] Its purpose would be to show that there had emerged in Europe in the middle twenties a revolutionary architectural style, exemplified by the buildings of Le Corbusier, Ludwig Mies van der Rohe, Gropius, and Oud—an "International Style," as Barr had already labeled it[50]—which should be introduced into the United States.

A building in this new style, as Barr characterized it, was not "a structure of brick or masonry with thick columns and supporting walls . . . [but rather] a skeleton enclosed by a thin light shell," which emphasized the volume of its interior space instead of its mass. Applied ornamentation was proscribed. Beauty "depends upon technically perfect use of materials whether metal, wood, glass or concrete; upon the fineness of proportions in units such as doors and windows and in the relationships between these units and the whole design."[51] The International Style, as Barr viewed it, both "in appearance and structure . . . is peculiar to the twentieth century and is as fundamentally original as the Greek or Byzantine or Gothic."[52] More important, in its aesthetic qualities, it was universal.

Before Hitchcock and Johnson's show took place in 1932, however, battles had begun to rage within the architectural profession among the modernists, Beaux-Arts followers, and the "modernistic" compromisers, who tried to merge new methods of construction with old styles of decoration. The controversy came to a head in 1931, when the Architectural League of New York, the bastion of Establishment styles, both Beaux-Arts and "modernistic," marked its fiftieth anniversary by mounting a more ambitious annual show than usual, at the Grand Central Palace. The selection committee excluded most International Style entries, although they did include the newly completed Philadelphia Savings Fund Society (PSFS) Building, the first International Style highrise in America, by George Howe and William Lescaze. In angry protest, Barr and Johnson quickly took counteraction. As Johnson recalled,

> some of us . . . set up an exhibition in a storefront on . . . [Seventh] Avenue which we called "Rejected Architects," after the famous Salon des Refusés of Paris a hundred years ago . . . and we made a lot of noise by having sandwichmen parade up and down Lexington Avenue in front of the Grand Central Palace, to call attention to the unfairness of the League.[53]

Johnson wrote at the time that the public was able "to witness an unusual fight. Not every day does the orderly profession of architecture dramatize itself in a blaze of controversy." Johnson concluded: "a Salon des Refusés has again served to announce a new departure. The International Style comes to New York. . . . [Indeed, it is given] what might be called its first formal introduction to this country."[54]

Then, on February 10, 1932, *Modern Architecture: International Exhibition*, curated by Hitchcock and Johnson, opened. It was the Museum's first traveling exhibition, touring the United States, in different versions, for over seven years. The show was accompanied by a two-hundred-page catalogue with a foreword by Barr and texts by Hitchcock and Johnson on the International Style and Lewis Mumford on city planning. Both the display and the catalogue were meant to be, in Barr's words, "an assertion that the confusion of the past forty years, or rather of the past century, may shortly come to an end."[55] And this assertion

was strengthened by the publication in 1932 of a book by Hitchcock and Johnson entitled *The International Style,* again with an introduction by Barr.[56]

Within weeks of the opening of *Modern Architecture,* new work that Howe and Lescaze submitted to the 1932 show of the Architectural League was rejected. Both architects resigned from the League. Johnson recalled that this was "just the opportunity he and his colleagues had been waiting for to strike a blow against reaction."[57] Johnson and Barr, with the help of Edward L. Bernays, a well-known publicist, saw to it that this move caught the public's attention, because as Howe and Lescaze's "PSFS was the principal ornament to the American section of the International Exhibition [at the Museum, Bernays] . . . succeeded in having the event reported on the front page of the *New York Times* on Sunday, 28 February 1932, and the item received wide coverage in other American cities as well as abroad."[58]

The controversy continued in the newspapers but did not exercise the general public much, probably because there was little International Style architecture built in the Depression thirties, possibly because, as Robert A. M. Stern says, "The realities of economic depression tended to trivialize issues of style."[59] However, the Museum's show was as important as the London Crystal Palace exhibition in 1851 or the Chicago Columbian Exposition in 1893, because it "named and legitimatized a brand of Modernism that came to dominate American and international developments."[60] At least, a change in the curricula of architectural schools did follow the Museum show.[61] Beaux-Arts design never recovered from the campaign of Barr, Johnson, and Hitchcock.

In his foreword to *Modern Architecture,* Barr suggested that the International Style was more functional and relatively less expensive than other architectural styles, but what he valued most was its modernity, originality, and aesthetic quality, especially the last. To put it another way, Barr focused on architecture as art and minimized the economic, social, and political side of the International Style mentality—the idealistic and moralistic belief that the new architecture would help usher in a brave new world.[62] Hence his use of the word *style* in the label International Style.

Barr was particularly critical of the rigid utilitarian or technologist supporters of modern architecture for their "artistic nihilism."[63] Indeed, in the preface of the Hitchcock and Johnson book, he suggested "post-functionalism" as an alternative label to the International Style.[64] As he remarked, the International Style could not reach maturity until the architects had been influenced by painters and sculptors, and "had passed through the discipline of cubism and were studying the esthetics of free asymmetric equilibria by means of interpenetrating rectangles (de Stijl) or the esthetics of volume without mass, of engineering, and of industrial textures and surfaces (the constructivists)."[65]

Barr's commitment to the International Style was reiterated in 1936 while the Museum was planning a new building. This was the Museum's best chance to propagate the faith. Philip Goodwin, a trustee, was selected as architect by his fellow trustees, and Barr concurred. But when the site was enlarged, Barr

deemed the project important enough to secure Mies van der Rohe, Gropius, or Oud as the associate architect and got permission from the Building Committee (Clark, Goodyear, and Nelson Rockefeller) to interview them.

Goodwin did not want any of the Europeans and quickly appointed a young American, Edward Durell Stone, as his associate. Without knowing of Goodwin's decision, Barr approached the European masters. Gropius and Oud were unavailable, but Mies was willing to collaborate with Goodwin. Goodwin would first have to agree, and Barr undertook to persuade him. This brought him into confrontation with one of his employers and most likely other trustees as well, but such was Barr's passion and courage that he risked the consequences. Because Barr believed that Goodwin's friends on the board might find it embarrassing to broach the issue of Mies themselves, he undertook to write Goodwin himself.

In his letter, Barr said:

The Museum was founded to show people the finest in modern art from all over the world. We have tried to do this but whenever we have consciously and deliberately fallen below this standard (as has happened) we have betrayed the purpose of the Museum. The Museum, I believe, has done more than any other institution to initiate the reform in American architecture by bringing before the public the finest European work which was, in 1930, from five to twenty-five years ahead of America. Since 1930 a whole generation of young American architects have tried to master modern principles (in spite of their anachronistic schooling) but they have not had time—at least the American-bred ones—or experience enough to prove their mastery. If we were to build five years from now I think we could choose a young and modern American with some confidence, but now I don't think we can, at least not for a building as important as ours should be.

For these reasons I think we are under obligation to consider one of the obviously superior Europeans. . . . I know that some of our Trustees are strongly nationalistic in feeling but I think they do not hesitate to buy their English clothes or French hats (if not French pictures)—nor do they seriously object to the Museum's owning foreign paintings. Why then should we be prejudiced against a foreign architect?

Barr went on to say that if Goodwin worked with Mies, he

would be backing . . . a man whom many of us believe is the greatest architect of our generation (granting that Corbusier is the most original and brilliant). . . .

The Museum, as a patron of modern architecture, cannot afford to run the risk of mediocrity in the design of its new building. It must have the superlatively best. . . . With you and Mies—whatever the difficulties—I think we would get a great building, something to be proud of twenty and

a hundred years from now, and what is just as important, something we can face the world with the day it is completed. . . .

Now I have written to you as a friend and, I hope, ally. If you wished you might misinterpret this letter—so I want to repeat what I said before —that I think you have an important and essential role to play in this business, not only as architect but also as the Trustee more responsible than any other for the Museum's architectural standards.[66]

Even after Goodwin confirmed his choice of Stone over Mies and threatened to withdraw if the matter was not dropped, Barr continued to lobby stubbornly for Mies, but without success. "Very tired and fed up,"[67] he resigned from the Building Committee. (However, Barr found Mies a commission to design a house, which enabled him to come to the United States in 1937.)

In his letter to Goodwin, Barr had predicted, "America will be going completely modern within the next few years," and, in 1944, he said: "The *battle* of modern architecture in this country is won." But there were other issues, for example, "The revaluation of the American past . . . and the development of a modern American architecture from the mingling of traditional American techniques and materials with the forms of [Frank Lloyd] Wright and the Europeans."[68] Indeed, there had been a growing interest in stone and wood "traditional vernacular building" and "native folk-architecture."

Regional architecture in California became the topic of a controversy in 1947. In an article in *The New Yorker,* Lewis Mumford attacked functionalism, abstract aestheticism, and the idea of architecture as a machine for living; he called instead for more of a "native and human form of modernism one might call the Bay Region style, a free yet unobtrusive expression of the terrain, the climate, and the way of life on the coast." Excerpts from Mumford's article became the basis for discussion at the symposium of architects organized by Barr at the Museum.[69]

Barr rose to the defense of the International Style by reiterating that he was "on the side of architecture as an art rather than on the side of mere building." He then went on to deal with several "misconceptions" about the International Style, again distinguishing it from "functionalism" (particularly the debased, commercially determined version that would turn out to be the most devastating enemy of International Style architecture), and dismissing the notion that the "International Style was conceived as a kind of rigid strait-jacket requiring architects to design cubistic, white stucco boxes on Lally columns, with flat roofs and glass walls." He stressed, in Hitchcock and Johnson's words: "The International Style is broad and elastic enough for many varying talents and for many decades of development."[70] And as he said elsewhere in the same year: "Spreading throughout the world the new style has been modified by national and local needs and traditions and, in this country, by an interchange of influences with Frank Lloyd Wright."[71]

Thus Barr questioned whether the "Bay Region Style" should be viewed as

an alternative to the International Style, as Mumford claimed it was, or as an "International Cottage Style . . . a kind of domestication of the International Style" that answers the "criticism of the doctrinaire functionalists for [its] not providing 'comfortable houses for ordinary living.' "[72]

At the end of World War II an immense building boom began in America. Most of what went up was debased modern, and by the end of the fifties, this was painfully obvious. In 1966, the year before Barr's retirement, the Museum published Robert Venturi's *Complexity and Contradiction in Architecture,* which was to be the opening salvo in a widespread attack on the International Style.

The Museum set out to change public attitudes not only toward architecture but toward design. In 1929 Barr endorsed the view that "culture depended not upon taste in Persian miniatures or Sheraton highboys but upon discrimination in motor cars, the shapes of steam radiators and ten-cent store crockery. . . . [Art] is not a means of escape from life but a stratagem by means of which we conquer life's disorder."[73] *Machine Art* (1934), curated by Philip Johnson, the first of the Museum's design shows, aimed to establish principles of good modern design that were closely related to those of the International Style, and to "illustrate a victory in the long war between the Craft and the Machine."[74] In a statement (in the catalogue of *Machine Art*) that remains the Museum's policy toward design, Barr concluded: "If . . . we are to 'end the divorce' between our industry and our culture we must assimilate the machine aesthetically as well as economically. Not only must we bind Frankenstein—but we must make him beautiful."[75] The Museum also intended that its design shows serve as a practical guide to consumers and as an incentive to businessmen to manufacture and sell artifacts of "good design." So well did it succeed in these aims that it discontinued its design shows in 1955.

The general public's response to the Museum's industrial arts and design shows was cordial. Advocates of "high" art, however, objected to the inclusion of "low" art in the hallowed precincts of the Kunstmuseum. For example, Hilton Kramer questioned the Museum's allegiance to the mass-produced artifacts of everyday life and kitsch culture. He granted that the Museum's purpose—to elevate public taste—was salutary at first. But he deplored "the commercial flim-flam—automobiles, sporting goods, atrocious Hollywood movies—whose presence under the same roof [as master paintings and sculptures] promised to blur the very distinctions of feeling upon which the great modern painters had founded their art." Kramer believed that the Museum's accommodation of mass culture had compromised and corrupted "art in its pure and autonomous forms."[76] Barr thought not—no need to confuse the two.

In 1936, Barr organized the most important surveys in his career: *Cubism and Abstract Art* and *Fantastic Art, Dada, Surrealism.* The Cubism show was huge, occupying all four floors of the Museum. It was Barr's kind of show, encompassing painting, sculpture, constructions, photography, architecture, the-

ater, films, posters, and typography. It traced the history of Cubism, step by step, beginning with Impressionism, and explored Cubism's relation to Fauvism, Futurism, Expressionism, Surrealism, and other styles and kinds of art, as well as to the succeeding abstract movements in Europe. The Dada and Surrealist show began with fantastic art of the fifteenth and sixteenth centuries and included the art of children and of the insane, folk art, commercial and journalistic art, and scientific objects.

Cubism and Abstract Art was impressive indeed, but it generated its share of controversy. Barr was taken to task, on the one hand, for his formalist interpretation, and, on the other hand, for treating Cubist-inspired abstraction as a dead end, an essentially historical tendency. In his catalogue text Barr stressed that abstract painters were motivated by an urge to abandon natural appearances and confine themselves to the "immediate, sensuous, physical surface" of their work. They assumed that a painting "is worth looking at primarily because it presents a composition or organization of color, line, light and shade . . . as an end in itself with its own peculiar value." It is, in a word, autonomous. Barr added: "Such an attitude of course involves a great impoverishment of painting, an elimination of . . . the connotations of subject matter, sentimental, documentary, political, sexual, religious [among others]. . . . But in his art the abstract artist prefers impoverishment to adulteration."[77] With an art so intent on formal matters, Barr was willing to adopt a formalist interpretation—but not because he himself preferred it.[78] He did distinguish "pure-abstractions" from "near-abstractions." The latter contained subjects that could be enjoyable, much as they were secondary to the "primary relationship of form and color *within* the picture." Thus, despite "the fact that the Cubists themselves and their most ardent admirers attached little importance to subject matter," Barr granted that Cubist subject matter was worthy of analysis, as his friend Meyer Schapiro insisted, and Barr devoted a long footnote to Schapiro's interpretation.[79]

But Barr was referring only to Schapiro's treatment of Cubist "near-abstractions." Schapiro, as he wrote in 1937, also meant his approach to apply to "pure-abstractions." In an article titled "Nature of Abstract Art," Schapiro praised Barr's catalogue as "the best . . . that we have in English on the movements now grouped as abstract art," while rejecting Barr's treatment of "this art as independent of historical conditions, as realizing the underlying order of nature and as an art of pure form without content."[80] As Schapiro saw it, the Neo-Plasticists, Constructivists, and Suprematists had been influenced in part "by the current conception and norms of the machine. . . . The painters thus tied their useless archaic activity to the most advanced and imposing forms of modern production. . . . They often looked upon their work as the esthetic counterpart of the abstract calculations of the engineer and the scientist."[81]

Schapiro did recognize the autonomy of art, as he wrote in 1936: "Art has its own conditions which distinguish it from other activities."[82] But with these alone, one could not understand why art has been so diverse and why it changes.

For such an understanding, it was necessary to situate art within changing historical and social contexts, to take into account the social conditioning of artists in their own time and place. This applied even to modern artists who claimed that art was the expression of an individual's personality, and/or a preoccupation with formal issues alone. Barr had attributed style changes to the exhaustion of styles through overuse and failures of imagination. Schapiro held changes in society primarily accountable.

There was some justification for Schapiro's criticism of Barr. Barr did not deal extensively with social and ideological considerations in his analysis of art; instead, he emphasized art-historical and aesthetic considerations, relating and comparing one style to another. In Schapiro's eyes, this made Barr a formalist. But he was not a formalist in the sense that the term has been used since the sixties; that is, as interpreted by the critic Clement Greenberg, who postulated that each of the arts was progressing toward "purity," occupied with what was unique and irreducible in its medium. Greenberg's approach was too narrow and deterministic for Barr; it ran counter to his desire for pluralism.

The controversy between Barr and Schapiro also took up a question of great concern to most artists and their audience during the Depression decade: the social use of art, particularly abstract art. Although Barr chose to focus on the formal qualities of Cubist painting and sculpture, he also felt the need—it was more like a tic in the thirties—to relate art to politics, describing how it was dealt with by the dictators of Communist Russia, Nazi Germany, and Fascist Italy. He concluded by condemning censorship and suppression by bureaucrats abroad and also at home, such as the customs officials who had refused duty-free entry to nineteen pieces of more or less abstract sculpture that Barr wanted for the Cubist show. In the end, what counted most to Barr was freedom of creation. As he said: "This essay and exhibition might well be dedicated to those painters of squares and circles (and the architects influenced by them) who have suffered at the hands of philistines with political power."[83]

Among those who opposed abstract art were also the American followers of Russian Communism who scorned its alleged bourgeois decadence and ivory-tower escapism. These allegations, despite their crudeness, were taken very seriously in intellectual and cultural circles during the Great Depression, when capitalism seemed in collapse. And so were the anything but crude ideas of anti-Communist Marxists, particularly those who were published in *Partisan Review* after 1937. Schapiro, for example, in addressing the question of the autonomy of art from a social point of view, wrote: "Artists who are concerned with the world around them in its action and conflict, who ask the same questions that are asked by the impoverished masses and oppressed minorities—these artists cannot permanently devote themselves to a painting committed to the aesthetic moments of life, to spectacles designed for passive, detached individuals, or to an art of the studio."[84] Unlike the Stalinists, however, and possibly in recoil from the retrogressive and dreary Socialist Realism they promoted, Schapiro did not specify what a socially conscious art should be.[85] And, in fact,

he did advance the possibility that the abstract artist who shunned "the common slogans of reform or revolution as possible halters on his personal freedom" could be thought of as "historically progressive, since it [his position] makes possible for the first time the conception of the human individual with his own needs and goals."[86]

This was the option that was taken in 1938, in articles in the anti-Stalinist *Partisan Review* by Leon Trotsky, Diego Rivera, and André Breton.[87] (Rivera was an old acquaintance, Barr having first met him during his trip to Russia in 1928,[88] and Breton was the "pope" of Surrealism, the movement that most engaged Barr at the time.) They proposed that self-realization was historically progressive, and their position came to be accepted by most independent Marxists. These articles affirmed that art must look to no other authority than its own requirements in order to avoid Stalinist dictation on the one hand and, on the other hand, bourgeois cooptation. As Trotsky wrote: "Truly intellectual creation is incompatible with lies, hypocrisy and the spirit of conformity. Art can become a strong ally of the revolution only in so far as it remains faithful to itself."[89] Employing a social revolutionary rationale to justify the autonomy of art in which Barr had always believed must have intrigued him, despite its belatedness, since this was precisely the rationale previously used to attack modern art.[90]

In retrospect, it is clear that Barr organized *Cubism and Abstract Art* because of the historical importance of Cubism, not because he believed in its potential for future development. He had written approvingly of Dutch de Stijl and related styles in Germany and Russia as early as 1928,[91] and by then these tendencies were some dozen years old. By 1930, much as he continued to admire the work of the innovators, notably Mondrian and Malevich, he had come to believe that their ideas were exhausted.[92] As he summed it up in 1933: "By 1915 some painters had achieved such purity of design that they were working with ruler and compass. By 1920 several of these purists had (literally) painted square canvases in pure white or black, thrown them (figuratively) out the window and turned to something really interesting such as photography or architecture."[93]

Having reached a dead end, Cubist abstraction had been superseded by new styles, notably Surrealism, in Barr's opinion.[94] In rejecting geometric abstraction, Barr did not repudiate all abstraction, not the abstraction formed from "the spontaneous scrawls of automatic drawing."[95] From the first, he hailed Miró as one of the leaders of the Surrealist group.[96]

Barr's turn to Surrealism was carefully considered, but there appears to have been a Surrealist cum Dada heart pumping lifeblood into his intellectual discipline even thirty years later. How else to explain his introduction to "Homage to New York: A self-constructing and self-destroying work of art conceived and built by Jean Tinguely," March 17, 1960?

Forty years ago Tinguely's grandadas thumbed their noses at Mona Lisa and Cézanne. Recently Tinguely himself has devised machines which shatter the

placid shells of Arp's immaculate eggs, machines which at the drop of a coin scribble a moustache on the automatistic Muse of abstract expressionism, and (wipe that smile off your face) an apocalyptic far-out breakthrough which, it is said, clinks and clanks, tingles and tangles, whirrs and buzzes, grinds and creaks, whistles and pops itself into a katabolic Götterdämmerung of junk and scrap. Oh great brotherhood of Jules Verne, Paul Klee, Sandy Calder, Leonardo da Vinci, Rube Goldberg, Marcel Duchamp, Piranesi, Man Ray, Picabia, Filippo Morghen, are you with it?

TINGVELY EX MACHINA
MORITVRI TE SALVTAMVS[97]

Barr's preference for Surrealism over Cubism is clear in *Cubism and Abstract Art.* He juxtaposed "Two main traditions of Abstract Art," one of the headings in his text. "The first and more important current" found its sources in Cézanne and Seurat and led to geometric abstraction. "The second—and until recently, secondary—current had its principal source" in Gauguin, and flowed through Matisse to Kandinsky. "After running under ground for a few years it reappears vigorously among the masters of abstract art associated with Surrealism." Barr went on to say: "The shape of the square confronts the silhouette of the amoeba."[98]

Later that same year he wrote that Surrealism "is serving as a link between psychology on one hand and poetry on the other; it is frankly concerned with symbolic, 'literary' or poetic subject matter . . . ; its esthetic of the fantastic, enigmatic and anti-rational is affecting art criticism and leading to discoveries and revaluations in art history."[99]

As to the upshot of the confrontation between Cubism and Surrealism, Barr remarked: "At the risk of generalizing about the very recent past, it seems fairly clear that the geometric tradition in abstract art . . . is in the decline. . . . The non-geometric biomorphic forms of Arp and Miro and Moore are definitely in the ascendant. The formal tradition of Gauguin, Fauvism and Expressionism will probably dominate for some time to come the tradition of Cézanne and Cubism."[100]

It is not surprising then that Barr had excluded young American geometric abstract artists from *Cubism and Abstract Art.* Not only did he not find their art interesting,[101] but as he said, they had been included the year before in a show of *Abstract Painting in America,* at the Whitney Museum.[102] However, the Whitney show, consisting mainly of semiabstractions, had been discouraging to the geometric abstractionists.[103] The Modern's exclusion of them from its Cubism show added to their disappointment.

The young Americans felt that they had been doubly rejected—by the Whitney and the Modern—and this provoked them to meet to consider how to present their works and ideas to the public. The upshot was the formation of the American Abstract Artists (AAA), which soon comprised some fifty members. They had welcomed *Cubism and Abstract Art* for revealing the history,

scope, and depth of the movement, and they found Barr's analysis to their liking,[104] but as George L. K. Morris recalled, the show was too "exclusively historical. The [Cubist] traditions were put forward as something finished and exhumed . . . [coming] near to playing into the hands of those critics who had been proclaiming for twenty years the demise of abstract art."[105] It was this attitude that the AAA set out to rebut.

The AAA did not give up on Barr yet. In 1938, it asked to hold its second annual show at the Museum. Carl Holty, a spokesman for the AAA, wrote to Barr: "It is natural that the group looks upon the Museum of Modern Art as the authentic place where contemporary thought and effort in art is clearly identified."[106] Barr responded that "as a matter of policy the Museum does not give exhibitions to artists' groups unless it is given full jury powers to select or omit."[107]

This rejection most likely provoked the American Abstract Artists to declare war on The Museum of Modern Art. In 1939, to celebrate its tenth anniversary and the opening of its new building, the Museum presented *Art in Our Time*, a huge show featuring American nineteenth-century painters and European twentieth-century innovators. The following year, the Museum displayed a major loan exhibition of Italian Renaissance painting,[108] which it coupled with its own show, *Modern Masters*, consisting mainly of late nineteenth-century European and American paintings. In April 1940, the Museum exhibited a selection of drawings and cartoons submitted to a contest sponsored by the newspaper *PM*. To the AAA that was the last straw; on April 15, some fifty members picketed the Museum. They distributed a leaflet designed by Ad Reinhardt (so striking that the Museum acquired one for its Design Collection) headlined: "How Modern Is the Museum of Modern Art?" The broadside answered its own question: "Lets look at the record. In 1939 the Museum professed to show ART IN OUR TIME—Whose time? Sargent, Homer, LaFarge and Hartnett [sic]? Or Picasso, Braque, Leger and Mondrian? Which time? If the descendants of Sargent and Homer, what about the descendants of Picasso and Mondrian? What about American abstract art? . . . Shouldn't 'modern' conceivably include the 'Avant Garde'?" The letter was signed by fifty-two artists, among them Josef Albers, Fritz Glarner, László Moholy-Nagy, and David Smith.[109]

Although Barr denied that Cubist-inspired geometric abstraction was avant-garde, the American Abstract Artists believed it was, and made a persuasive case, even though it did not convince Barr. He turned out to be right, however, if the verdict of history is the criterion. Despite the merit of Burgoyne Diller, Albers, and a few others, geometric abstraction in America proved to be the minor tail end of the movement. It was Surrealism that became the source of the next move in abstraction, which would lead to an independent American art, Abstract Expressionism, whose innovation, power, and quality Barr was among the first to recognize.

However, before the Abstract Expressionist avant-garde emerged, the Museum featured American Surrealists, Magic Realists, and Romanticists who did

not amount to much, those in *Americans 1942,* and *Realists and Magic Realists,* and *Romantic Painting in America* (1943). But it was on the right track and its historical shows were very timely indeed. Certainly *Paul Klee* (1941) and *Joan Miró* (1941–42) were revelations to a newly emerging avant-garde, including Arshile Gorky, William Baziotes, Robert Motherwell, Adolph Gottlieb, and Mark Rothko. Other exhibitions that influenced the development of American avant-garde art in the forties in ways that the Museum could not have predicted were its shows of primitive art (which incidentally were admired by the Surrealists): *American Sources of Modern Art* (Aztec, Mayan, Incan; 1933), *African Negro Art* (1935), and particularly *Indian Art of the United States* (1941). Adolph Gottlieb began to paint his primitivistic "pictographs" after *Indian Art,* and Jackson Pollock's totemic paintings of 1942–46 owed a debt to it as well.[110]

By 1943, The Museum of Modern Art had grown more or less into the institution we now know. Its permanent collection was, even then, the most distinguished of its kind in the world; its exhibitions, many of which traveled through its Department of Circulating Exhibitions, were justly renowned; the publications that accompanied them were noted for their scholarship, lucidity, and the quality of their design; the Museum's Architecture and Photography departments were established, as was an expanding program in industrial design; a Film Library and a general library, whose collection of books on modern art would soon be unsurpassed, were in place; an international program had been initiated; a Young People's Gallery was founded, a *Bulletin* was being published, and as of 1939, the Museum had been housed in a new modern building on West 53rd Street. All of this had been achieved under the directorship of Barr. And yet in 1943, he was summarily fired by Stephen Clark, at the time both President of the Museum and Chairman of its Board of Trustees.

From the start, Barr had recognized that he needed the confidence of his trustees—he called them "the noble gentry"[111]—but they were at times difficult to work with. Edward M. M. Warburg, a trustee, remarked that many of his colleagues considered it their right to participate in arranging exhibitions; they were "frustrated museum directors."[112] In the early days, some of them would not hesitate to remove from the walls works they did not like—and for reasons that did not involve the considerations of quality, history, and contemporary relevance that Barr brought to bear. He did object when he could, and at times trustees were offended. But he kept within the limits they set, employing what Goodyear spoke of as his "fine Italian hand" in guiding them.[113] Why then was he fired?

In part, personality differences between Barr and Clark were responsible. But these were largely the result of conflicting opinions as to what the mission of the Museum ought to be. At the root of the problem was the dual role of the Museum as a Kunstmuseum or permanent repository and a Kunsthalle, a showplace of new, often problematic, and even iconoclastic art. Clark considered the

first role primary, and possibly wished it could be the Museum's only role. Barr wanted the Museum to be active in both roles. He succeeded until the roles appeared to come into conflict, the one seeming to call into question the dignity of the other, of the Museum itself, at least in the opinion of Clark.

This occurred in 1942, when Barr approved the exhibition of a decorated shoestand by a New York folk artist named Joe Milone. Clark was appalled by what he considered Barr's frivolity. Barr's taste and judgment became even more suspect when he supported an exhibition of paintings by Morris Hirshfield, a retired Brooklyn slipper manufacturer. Barr's interest in "Modern Primitives" or "Artists of the People," as he called them, was well known. In 1941, he had devoted the first gallery of the newly installed Museum Collection to such artists, and in the *Bulletin* there had appeared a reproduction of a nude by Hirshfield.[114] The following year, Barr contributed a foreword to a book by Sidney Janis, *They Taught Themselves,* in which he wrote: "Each generation creates art. It also discovers art." One such discovery, a mainstream of modern taste, was the primitive, which included self-taught painters. "All this immense range of art has one extraordinary thing in common: it has been discovered esthetically and revalued within the past hundred years and mostly in the last fifty." In this regard, it was modern. "In fact it was just about fifty years ago that the greatest modern primitive, Henri Rousseau of France, was first given some appreciative recognition."[115]

The art critics ridiculed the Hirshfield show. *Art Digest* referred to him as the "Master of the Two Left Feet," because he painted only left feet, and Emily Genauer of the *New York World-Telegram* panned the show as "a stunt . . . a frivolous and ill-considered summer gesture (with Mr. Hirshfield the goat)."[116] A. Conger Goodyear allowed Genauer to publish an excerpt of a letter he had written to Clark: "It seems to me that this exhibition is very silly, perhaps the silliest we have ever had, and that I think is saying a good deal. . . . I have acquiesced in this exhibition, but I certainly am not going to do so in the future. . . . Really I think we must put a stop to it. It would be far better to have no exhibitions at all than things of this sort. . . . I think that together we can stop the present tendency."[117]

If the function of the Museum was to be that of a Kunstmuseum, as Clark and Goodyear evidently thought it should be, then Barr's primary if not sole value would be that of a scholar, removed from the organization of exhibitions. To this end, Clark assigned Barr as his main activity the writing of a book on the history of modern art. Barr, however, continued to occupy himself with Museum management; this prevented him from fulfilling his assignment and provided Clark with the excuse for his dismissal as Director. Barr stayed on at the Museum, nevertheless, and in 1947, he assumed the post of Director of Museum Collections.

The Museum's dual role as a Kunstmuseum and a Kunsthalle has continued to be controversial. The reputation of the permanent collection could not help but validate and provide cachet for problematic contemporary works that had

not yet met the test of time. Moreover, critics have claimed that the art-historical study of the new works in well-documented, excellently produced catalogues conferred on them a prestige that was premature: by giving the new art the same serious consideration that earlier art had received, Barr made the new, in a word, respectable. He has been viewed as having used his formidable connoisseurship, scholarship, and showmanship to brainwash the public on behalf of the new art by one set of his critics[118] and to have academicized avant-garde art by another set.[119]

As a caretaker of time-proven art, the Museum had historical hindsight to support its claims; as a talent scout for often iconoclastic art whose standards and values were not clear, it had only the hope of future acclaim. Each of its decisions as to what contemporary art to collect and to show was based not on an established consensus but on an estimation of the current situation in art which history did not always validate. This problem was exacerbated by the recognition painting, sculpture, architecture, design, and photography often achieved when exhibited at the Museum. Thus, the Museum has often been accused of influencing the course of the arts it was supposed to be documenting and preserving. Barr was extremely sensitive to these criticisms, but there was no way out of the dilemma, except to stop exhibiting and acquiring new art. This Barr refused to do since he believed it would turn the Museum into a mausoleum.

Differences in opinion as to what the Museum should acquire and exhibit remained, and because Barr's primary responsibility was its collection, they strongly affected his plans for it. In Barr's "Chronicle" of the collection, under the heading 1948, the following entry appears:

> Early in the year, some older members of the Committee on the Museum Collections, encouraged by adverse newspaper criticism, vigorously questioned the validity of certain acquisitions, including paintings called "abstract expressionist." Purchase was difficult. (Later, in 1952, a member of the Committee "reluctantly" resigned when a Rothko was acquired; another member had resigned when Giacometti's *Chariot* was purchased in 1951; it was "not a work of art," he wrote. Both men, however, remained on the Board of Trustees.)[120]

(It is noteworthy that the one trustee was Clark and the other Goodyear.)

In order to understand Barr's problems during the late forties, it is necessary to take into account both the adverse media criticism that inhibited his activities and how he countered it, and the differences between what he would have liked to do and what he was allowed to do, separating his aspirations from the Museum's actions. The issue of the acquisition of Abstract Expressionist paintings is a particularly sensitive one. It has often been said that Barr was late in recognizing and acquiring Abstract Expressionist works. Actually, Barr was

early in his recognition; the Museum, however, because of the reservations of the Acquisitions Committee, may have been late in its collecting, an assertion that has often been made and that is open to question. Differences in taste between Barr and the members of the Committee notwithstanding, they all were aware of and influenced by the climate of opinion about advanced art in the late forties, particularly in 1948, when modern art and the Museum came under its fiercest and most sustained attack—this just at the time that Abstract Expressionism was emerging. If the attacks had come only from chauvinistic philistines, they would have been bearable, as in the past, but they also came from enlightened, internationalist liberals, a number of them art-world and even Museum "insiders."

The know-nothings—newspapers and popular magazines generally, Congress and President Truman—considered abstract art "Communistic"; its purpose was to subvert American free enterprise. In 1946, Hearst newspapers and hidebound congressmen had prompted the cancellation of a U.S. State Department show titled *Advancing American Art* in the middle of a successful tour of Europe and Latin America. The show consisted of a cross-section of modern works purchased by the government, including works by several artists identified with the left and a number of abstract paintings. The picture that became the main butt of ridicule (recalling the public response to Duchamp's *Nude Descending a Staircase* some thirty years earlier) was *Circus Girl Resting* by Kuniyoshi. Although innocuous, the *Girl* was widely condemned for maligning American womanhood. President Truman remarked that it represented "a fat, semi-nude circus girl" and that "the artist must have stood off from the canvas and thrown paint at it . . . if that's art, I'm a Hottentot."[121] That made news, as did Truman's other descriptions of modern art as the "ham and eggs school" and "the vaporings of half-baked lazy people."[122] In July 1948, the collection of seventy-nine oil paintings and thirty-eight watercolors in *Advancing American Art* were ignominiously auctioned off as war surplus.

Vituperation like Truman's was to be expected. But what of art-world insider opinion in 1948? In an article in *Harper's Magazine*, "The State of Modern Painting," Lincoln Kirstein claimed that he was not one of what he called "the permanent Philistia—the academicians and nationalists who in every country and in every epoch defend inertia by invoking patriotism, social responsibility, or normalcy in the arts." Not he. He was a close friend and collaborator of Barr, a member of the Museum "family," who at the time his article appeared was mounting a Nadelman exhibition there. And yet he identified himself as a member of "a new opposition [which] is not conservative . . . [but] reactionary," an opposition hostile to "improvisation as a method, deformation as a formula, and painting (which is a serious matter) as an amusement manipulated by interior decorators and high pressure salesmen. The new opposition deplores a basic lack of general culture, historical and scientific, on the part of most of our painters, and their lack of stable technical processes and rational craftsmanship."[123]

One would suppose that Kirstein meant Pollock or Rothko, but no, he had Léger and Matisse in mind—Matisse, "a decorator in the French taste, the Boucher of his epoch, whose sources in the miniatures and ceramics of Islam are, inch for inch, his superior." And who was to blame? The Museum of Modern Art, because of the effectiveness of its publications and permanent collection.[124] If someone like Kirstein, who was respectfully listened to by powers at The Museum of Modern Art, could question its permanent collection because it contained works by Matisse, what chance was there for Pollock and his colleagues. This was what Barr—who was very hurt by Kirstein's attack— was up against.

Soon after Kirstein's article appeared, Francis Henry Taylor, the Director of The Metropolitan Museum of Art, published in *The Atlantic Monthly* "Modern Art and the Dignity of Man," which became notorious because of the following passage: "Instead of soaring like an eagle through the heavens as did his ancestors and looking down triumphantly upon the world beneath, the contemporary artist has been reduced to the status of a flat-chested pelican, strutting upon the intellectual wastelands and beaches, content to take whatever nourishment he can from his own too meager breast." His art communicated only to snobs, "an intellectual elite—the fashionably initiated." It was incommunicable to the average public. Taylor allowed that "the public must respect the artist's freedom of creation," but added that "in the same way the latter must acknowledge the public's freedom of acceptance or rejection." With regard to modern art, the public had rebelled, and in Taylor's opinion, with great justification.[125]

Also in 1948, Boston's Institute of Modern Art, founded in 1935 as an offshoot of The Museum of Modern Art, changed its name to The Institute of Contemporary Art. The change was fraught with significance. To Barr, "modern" was an open-ended term, denoting the "more challenging, original and not yet accepted movements in philosophy, theology and the arts. . . . That is why we used the word when the Museum of Modern Art was named."[126] But James S. Plaut, the Boston Institute's Director, wrote that today " 'modern art' describes a style which . . . has become both dated and academic." In Plaut's statement, titled " 'Modern Art' and the American Public," he wrote:

> Like all revolutionary movements, modern art had its imaginative leaders and brilliant apologists, its struggle with reaction. . . . Now that a full generation has passed since its inception, it has become imperative to reappraise the movement. . . . The artist gradually withdrew from a common meeting-ground with the public. . . . This cult of [bewilderment] rested on the hazardous foundations of obscurity and negation, and utilized a private, often secret, language.[127]

Of all the attacks, it was Plaut's that most troubled Barr, in part, because of the publicity it received—some 15,000 copies had been circulated;[128] in part,

because the Boston Institute was a museum of modern art, and one that had been established by The Museum of Modern Art itself; and in part, because it seemed, as Barr viewed it, one more move in a "general campaign to discredit modern art and the museum."[129] Barr launched a countercampaign, beginning with a confidential ten-page typewritten memorandum for use of the trustees and staff, in which he provided a paragraph-by-paragraph rebuttal of Plaut's argument.[130] As a summary, Barr wrote:

> [Plaut's] statement seems to me inconsistent and full of errors, both in theory and in fact, opportunistic, spineless and essentially reactionary. It is true that many artists and the general public are out of step. It is not true that this is the fault of the artist more than that of the public. It is not true that valid modern art stopped in 1914 and became a cult of bewilderment until it was brought to a close in 1939. Of the various 20th century movements only one could be called, after objective analysis, a "cult of obscurity and negation," and this is dadaism which lasted from 1916 to 1922. And even dadaism was inspired fundamentally by a strong sense of moral indignation and revulsion against the stupidity and inhumanity of "civilization" which had brought about World War I and postwar chaos. To admire the modern art of 35 years ago and attack the modern art of today reveals an embarrassing hardening of the arteries. To "enjoin" the artist seems to me an impertinence.
>
> The statement of principles, insofar as one can see beneath the cant and platitude, appears to be a confession of fear and incompetence; it fails to make clear how these self-righteous resolutions will be carried out in a practical program even superficially different from the past; nor does it indicate how contemporary art differs from now "defunct" modern art.
>
> In conclusion one may say that the artists have yet to be heard from.[131]

The artists were heard from, in protest meetings in Boston and New York, the latter at The Museum of Modern Art. But their agitation did not amount to much, and the issue subsided for a year, until *Life* magazine got around to the "Revolt in Boston," focusing on a show the Institute of Contemporary Art had organized titled *Milestones of American Painting in Our Century*. *Life* reported that the museum, no longer able to "stomach the word 'modern,'" supported the position that modern art was the imitation "of contemporary European schools" and thus "a silly and secretive faddism." In its place, the show promoted "the main trends in U.S. art of this century which [the museum believes] are chiefly rooted in native traditions that are romantic or realistic."[132] Barr saw his opportunity to reopen his campaign against Plaut and his supporters. He pointed out that the *Life* article had misinterpreted the purposes of the ICA exhibition by treating it as a confirmation of Plaut's manifesto of the year before. "The Boston exhibition itself is a very fair survey of American painting of the past half century," Barr wrote. But *Life* had made a "biased and highly unrep-

resentative selection [of reproductions] from the Boston show"; its purpose was unmistakably chauvinistic.[133]

On February 21, the day after the *Life* article appeared, Barr sent a telegram to Plaut with the following challenge: "May I urge that you publicly and in detail correct or repudiate the current article in Life which by its use of the Institutes name and arrant distortions of your catalog has greatly confirmed your institutions reputation as a compliant instrument of reactionary forces. Yours in an unofficial and friendly spirit."[134] Barr had evidently contacted other leading figures in the art world who had called or written Plaut, for on March 1, Plaut wrote to Lloyd Goodrich, Associate Director of the Whitney Museum: "LIFE's nationalistic bias is familiar to intelligent readers everywhere. The Institute has nothing whatever to do with LIFE's editorial policy and it would seem gratuitous for us to 'disassociate' ourselves from it." But Plaut had had enough and suggested a peace conference with representatives of the Whitney and The Museum of Modern Art to "clear the air which is charged today with bitterness and misunderstanding" and to "arrive at common principles."[135]

On May 17, 1949, Barr agreed to accept Plaut's proposal to formulate a three-museum statement:

> We both . . . Goodrich and I, responded privately that such a statement would involve a virtual reversal of the Institute's statement of the previous year. Plaut, without saying so explicitly, implied that such a reversal would not be disagreeable to Boston. . . .

Barr went on to say that in preparing the statement, he and Goodrich "had in mind the general state of popular confusion as well as the articles of Taylor, Kirstein, the recent *Life* statement, and above all, the Boston statement."[136] In drawing up the joint statement, Barr played the central role. He prepared the original draft, after which he and Goodrich discussed it at a meeting with Soby and Hermon More, Director of the Whitney Museum. Then the four men met with Plaut and Frederick S. Wight, Director of Education of the ICA. On the basis of these two meetings, Barr and Goodrich prepared the preliminary statement, which took a year to refine, Barr writing the final report. In the interim, Barr kept the pressure on, not only to keep the ICA from backsliding but because he may have sensed that the controversy might effect a significant change in American taste. For example, on April 25, 1949, a letter condemning the *Life* article was published in the magazine, signed by eleven museum directors whose institutions had lent works to the ICA show and by thirteen of the twenty private lenders.[137]

The final "Statement," issued in March 1950, proclaimed the "general principles" governing the relation of the three museums to contemporary art:

> We affirm our belief in the continuing validity of what is generally known as modern art . . . which has produced the most original and significant art of our period. . . .

We believe that a primary duty of a museum concerned with contemporary art is to be receptive to new tendencies and talents. . . .

We believe that the so-called "unintelligibility" of some modern art is an inevitable result of its exploration of new frontiers. . . .

We believe in the humanistic value of modern art even though it may not adhere to academic humanism with its insistence on the human figure as the central element of art. Art which explores newly discovered levels of consciousness, new concepts of science and new technological methods is contributing to humanism in the deepest sense, by helping humanity to come to terms with the modern world. . . .

Believing strongly in the quality and vitality of American art, we oppose its definition in narrow nationalistic terms. We hold that American art which is international in character is as valid as art obviously American in subject matter. We deplore the revival of the tendency to identify American art exclusively with popular realism, regional subject and nationalistic sentiment.

We also reject the assumption that art which is esthetically an innovation must somehow be socially or politically subversive, and therefore un-American.

The joint statement noted the Nazi and Soviet suppression of modern art and concluded:

We believe that it is not a museum's function to try to control the course of art or to tell the artist what he shall or shall not do; or to impose its tastes dogmatically upon the public. A museum's proper function, in our opinion, is to survey what artists are doing, as objectively as possible, and to present their works to the public as impartially as is consistent with those standards of quality which the museum must try to maintain. . . .

We believe that there is urgent need for an objective and openminded attitude toward the art of our time, and for an affirmative faith to match the creative energy and integrity of the living artist.[138]

The "Statement on Modern Art" was accepted by American museums generally. It also signaled a critical change in attitude of the art-conscious public toward contemporary art. After 1950, it was no longer intellectually respectable to attack modern art as if it were some joke. What this means is nothing less than that Barr's campaign against the Boston Institute was the catalyst for a discernible change in American attitudes toward modern art. The new attitude was reflected in the shows organized by the Museum, such as *Abstract Painting and Sculpture in America* (1951) and *Fifteen Americans* (1952), which featured first-generation Abstract Expressionists, and *12 Americans* (1956), which introduced members of the second generation.

Avant-garde artists felt embattled throughout the fifties. In 1950, eighteen

of them, the so-called Irascibles, protested against the anti-modern bias of the Metropolitan Museum, but as remarkable as the protest was the wide publicity that it received.[139] In the following year, however, Motherwell, Reinhardt, and Bernard Karpel (Librarian of The Museum of Modern Art) wrote: "Today the extent and degree of Modern Art in America is unprecedented. From East to West numerous galleries and museums, colleges and art schools, private and regional demonstrations display their mounting interest in original plastic efforts. One can say that by 1950, Modern Art in the United States has reached a point of sustained achievement worthy of a detached and democratic treatment."[140]

This may have been true in art-conscious circles. But know-nothing attacks were growing in number and intensity, and Barr turned his attention to them, not only because they were aimed at modern art but because they attempted to censor it, and artistic freedom was a lifelong cause for Barr. Indeed, what bothered Barr most in Plaut's statement was the remark: "We enjoin the artist to exercise his historic role of spiritual leadership, and to forge closer ties with an ever growing public in terms of common understanding."[141] Barr responded: " 'Enjoining' the artist is a highly debatable step. The leading 'enjoiners' of artists in the 20th century have been the Nazis and the Soviet Communists. . . . [The] *'excesses' of modern art exist only in free countries,* and desire to suppress them is generally and historically symptomatic of a fear of freedom."[142]

But Plaut's "enjoining" was mild compared to the mounting attacks on artistic freedom from other quarters. While framing the three-museum statement, Barr called attention to

> the demagogic propaganda appearing in the Hearst and McCormick newspapers, the State Department's suppression of the exhibition of modern paintings [*Advancing American Art*] . . . , the recent attacks on modern painting by Congressman Dondero of Michigan . . . on the charge that modern art is Communist. Dondero has repeated these charges on the radio *this very morning* [May 17], CBS, 7:45 news. Dondero is reported by CBS to have charged that *modern art was Communist propaganda,* and that *critics who support modern art should be attended to.* I consider this potentially a very serious propaganda line, and think that in our statement we should point out that the modern art which people such as Dondero call Communist and want suppressed is hated and actually suppressed in the U.S.S.R.

Barr pointed out that Plaut agreed since "only recently the Chairman of the Board of Trustees of the Boston Museum had angrily accused Rouault of being a Communist on the basis of his pictures."[143] Such was the hysteria at the time.

During the fifties, Barr was in the vanguard of every major battle for artistic freedom.[144] So passionate was he in this cause that in 1949, he jumped to the defense of Emily Genauer, disregarding her scurrilous attacks on him in the

past, when she was forced out of her job on the *New York World-Telegram* because of an attack by Congressman Dondero. Barr was particularly provoked by Federal censorship of the arts. In a speech at the convention banquet of the American Federation of Arts in 1953, Andrew H. Berding, the Assistant Director of the United States Information Agency (USIA), said that the role of the government was "delineating those important aspects of the life and culture of the people of the United States which facilitate understanding of the policies and objectives of the Government of the United States." That meant "communication, a means of interpreting American culture to other peoples." Therefore, the USIA was against exhibiting "experimental art. We want to show the artistic nature and achievement of America in ways that all peoples abroad can understand. . . . [Our] Government should not sponsor examples of our creative energy which are non-representational to the point of obscurity."[145] The USIA blackballed not only abstract artists but also those who were admitted Communists or those who refused to testify before congressional committees regarding their connection with the Communist movement.

In 1956, the USIA aborted the tour of a show it had sponsored titled *Sport in Art,* which was to have traveled to seven major museums in the United States and end up in Melbourne, Australia. Organized by the American Federation of Arts with partial funding from *Sports Illustrated,* the show was intended to commemorate the Olympic Games of that year. The cancellation was provoked by protests from patriotic groups in Dallas, Texas, demanding that alleged subversive artists be removed from the display despite the resistance of the Dallas Art Association (the host organization) and the Federation. Within a month, the USIA was once again embroiled with the Federation over another show, *100 American Artists of the Twentieth Century.* The USIA demanded that ten "politically unacceptable" artists be removed from the exhibition. The forty-two trustees of the Federation, of whom Barr was one, unanimously voted not to participate if any censorship took place. The tour was canceled.

Not only was Barr active in the Federation (and the American Civil Liberties Union), but he also wrote a public letter in which he called upon the American Federation of Arts, the American Council of Learned Societies, and the College Art Association to join in an "out-spoken defense of American principles of freedom" against both "the Communists and the fanatical pressure groups working under the banner of anti-communism."[146]

It is difficult now to imagine how hurt abstract artists were by assaults on their patriotism, sanity, and morality. They reacted with profound discouragement and a sense of alienation from American life (exacerbated by the enormous growth of mass culture). The despair is exemplified in a 1957 article by Meyer Schapiro advising artists to withdraw from public life in order to serve American culture best. The "artist must cultivate his own garden as the only secure field in the violence and uncertainties of our time . . . maintaining his loyalty to the value of art—to responsible creative work, the search for perfection, the sensitiveness to quality." Schapiro went on to say: "Painting by its impressive

example of inner freedom and inventiveness and by its fidelity to artistic goals . . . helps to maintain the critical spirit and the ideals of creativeness, sincerity and self-reliance, which are indispensable to the life of our culture."[147]

And yet, as Schapiro comforted artists, their condition was improving. By 1954, Paul Sachs could say: "Through courageous, audacious and crusading leadership, the Museum has changed the climate of public opinion from one of hostility to one that is today open-minded and receptive to all aspects of modern art. No longer is the new dismissed with contempt and ridicule. Instead, there is in the art world of America an attitude of curiosity, reflected in books and periodicals, in the daily press—yes, even in the universities."[148] Schapiro may have been somewhat too pessimistic, Sachs, prematurely optimistic, but within a decade, Sachs's statement would be substantially true.

Those who thought that the Museum should be more avant-garde in its orientation accused Barr of neglecting the new American painting, a claim that the record proves wrong. Had Barr not been held in rein by conservative members of the Acquisitions Committee and had the art-critical climate been more favorable to avant-garde art in the late forties, he would have acquired Abstract Expressionist paintings earlier and in greater numbers than he actually did, although what he did manage to introduce into the permanent collection was impressive indeed.

The idea that Barr was "late on Abstract Expressionism" was first advanced by Thomas B. Hess, executive editor of *Art News.* In the fifties *Art News,* under Hess's leadership, had become the "family" magazine of the New York School, as the first generation Abstract Expressionists and their followers were often called. As early as 1954, Hess complained about the Museum's "baffling lack of recognition of postwar American abstract painting and sculpture," a lapse prevented "from becoming a scandal" only by the *Americans* exhibitions of 1946 and 1952, organized by Dorothy C. Miller, Barr's close associate at the Museum.[149] Again, in the summer of 1957, Hess rebuked the Museum for speaking *"for* rather than to its enormous [presumably middlebrow] public."[150]

Barr responded by chiding *Art News*—not Hess—for its own neglect of Abstract Expressionism.[151] Barr could have mentioned that the very first article published by *Art News* on the new American painters—Gorky, de Kooning, and Pollock—was the English version of his preface to the catalogue for the twenty-fifth Venice Biennale, and that was only in 1950.[152] Barr's 1957 letter also defended the Museum's record in exhibiting and collecting avant-garde pictures prior to 1952. For example, he had acquired Gorky's *Garden in Sochi* (1941) in 1942. He saw *She-Wolf* at Pollock's first show at the Art of This Century gallery in 1943 and immediately reserved it for the Museum before the reviews of Greenberg and other critics were published,[153] and by the end of 1952, he had acquired fifteen more New York School works shortly after they were painted.[154]

Hess was quick to get Barr's point, for in response to his letter, he wrote: "Mr. Barr is probably the most informed, courageous and efficacious champion modern art has had since Apollinaire. But although he was the founding Director of the Museum of Modern Art and in the past ten years has headed its extensive collections, the Museum does not express his identity."[155] Hess did make one telling criticism, that the Museum had not devoted an entire show to Abstract Expressionism as it had previously done for other tendencies. This was not rectified until the following year when the Museum organized *The New American Painting,* which toured in Europe in 1958 and then was shown at the Museum in 1959.

The question remains: when did Barr come to appreciate Abstract Expressionism? In a letter to Hess in 1961, he wrote:

> Rothko I'd been following since the late '30s but without great enthusiasm until the Parsons show in 1950 although I had bought one earlier for Blanchette Rockefeller. The Stills I saw at Peggy Guggenheim seemed bad, and still do, but, later, Dorothy Miller brought one over from Parsons for me to study and I was convinced. Kline was love at first sight at Egan's— and fortunately Dave Solinger saved me from frustration by giving us the *Chief.* We showed de Kooning once in the 1930s but I'm ashamed to say . . . that I'd forgotten him entirely until Renée Arb spoke of him with admiration in 1947 and we bought one from Egan's first show a few months later. Baziotes I liked at Peggy's and Kootz but not enough to buy until 1947.[156]

In his public statements, Barr was open in his admiration of Abstract Expressionism. In 1949, in answer to a question put to him by the *Magazine of Art* as to whether there was a single "well-marked trend or direction" in contemporary American art, he replied in the negative, in keeping with his and the Museum's policy of pluralism. But in the next sentence, he added: "There is, however, a strong, broad and diversified movement toward abstraction, often highly original in character." Moreover, "American painting seems to me more vigorous and original than that of any single European country."[157] It is noteworthy that of the fifteen other distinguished critics and museum officials who were canvassed by the *Magazine of Art* on "the state of American art," only Greenberg and Douglas MacAgy, then Director of the California School of Fine Arts, singled out Abstract Expressionism for acclaim.

Although a number of Abstract Expressionists kept grumbling about Barr's neglect of them, they themselves acknowledged his sympathy for their art by inviting him to the three-day Artists' Sessions they organized at Studio 35 in April 1950. Not only was he the sole nonartist participant, but he was asked to serve with Richard Lippold and Robert Motherwell as a moderator.[158] Barr's recognition of Abstract Expressionism encouraged Dorothy Miller to include Pollock, Rothko, Still, Baziotes, and Tomlin in her *Fifteen Americans* show in

1952. That show marked the Museum's official acceptance of a number of Abstract Expressionists, only four years or so after their "breakthroughs" to mature styles.

Barr's interest in Abstract Expressionism was acknowledged not only by the artists, but by their aesthetic enemies as well, some forty-four of whom organized in 1953 to publish a magazine called *Reality*. [159] With Abstract Expressionism in mind, they wrote in their statement of purpose that "texture and accident, like color, design, and all the other elements of painting, are only the means to a larger end, which is the depiction of man and his world. Today, mere textural novelty is being presented by a dominant group of museum officials, dealers, and publicity men as the unique manifestation of the artistic intuition." The group associated with *Reality* pledged in the name of "humanism" to oppose those who had "produced in the whole world of art an atmosphere of irresponsibility, snobbery, and ignorance."[160] The main culprit was the Museum, and the *Reality* group called upon it to give realism "the same serious and scholarly consideration that the Museum has extended to abstract art recently, and to all forms of modern art in times past." They offered to meet with Museum representatives to discuss the issues, and two conferences were subsequently held—but as they saw it, the Museum's policy remained unchanged.[161]

Barr, René d'Harnoncourt, Director of the Museum, and Andrew C. Ritchie, Director of the Department of Painting and Sculpture Exhibitions, answered *Reality* in an "Open Letter":

> it is true that the Museum has responded to the very widespread and ebullient movement which has so greatly enriched the tradition of abstract art here and abroad during the past ten years—just as in the previous decade it paid heed to the various realistic and romantic tendencies which throve in that period under the names of "regionalism," "social consciousness," "neo-romanticism," "surrealism," "American Scene," et cetera. Time moves on and art changes but neither then or now, as a matter of policy, has the Museum tried to guide or influence artists or favor one direction more than another.[162]

There was no pleasing anyone, as Barr wrote in reply to Hess's criticism of the Museum in 1957: "Some of the Museum's friends have questioned this policy [of not committing itself entirely to one tendency], urging that the Museum align itself exclusively with the current avant-garde. Its bitterest enemies insist that the Museum has already done exactly that."[163] In 1958, in the introduction to the catalogue of *The New American Painting,* Barr concluded that to have written it was "an honour for an American who has watched with deep excitement and pride the development of the artists here represented, their long struggle—with themselves even more than with the public—and their present triumph."[164]

In the very year that he wrote this, however, Barr was questioning the

viability of Abstract Expressionism, not with regard to its pioneers but to their successors. Did the tendency continue to offer fruitful possibilities to a second generation? With characteristic courage, Barr broached this question in dialogue with Hess and Harold Rosenberg at one of the artists' gatherings known as the Club, before an audience composed primarily of younger Abstract Expressionists.

Barr asked: "Is the younger generation rebellious or is it basking in the light of half a dozen leaders? Are Tenth Street artists living on the energies of the painters of the forties or early fifties? Is this a good or bad thing? Or is it just inevitable? Is it unavoidable? Should there have been a rebellion by 1958? I looked forward to it, but I don't see it. Am I blind or does it not exist? Are painters continuing a style when they should be bucking it?"

Hess countered: "I don't see why an artist in 1958 has to rebel against a work done in 1950. This may be imposing a pattern of rebellion that doesn't necessarily apply. . . . [The] situation is different. A painter [today] . . . may not want to make a gesture of rebellion." Rosenberg agreed. He said that a break-through had occurred, and implied that it opened ways for talented artists who followed.

Barr then added: "It may be that the vein is rich enough that it may take a whole generation to mine it. It may take more time for boredom to set in. Working out veins leads to minor discoveries. I hope that I am wrong, that something new is happening. Temperamentally, I'd like to see some pictorial or verbal rejection by people in their twenties of people in their forties and fifties. What we value most in the last hundred years was achieved in rejection and reform."

The discussion turned to the need for a critical attitude on the part of artists. Barr pointed to "De Kooning's dissatisfaction with his own works. This is not apparent among his juniors and that is rather sad." Young Abstract Expressionists in the audience turned on Barr angrily; one called him a gravedigger who refused to see that the revolution was continuing. Another said: "I am surprised that a respectable head of a respectable museum should be calling for revolution."[165]

Soon after his appearance at the Club, Barr discovered a "new generation, some of them in conscious reaction against their elders [who would soon make] . . . their mark in Europe too."[166] He purchased three paintings for the Museum from Jasper Johns's first show at the Castelli Gallery, and he arranged for friends of the Museum to buy three more. Barr's acquisition of Johns's work in depth prompted later critics to suggest that he should have done the same with Abstract Expressionist pictures. However, given the funds the Museum had for buying art and the trouble Barr had in acquiring the avant-garde paintings that he did, it is doubtful that his committee would have permitted it. Barr's receptivity to Johns enabled him to recognize Frank Stella's black-stripe paintings, which were influenced by Johns, when he first saw them. Stella was given his "first" show by Dorothy Miller in her *16 Americans* at the Museum in 1959,

and Barr purchased a major painting from the exhibition. *16 Americans* heralded the Museum's exhibition and acquisition policy with regard to new art in the sixties, anticipating its support of the new hard-edge abstraction and Pop Art.

Barr retired from the Museum in 1967, but so powerful had been his impact that the controversies that had raged around him continued. In the seventies, modern architecture in general and the International Style and its debased variants in particular came under growing attack by the young architects and allied critics and historians commonly labeled post-modernists. Although Barr had been closely identified with the International Style, he personally was not taken to task, since he had not written on architecture for more than a decade, and it was the Museum's publication of Venturi's *Complexity and Contradiction in Architecture* in 1966 that ushered in post-modernist polemics. In the late seventies, the polemics shifted to the realm of the visual arts, where the butt of the post-modernist attack was nonobjective art, notably geometric abstraction, the counterpart in painting and sculpture of the International Style, and more specifically, Minimal Art.[167] Again Barr escaped criticism, since his conception of modernism was broad and he was not particularly associated with geometric abstraction or Minimalism.

However, in the eighties, when social-minded critics and historians—many of them neo-Marxists—launched a campaign of vilification against abstract art generally and especially against Abstract Expressionism, they aimed much of their abuse at Barr as its most prestigious champion. Neo-Marxists generally tend to be biased against abstraction—although they do not always own up to it. They favor realism, either for sentimental reasons, in the name of everyday life (Carol Duncan and Alan Wallach),[168] or for philosophic reasons, in the name of materialism (Timothy Clark).[169] Moreover, on the whole, neo-Marxist art critics and historians ignore art as art and art history, and concentrate instead on ideology and history,[170] an approach repugnant to Barr.

Focusing on the stature achieved by Abstract Expressionism at home and abroad, neo-Marxists correlated its artistic domination over other styles, as it were, with America's world hegemony. It was but a step from correlation to conflation. Neo-Marxists began to think of the new American painting itself as the artistic weapon in the arsenal of American imperialism in its cold war with international Communism. Because anti-Communist congressmen who considered the work subversive did not permit the State Department to wield this weapon (an irony that neo-Marxists do not seem fully to comprehend), The Museum of Modern Art was supposed to have been given that mission—unofficially, to be sure—by the rich trustees who controlled it. As the mind and soul of the Museum, Barr was poised in the front lines and became a major target for Marxist criticism.

Max Kozloff, a non-Marxist, in an article titled "American Painting During the Cold War," 1973, was the first to broach the idea that Abstract Expression-

ism might be dealt with in the context of politics, national character, and history since the end of World War II. He noted that "the switching of the art capital of the West from Paris to New York . . . coincided with the recognition that the United States was the most powerful country in the world." This led him to speculate about a possible connection between Abstract Expressionism and American society and to conclude that the content of both was freedom. Because artists in America were free, in contrast to their counterparts in Communist or Fascist countries, the Abstract Expressionists exemplified freedom in their works with "a grave sense of mission. Each of their creative decisions had to be supremely exemplary in the context of a spiritual privilege denied at present to most of their fellow men."

Their sense of mission was intensified by their awareness of French Existentialist ideas, notably Sartre's "notion that one is condemned to freedom, that the very necessity to create oneself, to give oneself a distinguishable existence, was a desperate, fateful plight." Thus, American Abstract Expressionist painting was excruciatingly relevant to its time. When it was sent abroad by the Museum and even by the United States Information Agency, it was, according to Kozloff, "as evidence of America's coming of creative age and as a glorifying of American civilization." But, he added quickly: "We are not so careless as to assume that such an ideal was consciously articulated by artists, or, always directly perceived by their audiences."[171]

Kozloff was praised by Eva Cockcroft in an article titled "Abstract Expressionism, Weapon of the Cold War," but she claimed that he was wrong in maintaining that the links between cultural cold-war politics and Abstract Expressionism were coincidental or unnoticeable. In her opinion, they were consciously forged by influential figures who controlled "the leading museum of contemporary art—The Museum of Modern Art" and who advocated "enlightened cold war tactics designed to woo European intellectuals." The success of Abstract Expressionism was the result not so much of the power of the art but of "the ideological needs of its [the Museum's] officers during a period of virulent anticommunism and an intensifying 'cold war.'"

Cockcroft viewed Barr's role as pivotal. As the "single most important man in shaping the Museum's artistic character and determining the success or failure of individual American artists and art movements," he was the major "cultural cold warrior." Moreover, Barr had formulated "the political rationale behind the promotion and export of Abstract Expressionist art during the cold war years. . . . [This is] set forth in a *New York Times Magazine* article Barr wrote in 1952, 'Is Modern Art Communistic?,' a condemnation of 'social realism' in Nazi Germany and the Soviet Union. Barr argued in his article that totalitarianism and Realism go together." Barr had argued nothing of the sort, but Cockcroft was correct in claiming that he was antitotalitarian, admired Abstract Expressionism, and promoted it abroad as best he could.[172]

In actuality, art-conscious capitalists and the museums of which they were trustees were hesitant until well into the fifties to collect Abstract Expressionist

paintings, even though prices were very low.[173] But assuming, as neo-Marxists have, that avant-garde art did interest them, what might the attraction have been? The answer, according to Duncan and Wallach in an article titled "The Museum of Modern Art As Late Capitalist Ritual: An Iconographic Analysis," was that Abstract Expressionism glorified "individualism, understood as subjective freedom" and was aesthetically detached, that is, "negating the world of human emotions and needs," "the content of everyday life."[174] But how could painting as abstract, subjective, and difficult as Abstract Expressionism be effective as cold-war propaganda? On the one hand, it was supposed to provide proof of the sophistication of American culture. On the other hand, its individuality and subjectivity could be taken as signifiers of the artist's freedom and, by extension, of the United States as a free society.[175]

As Duncan and Wallach saw it, it became the purpose of the Museum to establish individualism and "aesthetic detachment" as the goals toward which modern art had been progressing. They likened the Museum to great cathedrals of the past as buildings that "affirm the power and social authority of a patron class," instruments of "class domination." The layout of galleries in The Museum of Modern Art, like the Stations of the Cross, directed the spectators inexorably toward the high altar of Abstract Expressionism.[176]

If the "aesthetic detachment" of Abstract Expressionism became "the ultimate value of artistic experience," as Duncan and Wallach claimed it had, then it followed that the painting would be analyzed only in formal terms. Art had to be dealt with exclusively with reference to its medium and its stylistic history, which was governed by an internal formal dynamic or dialectic. Thus, formalism was considered by neo-Marxists to be the aesthetic ideology of capitalism. (There was also the implication that the ruling class would not want art dealt with in social and political terms.) Because Barr was pivotal, it was necessary to establish him as a formalist, and neo-Marxists did this by focusing on his formal analysis in *Cubism and Abstract Art,* and ignoring his disclaimers and everything else he had written. This created a gross distortion, to say the least, of Barr's essay on Cubism and his body of writing.[177]

In fact, Barr's interpretation of Abstract Expressionist paintings, in keeping with their aesthetics, was antiformalist. As he wrote in *The New American Painting:*

> [T]hey are never formalistic or non-objective in spirit. Nor is there (in theory) any preoccupation with the traditional aesthetics of "plastic values," composition, quality of line, beauty of surface, harmony of colour. When these occur in the paintings—and they often do—it is the result of a struggle for order almost as intuitive as the initial chaos with which the paintings begin.
>
> Despite the high degree of abstraction, the painters insist that they are deeply involved with subject matter or content. The content, however, is never explicit or obvious even when recognizable forms emerge, as in certain paintings by de Kooning, Baziotes, and Gottlieb. Rarely do any conscious

associations explain the emotions of fear, gaiety, anger, violence, or tranquillity which these paintings transmit or suggest.[178]

From the conjecture that Abstract Expressionism was the art of *late capitalism,* it was but a short step to presuming that it was the art of *American imperialism,* that it was at one and the same time created in direct response to the cold war and perceived to have been so by art-conscious cold warriors, who, in order to demonstrate that capitalist culture was superior to that of Communism, exported it in significant enough numbers to make a strong impact abroad —and all this by 1947–48, at the beginning and the height of the cold war. This was the central thesis in Serge Guilbaut's book, *How New York Stole the Idea of Modern Art.* He argued that: "The new painting was made [by the Abstract Expressionists] in the image of the new America, powerful and internationalist but anxious about the Communist threat,"[179] the cultural counterpart of the Truman Doctrine and Marshall Plan. According to Guilbaut, its creation and "victory" took place by the end of 1948.[180]

Guilbaut was wrong. Although several of the innovators of Abstract Expressionism did achieve their "breakthroughs" in 1947–48, the tendency had not yet had the time to achieve recognition at home, not to mention abroad. As I have shown, 1948 was a disastrous year for modern art in America. Barr was curbed by his trustees, and it was not until 1951 that a show of abstract art was mounted at the Museum, and not until 1952 that a significant number of Abstract Expressionists were exhibited in depth. Now that Abstract Expressionism is writ large in art history, it is easy to forget that in 1948, the entire avant-garde art world—artists, dealers, collectors, critics, museum personnel— comprised only about a hundred people, and that it was not until after 1950 that the new American painting was taken seriously outside this small circle.[181]

It was only after 1952 that the Museum launched an international program of any scope and ambition, a fact accepted by Kozloff and Cockcroft,[182] and not until 1958, a decade after the inception of the cold war, that a major show of Abstract Expressionist painting introduced it into Europe in numbers sufficient to make a strong impression. Ironically, by 1958 Barr had already become dissatisfied with the subjectivity central to Abstract Expressionism and was promoting younger artists who were reacting against it.

The question remains: what were Barr's motives in sending the new American art abroad? By 1952, he was certainly aware of the need to counter Communist expansion. In that year, *Partisan Review* held a widely publicized symposium titled "Our Country and Our Culture." Its editors and all but a few of the contributing writers and literary critics agreed that a large number of intellectuals had come to recognize in American democracy intrinsic, positive values that had to be defended against Russian totalitarianism.[183]

Barr concurred wholeheartedly. Even before Pearl Harbor, in his *Annual Report* of 1940, he asked how the Museum could engage in the struggle against Fascism and Nazism and in "the preservation of cultural freedom." Perhaps it

could strengthen national morale. He asked: "Could not the American's pride in his own civilization be confirmed by pointing to achievements in the arts?"[184] Barr himself exulted in the success of Abstract Expressionism abroad,[185] to the extent of indulging in a little irony, as no cultural imperialist would have, claiming that "its success . . . has tended to go to the heads of some of the artists and their supporters. Here and there one finds an almost chauvinistic insistence on the importance of the New York School. All the same, though, it *is* a highly novel and enjoyable situation in which one can worry even a little bit about excessive enthusiasm over the virtues and international fame of a group of American artists."[186] Pride, yes; chauvinism, no. "Granted that the New York School—specifically, the Abstract Expressionists and the painters sympathetically related to them—has had many men of enormous energy and talent. Nevertheless, it seems doubtful that they could have gone so far had it not been for the dozen or so [European] painters who found refuge in New York during the Second World War."[187]

Barr was aware of the need to combat Soviet expansion and of the potential role of American art in this effort. But he refused to separate this effort from the struggle against censorship in America. In a letter to the President of the American Federation of Arts on its selection of artists to be represented in the Venice Biennale of 1952, he remarked on

> the extraordinary scepticism toward us, and even hatred, which has arisen in Europe because of our reported resort to authoritarian fanaticism, repression, and censorship. McCarthyism may have thrown light on a few subversive characters, but it has done us immense damage among European liberals, especially within that very influential and important body of European intellectuals and artists who are anti-communist or neutral. . . . Our talk of freedom does not jibe with our willingness to tolerate its *unnecessary* suppression.
>
> We ought, therefore, for political effectiveness to send abroad exhibitions which are *not only as good in quality as we can possibly make them,* but which will also *demonstrate our tolerance* of self-criticism and diversity of social attitudes. Censorship and over-caution can interfere with the quality and esthetic values of our exhibitions as well as with their effective content. . . .

In a postscript Barr wrote:

> I might add that I have been deeply interested in the problem of artistic freedom for twenty-five years. I believe I have watched its disappearance in the U.S.S.R. and then in Nazi Germany with closer attention and over a greater period of time than anyone in the American art world. We are fighting an enemy who has boldly and shrewdly stolen our own thunder, first "democracy," then "peace." The Soviet propagandists are now hoping to

steal "freedom," too, for their own perverted uses. Let's not help them! And let us ask ourselves, when the question of censorship arises: first, what are we afraid of, and second, whom are we protecting?[188]

Barr simply was not going to let the Donderos get away with censorship. If they were going to try to keep the best of American art from being exhibited beyond our borders, he would try to make sure that it was. Ironically, it was precisely the McCarthyist anti-Communism exacerbated by the cold war that more than any other motive provoked Barr to want the best American art, regardless of whether it was abstract or created by alleged subversives, shown abroad, where it indeed served in the cause of anti-Communism.

By 1943, his last year as the Museum's Director, Barr had realized the plan for the Museum that he had formulated in 1929. He had also been responsible for acquiring an extraordinary permanent collection, mounting a series of brilliant loan exhibitions, and producing catalogues which established a model of excellence. This quality is particularly evident in his writings, many of which became (and remain) standard works on their subjects. Dwight Macdonald observed: "In the thirties, Barr developed a style of catalogue that both satisfied the cognoscenti and interested the laity by combining an elegance of format, a scholarly precision, and a richness of data, none of them usual in works on modern art at that time, with a clear readable style, which was even less usual. The Museum's pioneering catalogues, some of them really books, are still models of how to popularize without vulgarizing."[189] This body of work significantly fostered the interest of the general public in modern art—his *What Is Modern Painting?* has gone through eleven editions in English, as well as publication in Japanese, Portuguese, and Spanish—and the teaching of this subject in American universities and colleges. The College Art Association has recognized Barr's contribution by establishing an annual Award for Museum Scholarship in his name.

Barr's writings not only defined in large measure our conception of modern art but equally important, the issues they addressed continue to generate controversy today; the name of Barr as friend or foe recurs repeatedly in a variety of current polemics. In addition, Barr's writings are a pleasure to read; his "light, clear, and reasonable style is refreshing."[190] Macdonald wrote this in 1953, summing up a quarter of a century of Barr's work; it remains as apt some thirty years later.

A NOTE ON THE TEXT

Original spellings and punctuation have been retained; obvious typographical errors have been silently corrected. Ellipses points (. . .) have been used to indicate omission of text. Where plate and page references are no longer applicable, they have been deleted. A. N.

1. THE VISIONARY

When, in 1929, as the newly appointed director of The Museum of Modern Art, Alfred Barr announced its imminent opening, he used as his podium not only the official brochures put out by the Museum, but also—as he was to do frequently, with great effect, throughout his career—the pages of the popular press: of *Vogue, Vanity Fair,* and *Charm,* "the Magazine of New Jersey Home Interests." After declaring the issue—that museums all over the world provided "students, amateurs and the interested public with more adequate permanent exhibits of modern art than do the institutions of our vast and conspicuously modern New York"[1]—he proceeded to outline in the most methodically persuasive way, at once scholarly and concise, the history of the public's relationship to advanced art, the history of the formation of museums and their responsibilities, and the cultural necessity of The Museum of Modern Art. There was passion and a sense of the urgency of the historic act, but there was also a calm reasonableness, a reassuring implication that an intelligible frame of reference could be imposed on the always changing, sometimes threatening, modern idiom. Barr was determined to speak to the widest possible public, and so purposes of education were invoked, and financial common sense—art increased in value. Throughout was the tone of temperate self-assurance and the apparent absence of conflicts or doubts.

By the time he was twenty-seven, Barr already displayed the characteristics that would motivate him for the rest of his life: an absolute insistence on sound methodology (drummed into him in Charles Rufus Morey's courses on Early Christian and Medieval art at Princeton), a craving for tidy classification (he originally had wanted to become a paleontologist and was an amateur ornithologist), a self-imposed sense of mission to educate a broad public and overcome ignorant prejudice, an earnest belief in the continuing relevance of the historical approach, and an obdurate adherence to principle. His "vision," of course, was to apply this lofty combination to the study of modern aesthetic culture—for which he had a passionate enthusiasm—and his broad, inclusive definition of aesthetic culture. (This, too, was a legacy from Morey, from his consideration of the interrelation of all manifestations of culture from painting, sculpture, architecture, manuscripts, and ivories to folklore and theology.)

Barr also had an intuitive understanding of the power of effective presenta-

tion—of both physical objects and ideas. In the Museum galleries, he was to revolutionize the way paintings were hung, rejecting symmetrical, size- and shape-determined rows of canvases (which were traditional) in favor of installations that caused aspects of form or content to resonate in exciting or revealing ways. (Today Barr's innovation is almost prescribed.) In addition, he lowered the height at which works were usually hung because he felt the eye became too tired looking up. And nothing like his wall labels had been seen before: charming distillations of information and anecdote. In his other writing, he again followed his own instincts. It was not so much a matter of refusing to adopt an overblown or obfuscating style; in fact, as his endless revising indicates, Barr by constitution rebelled against communicating in any but the most lucid, articulate way.

The following articles trace the development of Barr's vision of modernism, his vision of the shape of the Museum, and his early statements of the themes whose variations will play through the story of MoMA. Barr was very careful not to define modern art "with any degree of finality either in time or in character" ("Modern and 'Modern'"), and even his famous "Chart of Modern Art" underwent a postpublication penciled revision. Yet he clearly knew what he meant by the term. In 1948, when the Boston Institute of Contemporary— formerly Modern—Art released a statement explaining the name change, Barr analyzed the statement in a memo. To their definition of "modern art" as a once "innocent phrase . . . denoting simply the art of our times [which] came to signify for millions comething [sic] unintelligible, even meaningless," he responded, " 'Modern Art' has rarely been a neutral phrase. . . . For three centuries 'modern' has been a term which involved the more challenging, original and not yet accepted movements in philosophy, theology and the arts. . . . That is why we used the word when the Museum of Modern Art was named."[2] Barr did not, in fact, subscribe to a predetermining notion of inevitable formal progression for art; but, as he phrased it some years later, his interest was "not nonpartisan" —he preferred "the quick to the dead."[3] Nevertheless, in these early writings, the procession of historical selections, one seemingly determining the next, and the basso continuo of his confident logic, have an irresistible momentum. That this was to shape generations of scholars there can be no doubt.

The earliest pieces were written while Barr was teaching at Wellesley the first course in an American college to be devoted entirely to modern art. By 1929, when he developed "A Course of Five Lectures on Modern Art," he had already been to the Bauhaus in Dessau, where high aesthetic ideals combined with utopian aspirations for technology to redraw the map of visual culture. Barr never practically confronted the utopian ideology, but the idea of a universal aesthetic confirmed the appropriateness of Morey's method. The visit's impact was profound *(Bauhaus 1919–1928),* and hovers just under the surface of the MoMA brochure "A New Art Museum." Over forty years later, while he was preparing the "Chronicle" of the collection that appeared in *Painting and Sculpture in the Museum of Modern Art 1927–1967* (1977), he penciled on a copy

of the second edition: "Contains 2 indirect references to 'multidepartmental plan'—all that I could get away with at that time."[4] (He marked "1 'The possibilities of The Museum of Modern Art are so varied that it has seemed unwise to the organizers to lay down too definite a program for it beyond the present one of a series of frequently recurring exhibitions during a period of two and a half years,' " and "2 'In time the Museum will expand beyond the limits of painting and sculpture in order to include departments devoted to drawings, prints and other phases of modern art.' ")

In the catalogue introductions, forewords, and prefaces, and the pamphlet *A Brief Guide to the Exhibition of Fantastic Art, Dada, Surrealism,* of the 1930s, Barr established the system of genera and species, and the vocabulary of terms that became so intimately identified with MoMA. With hindsight the focus may seem narrow and some of the material obsolete; we currently tend toward a more socially complex and artistically inclusive interpretation of the period. But the vividness and passion, intellectual rigor, and accessibility are as important a model, and many of the ideas as enlighteningly applicable, today as they were fifty years ago.

<div align="right">A. N.</div>

"Boston Is Modern Art Pauper"

Barr was twenty-four and beginning his first year as an associate professor at Wellesley College when he wrote the following. (He had spent 1924–25 as an assistant and graduate student at Harvard.) The article does not mention that the facsimiles on exhibition had been donated by Barr and his friend Jere Abbott to the Fogg. In January 1927, Barr sent a copy of this article to Forbes Watson, the editor of *The Arts,* with a note: "Written at the request of the Crimson, which omitted two thirds of the article garbled the rest and added head-lines." The *Crimson* "badly mangled my intentions,"[5] he added, but the article, which was reported on in local newspapers and national art journals, marks the beginning of Barr's controversial status. (From *The Harvard Crimson,* October 30, 1926.)

It is surprising, even shocking, to the stranger to find so little interest in Modern pictures in Boston and Cambridge, places which have a deserved reputation as centers of alert cultivation of the Seven Arts. One may search in vain for the works of the foremost living painters in the Boston Museum, in Fenway Court, or in the Fogg. Neither Matisse nor Bonnard, Picasso nor Derain is to be found in these three more or less comprehensive collections, save in a few prints and drawings. It is even more astonishing that the great founders of the contemporary tradition—men who have been dead twenty years are equally neglected. It is actually impossible for an amateur to study in any of these great galleries, a single painting by Cézanne, Van Gogh, Seurat, Gauguin, masters who are honored the world over—in London, Paris, Berlin, in Italy, Russia, Scandinavia, in the Low Countries, in Chicago and New York and Cleveland—but not in Boston. One must actually travel to Worcester to see paintings by Gauguin and Redon. In Boston, the development of 19th Century painting is half-heartedly illustrated through the Impressionist period. But after that we find only such fashionable virtuosos as Zuloaga and Sargent. Sculpture after Rodin is almost equally neglected.

The Fogg Museum with hitherto very limited space and funds has not been party to this spirit. Its splendid collection of drawings is carried through to Picasso and in the new Museum there is to be ample room for contemporary expression.

In the Print Room at present is an exhibition of recently acquired facsimiles and photographs published by The Dial in 1923. There are paintings in oil,

water colour, and tempera, drawings in crayon and pencil reproduced so miracu-
lously that under glass it is impossible to detect them from originals. Picasso
is there. Bonnard and Matisse, Vlaminck and Signac, and the Americans, John
Marin and Charles Demuth, three of whose watercolors the Fogg acquired
several years ago.

Wellesley and Modernism

Although unsigned, this article, describing the course Barr initiated and taught, has been attributed to Barr by a former student. (From the *Boston Evening Transcript,* April 27, 1927.)

Wellesley has taken another step in the study of modern artistic achievement, by the semester course in modern art offered by the art department for the first time this year. Almost the first course in any college devoted entirely to painting of the last hundred years, it treats the phases of tradition and revolt in contemporary art, with its development out of the successive trends of the nineteenth century. Since modernist tendencies are not confined to painting, the course makes a study of all the arts, aiming to comprehend the relation of modern expression to twentieth century civilization.

To keep abreast of the art work of the moment is the ideal of the course, and to acquire familiarity with the names and the accomplishments that are prominent not only in art circles but in all the currents of life. As an important variation from the usual methods of study, fine colored reproductions are used whenever procurable in place of photographs, since modern art cannot be fully understood without color. Museums, galleries, and private collections, the theater and the "movie," are drawn upon for material, and particularly current periodicals, in which are found not only critical material, but new drawings and prints, and the increasingly fine work in advertisements and typography. The class is thus necessarily informal, and opens each week with reports on events of timely interest before the more carefully prepared problems are introduced. The organization into a "faculty" makes each individual student responsible for her special division of the subject, with the opportunity of reporting the main outlines of its development to the class at some time during the term.

Primary attention is paid to painting, with special study in the nineteenth century of the forerunners of modern painting: Cézanne, Seurat, Van Gogh, Gauguin, Redon and their followers. Various contemporary movements, cubism, futurism and minor "isms," the post-war classicists and super-realists and the national tendencies, French, Russian, German, Italian, English and American, will be considered. In connection with this division of the course is the exhibition of modern painting now on view in the Farnsworth Museum at Wellesley,[6]

extending from Corot and Daumier down to post-cubistic developments, chosen from work by French, German, Russian and American masters.

Members of the "faculty" are studying industrial architecture, America's distinctive contribution to art, so that a trip to Boston resolves itself into a search for the three best factories to be seen from the train, an excellent method for discovery of really important architecture. During the term Russell Hitchcock of the department of fine arts at Harvard will lecture on modern architecture and a motor trip is planned to view such buildings as the Motor-Mart and the Necco factory.[7]

The industrial and decorative arts offer a wealth of material. The automobile, seen to advantage at the recent auto show, house and office furniture, including the unique "skyscraper furniture"; household appliances and labor-saving devices, refrigerators and filing cases and all sorts of utility objects are among examples of the industrial arts, while interior decoration, craft work and textiles are forms more intentionally decorative though frequently less interesting. The graphic arts include drawings, the etching and wood-cut and other prints, cartoons and comic strips. Advertising is the happy hunting ground of this group, showing how the modern pictorial style has filtered into the ordinary environment of life.

An amusing experiment connected with the industrial arts is the ten cent store competition for a "Still Life" made up of the three best objects to be found which are made of some strictly modern material such as aluminum or papier mache. It is rumored that the prize will be a papier mache dinosaur.

Two of the "Faculty" are devoted to the theater arts; that is, the drama as written and played, and especially recent changes in lighting, stage setting and direction, the Russian Ballet and its influence, the growing importance of dancing and the latest innovation, the George Antheil Ballet Mecanique.[8] Modern music is an essential factor here, and the search for Victrola records of modern music since Strauss and Debussy, the study of jazz and its derivatives, will culminate in a recital devoted to Schonberg, Stravinski, Les Six and other figures of recent significance. The history of the movie is another important subject, covering the technical perfection, German developments and such adventures into mechanique as the stupendous settings of "Metropolis."[9] Finally, a student is concentrating on modern criticism and aesthetic. Various recurring themes are stressed, the appreciation of primitive and barbaric art, the psychology of expressionism, the discipline in cubism and constructivism and the importance of the machine. The course proves valuable in infusing modernist interpretations of art through the college, and in stimulating an interest among the students in the vital and revolutionary creative work which is an integral part of twentieth century civilization.

A Modern Art
Questionnaire

The qualifying quiz that Barr prepared for students in his modern art course at Wellesley casts a wide net. As he described it a few months earlier, "Since modernist tendencies are not confined to painting, the course makes a study of all the arts, aiming to comprehend the relation of modern expression to twentieth century civilization."[10] *Vanity Fair,* the chic and informed cultural monthly (which, by the way, was the source of much of Barr's earliest acquaintance with modern art), allowed its sophisticated readers to flatter (or embarrass) themselves with their scores. Frank Crowninshield, the magazine's editor, two years later became a member of the original committee of seven that founded The Museum of Modern Art. (From *Vanity Fair,* August 1927.)

This is a primitive among questionnaires having been invented almost a year ago as a preliminary examination to test the student's background for a course in modern art at Wellesley College. It lacks the sophistication of the more recent manner. There are no spellbinders such as: Name four important artist-photographers whose names begin with St——, or: What poet wrote in honor of an English naval victory, "We bit them in the bight, the Bight of Heligoland"?, or: What daughter of an American clergyman published in Paris perhaps the most remarkable prose work of the century, written by an Irishman and forbidden in the United States? However, like many primitives it has its own peculiar, if humble, charm. For instance, it covers with careful proportion modern expression in architecture, sculpture, painting, graphic arts, music, prose, drama, poetry, the stage, decorative and commercial arts, movies, ballet, and modern criticism, chosen from French, British, Italian, Russian, Germanic and American sources. Furthermore, the list is carefully graded from very obvious to somewhat more difficult; only the most important accomplishments, with a few exceptions, are considered; the usual position of question and answer is reversed; and finally a few actual works of art are represented by photographs or quotations.[11]

WHAT IS THE SIGNIFICANCE OF EACH OF THE FOLLOWING IN RELATION TO MODERN ARTISTIC EXPRESSION?

1. George Gershwin
2. Max Reinhardt
3. Henri Matisse
4. *The Hairy Ape*
5. Miguel Covarrubias
6. James Joyce

7. John Marin
8. UFA
9. Alexandre Archipenko
10. Roger Fry
11. The Zoning Law
12. Alfred Stieglitz
13. *The Cabinet of Dr. Caligari*
14. Aristide Maillol
15. The Imagists
16. Jean Cocteau
17. *Saks-Fifth Avenue*
18. *Petrouchka*
19. Harriet Monroe
20. Paul Claudel
21. Gilbert Seldes
22. Franz Werfel
23. Gordon Craig
24. Forbes Watson
25. Oswald Spengler
26. Luigi Pirandello
27. *Les Six*
28. The Sitwells
29. Edgar Brandt
30. (who wrote this?)
 Thou art come at length
 more beautiful
 than any cool god
 in a chamber under
 Lycia's far coast
 than any high god
 who touches us not
 here in the seeded years;

ay, than Argestes
scattering the broken leaves.
31. Polytonic
32. The Barnes Foundation
33. Wyndham Lewis
34. Frans Masereel
35. Frank Lloyd Wright
36. George Antheil
37. John Quinn
38. *Sur-réalisme*
39. Arnold Schönberg
40. *Aria da Capo*
41. John Alden Carpenter
42. Frankl
43. Vsévolöd Meierhold
44. Harold Samuel
45. Fernand Léger
46. (who wrote this?)
 "Silence is not hurt by attending
 to taking more reflection than a
 whole sentence. And it is said and
 the quotation is reasoning. It gives
 the whole preceding. If there is
 time enough then appearances are
 considerable. They are in a circle.
 They are tendering a circle. They
 are a tender circle. They are ten-
 derly a circle."
47. Suprematism
48. *Das Bauhaus*
49. Le Corbusier-Saugnier
50. Richard Boleslavsky

ANSWERS TO ART QUESTIONNAIRE

1. George Gershwin: American. Among the manufacturers of Jazz this "White Hope" reveals as a musician a decided talent which has received great approbation.

2. Max Reinhardt: One of the foremost among German masters of the theatre arts. Known, unfortunately, in this country by *The Miracle*.

3. Henri Matisse: French. Very possibly the greatest living painter. Once one of *Les Fauves,* now accepted as a master by all critics save Mr. Cortissoz[12] who rejects his work because of its "lack of suavity in the manipulation of painted surface."

4. *The Hairy Ape:* Eugene O'Neill's

violent tragedy of maladjustment in the machine age.

5. Miguel Covarrubias: Mexican draughtsman and caricaturist. *"The Prince of Wales and other Americans,"* etc.

6. James Joyce: Irish cosmopolite. Author of *Chamber Music, Ulysses, Dubliners,* and master of prose in the "stream of consciousness" manner which sacrifices clarity and form for the illusion of exhaustive completeness.

7. John Marin: American artist. In his watercolors considered in the first rank; a position trumpeted by the recent sale of one of his paintings to a magnanimous Washington collector for $6000.

8. UFA: German moving picture company. Perhaps the only great film producers who frequently sacrifice commercial for artistic values, UNIVERSUM FILM AKTIENGESELL-SCHAFT.

9. Alexandre Archipenko: Russian Sculptor now conducting a school in New York. Famous for his masterly and highly sophisticated fusion of late Renaissance elegance with the cubistic formula.

10. Roger Fry. Organizer of the first Post-Impressionist Exhibition in England—the most brilliant English art critic supporting the modern aesthetic attitude *(ma non troppo).*

11. The Zoning Law: Ordinance in New York and other large cities governing the height of tall buildings in proportion to the width of the street, thus safeguarding light. Resulting in the "step-back" design of the newer skyscrapers, this

law is of infinitely greater importance to American architecture than all the stillborn and sentimental archaism of the so-called revolutionary architects.

12. Alfred Stieglitz: American photographer, pioneer and prophet of modern art in America, founder of "291" and the *Intimate Gallery,* impresario of the Seven Americans, husband of Georgia O'Keeffe, and the only New York art dealer who employs the Socratic method without destroying patronage.

13. *The Cabinet of Dr. Caligari:* Epoch-making German moving picture. First film with expressionist settings to attract popular attention in America.

14. Aristide Maillol: One of the greatest living sculptors.

15. The Imagists: A group of poets English and American, attempting to isolate and realize vividly sensations and emotions by a sparse and enameled imagery wrought in free verse form but influenced by such diverse classical sources as the Chinese and Hellenic. Among them are or were John Gould Fletcher, Ezra Pound, Richard Aldington, Amy Lowell and the not quite anonymous H. D.

16. Jean Cocteau. Parisian modernist of incredible versatility—poet, novelist, dramatist, satirist, inventor of ballets, and staunch champion of all that is witty and adventurous in the arts.

17. *Saks-Fifth Avenue:* Through its advertisements and show windows this department store has done more to popularize the modern

mannerism in pictorial and decorative arts than any two proselyting critics.

18. *Petrouchka:* Ballet with music by Stravinsky.

19. Harriet Monroe: Editor of *Poetry,* matriarch of Chicago poets.

20. Paul Claudel: French poet, mystic, dramatist, now Ambassador to—of all places—the United States.

21. Gilbert Seldes: Editor, dramatic critic, author of *The Seven Lively Arts* in which the relative qualities of Beethoven, George Gershwin, and Puccini are clearly discerned. Ernest Newman[13] will not comprehend.

22. Franz Werfel: Noted German dramatist in the Expressionist manner. *The Goat Song,* etc.

23. Gordon Craig: "Old master" of the modern theatre and the modern woodcut.

24. Forbes Watson: Art critic of *The New York World* and editor of The Arts in which he maintains a standard of criticism and scholarship which is both conscious of the past and sensitive to the present.

25. Oswald Spengler: German philosopher. In his *Der Untergang des Abendlandes* (The Decline of the West) he proves by cumulative analogy a cyclical theory of history and the decadence of our civilization. If, however, decadence is the "inability to create new forms" the personalities and works of art included in this questionnaire are at least attempting a refutation.

26. Luigi Pirandello: Italian dramatist who twines his audiences, his directors, his actors, and himself in a spider web of problems ontological and epistemological. *Six Characters in Search of an Author, Enrico Quattro,* etc.

27. *Les Six:* Honegger, Auric, Tailleferre, Milhaud, Poulenc, Wiéner, —once a group of youthful Parisian composers but now individuals mature and divergent. Erik Satie, their leader—be it never said without tears—is dead. His cohort embraces most of the progressive musical talent of France.

28. The Sitwells: Edith, Osbert, and Sacheverell Sitwell, until the marriage of the last, a trio inseparable and prodigious, forming the core of a highly sophisticated group in London.

29. Edgar Brandt: Distinguished for his wrought iron in the modern manner.

30. Hilda Doolittle, (H. D.) in *Heliodora.*

31. Polytonic music is composed in two or more keys often played simultaneously.

32. The Barnes Foundation: Merion, Pennsylvania. A privately owned institution for education in the aesthetic appreciation of the fine arts. It possesses the finest collection of modern French pictures in America, including several hundred Cézannes and Renoirs, many great Picassos and Matisses, fine Daumiers and Van Goghs and a recently acquired masterpiece by Seurat.

33. Wyndham Lewis: English painter, critic and novelist. Founder of *Vorticism,* editor of *Blast,* author of *The Art of Being Ruled* in which he emerges as an English Mencken

who thinks before he mocks, but not enough.

34. Frans Masereel: Modern Belgian artist known primarily for his woodcuts.

35. Frank Lloyd Wright: Among the first American architects to become conscious of modern forms as an expression of modern structure. His name is a byword among progressive architects the world over.

36. George Antheil: American composer and pupil of Stravinsky recently returned from Paris to direct his very remarkable *Ballet Mécanique,* played by one mechanical piano, ten pianos, four bass drums, two wind machines, eight xylophones, electric bells—and, we hope, an E-flat alarm clock and a contra-bass metronome.

37. John Quinn: American lawyer and bibliophile who before his death was the most emancipated among the great American collectors of modern art. Pictures from his collection are now in the Louvre and the Art Institute of Chicago.

38. *Sur-réalisme:* A new and increasingly powerful cult prevalent in Europe. To its ranks flock many who previously wrote or painted under the oriflamme of *Dada* or *Expressionismus.* Devoted to the exploration of the subconscious, believing in the artistic validity of dreams, it is an expression of faith in Twentieth Century psychology, just as Impressionism received the sanction of the Nineteenth Century physics.

39. Arnold Schönberg: Viennese composer who discards any definite key or tonality and employs a musical form, algebraic, laconic, cerebral, in contrast to the predominant rhythms, Russian folk tunes and "back to Bach" creed of Stravinsky, his chief rival for leadership among contemporary European musicians.

40. *Aria da Capo:* Early play by Edna St. Vincent Millay.

41. John Alden Carpenter: Composer of American ballets, *Krazy Kat* and *Skyscrapers.*

42. Frankl: New York. One of the very few firms exclusively devoted to the designing and manufacture of modern furniture which makes "no compromise with reminiscence."

43. Vsévolöd Meierhold: Most important figure in the contemporary Russian theatre opposing Constructivism to the super-Belasco realism of Stanislavsky and the Moscow Art Theatre.

44. Harold Samuel: English pianist famous for his magnificent performances of music by that greatest modern composer, Johann Sebastian Bach.

45. Fernand Léger: French cubist whose forms are polished and cylindrical like steel, clangorous in red and black like new fire engines.

46. Gertrude Stein.

47. Suprematism: Russian ultra-cubism in which painting is reduced by an almost scholastic dialetic to the just disposition of a black square in a white circle.

Malevitch and Rodchenko are masters of this pictorial quintessence.

48. *Das Bauhaus:* At Dessau, formerly at Weimar, Germany. A publicly supported institution for the study and creation of modern architecture, painting, ballet, cinema, decorative and industrial arts. Among the professors are Kandinsky, the Expressionist, Paul Klee claimed by the super-realists, and Moholy-Nagy, the Constructivist.

49. (Le Corbusier-Saugnier) Architect and leader of the Constructivists in France. Author of *Urbanisme, Vers une Architecture,* among others.

50. Richard Boleslavsky: Of the Russian theatre, now director of the Laboratory Theatre in New York City.

The Necco
Factory

"The Necco Factory" was probably written before Barr's 1927–28 European trip, which included his visit to the Bauhaus in Dessau. A viewing trip to the factory was part of his Wellesley course from its beginning. (From *The Arts,* May 1928.)

Architecture is the criterion of the integrity, the judgment, and the seriousness of a nation.

RENAN [14]

The enemy is not science but vulgarity, a pretence to beauty at second hand.

W. R. LETHABY [15]

N. B.—Ecoutons les conseils des ingénieurs américains. Mais craignons les architectes améri-cains.

LE CORBUSIER-SAUGNIER [16]

Utilitas, Firmitas, Venustas—these, according to Vitruvius, are the three quali-ties of architecture. *Venustas,* architectural beauty, is a difficult and often treach-erous problem for discussion, depending, as it does, upon that most mutable factor, aesthetic sensibility. At some periods, the Renaissance for instance, *Venustas* seems the creation of archaeology and taste. At others, as in the Gothic, it was perhaps a function of *Firmitas,* of exquisite structural virtuosity; and at present, in that architecture which is genuinely modern, it seems primarily the by-product of *Utilitas.*

To Vitruvius, whose ideas were gray with the dust of still-born pedantry, *Venustas* meant the careful codification of Greek rules of proportion, numbers of columns, varieties of capitals, *genera* of temple types. The Roman engineers, contemporaries of Vitruvius, and untrammeled by dead tradition, built aque-ducts and bridges, amphitheatres and fortifications. By such works the virtue and power of Rome were clarified. But her spiritual poverty and aesthetic vacillation also were exhibited by other works—temples, baths, markets—often magnificently constructed in reinforced concrete[17] and then decorated by ar-chitects with motives pilfered from Greece and the Levant. The result is ostenta-tiously expensive but essentially cheap, outwardly grandiloquent and inwardly poverty-stricken.

Comparisons between Roman and American architecture are platitudinous yet the parallels between the magnificence of Roman and American engineering and the timid traditionalism of Roman and American academic architecture can scarcely be too often emphasized. If we omit domestic dwellings one might

almost evaluate American architecture by its degree of removal from American architects. Such an evaluation leads to a rough classification of our important buildings according to their purpose—ecclesiastical, academic, civic, commercial, and industrial. If we examine these categories we find that they form a graded series through which we pass from architect to engineer and from derivative eclectic architecture to creative architecture. It is necessary merely to mention our churches, our collegiate Gothic and collegiate Georgian, our neoclassic banks and state capitols, to indicate their unimportance as original contributions to architectural history. Our railway terminals are a little more interesting, our garages more so, especially when architects have not been employed. The skyscraper, however, is the most instructive because it is the most flagrant example of confusion and dearth of architectural imagination. Nothing is more characteristic or more vain than American pride in the skyscraper architecture. Height, sheer ostentatious verticality, is good advertising but it does not make architecture, even though it has immense potentialities. These unfortunately are rarely realized. For one good skyscraper, such as the Fifth Avenue French Building,[18] we have a score of execrably bad ones. Instead of approaching the challenging problem of the skyscraper by an intelligent attempt to discover for themselves its inherent possibilities, our architects dabble untidily in the past and festoon the bright stark structure of the engineer with shoddy detail borrowed from Romanesque Abbeys, Venetian *palazzi* and *François Premier chateaux.* If only some archangelic hand would shave away the Gothic stubble of the Woolworth Building[19] and purge the Ritz Tower[20] of its Baroque cosmetics! They would not thereby become great architecture, but they would at least be clean.

The architectural experiences of Massachusetts Avenue, from Symphony Hall in Boston[21] to Harvard Square in Cambridge, express American civilization at its funniest if not at its worst. The sad gray halls of Technology and the monstrous rear of the Widener library[22] bracket between them miles of cheap apartment houses, little shops perpetually in a state of fire-sale, turretted Victorian warehouses, a fine "Mansard" house of the eighties, and two or three quite presentable garages. Amid this rabble, strange in its austerity, towers the Necco factory.

The New England Confectionery Company, in addition to its industrial requirements, desired a building which would be beautiful. The demand for "beauty" in a factory usually implies the intervention of the architect, who courageously contributes a few Gothic arches or Renaissance cornices, sometimes both, thus reducing the factory to the mongrel level of the usual skyscraper. It was very fortunate therefore that Lockwood, Greene and Company left the design of the Necco factory as well as the construction entirely in the hands of its engineering department.

In any criticism of modern industrial architecture it is important, though not always possible, to distinguish carefully between consciously architectural effects and the unconscious, or at least involuntary effects of structural or

utilitarian requirement. Such discrimination, of course, calls into question any definition of architecture. But in this difficulty, history helps us pragmatically if not fundamentally. For whether or not the Gothic master-builder was primarily an engineer or an architect, his cathedral by general consent is architecture. Similarly by analogy, if not by general consent, the Necco factory is architecture even though it be as far removed from the Beaux-Arts tradition as a Frigidaire refrigerator is from a *Louis Quinze* Victrola.

We will find then that F. C. Lutze, engineer and chief designer of the Necco factory, has achieved architecture positively by manipulation of proportions and masses, and by the restrained use of handsomer materials than were structurally necessary; negatively by the utmost economy in decorative motive and by the frank acknowledgment of utilitarian necessity both in plan and elevation.

The technique of structure scarcely concerns us. It is interesting to note, however, that a flat-slab, rod-reinforced concrete system is used instead of the steel girder cage familiar to the general public in skyscrapers. And at the risk of offending machine idolaters we must pass over, a little regretfully, the interior filled with an amazing complex of dynamos, boilers, automatic sprinklers, miles of process pipes, filters, refrigerators, pulverizers, dehumidifiers, and pumps.

Seen from the outside the factory is composed of an immense C shaped block which embraces the much smaller power house. The irregularity of the plot of ground, which would have troubled the academic architect, has resulted in several courageous departures from the rectangle in plan, especially along the northern façade. The corner tower placed at the junction of the two street façades seems more deliberately decorative in conception, but is in actuality a circulation core with stairways and elevator shafts. Utility also required on the inside of the court a series of striking recessions, one of which is used for a second elevator shaft, another for a novel form of fire-escape called the Philadelphia Smoke Tower. The whole composition is greatly enhanced by the chimney somewhat as an Italian basilica and its campanile are mutually complimentary.

The exterior of most of the structure is of concrete with very simple pilaster strips and horizontal brick "spandrels"[23] beneath the windows. The power house and the façades of the main building visible from the street are faced entirely in limestone and rich yellow brick. The corner tower, with its emphasized verticals, bronze window spandrels and rather paltry colonnette mullions, is the most elaborate and perhaps least successful element in the exterior. A triple horizontal division of the street façades is suggested by the limestone facing of the ground story and the heavily mullioned windows and clean glass of the top story. This external differentiation of stories, which is obviously of considerable value in organizing the design of the façades, is in fact expressive of interior function since the top story is used only for offices, the ground story for display rooms.

Factory fenestration, so monotonous to the casual eye, is here made remark-

ably interesting both by varying the size and proportions of the windows and by decorative, but purely utilitarian, variations in glazing. There are altogether over twenty kinds of windows in the Necco factory. [From one view] we find four or five varieties: the heavily mullioned windows of the top story offices previously noted; below, the ordinary factory type subdivided by square casements, which themselves when open serve as valuable accents; to the left a tier of plain oblong windows followed in succession by the black unglazed apertures of the Philadelphia Smoke Tower and the narrow vertical armatures of the elevator shaft.

The dead horizontal rooflines, potentially so uninteresting, present a difficulty which is very helpful in clarifying the attitude of the engineer-designer of industrial architecture and the problem of the critic. The solutions of this difficulty, that is, the various means by which this monotony is relieved, fall into three divisions. There are the purely decorative devices invented by the designer but of no utilitarian value. To this category belong the narrow coping, somewhat raised at the corners of the main blocks, and the elaboration of the tower silhouette. To the second belong purely utilitarian devices which, however, are approved of and to some extent arranged or composed by the designer. In the case of Mr. Lutze's factory these are the elevator "penthouses," the zig-zag outline of the recessions, and of course the great chimney. To a third division belong the whirlwind dust collector and whistle over the power house, the black low-lying mass of the sprinkler tank, and the gyrating autoforce ventilators. These ventilators by their humorous silhouettes rival those Gothic drains or waterspouts which we term more picturesquely gargoyles, but are superior to them in their ability to present, like weather vanes, a new aspect with every change of the wind. All these pleasant objects belong to our third category because their value was not appreciated by Mr. Lutze who seemed to regard them, apologetically, as necessary evils. It is greatly to his credit, however, that he did not consider it necessary to conceal them behind a false attic or parapet as our architects by means of Baroque cupolas conceal the rotund water tanks of skyscrapers.

To recapitulate and generalize, we have then three sources of style in American industrial architecture: first, elements consciously borrowed from the *Venustas* of previous styles and applied for the most part as superficial decoration; secondly, utilitarian and structural elements which sufficiently resemble traditional forms to permit of their assimilation into our conventional concept of what is beautiful, for example, chimneys and elevator penthouses; thirdly, those elements of *Utilitas* and *Firmitas* which to Americans still seem too inconsistent with architectural beauty to be readily acceptable. These remain, as it were, temporarily undigested.

These three sources of style are continually in a process of interaction. The third becomes gradually transmuted and absorbed into the second so that the purely utilitarian and structural elements increase in number and variety and

richness, while at the same time they tend to exclude borrowed elements as otiose. The various stages of this evolution are most interestingly and clearly illustrated by the Necco factory and the attitude of its designer.

The Necco factory is encouraging, though still distinctly inferior to the factories of Dudok and Mendelsohn. It will exist for the new generation not merely as a document in the growth of a new style, but as one of the most living and beautiful buildings in New England.

A Course of
Five Lectures
on Modern Art

This lecture series, distinct from his Wellesley course, was prepared after Barr had visited London, the Hook of Holland, Berlin, Dessau, Dresden, Moscow, Leningrad, and Paris (among other places) during the fall, winter, and spring of 1927–28.

DEPARTMENT OF ART, WELLESLEY COLLEGE

April and May 1929

I *April 17* MODERN PAINTING: THE IDEAL OF A "PURE" ART

The important tendencies in painting of twenty years ago: the neo-renaissance in Derain; the decorative in Matisse; the cubistic in Picasso. The formalist attitude toward Medieval, Renaissance, and Baroque painting. The immediate antecedents of cubism: Degas, Gauguin and the "angle shot"; Seurat and the theory of pure design; Cézanne's natural geometry; abstraction in primitive art. The development of cubism in Paris. Kandinsky and abstract expressionism in Germany. The final purification of painting: Mondriaan in Holland; the suprematists in Russia. André Lhote and the new academic. The influence of abstract painting upon architecture, the theatre, the films, photography, decorative arts, typographical layout, commercial art. Conclusion: the "demon of the absolute."

II *April 24* MODERN PAINTING: THE DISINTEGRATION SINCE CUBISM

The pseudo-classic mannerist, (Picasso). The "new objectivity," (Otto Dix). New adventures in appreciation; the child, the savage, the lunatic, and the dream. The "metaphysical," (de Chirico). The fantastic and grotesque, (Chagall and Paul Klee). The *sur-réalistes* as the ultimate devotees of spontaneity. Conclusion: Descartes versus Rousseau.

III *May 1* MODERN AMERICAN PAINTING: A CROSS-SECTION

The impressionist generation. The Cézannists. Abstraction. The Precisionists. The "sentimental" and "literary." The American scene. What is "American" painting?

IV *May 8*[24] THE BAUHAUS AT DESSAU

Post-war Germany. Towards re-integration. The Bauhaus as a paradox. Walter Gropius the visionary; the executive; the architect. The principles of constructivism. The painters Kandinsky, Feininger and Klee as "expressionist counterpoint." The curriculum: Material, Technique and Form, (Albers); architecture, (Gropius, Hannes Meyer); furniture and decorative arts; photography, (Moholy-Nagy); theatre and ballet, (Schlemmer); typography and posters, (Bayer). The Bauhaus as a national and international influence.

V *May 22* THE LYEF GROUP OF MOSCOW

The Artist and the Marxian ideal. "Down with aestheticism." "Chicagoism" and the cult of materialistic efficiency in a collectivist society. The fall of futurism and the rise of constructivism. Literature, (Tretyakov); the theatre, (Meyerhold); the kino, (Eisenstein); typography, photography, photomontage, and the "death of painting," (Rodchenko and Stepanova). The triumph of the artist.

A New Art
Museum

The brochure that described the new venture to the public was issued in August of 1929 by the seven founders of the Museum. Nearly fifty years later, Barr wrote in the "Chronicle of the Collection of Painting and Sculpture," "In preparing a draft for the brochure, the Director proposed: 'In time the Museum would probably expand beyond the narrow limits of painting and sculpture in order to include departments devoted to drawings, prints, and photography, typography, the arts of design in commerce and industry, architecture (a collection of *projets* and *maquettes*), stage designing, furniture and the decorative arts. Not the least important collection might be the *filmotek,* a library of films. . . .'

"The above ambitious prospectus was cautiously edited by the Trustees to read: 'In time the Museum would expand . . . to include other phases of modern art.' "25

The Museum opened in November 1929 on the twelfth floor of the Heckscher Building at Fifth Avenue and Fifty-seventh Street, where it remained until May 1932.

A group of American collectors and patrons of art have announced the establishment in New York City of what should become an important and permanent museum of modern art. Their immediate purpose is to hold, in a gallery on Fifth Avenue, some twenty exhibitions during the next two years. These exhibitions will include as complete a representation as may be possible of the great modern masters—American and European—from Cézanne to the present day. With the co-operation of artists, collectors and dealers the committee believe that there can be obtained, for their forthcoming exhibitions, paintings, sculptures, drawings, lithographs and etchings of the first order.

Their ultimate purpose will be to acquire, from time to time, either by gift or by purchase, a collection of the best modern works of art. The possibilities of The Museum of Modern Art, which is the name of the new enterprise, are so varied and so great that it has seemed unwise to the organizers to lay down too definite a program for it beyond the present one of a series of frequently recurring exhibitions during a period of at least two years.

All over the world the rising tide of interest in modern movements in art has found expression, not only in private collections but also in the formation of public galleries created for the specific purpose of exhibiting permanent as well as temporary collections of modern art.

Nowhere has this tide of interest been more manifest than in New York. But New York alone, among the great capitals of the world, lacks a public gallery where the works of the founders and masters of the modern schools can today

be seen. That the American metropolis has no such gallery is an extraordinary anomaly. The municipal museums of Stockholm, Weimar, Düsseldorf, Essen, Mannheim, Lyons, Rotterdam, The Hague, Detroit, Chicago, Cleveland, Providence, Worcester, and a score of other cities provide students, amateurs and the interested public with more adequate permanent exhibits of modern art than do the institutions of our vast and conspicuously modern New York.

In these museums it is possible to gain some idea of the progressive phases of European painting and sculpture during the past fifty years. But far more important than these smaller exhibitions are the modern public collections in the great world-cities—London, Paris, Berlin, Munich, Moscow, Tokio, Amsterdam. It is to cities such as these that New York may confidently look for suggestions, for they have each solved the museum problem with which New York is now so urgently confronted.

For the last dozen years New York's great museum—the Metropolitan—has often been criticized because it did not add the works of the leading "modernists" to its collections. Nevertheless the Metropolitan's policy has been carefully considered and is reasonable. As a great museum, it may justly take the stand that it wishes to acquire only those works of art which seem certainly and permanently valuable. It can well afford to wait until the present shall become the past, until time, that nearly infallible critic, shall have eliminated the probability of error. But the public interested in modern art does not wish to wait. Nor can it depend upon the occasional generosity of collectors and dealers to give it more than a haphazard impression of what has developed in the last half century.

Experience has shown that the best way of giving to modern art a fair presentation is to establish a gallery devoted frankly to the works of artists who most truly reflect the taste, feeling and tendencies of the day: The Louvre, the National Gallery of England and the Kaiser Friedrich Museum, to mention only three national museums, follow a policy similar to that of our Metropolitan. But they are comparatively free of criticism because there are in Paris, London and Berlin—in addition to and distinct from these great historical collections— museums devoted entirely to the exhibition of modern art. There can be no rivalry between these institutions because they *supplement* each other and are at times in close co-operation.

The Luxembourg, for instance, exhibits most of the French national accumulation of modern art, a collection which is in a state of continual transformation. Theoretically all works of art in the Luxembourg are *tentatively* exhibited. Ten years after the artist's death they *may* go to the Louvre; they may be relegated to provincial galleries or they may be forgotten in storage. In this way the Louvre is saved the embarrassment of extending its sanction to the works of living artists. At the same time it is possible for the Luxembourg to buy and show the best works of living men while they are still the subject of popular interest and controversy and before death sends the prices of their works beyond the range even of national institutions.

In Berlin, similarly, the historical museums are supplemented by the National-Galerie in the Kronprinzen Palast. Here Picasso, Derain and Matisse rub shoulders with Klee, Nolde, Dix, Feininger and the best of the modern Germans. In Munich the Neue Staatsgalerie[26] with its five Cézannes and six Van Goghs, its Maillols and Matisses, competes with the series of old masters in the Alte Pinakothek. In Amsterdam the Stedelijk Museum bears a similar relation to the Rijks Museum. Even in London, a city which Americans tend to consider rather conservative in art, there has been the most remarkable activity. To the Tate Gallery have been added, largely through the gifts of Mr. Samuel Courtauld, magnificent rooms of modern French paintings—Seurat, Cézanne, Gauguin, Van Gogh, Matisse, Bonnard, Braque, Rouault, Utrillo, Dufresne. Very recently Sir Joseph Duveen has given money for a new gallery of modern sculpture, for which works by Maillol, Epstein, Méstrovic, and Modigliani have already been acquired.

New York, if fully awakened, would be able in a few years to create a public collection of modern art which would place her at least on a par with Paris, Berlin and London.

The Museum of Modern Art would in no way conflict with the Metropolitan Museum of Art, but would seek rather to establish a relationship to it like that of the Luxembourg to the Louvre. It would have many functions. First of all it would attempt to establish a very fine collection of the immediate ancestors, American and European, of the modern movement; artists whose paintings are still too controversial for universal acceptance. This collection would be formed by gifts, bequests, purchase and perhaps by semi-permanent loans.

Other galleries of the Museum might display carefully chosen permanent collections of the most important *living* masters, especially those of France and the United States, though eventually there should be representative groups from England, Germany, Italy, Mexico and other countries. Through such collections American students and artists and the general public could gain a consistent idea of what is going on in America and the rest of the world—an important step in contemporary art education. Likewise, and this is also very important, visiting foreigners could be shown a collection which would fairly represent *our own* accomplishment in painting and sculpture. This is quite impossible at the present time.

In time the Museum would expand beyond the limits of painting and sculpture in order to include departments devoted to drawings, prints and other phases of modern art. In addition to the Museum's permanent collections, space would be set aside for great and constantly recurring loan exhibitions, national and international.

Even the beginnings of such a museum are not created overnight. A suitable building, a trained staff, as well as notable collections, will eventually be needed —and none of these can be had immediately. To make a gradual approach the following plan has been adopted:

The Museum of Modern Art will function, during the first two years, as a

gallery for temporary loan exhibitions. An ample and centrally located gallery at Fifth Avenue and 57th Street will house six or seven major and perhaps a dozen minor exhibitions during each year. The first exhibition, to open in October 1929, will perhaps comprise a collection of a hundred or more paintings and drawings by Cézanne, Van Gogh, Gauguin, Renoir and Seurat.[27]

Other exhibitions will probably include:

Paintings by American masters of the past fifty years—Ryder, Winslow Homer, Eakins.

A Daumier memorial exhibition.

Paintings by distinguished contemporary American masters.

Canvases by the outstanding French painters of today.

A survey of Modern Mexican Art.

Works by American, French and German sculptors.

For all of the Museum's exhibitions the co-operation of other museums, private collectors, and dealers is warmly invited. Nothing in the Museum will be for sale. It will function purely as an educational institution.

It is not unreasonable to suppose that within ten years New York, with its vast wealth, its already magnificent private collections and its enthusiastic but not yet organized interest in modern art, could achieve perhaps the greatest modern museum in the world.

The seven organizers of the Museum of Modern Art are: Miss Lizzie Bliss, Mrs. W. Murray Crane, Professor Paul J. Sachs, Mrs. Cornelius J. Sullivan; Mrs. John D. Rockefeller, Jr., Treasurer; Mr. Frank Crowninshield, Secretary; and Mr. A. Conger Goodyear, Chairman.

The Director of the new museum will be Alfred H. Barr, Jr., whose writings on modern art, and whose studies at Princeton, Harvard, the Fogg Museum and abroad, qualify him admirably for the post.

A New
Museum

Between August 1929 and January 1930 Barr wrote two editions of a fund-raising brochure, three articles in popular magazines, and delivered a paper to the College Art Association Annual Meeting that later appeared in *Art News,* describing—and justifying—the establishment of The Museum of Modern Art. All followed the same pattern of reasoning. (From *Vogue,* October 1929.)

Announcement has been made of the establishment in New York of what may well become the most important Museum of Modern Art in America. The inception of the Museum has been brought about by seven collectors and connoisseurs of modern art, who have formed themselves into a committee composed of Miss Lizzie Bliss, Mrs. W. Murray Crane, Professor Paul J. Sachs, Mrs. Cornelius J. Sullivan; Mrs. John D. Rockefeller, junior, Treasurer; Mr. Frank Crowninshield, Secretary; and Mr. A. Conger Goodyear, Chairman.

The reasons for the foundation of such a museum are manifold. Its educational value will be inestimable—to painters looking for encouragement and inspiration, to students of the history of art, to students of contemporary culture, to critics searching for some canon of comparison, to the general public which likes to look at pictures. But a more fundamental urge to the creation of this museum is the overwhelming interest in modern art developed during the last twenty years.

In the history of art, as in more materialistic matters, money talks vividly. Let us not be ashamed to listen. When two of the greatest modern painters, Cézanne and Van Gogh, died, the accumulated income from the sale of their pictures would scarcely have paid for adequate funerals. To-day, twenty-five or thirty years later, a good Cézanne or a good Van Gogh brings fifty thousand dollars. During Seurat's lifetime, his pictures wanted purchasers. Thirty years after his death, the American collector, John Quinn, paid seven thousand dollars for "Le Cirque." To-day, only ten years later, this same picture would probably bring one hundred and fifty thousand dollars; that is, if the Louvre, to which Quinn bequeathed it, decided to sell. But far more significant are the prices paid for the work of living artists. Derain and Matisse have comparatively luxurious incomes, and Picasso seems to thrive to-day by those very tactics which would have left him a penniless bohemian fifty years ago. Even the ultramodernists

of 1929, Joan Miró, Otto Dix, Jean Lurçat, Pierre Roy, are adequately rewarded financially, as well as acutely appraised critically.

In short, the attitude towards the advanced artist has changed astonishingly. Of course, he is still called (by the obtuse) madman, degenerate, and (more absurdly) bolshevik, but, on the whole, his position seems better than at any time since the French Revolution.

Now let us ask ourselves questions. Are we not in America participants in this new attitude towards the modern artist? Do not our collectors turn increasingly from old masters to the adventure of buying the works of living men? A host of names spring to mind, in answering this question—in Chicago, Mrs. John Alden Carpenter, Martin Ryerson; in Baltimore, the Misses [Claribel and Etta] Cone; in Philadelphia, Dr. Albert Barnes; in Boston, John Spaulding, Robert Treat Paine, second, Mrs. Shaw McKean; in Columbus, Ferdinand Howald; in Detroit, Ralph Booth; in Washington, Duncan Phillips; in New York—but, in New York, the list is too long even to begin.

Are not our critics flexibly minded, sympathetic to innovation? Our picture dealers, do they not dare to experiment especially in this field, which has expanded so astonishingly in the last ten years? The great public itself, which can not afford to collect, is thoroughly aroused. The rage, untutored as it is, for modernistic furniture is evidence of a new taste.

Now, this general enthusiasm for contemporary art of an advanced character is no new thing, though it may seem so as we look back over the last hundred and fifty years, which seems to have been a period of abnormal divergence between the achievements of important artists and the tastes of their public. Previous to 1800, artists, even the most courageous innovators, had been understood, or at least accepted with remarkable facility. Giotto, the fourteenth-century modernist, secured contracts from Chambers of Commerce and churches, business men and noblemen in a dozen Italian cities. Donatello, Piero della Francesca, Botticelli, Jan van Eyck, and the Bellinis were famous and honoured. Popes bowed to Michelangelo, an emperor to Titian. The uncompromising Poussin, the temperamental Bernini took turns at snubbing Louis XIV. Rubens painted for three or four kings. El Greco—master of distortion—had he been half so tactful as Velazquez would have been official court painter. As it was, he was acknowledged the best painter in Spain. The eighteenth-century master was for the most part as well provided for as were his Renaissance and Baroque predecessors. Gainsborough, Chardin, Tiepolo, Boucher, and even those arch rebels, David and Goya, maintained fairly harmonious relations with the society in which they lived.

But after 1800, the condition of the adventurous artist is extraordinarily altered. Delacroix, Constable, Ingres (in his early years) are ridiculed. Courbet, Manet, Degas, Renoir, Monet, Cézanne, almost every great name, calls up its corresponding story of contempt and neglect. Waves of laughter and wrath break over the next generation—Gauguin, Seurat, Van Gogh. Most critics jeer; most collectors follow their lead. All but a few dealers invest their money in Meisso-

niers and Henners. Shortly before his death, poor Cézanne is made happy by the mere sight of his pictures in real frames "like old masters"—even though very few are sold. Only octogenarians like Monet survive to find their art accepted and, ironically, established in orthodoxy to confront the turbulent youth of the early twentieth century, *les Fauves.* And now the twenty-fifth anniversary of the *Fauves* movement is being celebrated, not defiantly, not rebelliously, but with dignity and confidence, for these "wild beasts" of 1905 —Matisse, Vlaminck, Braque, Friesz, Derain—are now, at the height of their matured powers, among the most respected living artists.

Far more remarkable is the fact that their juniors have fared even better. The cubists and subsequent rebels have made continuously fresh assaults upon the rapidly weakening opposition. Until now, few critics dared to condemn too quickly the new thing, be it the *neue Sachlichkeit* or *sur-réalisme.*

Indeed, it looks as if the world had learned its lesson. Enthusiasm, aesthetic curiosity, and tolerance, abetted, it must be confessed, by some snobbery and speculation, have gone far in transforming the position of the modern artist, closing that breach of misunderstanding and mutual indifference which had come between him and his public, though in a manner very different from that which existed before the nineteenth century.

And now our most important question—our museums—what have they done? Have they kept pace with the progressive spirit of our collectors and critics, and the general public?

The answer to this question embodies strange contradictions. In Detroit, Dr. [W. R.] Valentiner has brought together a very stimulating collection of modern paintings, American, German, and French. The Chicago Art Institute houses the magnificent Birch-Bartlett room of masterpieces by Cézanne, Seurat, Picasso, and Matisse. The Fogg Museum of Harvard University held, last spring, the finest exhibition of modern French painting since the Armory Show of 1913. San Francisco, Cleveland, Minneapolis, and Worcester have excellent modern pictures of the non-academic kind. But, in New York, that vast, that exceedingly modern metropolis, we discover a curious anomaly. The Metropolitan, the foremost museum in America, owns no Van Gogh, no Gauguin, no Seurat, no Toulouse-Lautrec, men long dead, and, among the living, no Matisse or Picasso, no Segonzac, no Derain or Bonnard, or Laurencin; and among Americans, no Walt Kuhn or Dickinson; no Max Weber, Lachaise, or Georgia O'Keeffe.

In spite of her many and voluble critics, the policy of the Metropolitan is easily defended, because it is reasonable. She can not afford to extend her sanction rashly. She can not afford to take a chance on being wrong. Her great historical collections are not journalistic; they can not, nor should they attempt, to tell us what new things are going on in the world. Novelties are impermanent, and taste is embarrassingly transitory.

But the Metropolitan is in no sense alone in her staid policy. The Louvre ignores artists till long after death. The Kaiser Friedrich Museum devotes itself to old masters. The National Gallery in London, the Alte Pinakothek in Munich,

and the Museum of Art in Moscow ignore modern art, not tentatively, but absolutely. Why? Because there are in each of these great cities museums devoted solely to modern art. Berlin has the National-Galerie in the Kronprinzen Palast, where works by the best modern German and French painters can be seen. Munich has the Neue Staatsgalerie, Moscow, three modern museums with fifty-five Picassos and twenty Cézannes.[28] London, mainly through the efforts of Samuel Courtauld and Sir Joseph Duveen, has added magnificent modern rooms to the Tate Gallery, where one may see fine Van Goghs, Seurat's "Le Baignade," Matisse, Braque, Utrillo, and many others. Finally, in Paris, there is in addition to the Louvre, the Luxembourg. Between these two French galleries, as between those in the cities just mentioned, there can be no rivalry, for they supplement each other. The finest works in the Luxembourg, those that have stood time's criticism, ten years after the painter's death, may be admitted to the Louvre; others are conveniently got rid of when interest in them is found to have passed (though it must be kept in mind that works of art which are vitally important to us deserve careful consideration, even though our grandchildren may despise them).

It was with these modern museums of London, Berlin, and Paris in mind that the small group of influential men and women, mentioned at the beginning of this article, have organized in New York a gallery to be known as the Museum of Modern Art. This undertaking, immense in its potentialities, will begin with a modest experiment. For the first two years, a series of loan exhibitions will be held on the twelfth floor of the Heckscher Building on Fifth Avenue at Fifty-seventh Street. Cézanne, Van Gogh, Gauguin, and Seurat, the ancestors of the modern movement, will form the first show, to be followed by our American ancestors, Ryder, Winslow Homer, and Thomas Eakins, the last of whom is possibly of more interest to the younger generation than even the great Frenchmen previously named. Other exhibitions will be devoted to the work of living Americans, living French painters, German sculptors, Russian painters, modern Mexican art, with, perhaps, "one-man shows" for Daumier, Seurat, and others. For these exhibitions, funds are being raised. The cooperation of collectors, critics, and dealers will, of course, be invited. (Already there is every evidence that abundant interest and enthusiasm will be forthcoming.)

At the end of two years, we should be able to discover whether New York really wants a Modern Museum, which may easily become the greatest of its kind in the world.

Modern
Architecture:
International
Exhibition:
Foreword

Barr and Henry-Russell Hitchcock had been friends since they met as students at Harvard, and Hitchcock had been a guest lecturer for Barr at Wellesley. In early 1932, while Hitchcock was teaching at Vassar, he and Philip Johnson, then just out of Harvard, organized *Modern Architecture: International Exhibition* at The Museum of Modern Art (the Museum's first show to break away from the traditional mediums of painting and sculpture) and wrote the accompanying catalogue, which also had an essay, "Housing," by Lewis Mumford. Barr wrote the Foreword.

Expositions and exhibitions have perhaps changed the character of American architecture of the last forty years more than any other factor. The Chicago Columbian Exposition of 1893 established that refined archaeological taste for antique colonnades which almost immediately became the official style for American public buildings. This Classical Revival was later accompanied by the revival of "good taste" in Colonial houses, Gothic college dormitories, Spanish country clubs and a dozen other varieties of evidence that our architects knew their history. Unfortunately this flood of revivalism not only brought to an end the robust bad taste of our late nineteenth century building but very nearly stifled the one genuinely important tradition in modern American architecture, the thread which passed from Richardson to Sullivan, from Sullivan to Frank Lloyd Wright. By 1922, thirty years after the Chicago Exposition, the American public was entirely persuaded that, however secondary to the European arts American painting or sculpture or music might be, in architecture we led the world. This feeling seems to have been based partially upon the ability of our architects to imitate past European styles more tastefully even than the Europeans themselves, and partially upon our technical proficiency whether in central heating, bathroom furniture or the rapid erection of skyscrapers. It was the skyscraper especially that confirmed our pride, for we had not yet come to realize

that it was the engineer, perhaps more than the architect, who made our sky-scrapers imposing.

Strangely enough it was in the field of skyscraper design that our complacency was to receive a severe jolt. In 1922 the competition for the Chicago Tribune Tower brought forth scores of projects from all over the world. Almost without exception the American designs were Renaissance or Roman or Gothic; most of the European projects proved equally derivative though several were genuinely modern and several others transitional or half-modern. A Gothic design by the New York architect Raymond Hood was given first prize by the *Tribune.* Saarinen, a Finnish architect, won the second prize. His project which was enthusiastically acclaimed by American architects was an agreeable eclectic compromise achieved by applying novel ornament upon an emphatically vertical façade which rose from a Neo-Classic ground story. By common consent a foreign architect had surpassed Americans in solving a peculiarly American problem. Saarinen's triumph might have been all the more embarrassing had it been generally realized that his principles of design derived primarily from the neglected Sullivan, and that his new ornament was less original than that of Frank Lloyd Wright, since 1910 one of the chief inspirations of modern European architecture.

The exhibition which included Saarinen's project traveled throughout the country and did much to shake the confidence of American architects in the sufficiency of historical styles for modern purposes. The Paris Exposition of Decorative Arts in 1925 was even more disturbing. The United States was not represented in the Exposition because its exhibits were not sufficiently modern. We are still suffering from this backwardness—both commercially and architecturally. Only recently has the deluge of "modernistic" decoration from Vienna, Paris, Stockholm and Amsterdam begun to diminish, but not before our more advanced architects, already stimulated by Saarinen's success, had accepted the modernistic mode with enthusiasm and ornamented their buildings with zig-zags and chevrons instead of Gothic crockets and Classical modelings. The modernistic style has become merely another way of decorating surfaces.

As a result of these forty years of successive and simultaneous architectural fashions the avenues of our greatest cities, our architectural magazines and annual exhibitions are monuments to the capriciousness and uncertainty of our architecture.

The present exhibition is an assertion that the confusion of the past forty years, or rather of the past century, may shortly come to an end. Ten years ago the Chicago Tribune competition brought forth almost as many different styles as there were projects. Since then the ideas of a number of progressive architects have converged to form a genuinely new style which is rapidly spreading throughout the world. Both in appearance and structure this style is peculiar to the twentieth century and is as fundamentally original as the Greek or Byzantine or Gothic. In the following pages Mr. Hitchcock and Mr. Johnson have outlined its history[29] and its extent. Because of its simultaneous development in several

different countries and because of its world-wide distribution it has been called the International Style.

The aesthetic principles[30] of the International Style are based primarily upon the nature of modern materials and structure and upon modern requirements in planning. Slender steel posts and beams, and concrete reinforced by steel have made possible structures of skeleton-like strength and lightness. The external surfacing materials are of painted stucco or tile, or, in more expensive buildings, of aluminum or thin slabs of marble or granite and of glass both opaque and transparent. Planning, liberated from the necessity for symmetry so frequently required by tradition is, in the new style, flexibly dependent upon convenience.

These *technical* and *utilitarian* factors in the hands of designers who understand inherent aesthetic possibilities have resulted in an architecture comparable in integrity and even in beauty to the styles of the past. But just as the modern architect has had to adjust himself to modern problems of design and structure so the modern public in order to appreciate his achievements must make parallel adjustments to what seems new and strange.

First of all, the modern architect working in the new style conceives of his building not as a structure of brick or masonry with thick columns and supporting walls resting heavily upon the earth but rather as a skeleton enclosed by a thin light shell. He thinks in terms of *volume*—of space enclosed by planes or surfaces—as opposed to *mass* and solidity. This principle of volume leads him to make his walls seem thin flat surfaces by eliminating moldings and by making his windows and doors flush with the surface.

Two other principles which are both utilitarian and aesthetic may be called *regularity* and *flexibility*. The architects of the Classical and Renaissance, and often of the Medieval periods, designed their façades and plans in terms of bilateral symmetry, that is of balanced masses on either side of a central axis. They also usually divided their façades horizontally in three parts: the bottom or base, the wall or middle section and the top or cornice. In the International Style these arbitrary conventions of symmetry and triple division are abandoned for a method of design which accepts, first, both vertical and horizontal repetition and, second, flexible asymmetry, for both are natural concomitants of modern building. The modern architect feels it unnecessary to add an elaborate ground floor and an elaborate crowning decoration to his skyscraper, or a gabled porch in the center and at either end of his school or library. He permits the horizontal floors of his skyscraper and the rows of windows in his school to repeat themselves boldly without artificial accents or terminations. And the resulting *regularity,* which may in itself be very handsome, is given accent by a door or ventilator, electric sign, stair tower, chimney, or fire escape, placed asymmetrically as utility often demands, and the principle of *flexibility* permits. The Bauhaus at Dessau in the present exhibition is a clear illustration of these principles of design.

A fourth comprehensive principle is both positive and negative: positive

quality or beauty in the International Style depends upon technically perfect use of materials whether metal, wood, glass or concrete; upon the fineness of proportions in units such as doors and windows and in the relationships between these units and the whole design. The negative or obverse aspect of this principle is the elimination of any kind of ornament or artificial pattern. This lack of ornament is one of the most difficult elements of the style for the layman to accept. Intrinsically there is no reason why ornament should not be used, but modern ornament, usually crass in design and machine-manufactured, would seem to mar rather than adorn the clean perfection of surface and proportion.

These principles are not as dogmatic as they must necessarily seem in so brief a discussion: on the contrary they have been derived from the evolution and intrinsic character of the architecture itself. A study of these principles in relation to most of the models and photographs in the present exhibition will enable the visitor to understand what is meant by the International Style and how it differs from the modernistic or half-modern decorative style, which with the persistence of the revived styles of the past, has added so much to the confusion of contemporary architecture.

In this exhibition the International Style is illustrated by the work of its leading exponents in Europe and in America. One very great architect, however, is included who is not intimately related to the Style although his early work was one of the Style's most important sources. Mr. Hitchcock explains how fundamental was Frank Lloyd Wright's influence upon the important Dutch architect J. J. P. Oud. The Germans, Gropius and Miës van der Rohe, also seem to have studied his work at some time in their careers. But Wright while he does not precisely disown these architectural nephews remains, what he has always been, a passionately independent genius whose career is a history of original discovery and contradiction. While he is much older than the other architects in the exhibition his role is not merely that of "pioneer ancestor." As the embodiment of the romantic principle of individualism, his work, complex and abundant, remains a challenge to the classical austerity of the style of his best younger contemporaries.

Another exception, Raymond Hood, is included because, of all the megalopolitan architects, he seems the most straightforward as well as the most open to new ideas. It is true that his work in retrospect appears somewhat inconsistent, but he must be credited with having designed the finest skyscraper in the vertical style and, a year later, the finest New York skyscraper with a horizontal emphasis (which suggests the definite influence of the International Style).[31] Time will shortly reveal whether his inclusion in the exhibition is a prophecy that a brilliant future awaits our commercial architecture or whether as in the past fifty years our best building will be designed by non-conformists and rebels.

The four founders of the International Style are Gropius, Le Corbusier, Oud and Miës van der Rohe. It happens that one is a Parisian of Swiss birth, another a Dutchman, the other two Germans; but it would be very difficult to find in their

work any national characteristics. For Le Corbusier is perhaps the greatest theorist, the most erudite and the boldest experimenter, Gropius the most sociologically minded, Miës van der Rohe the most luxurious and elegant, while Oud of Rotterdam possesses the most sensitive and disciplined taste. These four masters prove not only the internationalism of the Style but also, as Mr. Hitchcock makes clear, the wide personal variations possible within what may seem at first glance a restricted range of possibilities.

Among American architects are five others whose work is given special emphasis in the exhibition. The new skyscraper by Howe & Lescaze in Philadelphia is a monument to the persistence and artistic integrity of a firm which has only recently, after years of discouragement, persuaded clients, real estate brokers, and renting agents that the International Style may not be a commercial liability. Whether conservative New York will take Howe & Lescaze's housing project as seriously as it deserves remains to be seen.

Principally because of his writing the Austrian-born Neutra is, among American architects, second only to Wright in his international reputation. His executed buildings permit him to rank as the leading modern architect of the West Coast. The Bowman Brothers of Chicago have as yet built very little but their thorough study of steel construction in relation to architecture, both technically and legally, may revolutionize certain phases of American architecture within the next few years. Their concern with structural probity and frankness has led them very naturally to work in the International Style.

Many difficult architectural problems are touched upon in the exhibition—the private house, the school, apartment houses, both urban and suburban, the church, the factory, the department store, the club and (alumni please note) the college dormitory. But more urgent than any of these is the problem of low-rent housing. Lewis Mumford's article[32] is an admirable and challenging exposition of this subject, more vital in these days of superfluous population than ever before. The aerial photographs of "slums and super-slums" are instructive criticisms of contemporary city planning—or lack of planning. But of even more positive value is the model of a housing development, by the German Haesler, one of the foremost European experts. In this project the economy, adaptability and beauty of the International Style are as clearly demonstrated as in the more costly kinds of building shown elsewhere in the exhibition.

Modern and "Modern"

Nineteen thirty-four marked the Museum's fifth anniversary and the permanent acquisition of the Lillie P. Bliss Collection. Both events gave the Museum a new sense of security about its stature and optimism about its future. Barr never needed much of an excuse to look at the big historical picture, and here he acknowledges the issues inevitably arising with the burgeoning permanent collection, and sets the stage for the great survey shows of 1936. Echoes of this early essay are to be found in two major statements of later years: Barr's confidential notes on " 'Modern Art' and the American Public" by James D. Plaut (1948), and "A Statement on Modern Art" by The Institute of Contemporary Art, Boston, The Museum of Modern Art, New York, and the Whitney Museum of American Art, New York (1950). *(See pp. 32ff.)* (From *The Bulletin of the Museum of Modern Art,* May 1934.)

[handwritten: "name as x ample of fixed ..."]

Modern history is an ambiguous and flexible term. When opposed to ancient history, modern history may begin with the fall of the Roman Empire. But if medieval history is granted autonomy then modern history is said to begin with the Fall of Constantinople or the Discovery of America. Yet if one takes up a "History of Modern Europe" one is just as likely to find the French Revolution or the Council of Vienna or the Franco-Prussian War has been used as a point of departure.

The word *modern* when applied to art is even more confusing. During the Renaissance *modern* was an adjective of confident approval applied to the new style which had arisen in emulation of the art of the "Antique" or Graeco-Roman world. Cimabue and Giotto were considered the founders of the modern manner. In the eighteenth century however, when an orthodox "Classicism," based on both archeological research and aesthetic theory, had shattered the self-assurance of the Renaissance, the word *modern* was often used with humility (or even hostility) to describe the work of the recent past which was thought to have fallen far below the achievement of the "Antique."[33] In the nineteenth century *Renaissance* was applied more and more to the earlier centuries of the modern period and *Baroque* to the post-Renaissance art of about 1575–1775.

Today one may begin the history of modern art with David's dictatorship in 1792, the Delacroix-Constable *Salon* of 1824, Courbet's one man revolt of 1855, or the First Impressionist Exhibition of 1874—or if one wishes one may start with Caravaggio or even with Giotto.

"MODERN"

The term *modern art,* chronologically speaking, is then so elastic that it can scarcely be defined. But the colloquialism "Modern Art" in caps or quotes is often no mere question of academic chronology. "Modern Art" is recurrently a matter for debate, to be attacked or defended, a banner for the progressive, a red flag for the conservative. In this sense the word *modern* can become a problem not of periods but of prejudices.

In "Modern Painters" Ruskin defended Turner[34] and Holman Hunt against the British philistines but twenty years later called one of Whistler's *Nocturnes* "a paint-pot flung in the face of the public." Whistler brought a lawsuit against Ruskin but himself did not hesitate to call Cézanne's paintings childish. Cézanne in his old age voiced his contempt for "Modern Art" as he saw it in the work of Gauguin and van Gogh who in turn, had they lived long enough, would doubtless have damned Cubism.

A VARIABLE TERM

Today Cubism is twenty-five years old and some of the believers in the over-emphasis of plastic design which gave rise to Cubism would like to establish an orthodox definition of "Modern" art. A few months ago a well-known New York artist and critic wrote: "The word 'Modern' as applied to pictures *has* acquired an international definition. . . . The modern work for instance definitely breaks with all transferring of actual appearances from nature—all copying or mere reporting of facts. It creates all data into an invention. The integration of spaces, colors and forms weaves into a plastic or controlled picture surface. . . ."

Fifteen years ago this definition might have seemed plausible, but in 1934 it is scarcely more valid than Ruskin's exposition of the aims of the Pre-Raphaelites, the revolutionary "Modern" painters of 1850: "They will draw what they see . . . the actual facts of the scene . . . irrespective of any conventional rules of picture making." The Superrealists,[35] the most conspicuous advance-guard movement of today, even more than the Pre-Raphaelites, disregard at least so far as their program is concerned the importance of "plastic values."

Since the war, art has become an affair of immense and confusing variety, of obscurities and contradictions, of the emergence of new principles and the renascence of old ones. As evidence of this complexity one may recall the by no means complete cross-section of modern painting in the Museum's Summer Exhibition of 1933;[36] or glance through such books as Herbert Read's *Art Now*[37] or Franz Roh's *Nach Expressionismus,*[38] or the catalogs of the Museum's American exhibitions. The truth is that modern art cannot be defined with any degree of finality either in time or in character and any attempt to do so implies a blind faith, insufficient knowledge, or an academic lack of realism.

Cubism and Abstract Art: Introduction

Barr had wanted to mount a show of international abstract art since the Museum was founded. This exhibition in 1936 was the first in a projected series of shows that Barr intended, as he wrote in the pamphlet *A Brief Guide to the Exhibition of Fantastic Art, Dada, Surrealism,* "to illustrate some of the principal movements of modern art in a comprehensive, objective, and historical manner." Because he had had the ideas in his head since his years at Wellesley, the 249-page catalogue was written, laid out (by Barr), and printed in six weeks.

THE EARLY TWENTIETH CENTURY

Sometimes in the history of art it is possible to describe a period or a generation of artists as having been obsessed by a particular problem. The artists of the early fifteenth century for instance were moved by a passion for imitating nature. In the North the Flemings mastered appearances by the meticulous observation of external detail. In Italy the Florentines employed a profounder science to discover the laws of perspective, of foreshortening, anatomy, movement and relief.

In the early twentieth century the dominant interest was almost exactly opposite. The pictorial conquest of the external visual world had been completed and refined many times and in different ways during the previous half millennium. The more adventurous and original artists had grown bored with painting facts. By a common and powerful impulse they were driven to abandon the imitation of natural appearance.

"ABSTRACT"

"Abstract" is the term most frequently used to describe the more extreme effects of this impulse away from "nature." It is customary to apologize for the word "abstract," but words to describe art movements or works of art are often inexact: we no longer apologize for applying the ethnological word "Gothic" to French thirteenth century art and the Portuguese word for an irregular pearl, "Baroque," to European art of the seventeenth century. Substitutes for "abstract" such as "non-objective" and "non-figurative" have been advocated as

superior. But the image of a square is as much an "object" or a "figure" as the image of a face or a landscape; in fact "figure" is the very prefix used by geometers in naming A or B the abstractions with which they deal.

This is not to deny that the adjective "abstract" is confusing and even paradoxical. For an "abstract" painting is really a most positively concrete painting since it confines the attention to its immediate, sensuous, physical surface far more than does the canvas of a sunset or a portrait. The adjective is confusing, too, because it has the implications of both a verb and a noun. The verb *to abstract* means to *draw out of* or *away from.* But the noun *abstraction* is something already drawn out of or away from—so much so that like a geometrical figure or an amorphous silhouette it may have no apparent relation to concrete reality. "Abstract" is therefore an adjective which may be applied to works of art with a certain latitude, and, since no better or more generally used word presents itself, it shall be used from now on in this essay without quotation marks.

NEAR-ABSTRACTIONS AND PURE-ABSTRACTIONS

The ambiguity of the word abstract as applied to works of art is really useful for it reveals the ambiguity and confusion which is inseparable from the subject. Perhaps keeping in mind the "verb" and "noun" meanings of *abstract* may help to clarify. For example, the Suprematist painting [*Suprematist Composition*] by Malevich is composed of a black and red square. This painting has absolutely no dependence upon natural forms. It is purely abstract in its genesis as well as in its final form. In it Malevich carried out his program by combining two of the elementary geometrical forms which he had set up as the fundamental vocabulary of Suprematism [*Fundamental Suprematist Elements*, 1913]. This painting is *abstract* in the "noun" sense of the word. Similar to it are Mondrian's *Composition* [1926] and Gabo's *Space Construction* [*Monument for an Airport*, 1925–26]. Different in character and genesis but equally abstract, at least in intention are certain paintings of Kandinsky who used non-geometrical [*Improvisation*, 1915] as well as geometrical forms [*Composition no. 1*, 1921]. These works of Malevich, Mondrian, Gabo, Kandinsky, may be called *pure-abstractions.*

However, Mondrian's "plus and minus" composition of 1915 despite its appearance is not a pure-abstraction. It is actually based upon a seascape just as van Doesburg's painting [*Esthetic Transformation of the Object*, c. 1918] has been *abstracted* (note the *verb*) from the form of a cow. After 1920 Mondrian and van Doesburg abandoned the process of "abstracting," and composed pure-abstractions.

Arp's reliefs [*Head*, 1924–25; *Relief*, 1930] are also impure abstractions even though their forms are so far removed from nature that it is often difficult to tell whether a given object represents a head or a cloud or Paolo and Francesca. Similarly, a Picasso landscape of 1912 may sometimes be mistaken for a still life or a portrait. The cords which tie these works to nature are tenuous,

" pure/ "adulterated "

reductive.
def.
reduces
t formal
cooler
previously,
as with
Russians

but unbroken—nor would the artist wish them broken. In fact Arp and Picasso usually *name* their works—"Guitar," "Head," or "Fork and Plate." Because of these vestiges of subject matter, even though little more than a name, it is clear that such works should be described as quasi- or pseudo- or near-abstractions. Perhaps the last is the least objectionable.

To resume: pure-abstractions are those in which the artist makes a composition of abstract elements such as geometrical or amorphous shapes. Near-abstractions are compositions in which the artist, starting with natural forms, transforms them into abstract or nearly abstract forms. He approaches an abstract goal but does not quite reach it.

There are of course several variations within these two classifications and several without, for example, the famous Kandinsky *Improvisation no. 30* [1913] in which the artist intended to paint an abstract composition but unconsciously (he says) introduced a couple of cannon in the lower right hand corner. So we have in this case a near-abstraction which the artist had intended to be a pure-abstraction.

DIALECTIC OF ABSTRACT ART

Abstract art today needs no defense. It has become one of the many ways to paint or carve or model. But it is not yet a kind of art which people like without some study and some sacrifice of prejudice. Prejudice can sometimes be met with argument, and for this purpose the dialectic of abstract painting and sculpture is superficially simple enough. It is based upon the assumption that a work of art, a painting for example, is worth looking at primarily because it presents a composition or organization of color, line, light and shade. Resemblance to natural objects, while it does not necessarily destroy these esthetic values, may easily adulterate their purity. Therefore, since resemblance to nature is at best superfluous and at worst distracting, it might as well be eliminated. Hans Arp, although he long ago abandoned pure-abstraction, has expressed this point of view with engaging humor:

> Art is a fruit growing out of a man like the fruit out of a plant, like the child out of the mother. While the fruit of the plant assumes independent forms and never strives to resemble a helicopter or a president in a cutaway, the artistic fruit of man shows, for the most part, ridiculous ambition to imitate the appearance of other things. I like nature but not its substitutes.[39]

Such an attitude of course involves a great impoverishment of painting, an elimination of a wide range of values, such as the connotations of subject matter, sentimental, documentary, political, sexual, religious; the pleasures of easy recognition; and the enjoyment of technical dexterity in the imitation of material forms and surfaces. But in his art the abstract artist prefers impoverishment to adulteration.

The painter of abstractions can and often does point to the analogy of music in which the elements of rhythmic repetition, pitch, intensity, harmony, counterpoint, are composed without reference to the natural sounds of either the "helicopter" or the "president in a cutaway." He looks upon abstract painting as independent painting, emancipated painting; as an end in itself with its own peculiar value.

To support their position defenders of abstract art during the past twenty-five years have often quoted a famous passage from the *Philebus* of Plato, Section 51c:[40]

> Socrates: What I am saying is not indeed directly obvious. I must therefore try to make it clear. I will try to speak of the beauty of shapes, and I do not mean, as most people would think, the shapes of living figures, or their imitations in paintings, but I mean straight lines and curves and the shapes made from them, flat or solid, by the lathe, ruler and square, if you see what I mean. These are not beautiful for any particular reason or purpose, as other things are, but are always by their very nature beautiful, and give pleasure of their own quite free from the itch of desire; and colors of this kind are beautiful, too, and give a similar pleasure.

NEAR-ABSTRACTIONS AND THEIR TITLES

Why then do Arp and Picasso give names such as "Head" or "Still Life" to works which are so abstract that at first glance they baffle recognition of any resemblance to nature? Why do they not, like Malevich and Kandinsky, go the whole way and call their pictures simply "compositions" or "improvisations"? This naming of near-abstractions after concrete objects certainly confuses and exasperates the layman who might otherwise be ready to enjoy the beauties of form and color which the near-abstractions offer.

For this reason critics and amateurs of abstract art have sometimes considered the titles given by Arp or Picasso to their near-abstractions as stumbling-blocks which may well be ignored or forgotten. This is, however, an unwarranted simplification of which, as has been remarked, the artists themselves do not approve. For a Cubist painting or an Arp relief *is* a *near-* abstraction, and offers an impure and ambiguous enjoyment to which the title is a guide. It is not merely the primary relationship of form and color *within* the picture which are enjoyable but also the secondary relationships between the picture *and* the subject matter of which the picture is an abstraction. Take for instance Picasso's *Violin* [ca. 1912]: starting with the idea or image of a violin Picasso makes an angular, quasi-geometrical composition which displays his power not merely of *composing* abstract forms but of breaking up and assimilating natural forms. As evidence of this abstracting and transmuting process and as a guide to our enjoyment of it he leaves certain vestiges of the violin, the spiral line of the scroll, the shape of the sound-holes, the parallel lines of the strings and the curves of the

purflings; and as further explanation he gives the name of the original object
—*Violin.*

ABSTRACT ART AND SUBJECT MATTER

Further examination of subject matter not merely as a point of departure but
as something of interest in itself may seem anomalous in a discussion of abstract
art; for, abstract art, in so far as it is abstract, is presumably devoid of subject
interest. Nevertheless, subject matter, although it can be ignored by the purist,
has played a part of some importance in several of the movements which will
be considered hereafter in these pages from a primarily formal point of view.

The Cubists seem to have had little conscious interest in subject matter. They
used traditional subjects for the most part, figures, portraits, landscapes, still
life, all serving as material for Cubist analysis.[41] On the contrary, to the Italian
Futurists subject matter was of real importance. The exaltation of the machine
and of the noise and confusion of modern life was as conscious a part of their
program as the abstract analysis of movements and forces. The French Purists
after the War used the silhouettes of deliberately chosen familiar objects with
which to make near-abstract compositions.

In Germany the Russian Kandinsky passed beyond subject matter except
when it appeared without the conscious intention of the artist. But Franz Marc's
poetic sentiment for animals lingered even in his most Cubistic compositions and
Feininger never eliminated entirely his romantic feeling for architecture and the
sea. Klee's subject matter is as ingenious and interesting as his form.

The Dadaists, who mocked all kinds of art including abstract, had no preju-
dice against subject matter though sometimes they eliminated it. Their succes-
sors, the Surrealists, however, would, as conscientious Freudians, maintain that
even squares and circles have symbolic significance. But even in much Surrealist
painting subject and symbol are obscured or entirely lost in what is virtually an
abstract design.

The cows and seascapes and dancers which lurk behind the earlier abstract
compositions of Mondrian and Doesburg have no significance save as points of
departure from the world of nature to the world of geometry. Malevich, however,
who founded Suprematism by drawing a perfect square discovered inspiration
for some of his subsequent and more elaborate compositions in the airplane
photographs of cities.

In summary it may be said that only in Futurism, Dadaism, Surrealism and
Purism had subject matter any real importance, at least so far as the conscious
program of the artists was concerned.

ABSTRACT ART AND POLITICS

It is its style, its abstract quality, as a general rule, and not its content or avowed
program, that has from time to time involved abstract art in politics. Exceptions

to this generalization were Futurism and Surrealism. The former in much of its program anticipated Fascism and the latter has been involved in Communism.

Pre-War Italian Futurism was latently Fascist in its patriotism, esthetic enjoyment of war and exhortation to the dangerous and dynamic life. Marinetti, its promoter, is now a Fascist senator, and Boccioni, its most important artist, died in military service, from the effects of a fall from his horse.

In Moscow after the Revolution, the Russian Futurists, Suprematists and Constructivists who had been artistically revolutionary under the Czar came into their own. For three years they dominated the artistic life of the larger cities, taught in the art academies, designed posters, floats in parades, statues to Marxian heroes and gigantic Cubistic facades to screen the Winter Palace during mass celebrations. Malevich's *White on White* of 1918 might have counted as a *tabula rasa* upon which to build a new art for a new order, but it was as unintelligible to the proletariat as his earlier Suprematist pictures had been to the bourgeoisie. Tatlin's and Rodchenko's constructions may have been abstract exercises in technological discipline but what the land desperately needed was practical mechanics. Highly cultivated Bolsheviks, such as Trotzky and Lunacharsky, understood and supported the artists of the advance guard, but Lenin, with his broad and penetrating vision of the practical needs of the U.S.S.R., found no joy in the Suprematists, the Cubo-Futurists and Tectonic Primitivists. He summarized the left-wing art and literature of 1920 as "the infantile disorder of Leftism" and felt that movies were more useful to the Soviet State. In 1921 came the New Economic Policy, the era of reconstruction and practical materialism. An attitude of toleration towards Leftism turned to impatience. A schism appeared in the ranks of the artists themselves. One faction wanted to maintain art for art's sake; their opponents wanted to put art at the service of the new order. The atelier of Pevsner and Gabo at the Moscow Academy was closed; they and Lissitzky left for Berlin; Kandinsky left for Germany to join the Bauhaus; Malevich took a post in less influential Leningrad; and most of the Suprematists and Constructivists who stayed in Moscow left art, in the narrow sense of the word, for typography, photography, posters, movies, engineering, stage design, carpentry—anything but painting or sculpture. Today abstraction or stylization in art is still considered a "left deviation" in the U.S.S.R. and is discouraged.

The political atmosphere of the Dadaists, the West-European contemporaries of the Russian Leftists, might be described as anarchist. That of their successors, the Surrealists, was Communist, although it would be hard to find anything specifically Communist in their paintings. The schism which had divided the Moscow Constructivists of 1920 reappeared ten years later in Surrealism. Aragon, the Surrealist writer, insisted, as Tatlin and Rodchenko had done, that the artist should place his talents practically and exclusively at the service of the Revolution. The Constructivist heretics who insisted upon the independence of art had found it advisable to leave Communist Moscow for Social Democratic Germany; but the Surrealists, Communist or not, continue to work in Paris

without serious molestation from either the Left or the Right (except when showing films).

Abstract art which had begun in Munich flourished in post-War Germany. In addition, the esthetic ideals of the Dutch *Stijl* group and of the Russian Constructivists were brought to Berlin by refugees from active Soviet philistinism or its more passive Dutch equivalent. Gradually abstract art, and the architecture which it influenced, became associated with the Social Democracy in the minds of its bitter enemies, the National Socialists. Modern architecture of the "International Style" had been used extensively in the housing developments authorized by Social Democratic burgomasters.

To the Nazis the cultural expression of the shameful fourteen years between the Treaty of Versailles and the National Resurgence of 1933 was—and is— anathema. Abstract art was considered *Kunstbolschewismus*, [42] and after the Nazi revolution many artists were dismissed from official positions or otherwise "discouraged." The flat roof and the white, clean lines of "Bauhaus" architecture were likewise forbidden in favor of a renascence of genuine Biedermeier (the German version of the International style of the 1830's).

About the same time, in the early thirties, the U.S.S.R. turned against modern architecture in favor of a monumental style derived from Imperial Rome and the Czarist 18th century. But Fascist Italy and conservative England, to complete the confusion, accepted modern architecture with enthusiasm. The railroad station in Florence has been completed in the *stile razionale,* and Lubetkin, a former Russian Constructivist, has designed new buildings for that British stronghold, the London Zoo.

This essay and exhibition might well be dedicated to those painters of squares and circles (and the architects influenced by them) who have suffered at the hands of philistines with political power.[43]

TWO MAIN TRADITIONS OF ABSTRACT ART

At the risk of grave oversimplification the impulse towards abstract art during the past fifty years may be divided historically into two main currents, both of which emerged from Impressionism. The first and more important current finds its sources in the art and theories of Cézanne and Seurat, passes through the widening stream of Cubism and finds its delta in the various geometrical and Constructivist movements which developed in Russia and Holland during the War and have since spread throughout the World. This current may be described as intellectual, structural, architectonic, geometrical, rectilinear and classical in its austerity and dependence upon logic and calculation. The second—and, until recently, secondary—current has its principal source in the art and theories of Gauguin and his circle, flows through the *Fauvisme* of Matisse to the Abstract Expressionism of the pre-War paintings of Kandinsky. After running under ground for a few years it reappears vigorously among the masters of abstract art associated with Surrealism. This tradition, by contrast with the first, is

intuitional and emotional rather than intellectual; organic or biomorphic rather than geometrical in its forms; curvilinear rather than rectilinear, decorative rather than structural, and romantic rather than classical in its exaltation of the mystical, the spontaneous and the irrational. Apollo, Pythagoras and Descartes watch over the Cézanne-Cubist-geometrical tradition; Dionysus (an Asiatic god), Plotinus and Rousseau over the Gauguin-Expressionist-non-geometrical line.

Often, of course, these two currents intermingle and they may both appear in one man. At their purest the two tendencies may be illustrated by paintings of twenty years ago: a Suprematist composition by Malevich and an *Improvisation* by Kandinsky. The geometrical strain is represented today by the painter Mondrian and the Constructivists Pevsner and Gabo; the non-geometrical by the painter Miro and the sculptor Arp. The shape of the square confronts the silhouette of the amoeba.

Chart of Modern Art

The original version of the chart appeared on the dust jacket of the catalogue for *Cubism and Abstract Art* in 1936. The revisions indicated here were made over time. In 1941 Barr wrote that corrections should be made as follows: "Omit the arrow from 'Negro Sculpture' to 'Fauvism.' Add a red arrow from 'Machine Esthetic' to 'Futurism.' The three dotted arrows leading from 'Purism,' 'de Stijl' and 'Neo-Plasticism' and 'Bauhaus' to 'Modern Architecture' should be solid, not dotted. There should be a black arrow from 'Abstract Expressionism' to 'Abstract Dadaism' and another black arrow from 'Abstract Expressionism' to 'Abstract Surrealism.' The dotted arrow from 'Redon' to 'Abstract Surrealism' should be omitted."[44]

Barr never considered the chart to be definitive.

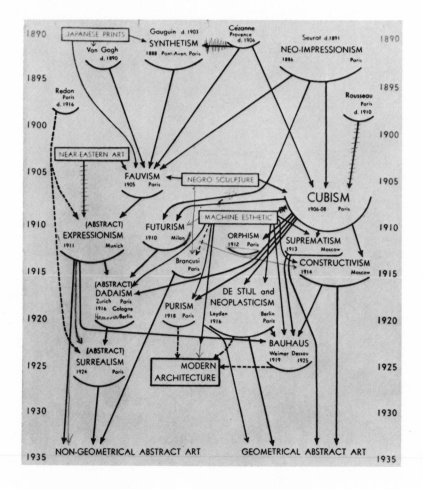

A Brief Guide
to the Exhibition
of Fantastic Art,
Dada, Surrealism

The catalogue for *Fantastic Art, Dada, Surrealism* was not ready in time for the exhibition, and so the introduction was printed as a pamphlet that was given away. This version is published here. The catalogue essays were by Georges Hugnet, an active participant in the Surrealist movement, but Barr wrote the introduction, compiled the list of Surrealist "devices, techniques, and media" employed by artists represented, and chose the works. Catalogue numbers, indicating which works illustrated which characteristics, have been omitted.

The exhibition of Fantastic Art, Dada, and Surrealism is the 55th exhibition assembled by The Museum of Modern Art and the second of a series intended to illustrate some of the principal movements of modern art in a comprehensive, objective, and historical manner. The first exhibition of the series was devoted to Cubism and Abstract Art, a movement diametrically opposed in spirit and esthetic principles to the present exhibition. In exhibiting these movements the Museum does not intend to foster any particular aspect of modern art. Its intention is, rather, to make a report to the public by offering material for study and comparison.

The explanation of the kind of art shown in this exhibition may be sought in the deep-seated and persistent interest which human beings have in the fantastic, the irrational, the spontaneous, the marvelous, the enigmatic, and the dreamlike. These qualities have always been present in the metaphors and similes of poetry but they have been less frequent in painting, which in the past was largely concerned with reproducing external reality, with decoration, or, as in some of the more advanced movements of recent years, with the composition of color and line into formal design.

FANTASTIC ART OF THE PAST

Fantastic subject matter has been found in European art of all periods. The art of the middle ages, with its scenes of Hell and the Apocalypse, its circumstantial

illustrations of holy miracles and supernatural marvels, seems from a rational point of view to have been predominantly fantastic. Most of this subject matter was of a traditional or collective character, but the Dutch artist Bosch, working at the end of the Gothic period, transformed traditional fantasy into a highly personal and original vision which links his art with that of the modern Surrealists.

During the Renaissance and the 17th century, fantastic art is to be seen principally in the art of minor men or in obscure works of great masters. Such technical devices (now used by the Surrealists) as the double-image, the composite image, distorted perspective, and the animation of the inanimate, were developed during this period. It should, however, be pointed out that many of the fantastic works of the past, such as the engravings of Hogarth, have a rational basis, satirical or scientific, which distinguishes them from the art of the recent Dadaists and Surrealists.

The beginning of Romanticism in the mid-18th century brought with it a more serious kind of fantastic art in the terrifying prison perspectives of Piranesi, and the nightmares of Füssli. By the year 1800, two of the greatest artists of the period, Blake and Goya, were expressing themselves in their most significant work by means of fantastic, enigmatic images.

In the 19th century fantastic satire or humor was often used by European and American caricaturists. A purer vein of fantasy is to be found in the drawings of Gaillot, Victor Hugo, and Grandville in France; Carroll and Lear in England; Busch in Germany; Cole and Beale in America. By the end of the century a poetic tradition which passed in literature from Poe and Baudelaire through the French symbolists found its pictorial counterpart in certain works of Redon.

FANTASTIC AND ANTI-RATIONAL ART OF THE PRESENT

It is probable that at no time in the past four hundred years has the art of the marvelous and anti-rational been more conspicuous than at the present time. The two principal movements, Surrealism and its precursor Dadaism, together with certain related artists, are discussed at length in M. Hugnet's articles in the Museum Bulletin[45] and in the chronology of the catalog.

Dada began in New York and Zurich about 1916 and flourished after the Great War in Cologne, Berlin, Hanover and Paris. The Dadaist painters and poets were moved by indignation and despair at the spectacle of the Great War and the ensuing Peace (just as Blake and Goya had cried out against war and the hollow conventions of religion and society during the period of the Napoleonic Wars). With robust iconoclastic humor the Dadaists mocked what they considered the sorry shams of European culture. They even attacked art—especially "modern" art—but while they made fun of the pre-War Cubists, Expressionists and Futurists, they borrowed and transformed many of the principles and techniques of these earlier movements.

In so doing the Dadaists, while attempting to free themselves from conventional ideas of art, developed certain conventions of their own—for example, automatism or absolute spontaneity of form, extreme fantasy of subject matter, employment of accident or the laws of chance, fantastic use of mechanical and biological forms.

In many of their ideas the Dadaists had been anticipated by Kandinsky, Klee, Chagall, de Chirico, Duchamp, Picasso.

SURREALISM

Dada died in Paris about 1922 but from its ashes sprang Surrealism, under the leadership of the poet André Breton. The Surrealists preserved the anti-rational character of Dada but developed a far more systematic and serious experimental attitude toward the subconscious as the essential source of art. They practiced "automatic" drawing and writing, studied dreams and visions, the art of children and the insane, the theory and technique of psychoanalysis, the poetry of Lautréamont and Rimbaud.

Among the original Surrealist artists were the ex-Dadaists Ernst, Arp, and Man Ray. About 1925, Masson and Miro joined the ranks for a few years, then Tanguy, Magritte and Giacometti, and, about 1930, Dali. The Surrealists also admired and claimed independent artists such as de Chirico, Klee, Duchamp, and Picasso.

Technically, Surrealist painting falls roughly into two groups. The first group makes what can be called (to use Dali's phrase) *hand-painted dream photographs* —pictures of fantastic objects and scenes done with a technique as meticulously realistic as a Flemish primitive. Dali, Tanguy, Magritte are the chief masters of "dream photographs" but they owe a great deal to the early work of both de Chirico and Ernst.

The subject matter, the images, of Dali and Magritte are, supposedly, of extreme uncensored spontaneity; but their precise realistic technique is the opposite of spontaneous. The second kind of Surrealist painting suggests by contrast complete spontaneity of *technique* as well as of subject matter. The free and almost casual technique of Masson and Miro belongs somewhat to the tradition of "automatic" drawing and painting previously carried on [in many works] by Kandinsky, Klee, and Arp.

Picasso and Ernst, the most versatile of the artists associated with Surrealism, are masters of many techniques. Ernst is the foremost master of Surrealist *collage* and of the semi-automatic technique of *frottage*.

THE SURREALIST OBJECT

Shortly before the War the Cubists incorporated in their painting and sculpture fragments of ordinary materials such as matches, playing cards, bits of newspaper, calling cards, etc., thereby undermining the tradition that "art" must

necessarily be in conventional media such as oil painting or bronze or marble.

Cubist objects appealed to a sense of design or form but Dada and Surrealist objects have primarily a psychological interest—bizarre, dreamlike, absurd, uncanny, enigmatic. They are objects of "concrete irrationality."

In 1914 Duchamp signed as a work of art an ordinary bottle drier, the first of a long series of "ready-mades" or ordinary manufactured objects which were to appear in Dada and Surrealist exhibitions. Some were shown unaltered, others were elaborately "assisted." The most famous Dada "ready-made assisted" is Duchamp's *Why not sneeze?* [1921], a bird cage, filled with marble cubes made to look like lumps of sugar, out of which sticks a thermometer. *Why not sneeze?* is an object remarkable for the subtlety, complexity and humor of its multiple incongruities; Oppenheim's *Fur-covered cup, plate and spoon* [1936] is simple by contrast but seems to exert an extraordinary and disquieting fascination: it is probably the most famous tea set in the world.

Many other kinds of objects have a Surrealist character: for instance, the *Oval wheel* [1878, found by Man Ray and Paul Eluard], the *Object made from a Sears-Roebuck catalog* [from northern Vermont, 1936, in the study collection of The Museum of Modern Art], mathematical objects [*e.g.*, Wenzel Jamnitzer, Etching from *Perspectiva Corporum Regularium*, 1568], botanical models, etc.

ART OF CHILDREN AND THE INSANE

Why should the art of children and the insane be exhibited together with works by mature and normal artists? But, of course, nothing could be more appropriate as comparative material in an exhibition of fantastic art, for many children and psychopaths exist, at least part of the time, in a world of their own unattainable to the rest of us save in art or in dreams in which the imagination lives an unfettered life. Surrealist artists try to achieve a comparable freedom of the creative imagination, but they differ in one fundamental way from children and the insane: they are perfectly conscious of the difference between the world of fantasy and the world of reality, whereas children and the insane are often unable to make this distinction.

CONCLUSION

We can describe the contemporary movement toward an art of the marvelous and irrational but we are still too close to it to evaluate it. Apparently the movement is growing: under the name of Surrealism it is now active in a dozen countries of Europe, in North and South America, in Japan; it is influencing artists outside the movement as well as designers of decorative and commercial art; it is serving as a link between psychology on one hand and poetry on the other; it is frankly concerned with symbolic, "literary" or poetic subject matter and so finds itself in opposition to pure abstract art, realistic pictures of the social scene and ordinary studio painting of nudes or still life; its esthetic of the

Right to left: Alfred Barr, Jere Abbott, and their guide, Piotr, in Moscow, 1928, on a souvenir postcard

Reverse of the postcard

Cézanne, Gauguin, Seurat, Van Gogh, the Museum's first exhibition, installed in six rooms of the Heckscher Building, November 1929

Barr at twenty-seven, Director of The Museum of Modern Art

In May 1932, MoMA moved to a limestone townhouse at 11 West 53rd Street

The Museum staff in 1937, including (back row, right to left): Beaumont Newhall, later to become Curator of the Department of Photography; Barr; Barr's assistant Thomas Dabney Mabry, Jr.; and (front row, third from left) Dorothy C. Miller

Three shows that took place in
the West 53rd Street building:
Cubism and Abstract Art, 1936;
Fantastic Art, Dada, Surrealism,
1936–37; *Machine Art*, 1934

Jury for the 1934 Carnegie Institute International. Left to right: Gifford Beal, artist; Elizabeth Luther Cary, art editor, *The New York Times;* Homer Saint-Gaudens, Director of Fine Arts, Carnegie Institute; Barr

Bauhaus 1919–1928, 1938, installed in the underground concourse of Rockefeller Center during construction of the Museum building at the 53rd Street site

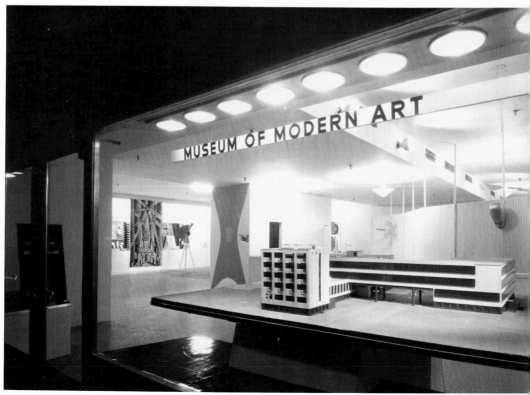

Trustee Philip Goodwin and Edward Durell Stone, architects of the 1939 International Style building

Left to right: Trustees John Hay Whitney, Mrs. John S. Sheppard, Nelson A. Rockefeller (incoming President), A. Conger Goodyear (outgoing President), at the opening of the new building in 1939, the tenth anniversary of the Museum

Useful Objects of American Design Under $10, 1940. The Museum's almost annual Good Design shows were intended to elevate public taste. They were extremely popular, but drew criticism for compromising "pure" art

Barr, Dorothy C. Miller, and James Thrall Soby with *Oriel Ross* by Jacob Epstein

René d'Harnoncourt, Nelson Rockefeller, and Stephen C. Clark at the 1941 *Indian Art of the United States* exhibition, organized by d'Harnoncourt, who did not officially join the Museum staff until 1944

At the preview of *The Latin-American Collection of the Museum of Modern Art*, May 1943. Left to right: Stephen C. Clark, Chairman of the Board and President after John Hay Whitney joined the Air Force; Mrs. Whitney; Pvt. Lincoln Kirstein (director of the exhibition); and John E. Abbott, Executive Director of the Museum

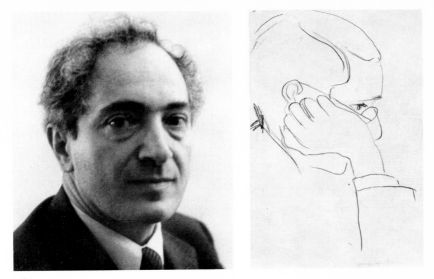

Meyer Schapiro, c. 1953, and a drawing he did of Barr at a meeting of the Advisory Council, c. 1943

The Board of Trustees meeting in the new building, including René d'Harnoncourt (second from left), Barr (fourth from left), and John Hay Whitney (far right)

Left to right: Marcel Duchamp, Barr, and Sidney Janis judging the
"Bel-Ami International Competition and Exhibition of New Paintings by
Eleven American and European Artists 1946–1947." The contest was
organized to choose a featured painting for the film *The Private Affairs of
Bel-Ami*, and the exhibition was circulated by the American Federation
of Arts. Max Ernst won first prize for his *Temptation of St. Anthony*

Left to right: René d'Harnoncourt; Mme. Henri Bonnet, wife of the
French Ambassador; Barr; Jean Daridan of the French Embassy; Nelson
Rockefeller, at the opening of *Henri Matisse*, 1951. The show was the
occasion of the publication of Barr's seminal *Matisse: His Art and His
Public*

fantastic, enigmatic and anti-rational is affecting art criticism and leading to discoveries and revaluations in art history. When the movement is no longer a cause or a cockpit of controversy, it will doubtless be seen to have produced a mass of mediocre and capricious pictures and objects, a fair number of excellent and enduring works of art and even a few masterpieces. But already many things in this exhibition can be enjoyed in themselves as works of art outside and beyond their value as documents of a movement or a period.

LIST OF SOME OF THE DEVICES, TECHNIQUES, AND MEDIA SHOWN IN THE EXHIBITION

1. *Simple composite image* (e.g.: a human figure composed of garden implements).
2. *Double image* . . . : *a.* monaxial (to be seen without turning picture); *b. biaxial* (to be seen by looking at picture both horizontally and vertically).
3. *Collaborative composition* (that is, made by two or more artists working in sequence).
4. *Fantastic perspective* (flattened or reversed).
5. *Animation of the inanimate* (e.g.: a sofa dancing with an armchair).
6. *Metamorphoses.*
7. *Isolation of anatomical fragments.*
8. *Confrontation of incongruities.*
9. *Miracles and anomalies.*
10. *Organic abstractions* (semi-abstract forms derived from or resembling organic forms).
11. *Fantastic machinery.*
12. *Dream pictures.*
13. *Creation of evocative chaos.*
14. *Automatic and quasi-automatic drawing and painting.*
15. *Composition by artificial accident.*
16. *Frottage* (semi-automatic process for obtaining patterns or designs by rubbing canvas or paper which has been placed over a rough surface such as planking, embossing, a brick wall, etc.).
17. *Collage* ("the cutting up of various flat reproductions of objects or parts of objects and the pasting them together to form a picture of something new and strange"— Max Ernst).
18. *Combination of real and painted objects* (similar to *collage* but the objects are actual realities rather than flat reproductions).
19. *Found objects* of Surrealist character ("Ready-mades," *i.e.* manufactured commercial objects; mathematical and other scientific models; natural objects, etc.).
20. *Found objects "assisted"* (*i.e.* altered, transformed, or combined by the artist).
21. *Dada and Surrealist objects* (objects made by artists as distinguished from objects "found" or merely "assisted").

Bauhaus
1919–1928:
Preface

The 1938 exhibition was assembled and installed in the underground Concourse in Rockefeller Center (while the new Museum was being built) by Herbert Bayer with the involvement of Walter Gropius, Alexander (Xanti) Schawinsky, and Josef Albers, all formerly of the Bauhaus. Bayer and Walter and Ise Gropius edited the catalogue.

It is twenty years since Gropius arrived in Weimar to found the Bauhaus; ten years since he left the transplanted and greatly enlarged institution at Dessau to return to private practice; five years since the Bauhaus was forced to close its doors after a brief rear-guard stand in Berlin.

Are this book, then, and the exhibition which supplements it, merely a belated wreath laid upon the tomb of brave events, important in their day but now of primarily historical interest? Emphatically, no! The Bauhaus is not dead; it lives and grows through the men who made it, both teachers and students, through their designs, their books, their methods, their principles, their philosophies of art and education.

It is hard to recall when and how we in America first began to hear of the Bauhaus. In the years just after the War we thought of German art in terms of Expressionism, of Mendelsohn's streamlined Einstein tower, Toller's *Masse Mensch*, Wiene's *Cabinet of Dr. Caligari*. [46] It may not have been until after the great Bauhaus exhibition of 1923 that reports reached America of a new kind of art school in Germany where famous expressionist painters such as Kandinsky were combining forces with craftsmen and industrial designers under the general direction of the architect, Gropius. A little later we began to see some of the Bauhaus books, notably Schlemmer's amazing volume on the theatre and Moholy-Nagy's *Malerei, Photographie, Film*.

Some of the younger of us had just left colleges where courses in modern art began with Rubens and ended with a few superficial and often hostile remarks about van Gogh and Matisse; where the last word in imitation Gothic dormitories had windows with one carefully cracked pane to each picturesque casement. Others of us, in architectural schools, were beginning our courses with gigantic renderings of Doric capitals, or ending them with elaborate projects for colonial gymnasiums and Romanesque skyscrapers. The more radical American

architects and designers in 1925, ignoring Frank Lloyd Wright, turned their eyes toward the eclectic "good taste" of Swedish "modern" and the trivial bad taste of Paris "modernistic." It is shocking to recall that only one year later the great new Bauhaus building at Dessau was completed.

It is no wonder then that young Americans began to turn their eyes toward the Bauhaus as the one school in the world where modern problems of design were approached realistically in a modern atmosphere. A few American pilgrims had visited Dessau before Gropius left in 1928; in the five years thereafter many went to stay as students. During this time Bauhaus material, typography, paintings, prints, theatre art, architecture, industrial objects, had been included in American exhibitions though nowhere so importantly as in the Paris *Salon des Artistes Décorateurs* of 1930. There the whole German section was arranged under the direction of Gropius. Consistent in program, brilliant in installation, it stood like an island of integrity, in a mélange of chaotic modernistic caprice, demonstrating (what was not generally recognized at that time) that German industrial design, thanks largely to the Bauhaus, was years ahead of the rest of the world.

And the rest of the world began to accept the Bauhaus. In America Bauhaus lighting fixtures and tubular steel chairs were imported or the designs pirated. American Bauhaus students began to return; and they were followed, after the revolution of 1933,[47] by Bauhaus and ex-Bauhaus masters who suffered from the new government's illusion that modern furniture, flat-roofed architecture and abstract painting were degenerate or bolshevistic. In this way, with the help of the fatherland, Bauhaus designs, Bauhaus men, Bauhaus ideas, which taken together form one of the chief cultural contributions of modern Germany, have been spread throughout the world.

This is history. But, one may ask, what have we in America today to learn from the Bauhaus? Times change and ideas of what constitutes modern art or architecture or education shift with bewildering rapidity. Many Bauhaus designs which were once five years ahead of their time seem now, ten years afterward, to have taken on the character of period pieces. And some of its ideas are no longer so useful as they once were. But this inevitable process of obsolescence was even more active in the Bauhaus while it still existed as an institution for, as Gropius has often insisted, the idea of a Bauhaus style or a Bauhaus dogma as something fixed and permanent was at all times merely the inaccurate conclusion of superficial observers.

Looking back we can appreciate more fully than ever certain magnificent achievements of the Bauhaus which are so obvious that they might be overlooked. It is only eight years since the 1920's came to an end yet I think we can now say without exaggeration that the Bauhaus building at Dessau was architecturally the most important structure of its decade. And we can ask if in modern times there have ever been so many men of distinguished talent on the faculty of any other art school or academy. And though the building is now adorned with a gabled roof and the brilliant teaching force has been dispersed

there are certain methods and ideas developed by the Bauhaus which we may still ponder. There are, for instance, the Bauhaus principles:

that most students should face the fact that their future should be involved primarily with industry and mass production rather than with individual crafts-manship;

that teachers in schools of design should be men who are in advance of their profession rather than safely and academically in the rear-guard;

that the school of design should, as the Bauhaus did, bring together the various arts of painting, architecture, theatre, photography, weaving, typography, etc., into a modern synthesis which disregards conventional distinctions between the "fine" and "applied" arts;

that it is harder to design a first rate chair than to paint a second rate painting —and much more useful;

that a school of design should have on its faculty the purely creative and disinterested artist such as the easel painter as a spiritual counterpoint to the practical technician in order that they may work and teach side by side for the benefit of the student;

that thorough manual experience of materials is essential to the student of design—experience at first confined to free experiment and then extended to practical shop work;

that the study of rational design in terms of technics and materials should be only the first step in the development of a new and modern sense of beauty;

and, lastly, that because we live in the 20th century, the student architect or designer should be offered no refuge in the past but should be equipped for the modern world in its various aspects, artistic, technical, social, economic, spiritual, so that he may function in society not as a decorator but as a vital participant.

This book on the Bauhaus is published in conjunction with the Museum's exhibition, *Bauhaus 1919–1928*. Like the exhibition it is for the most part limited to the first nine years of the institution, the period during which Gropius was director. For reasons beyond the control of any of the individuals involved, the last five years of the Bauhaus could not be represented. During these five years much excellent work was done and the international reputation of the Bauhaus increased rapidly, but, fortunately for the purposes of this book, the fundamental character of the Bauhaus had already been established under Gropius' leadership.

This book is primarily a collection of evidence—photographs, articles and notes done on the field of action, and assembled here with a minimum of retrospective revision. It is divided into two parts: Weimar, 1919–1925, and Dessau, 1925–1928. These divisions indicate more than a change of location and external circumstances, for although the expressionist and, later, formalistic experiments at Weimar were varied and exciting it may be said that the Bauhaus really found itself only after the move to Dessau. This book is not complete, even within its field, for some material could not be brought out of Germany. . . .

2. THE CRITIC/HISTORIAN

In the late 1920s and early 1930s, there was no clearly bordered, unified territory of "modernism." There were villages and fiefs, and skirmishing insurgents with a serviceable, but primitive, communications network. The fragmentation must have been irresistible to Alfred Barr, with his passion for organization; he ventured forth with a crusader's devotion (indeed, he called his summer European scouting expeditions "campaigns") and an anthropologist's appetite for collecting data. Few had gone before him and the literature was meager. Before he could analyze, synthesize, and package it, he had to gather the evidence in its primary abundance. He traveled and looked, interviewed and questioned. He made notes during his tours, distributed questionnaires to artists, and earnestly corresponded with scholars, dealers, students, and collectors. A trained historian, demanding critic, and instinctive journalist rolled into one, he seldom missed a detail, whether it was a rare bird, an artistic affinity spanning centuries, the silhouette of a chimney, or the fine points of a Soviet scientist's attire. And he had a positivist's belief in the power of all kinds of information: if the facts were accurately, articulately presented, truthful conclusions would follow.

His writing is so jammed with data that one might expect to find it daunting; in fact, the reader is disarmed by the flow and elegance of the language, and only in retrospect remarks Barr's spectacular powers of compression. (A youthful historical outline of Russian icon painting, "Russian Icons," published in *The Arts,* February 1931, is a daring example.) This talent Barr was famous for, and it provoked much admiration—"Your adjectives and adverbs . . . are of a precision, wit and psychological value that gives you authority in its most difficult verbal form, especially in writing about art—condensation,"[1] Janet Flanner wrote in 1955, after reading his contribution to *Masters of Modern Art.* Yet the grace of the style belies the author's strenuous effort. Barr's eyes were chronically strained, and so excruciatingly sensitive that he had the walls of his bedroom painted black at one point, and his mental and psychological exertions led to chronic indigestion and lifelong insomnia. What is so extraordinary is that such a man should have been able to see the things of the world so vividly, digest vast implications so thoroughly, and produce writing of such natural—seemingly effortless—ease.

Physical weakness is a source of frustration in the "Russian Diary," where it often would prevent Barr from doing all that he wished to do (or all that his companion, Jere Abbott, was able to do), but it was also responsible for getting Barr to the right place at the right time to witness one of the twentieth century's most chilling moments. On a leave of absence from the museum in 1932–33, Barr was in Stuttgart, being treated for exhaustion and insomnia, from the middle of January through April 1933. The National Socialist German Workers' Party won the Reichstag election at the end of January, and Barr was able to record the immediate imposition of their wrenching cultural policies. He spent the remainder of his rest cure writing four articles, which he tried to have published upon his return to New York. To his increasing chagrin and great emotional anguish, "Hitler and the Nine Muses" (as they were collectively titled) was turned down by over half a dozen periodicals—among them *Scribner's, North American Review, The New Republic, The Nation,* and *Harper's.* One article, "Nationalism in German Films," was finally published in *The Hound & Horn,* which was edited by Barr's friend Lincoln Kirstein. Two letters by Barr concerning these articles provide revealing insights into his own rhetorical strategy. In 1933 he wrote Paul Sachs that the series was "written for one of the popular magazines such as The Atlantic or Harper's. The editors feel, however, that it is too detailed and too localized. Detail and specific locality seem to me, however, to be its chief virtues and give it a reality which I have not found in most of the articles on national socialism. . . ."[2] Twelve years later, when the now combined article was published in *The Magazine of Art* as a counterpoint to a postwar discussion on the subject by Kirstein, Barr wrote to the editor, John D. Morse: "I wrote these articles in a rage, intending them to serve as warning propaganda, but such was the indifference in this country toward the cultural crisis—as distinguished from the political and racial issues—that the articles met with little interest. For propaganda purposes, I adopted a very objective and factual style, intending far more objectivity than I felt."[3]

Although Barr was manifestly capable of an objective presentation of facts to establish "a reality," he was also inclined to create the charming (and equally subliminally "propagandistic") package, as in the chart of "Italian Sources of Three Great Traditions of European Painting." But the most satisfying articles to read today are those in which he synthesized the disciplines of history, criticism, and journalism and created a vital, breathing picture of a personality or movement. In the essay on Italian Futurism, in "Matisse, Picasso, and the Crisis of 1907," Barr's reanimation of a historical episode is concise, balanced, and—a most significant quality of his writing—thoroughly pleasurable.

A. N.

Russian Diary

Margaret Scolari Barr writes: "In the academic year 1926–27 the protagonists of this diary, Alfred Barr and Jere Abbott, were promising young art historians. In Cambridge they shared living quarters; they were both doing graduate work at Harvard where Prof. Paul Sachs had just started his now famous Museum Course. Alfred Barr, besides studying, commuted to Wellesley, where he taught a course in modern art 'unbelievably ahead of its time' (Abbott's words).

"They had both travelled extensively in Europe and had seen the conventional sights. This time, however, the trip they gradually plotted was focussed exclusively on recent art and architecture; among their first objectives was the Bauhaus in Dessau. The thought of Russia never crossed their minds. How things went had best be told in the words of the late Jere Abbott in two letters he wrote me from Dexter (Maine) in 1977. His words ring true and set the tone for the whole diary. With his consent I quote from them with slight transpositions and elisions:[4]

'As an introduction to what follows let me make the general statement that in the winter of 1927–28 the Russians were far too busy trying to reorganize essentials and for that reason, mainly, there was no supervision over the few visitors from the outside world. We went anywhere we pleased; life there was less regulated and easier than it was ever to be again. The change began shortly after we left. INTOURIST had been started but it so stumbled along that no one bothered with it. I am sure that we were never followed and we had no official guides. We saw Russia freely and exposed.

'The people were hopeful for a simple reason. They felt that Russia was theirs. They couldn't realize or suspect that much of the "old Russia" was still in the genes and would return. Regulation by the few, class distinction, and cruelty would appear in their stubborn way. Quite a bit of French and English was still spoken without fear. It was truly a transitional period.

'As we planned our trip there was no mention or intent later to go to Russia when we were in Cambridge during the winter of 1926–27. Information about Russia, aside from meager accounts in the daily press, was nonexistent. Alfred preceded me to England. Early in the fall of 1927 I joined him in London. We got to know Wyndham Lewis, the artist, critic, and writer. Through him we met an extraordinary London "character," Nina Hamnett, who knew all the art crowd and was enthusiastically Communist in spirit. There was discussion about Russia. We decided to go there. It was that simple.

'We felt we were about to go to the moon and our first surprise was the ease—the matter of fact way—with which we got visas in Berlin. The wait was only about a week! The night before Christmas we left Berlin's Ost Bahnhof. We separated ourselves from a distinctly drab crowd and settled into our sleeping compartment which we had reserved. The next day we were crossing Poland. Except for the log farm houses the landscape was Maine in deep winter. We got to the Russian border in the evening and changed trains. In Russia as in Spain, the rail gauge is different. As I recall, we were surprised, rather, to find that our reservation of a compartment was honored, and we had it on to Moscow. We arrived at two o'clock the next day. No Russian met us. Nina's

friend May O'Callahan greeted us and took us to the Hotel Bristol. Nothing surprising. All the usual old-time routine. Passports turned in etc. They were given back to us in a few days.

'Everyone was pleasant and appeared to be completely baffled as to why we were there. Meyerhold told us to drop in any time to watch rehearsals and of course Sergei Eisenstein became a close friend almost at once. Engaging. Very extrovert and witty. I was very fond of him and used to see him later when he came to this country. He died February 9, 1948 of a heart attack. Our introduction to both of these brilliant men was through May O'Callahan.

'There was no time limit to our visas. We'd thought to stay two or three weeks. However we quickly came to feel completely at home and we stayed on and on. We left Leningrad in March. The dollar was pure gold in those days so money did not limit our length of stay.

'In 1927, even foreigners were not in a position to judge about repression. Churches were open. There were still some private shops and some excellent book shops. The Jewish Theater, with the delightful Chagall murals in its foyer, put on the brightest musicals. We were drowned in theater, cinema, ballet. As I look back on it we met few Russians. Alfred and I went everywhere alone or with our thoroughly delightful young Man-Friday helper and guide of sorts, Piotr, whose family name I don't recall; it sounded like Lick-a-cheff. The last syllable pronounced 'choff.'

'Much barter was taking place, but things were sold in some private shops which still were in business. Moscow's streets were crowded day and night and there were thousands of people there from the provinces. They were in tattered native costumes. The men's clothing shops—private shops—still did a big business and prices were high. We outfitted Piotr in one of them; the material from the government shops was so sleazy and awful. My icon I bought in an outdoor 'flea' market which was private. Control was spotty. There was a lot of trading of family furnishings. The mass of forms—paper regulations—and of domestic permits had not yet developed.

'Piotr went to Leningrad with us to visit relatives. I can't recall our departure from Russia except that Alfred and I were depressed. Piotr was small for his 19 years and he had had such a good time with us and he looked so forlorn as he waved from the railway platform that Alfred and I dissolved shamelessly into tears.' "[5]
(From *October,* Winter 1978.)

Dec. 24, 1927

6:52—We leave Berlin from the Schlesischer Bahnhof—second class—since there are no third class sleepers. Bad air but comfortable beds and a pleasant feeling of finality in our direction. Germans, Poles, Orientals in our car. No English, but one American passport besides ours.

11:00—Our passports collected for German inspection.

11:30—Polish inspection.—Sleep.

Dec. 25, 1927

10 A.M. (?)—pass through Warsaw—according to Jere—I being asleep in my upper berth. Poland covered with patches of clay-yellow snow-thatched mushroom-like houses in one street; villages with radiating fields about them—few towns. We read the Soviet guide—and the alphabet causes us dismay.

7 P.M.—Polish inspection at Stolby.

9:00—Our first Russian official in ankle-length military greatcoat appears and takes our passports.

9:30—Niegorelye—the first stop in Russia. Into a shed-like customs house for baggage inspection. Our books examined—especially Jere's Peruvian magazines on Inca archeology which cause the poor officials puzzlement. No duty.

10:00—I go in search of the Reisebüro official who has our Russian tickets ready for us. We mail postcards.

10:30—We climb aboard our third-class sleeper and are ushered by a bewhiskered guard into a four-bunk—or rather shelf—compartment. Patting the shelves meaningfully produces pallets for one ruble.[6]

In the compartment to the left are English-speaking Russians returning from Berlin for a visit to Moscow; to the right are three Chinese. Down the corridor comes a huge long-coated officer of the Red Army. *"Ich weiss nur ein Wort* in English: 'Goodbye,' "* he smiles boyishly.

11:20—We sit, reflecting, on our shelves. I begin to stuff a laundry bag for a pillow. The guard slides back the door and in come our two companions for the night—a pretty Russian Jewess and her bashful daughter—and we bow.

We go out in the corridor to smile in privacy—while they stow their belongings. She appears at the door—*"Vielleicht Sie sprechen Deutsch?"*

(11:30—the train starts.)

She calls the guard in Russian and he appears with bags full of spotless bed linen and blankets (2 rubles). We ask her to ask him for the same for us. She does. Then she asks us to remain outside while daughter prepares for bed. While we are *"bleib*ing" in the corridor we talk with the Russian next door about Moscow.

Soon the lady, our companion, opens the door and asks the guard for tea. She asks if we'll have some. Daughter looks down from the top shelf. Then the "curtains are drawn" for another fifteen minutes and finally we come in. They are both "asleep," their faces to the wall. We get into our pajamas and pass a very passable—if somewhat airless night.

December 26

10:30 A.M.—I wake to find "daughter's" black eyes staring. *"Morgen,"* I grunt. She blinks. I look down. "Mother" sleeps. Beneath me Jere's shelf is empty. I turn over and sleep till eleven. Then I dress and we walk a dozen cars to breakfast. One of the third class "wagons" has a loudspeaker belching music. We have coffee which is mostly cocoa, and bread and cheese.

We talk in bad German with our friends and amuse them by trying to pronounce Russian. On the way back to our car we stopped to listen to the radio. A military band played a Couperin dance with bassoons, trombones, and percussion. Outside the snow is deep, the peasants wear furs and their horses high collars. Black and white magpies sit on the telephone wires. Occasionally a five-domed church.

2:15—Quite on time, we arrive in Moscow. To our immense relief Rozinsky

is waiting for us. He speaks very good English. There are only four "state" taxis outside the station and these are all taken. The meterless taxis are treacherous so we climb into a tram.

Moscow asserts its character immediately—utterly lacking in any consistent style—a huge tasteless triumphal arch in front of the station. Behind the arch a monastery in very delicate Russian rococo of the eighteenth century. The snow covers much unpicturesque disorder.

Our hotel (the Bristol, Tverskaya 39) is not prepossessing, but our room is very large with two tiny beds and only three rubles apiece. R. helps us to make ourselves *chez nous.* He is most interested in music and knows the Russian field very thoroughly though he is not especially interested in the "left." He also knows his theater and promises to be of the greatest help.

We walk about the town past the new and bad telegraph building to the theater square. Jere sends a cable home. To our wonder, Dexter [Maine] is in the cable list. The buildings, through disrepair, have a most delicate tone— pinks, greens, and pale yellows; much baroque, rococo, and *"drittes* Rococo."

We stop in at the Savoie while R. phones up to another protégé, a Russian-born South African. We arrange a kino party.[7] Have tea and cakes and go to the theater, where we meet the South African, and an English Quaker, Miss White. The film is excellent—a propaganda, revolutionary "October" theme, but superbly photographed and directed. Its bias gave it dignity and punch. (*The End of St. Petersburg.* Dir. V.I. Pudovkin—Mezhrabpom-Russ.)[8]

Back to the Bristol with the full intention of going to bed. While we're undressing I hear English spoken outside our door. I go out to look them over and decide to speak. One of them, an elderly man, Dana by name, is very cordial. We ask them in to get acquainted. A second named Wolf is on *The New Masses.* He came over as a delegate to the October celebration and is staying on to study films. A third is a Hindu, the son of Rabindranath Tagore, a communist, "wanted" by the British. Goes by the name of Spencer. Dana turns out to be Harry Dana. Henry Wadsworth Longfellow Dana of Cambridge, a delightful and very friendly person. He is here working on the theater and poetry.

After an hour's talk they leave but Dana returns to say that May O'Callahan, Lydia Horton's friend, wanted to see us right away. So we dressed and went upstairs to Dana's room for midnight tea and biscuits. May is very thoroughly Irish, ostentatiously frank, but seems to like us. She knows many people. She and Dana will help us very much. To bed by 1:30.

We feel as if this were the most important place in the world for us to be. Such abundance, so much to see: people, theaters, films, churches, pictures, music and only a month to do it in, for we must attempt Leningrad and perhaps Kiev. It is impossible to describe the feeling of exhilaration; perhaps it is the air (after Berlin), perhaps the cordiality of our new friends, perhaps the extraordinary spirit of forward-looking, the gay hopefulness of the Russians, their awareness that Russia has at least a century of greatness before her, that she will wax, while France and England wane.

Dec. 27

"To bed" at 1:15, "but not to sleep," my companions were—or perhaps was an—enthusiastic bed bug(s). We fought till four when all of us slept through sheer fatigue—they from feeding and I from being fed on. Awake by 10:30. As we dressed, Robert Wolf knocked on our door and presented Mary Reed, a comely American damsel who asked us whether we'd care to see the Mezhrab-pom-Russ kino studio in action. May O'C had asked us to dine at four and I felt too tired anyway, but Jere felt inclined. So I decided to take our passports over to the bureau to get our local permit and then go back to bed. The former proved too much for me. The building had eight entrances and four floors, all signs in Russian in spite of the fact that foreigners were forced to frequent it. After half an hour's inquiry (by thrusting a card written by Roz. under people's noses) I was ushered into a room where, over the heads of some forty Mongols and Turkomans, I saw a solitary, yes, pathetic bureaucrat filling out forms by dictation. I computed that it would take two and a half working days before he reached me so I gave up and staggered back to bed feeling very weary. I slept all day while Jere wrote. Dined with O'C and in the evening went to Prof. Weekstead's with Dana. Prof. W. teaches English at the Academy. I hope to see him next week.

In the evening Roz. called and we talked music for an hour or so. He brought me some Zwieback and Metchnikov sour milk, the latter powerfully unpleasant.

Dec. 28

Much rested but still a little weary. Breakfast late with Dana and Mary Reed. A fine day so we went for a walk to the German embassy, a shop, and then to the room (one) where dwelt a man, wife, child (4 yrs.), and sister of wife. The two girls play and dance and sing at the Dom Gertsena—the authors' club of Moscow.[9] They were both there and welcomed us with much theatrical mincing. The child Susanny danced and sang, very prettily while her mother and "aunt" played the guitar—stirring Russian folktunes. They seem to live with the most extraordinary gaiety and verve. Piotr,[10] Dana's Russian interpreter, found them too gay—too much like geishas.

In the afternoon I slept while Jere wrote.

About eight o'clock May O'C came to take us to Tretyakov's.[11] He is one of the leaders of the *Neue Sachlichkeit* in Russian literature, though some years back he was an influential futurist. Before the revolution he was professor of Russian literature in Peking University.

He lives in one of the four "modern" buildings in Moscow—an apartment house built in the Corbusier-Gropius style. But only the superficials are modern, for the plumbing, heating, etc. are technically very crude and cheap, a comedy of the strong modern inclination without any technical tradition to satisfy it.

Tretyakova received us cordially speaking adequate English; with her husband I spoke German. She was solidly built and curvilinear, very energetic, and entirely devoid of feminine charm, which is doubtless a bourgeois perversion.

Tretyakov was very tall, his head well shaped and completely shaved. He was dressed in heavy khaki whipcord blouse and breeches with grey golf stockings. The costume seemed ostentatiously practical though May O'C assures us that he is entirely without affectation. Their daughter was remarkably uncomely, squat and heavy with puffy eyes; her mother explained that hooligans (sic) had tried to rob her of her skis and that she had been badly shocked.

Among the company on our arrival were Eisenstein, the great kino producer, and two Georgian kino men. The former was just on the point of leaving but May arranged with him so that we hope to see parts of his two new films in a fortnight: *October* and *The General Line.* [12] Both were intended for the October celebration but were delayed. The Georgians seemed interesting but spoke only Russian. Tretyakov showed first some photographs he had made of the region around Tiflis, a walled town in a fine mountain setting. Madame showed us architectural magazines.

Tretyakov seemed to have lost all interest in everything that did not conform to his objective, descriptive, self-styled journalistic ideal of art. He had no interest in painting since it had become abstract! He no longer writes poetry but confines himself to "reporting."

He showed me his latest work in ms., a "bio-interview" he called it, giving as completely as possible the life of a boy in China. He spent hours daily for many months talking with a Chinese boy in Moscow trying to learn all he could about his life in one of the remote provinces of South China.[13] To what the boy could tell him he added his own thorough knowledge of China, thus achieving what he believes to be the most realistic and intimate account of life in China in any foreign language. His aim however is not in the least artistic as was Turgenev's or Gogol's but is purely documentary reporting of the most thorough kind, intended to produce greater understanding between Russia and China.

When I asked about Malevich and Pevsner and Altman he was not interested —they were abstract artists, he was concrete, a unit in a Marxian society where . . . [sentence unfinished]. He was more interested in Rodchenko who had left suprematism for photography. He showed us a ms. of poems for children written by himself and illustrated by Rodchenko and his wife with photographs of paper puppets, very fine in composition and witty as illustrations.[14] This volume had been vetoed by the government official because the pictures were not literal, realistic illustrations of the subject matter of the verses. (T. was not sure whether this censorship was Victorian or postexpressionistic.)

Before we went out to tea and salad in the dining room, Tretyakova showed us her apartment. The building was intended to house the workers in the government insurance office. These privileged members paid about ten rubles (very little) for their apartments. A few were left over and these were rented to outsiders (New Economic Policy profiteers, i.e., independent merchants or manufacturers—"bourgeois") and others. They have to pay 200R a month. The apartments were poorly built: circulation bad, doors too wide, door fixtures bad,

piping crude, taps rusty, garbage chute inconvenient, bath plumbing pathetic. After salad we said goodnight since I needed sleep and went back home; a fine walk, fine company, a fine evening, very instructive though no more enlightening than our hour this morning at Pava.

Apparently there is no place where talent of an artistic or literary sort is so carefully nurtured as in Moscow; poets, even, are well paid, especially if they are useful in propaganda. Poetry is paid for by the line, thus explaining much of the irregularly printed free verse which is most of it, metrically, quite regular.

We'd rather be here than any place on earth.

Dec. 29th, 1927

Last night the Indians next door kept me awake by their loud debate— perhaps they were rejoicing over the new anti-British boycott or perhaps they were welcoming Diego Rivera, who arrived recently from Mexico to do some frescoes for the Soviet. They told me of his coming and seemed to know him well. I hope to see him as he has a complete series of photographs of his Mexico City frescoes.

After a late breakfast Dana and we start for the Shchukin collection but arrive by mistake at the Historical Museum at the Iberian gate. We look at several mediocre icons, fine textiles, and some early prehistoric Caucasian sculpture; also an interesting show illustrating Moscow life in the seventeenth century. Then we walk through the Red Square past Lenin's tomb (a well-designed wooden structure in the Assyrian style) to St. Basil's Cathedral—magnificently rich in a genuinely barbaric style—reds, greens, and oranges in deep tones.[15] Coming back we stepped into the shrine of the Iberian Madonna. Prayers handed to the priest by worshippers on slips of paper were intoned before a fine late Byzantine Madonna just barely visible behind a clutter of gaudy bric-a-brac. Outside the shrine on the wall to the left is the inscription in large red letters: "Religion is an opiate for the people," in which there is as much truth as falsehood from a social-scientific position.

Coming back I bought for a few kopeks a child's book of ballads about Robin Hood, very well illustrated with lively, well-composed drawings by Pronov— apparently influenced by the iconism of Grigoriev, Sudeikin, etc.[16]

Then we had dinner at a vegetarian restaurant: soup (very complex and rich) 30K, vegetables 25K, kompot 35K, tea 10K.

In the evening we went to the Revolutionary Theater, one of Meyerhold's offspring, to see a play by [Barr's omission] called *The End of Twisted Snout*— a mixed farce, satire, and melodrama on the theme of the disintegration of the small-town, bourgeois society after the revolution. It lasted from 7:30 to 11:30 —five acts and seven scenes without any flagging of interest, the action was so rapid, the sets so interesting, and the acting so extraordinarily high in quality. Of a cast of forty, none was poor and a dozen were very good. There must be twice as many fine actors in Moscow as in any other city in the world. [A sketch

of one of the sets inserted.] The audience was also entirely proletarian. The play was therefore very obvious in plot, unsubtle in psychology, and broadly acted, but highly entertaining.

Dana's interpreter was an officer aboard the Aurora during the mutiny.[17]

After the play we went to the Dom Gertsena for beer and cheese. The girl whom we visited yesterday morning played "Hallelujah" on the grand piano in a grand concerto manner, with interesting rhythmic effects but without any feeling for jazz. There were many literary folk about but no major lions. Bed by 2:15.

Dec. 30

After a late breakfast I was able at last to persuade the concierge to get me some stamps for our long delayed letters home.

Then to the first Museum of Modern Foreign Painting, formerly the Shchukin Collection—perhaps it is the finest collection of modern French painting after Barnes's in Philadelphia and Reber's at Lugano—8 Cézannes, 48 Picassos, 40 Matisses, a dozen Derains, etc.[18] The early Picassos are particularly valuable historically since the development of cubism is here better illustrated than anywhere else, though there are too few Braques and Henri Rousseaus. We wonder if the Morosov is equally fine.

We met Bob Wolf in the gallery and had dinner with him at another Tolstoyan restaurant.

In the evening Rozinsky called for us to take us to a Scriabin concert. According to R., Scr's music can only be appreciated after extensive study of the man's life and philosophy. S. was a mystic, a theosophist, a Rosicrucian, and whatnot and felt driven to save or transform or destroy mankind by a great "mystery" in the form of a musical composition. He died before he had begun this magnum opus, though he left notes for a prelude to it. Rozinsky takes all this very seriously and firmly believes S. to be the greatest of all the Russian composers. In this he may well be right though Moussorgsky, Stravinsky, and Borodin are not to be ignored in a competition.

Scriabin's music did not convince us. Up to opus 40 he seemed unable to escape the romanticism of Chopin though much of his music is richer and more complex than any of Chopin. After no. 40, in the 5th and 9th Sonatas and in the *Poème d'extase*, which Koussevitzky played in Boston last year, he seems to go far beyond Chopin in a passionate staccato style, very powerful but incomplete and still to my thinking romantic, though R. held that after opus 25 he was increasingly philosophical and not in the least romantic. R. confuses intention with conclusion.

Dec. 31

A badly used day. We set out with Dana and Piotr to do some shopping for blouses and books and theater tickets, but the day before New Year's proved the wrong time. I found a few good books on painting and posters at the State

Publishing House, but they are too few. There seems to be no good book on Soviet painting in Russian. The American book by Lozowick and the German by Konstantin Umansky will have to serve me for the time being.[19]

Even though we had little success with our purchases it is always interesting to walk in Moscow. It is almost impossible to meet with an uninteresting costume, and most of the facial types are extraordinarily vivid and differentiated. As to the architecture, Moscow seems to have had a particularly severe attack of *"drittes* Rococo." Viennese ideas of 1905 seemed to have been imported indiscriminately. The interior of the large food store opposite our hotel is the frightfullest art nouveau I've ever seen and there is also much very bad "Beaux-Arts" and baroque and rococo importations of the last three centuries.

The many churches and monasteries however are very wonderful in tone and picturesque in composition. Of the three or four modern buildings, the telegraph office seems the most pretentious and the worst—a badly studied potpourri in detail though interesting in composition. The apartment where the Tretyakovs live is merely Bauhaus academic. The Mosselprom building is good as an adaptation of factory style to an office building. There is some good steamboat detailing on the Izvestia [building].

In the evening we went to the Dom Gertsena with Mary Reed and Dana. Mayakovsky was there but on the whole the party was boringly bourgeois—bad jazz, no room for dancing, ostentatious Charlestoning, good food. Before we left, Pava, who was in great form, struck up a Hopak and some of the older people threw a mean folk dance, a great relief after "Tea for Two." There was one boiled shirt on a very American-looking youth who turned out to be a Dane.

With O'C and Dana to the Novodevichi Monastery or Convent—unfortunately the church was closed with its important monuments and icons. But the monastery close by was very beautiful, the exterior of the principal church through the old archway quite magical. Most of the grave monuments were worse than Western ones; Chekhov's was good, we didn't see Scriabin's.

Then we took a brisk walk out toward the Lenin hills and back by bus through the town to the [Barr's omission], a small and ancient church near the Chinese wall. A priest let us in but it was too dark to see some rather second-rate icons.

After dinner we went with O'C to see Gogol's *Revizor (The Inspector-General)* at Meyerhold's theater, a long, exhausting, and highly interesting evening— 7:30 to ten of twelve.[20] Before the show we were taken backstage to see the astonishing mechanics: the double intersecting quarter-turntables which carried alternate tilted platform-stages out to the main stage. We saw also the lighting bridge at the rear of the theater where all the switches are concentrated, instead of the customary division between the proscenium and wings and back. The museum was very interesting also, showing beautiful models of all of Meyerhold's productions. We sent our cards back to him and received an appointment for next Wednesday morning: interview and rehearsal.

Revizor is a comedy of small town bureaucracy in the 1860s (?) The mayor and his . . . etc.

Meyerhold combined the most theatrical elements in *two* versions—an early and late—of Gogol's play. The characters are intensely individualized—that of the impostor is a fantastic caricature of the fashionable young man who, when drunk, believes in his own fabulous importance. (Meyerhold's wife—who takes the principal female role—is overemphasized.)

The sets are extremely interesting. A Giottesque stage, tilted and trapezoidal, with carefully composed and rather blocky furniture. Some of the scenes, such as the late scene when the letter is read, were extremely crowded, forty people massed so that they could scarcely move—very like Rowlandson in feeling.

The final effect is one of astonishing, overpowering virtuosity and originality in direction, but at too many moments, extravagance and distortion. The alternations of minutely characterized realism with shocking expressionism are very uncomfortable. The stage itself is too small for the visual comfort of the audience if not for the physical convenience of the actors.—Lastly, like many things in Russia, the play is *too long* and lacks concentration.—Nevertheless it was the most enthralling "theater" I have ever seen.

Jan. 3

To VOKS[21] but found our passports were not yet ready. They were able to get in touch with El Lissitzky, the architect and book designer (formerly a painter—"Prounism"). We took a trolley across the river to the Revolution Square near where he lived in a curious house built of split logs left in the rough. His quite charming German wife received us. She showed paintings by her children (who are being educated in Germany) and architectural *projets* by her husband. They were handsome in rendering, using quadrillé paper, transparent gummed paper, varnish, etc. for different textures. His schemes were for ambitious public buildings of great engineering difficulty—the most frankly paper architecture I have seen. He showed also books and photographs, many of them quite ingenious, suggesting Moholy-Nagy. I asked whether he painted. He replied that he painted only when he had nothing else to do, and as that was never, never. Gropius's card to El Lissitzky was well received. He is evidently very friendly with the Bauhaus.

We got back a little late for our date with O'C to go to see the head of the State Publishing Corporation who is also editor of *Kino,* an important film journal (8,000 circulation). He spoke a little German and was very genial—gave Jere some film magazines and me a valuable periodical on the paintings of 1919, Tatlin, Malevich, etc. We had excellent tea and cakes and a little three-year-old Gershwin from *Lady Be Good.* He said the subscriptions to periodicals in general had doubled in a year, but that they were still publishing at a loss, which the state of course makes up. Many new technical encyclopedias are being written. The new general encycl. is finished through the letter G. The thousands of new

readers, peasants, and workers who never read before, are a great problem. This new public demands Jack London (who is extremely popular) and James Oliver Curwood and Burroughs (?), the author of *Tarzan of the Apes,* etc.

An hour after we left him we went with O'C and Tretyakova to see Rodchenko and his talented wife. Neither spoke anything but Russian but both are brilliant, versatile artists. R. showed us an appalling variety of things—suprematist paintings (preceded by the earliest geometrical things I've seen, *1915,* done with compass)—woodcuts, linoleum cuts, posters, book designs, photographs, kino set, etc., etc. He has done no painting since 1922, devoting himself to the photographic arts of which he is a master. R's wife is managing editor of *Kino.* When I showed her Mrs. Simon's film [*Hands* by Stella Simon] she was much interested and asked for four stills to reproduce with an article. It will be fun to be paid in rubles (if any). I arranged to get photographs of Rodchenko's work for an article.[22]

We left after 11:30—an excellent evening—but I must find some painters if possible.

Jan. 4

To Meyerhold's theater with O'C and Dana for an interview followed by a rehearsal. M., who spoke German, was very cordial. Through O'C, who speaks Russian excellently, I asked him:

1. Whether he'd been directly influenced by Giotto in his stage for *Revizor* —tilted trapezoid, figure massing, and props. He answered very much in the affirmative.
2. Whether he found the obligation to propagandize a stimulus or a handicap. He replied that his theater was an expression of the time-spirit and dealt with revolutionary material naturally and inevitably. Remembering his official position in 1919, his answer was not entirely satisfactory.
3. Whether his actors weren't discomfited by the small stage in *Revizor*— answer *"No"* (accepted with doubt).
4. Whether he approved of the mingling of film and theater as in the Piscator Bühne in Berlin. He answered that he employed such a mixture in *The Window on the Village.*

While we were talking, the orchestra was practicing some jazz. The ghoulish row of *Revizor* wax figures were still on the stage.

Then we went to the museum where M. went over the sets, commenting on them. I was able to get a complete set of the M. literature but still lack some photographs of the *Revizor*. We were asked to fill out cards and to write something in a book which was filled with important names beneath blurbs in all languages. Chinese, Spanish, French, etc.—recent names were Lee Simonson, Scott Nearing, and Tagore's son, etc.

Then to a rehearsal upstairs, a revival of an old play of 1923: *The Magnanimous Cuckold* (from the French) using constructivist setting—platforms, chutes, etc.[23] The action was acrobatic.

Then to luncheon at the Dom Gertsena with Dana. Tolstoya joined us. She was very friendly—offered to guide us through the Tretyakov Museum where there are many pictures of her grandfather.

In the evening we went to *Les* [*The Forest*]—a rustic fantasia by Ostrovsky. A spiral inclined plane was used at the left very effectively. A maypole-like swing-about was used in the center. A delightful dialogue between lovers while they swung around—accordion—Andreyev.

Piotr, Dana's young interpreter, is very interesting. The other day he astonished Jere by whistling part of the *D Minor Toccata*. Jere asked him what the younger generation read in Russia. He said that once Conrad, Conan Doyle, and Jack London were very popular, but that now novels were less read and technical books were taking their place, very significant.

Before the theater Dana called us up to his room to meet Diego Rivera, the famous Mexican painter. He seemed a large, hearty, rather Rabelaisian character; is going to take us to the Lenin Academy where he is teaching fresco painting and composition.

Jan. 5

To VOKS where we at last got our local visas which are good til Jan. 25 when they must be renewed (7 rubles). Permission to leave will cost us 22R.

After VOKS, to Meyerhold to see a rehearsal of his new play. It was in its initial stages, but M. himself was in top form. As Rivera (who was along) remarked he was a finer actor than all his troupe combined. He puts immense energy into his directing.

At 3:30 Dana and we met Rozinsky for dinner. He had brought a young composer and his wife. After eating we went with them to their rooms where he played some Scriabin, some of his own compositions which suggested Cyril Scott to me, Debussy to Jere. They were about twenty years behind the times, very romantic. He and R. wish to take us to see Alexandrov and Myaskovsky, the two most important Russian composers still in Russia. ([Ippolitov-] Ivanov is old and Glière of not much importance; Prokofiev and Stravinsky in Paris.)[24]

After the music a friend from the Musical Studio of the Moscow Art Theater arrived and gave us an agonizingly funny puppet show in which monkeys, dogs, etc. took parts in sentimental songs which [he] sang behind the screen. He had been on the American tour playing in *Lysistrata* and *Carmencita*.

Then we tore to the Meyerhold again to see Tretyakov's *Richi-Kitai* [*Roar, China!*]: a propaganda play again—English and American interference in China. All the English and the one American were caricatures while the coolies stood out as noble victims of foreign truculence. The whole play was acted before and upon an excellent representation of a river gunboat—the Cockchafer.[25] It was

superbly directed and intensely dramatic, though the imbalance caused by the propaganda was aesthetically unpleasant. Shaw, who would have written a surpassingly good play on this theme, would not have been guilty of such one-sidedness, but revolutionary drama is young.

Jan. 6

At this point it is well to note before it be too late that for five nights we have foiled the bedbugs—powder and *baume analgésique* having miserably failed, we arranged ourselves in pajamas, four pairs of socks, two for the feet, two for the hands, and a kerchief around the neck. They refuse adamantly and obligingly to come out in the cold so that our ears and faces are safe.

We wrote our journals all morning since [the] exhibition to which Diego Rivera was to take us was closed suddenly. Two reasons were suggested by the Mexican—first there were portraits of some of the opposition, second, because in a group representing Lenin's funeral some figures were nude.

In the afternoon we went with Rozinsky to see an exhibition of paintings by "peasants and workers" at the First University. Some were very good. We bought for five rubles each a couple of paintings by a sixteen-year-old boy from central Russia. We may buy some others.

From the exhibition we went to the Jewish Theater to see the comic operetta *200,000*, a welcome relief after the strenuous evenings at Meyerhold's. It was beautifully done with much Chagall flavor, faded yellows, greens, and lavenders —strong dark oranges. It lacked of course the terrific intensity of the Habima[26] but had much of the same character.

Why is the theater so popular here? There are over twenty-five repertory theaters in Moscow, a city of two million. New York struggles to support one; Chicago has none.

Perhaps the theater has taken the place of the church since the revolution mocks at religion.

Perhaps it is because the theater is so good, but it is good because of a demand, so that a virtuous circle is formed.

Jan. 7

The morning rather wasted in an abortive effort to make plans for a visit tomorrow to the churches and monasteries at Sergievo about 70 kilometers from Moscow. Brent Allinson, a young and beautiful Harvard "poet," wanted our company. As he was intent on making it a social occasion and we on icons we decided not to join forces.

I wrote a little on my article for *Kino*. Movies require a new critical apparatus.

In the evening to the Kamerny with Jere to see *Desire Under the Elms* very unintelligently given. Tairov employed his customary commedia dell'arte theatricality and completely missed the point. The acting was unsubtle. It is a play for the Moscow Art Theater, for restrained introspective acting. Tairov's Victo-

rian New England peasants threw themselves about like eighteenth-century buccaneers roaring and swaggering.

The setting was good intrinsically but looked more poured concrete than cheap timber construction. The costumes suggested *Tristan and Iseult.*

In the afternoon we went with Rozinsky to see Alexandrov, who is the foremost Russian composer after Myaskovsky (except the Parisians). His songs were sensitive and charming. His 6th Sonata lacked any consistent style, wavering between Scriabin and Prokofiev. He and his wife, who is Professor of Dalcroze Eurythmics at the First University, were very eager to hear about music in America.

Our visit confirmed our opinion that Russian music is at present curiously romantic and about 10 or 15 years behind the rest of the world. The acknowledged leader, Myaskovsky, is apparently a skillful eclectic, drawing from Moussorgsky, Tchaikovsky, and Scriabin.

My ideas about Meyerhold begin to take shape. He seems to me . . . later—

On the way back from Alexandrov we passed the Trades Union Building, easily the finest modern architecture in Moscow, very Gropius in style with all glass sections, steamboat balconies, etc.

Rozinsky and Dana had a smart tiff over "realism" and "naturalism," the Russian using the word in its philosophical sense, the American in its French (and English) sense.

Sunday, Jan. 8

To the Morosov collection; at least as fine as the Shchukin; eighteen Cézannes, eleven Gauguins, a finer lot though fewer than the First Museum. The great Van Gogh *Billiard Room* (*Café at Night*), a wall of superb Matisses, many Marquets, Friesz, Rouault, Derain. The finest Bonnards I've seen, also some large and regrettable Daphnis and Chloe decors by Maurice Denis—too sweet and milky—the usual Monets, but six good Sisleys. Curiously we have seen no Seurats in Moscow. We asked to see the director, Ternowetz by name.[27] He has just published (1928) a new book on Giorgio de Chirico. Doubtless he is responsible for the Joan Miró and the Légers in the Shchukin, since he is director of both galleries. We hope to see him again.

Back to the hotel to find our first mail, Christmas cards, had arrived. We decide to go to Sergievo Wednesday with Dana and Diego Rivera.

In the evening with the grandson of Longfellow and the granddaughter of Tolstoy to see the nephew of Chekhov in *Hamlet* at the Second Moscow Art Theater. To judge from his film *The Waiter in the Palace Hotel,* Chekhov was wearing a false chin in Hamlet and seemed to be encumbered. Also he has tuberculosis of the throat, but in spite of these handicaps he gave a magnificent performance, albeit a bit over-agonized. Many things seemed wrong with the play as a whole. The chorus was amusing in mouselike grey and black but far too conspicuous. The Queen and Polonius were poor (all the male courtiers and

P. wore "bald" wigs). The ghost scene was excellent in setting but there was no ghost—Hamlet carrying on a monologue in the second person. "You are my father's ghost!" etc. Hamlet did not appear in the prayer scene, a very serious omission, perhaps he was gargling. Chekhov carried the torment to an extreme without indicating the tragic quality of Hamlet's introversive activity. Many of the settings were ornamental with pseudomedieval stained glass in the 1905 Burne-Jones tradition, though the ghost scene was more Robert Edmund Jones.

Between the acts we talked with Brent Allinson who was much excited by the censorship of his poem on Sacco and Vanzetti. He had used the phrase "God save us!" and mentioned the "souls" of the martyrs and had personified "Pity" with a capital P. These heterodoxies were expunged.

The play within a play was superbly done by members of the ballet.

Monday Jan. 9

Museum's closed. Went with Dana to a Russian peasant shop. We bought some very fine dolls for a few kopeks apiece. Interesting technical expressions in carved and turned dolls. Later with Dana and Allinson to see a film at the Mezhrabpom-Russ. *Dina,* a film, Caucasian story, a few fairly good shots, melodramatic banality superimposed on fine local color.[28] Worst continuity I've ever seen.

Dinner at the Tolstoyan (vegetarian) restaurant. Long bicker with Dana on the sources of romanticism in English poetry and then in French painting. I look forward to seeing him next winter.

The director at the M. promised to let us see Gorki's *Mother* next week. On Saturday we are to go to Eisenstein's and the Sovkino. Worked on my article for *Kino.*

Tuesday, Jan. 10

Many mornings before we get up, soldiers pass singing. I now remove the socks from my hands and handkerchief from my neck, but keep them on my feet. No bugs have bitten for over a week and the Hindu conspirators next door are very quiet.

William Gropper's wife showed us an invoice of two pounds of chocolate candy and six pairs of silk stockings. The duty was 206R. She sent them back.

We went into the First University to see if we could carry away our pictures which we'd reserved from the peasant and workers exhibition. As we went around the room picking them off the walls at [the] colossal sums of 5 or 6 rubles, a crowd formed in wonder at our eccentricity. They gave advice to the artists, most of whom seemed to be there. We spent 35R. between [us] and got very good things. One of the artists, Boris Sachs, who speaks a little German, is coming to see us. His things are very sensitive, more sophisticated, though he seems only 16 or 18 years old.

I bought my first lot of children's books.

At four o'clock we dined with O'C in the Luxe Hotel—the food provided by her private cook. The food was excellent, though vegetarian. Very fine caviar on rye bread, excellent sweetish Georgian wine which tasted like Asti.

Later she asked us up to her room to meet two men of about 35 or so, one a student of the kino and French and German literature. The other a student of English literature. Later we went to see *Spartacus* by the Ukrainian Film Co. It turned out to be ten years old and very bad. *Quo Vadis* of 1914 was very much better. Even the story of Spartacus was absurdly garbled.

Tomorrow to Sergievo so I spent the rest of the evening cramming Kondakov, whose book on icons is not as lucid as one might wish nor is the archaeology of icons at all a simple affair: Suzdal, Pskov, Moscow, Novgorod, telling them apart is beyond me at present.[29] The Rublev *Trinity* looks interesting.

Jan. 11 Wednesday

Dana with us (Rivera couldn't). Up at 7:30, but find no taxis in the square and the buses too full. Finally hail a taxi and make the train at the Yaroslavl Station with half a minute to spare. (9:00) The 3rd class carriages were packed with peasants and all the windows down so we stood on the rear deck. The landscape very beautiful—new snow heavy on the trees. Reached Sergievo about 10:45 (70 kilometers) and took a taxi to the Troitzko-Sergievskaya Monastery about half a mile from the station. We passed a market teeming with peasants in brown coats and came to high walls, then through a gate into the enclosure of the most fantastic unreality. Some of the buildings were beautiful, some very Coney Island. The refectory was gaudy beyond description. The Uspensky Cathedral a simple and rather poorly proportioned box on the outside with very bad seventeenth-century decadent frescoes in the interior, among them a Last Judgment with some western puritans among the damned. The campanile, over 325 feet high, was composed of a series of eighteenth-century pavilions, telescoped one above the other. The effect was rich but ineffectual in scale. The severe tomb of Boris Godunov seemed buried in the snow.

After some difficulty we found an assistant curator (?) who spoke enthusiastic French through a long grey beard. He took us first through the museum of liturgical vestments, treasures of silver, etc. and then into the Troitzka Cathedral. The exterior is very beautiful Vladimir fifteenth century, marvelously toned, the interior very somber with the deep reds and greens of long-uncleaned, smoke-discolored icons. To the right among the icons of the towering reredos was the Rublev *Trinity*—very beautiful in color—wine-colored purple, pale blues and greens and ivories—and finer in drawing and larger than I had expected. There were other excellent icons especially of the life of Christ, *some* of which had been cleaned.

Then we went into a room where several icons lay about in various states of cleaning. Now that the monastery is turned into a museum these important

works of art are reappearing beneath their wretched eighteenth- and nineteenth-century repaintings and varnish.

After the refectory and icon gallery, which was a little disappointing, and the interior of the Uspensky, which was 5 below zero, we left for the station, arriving twenty minutes before the train left. We had tea, while waiting for the train to pull in. And while we grew impatient at its lateness it pulled out from the other end of the station about a hundred yards away. Dana was frantic since he had an engagement to see the premiere of O'Neill's *Gold.* After two hours of waiting during which Dana and I played chess with watches, lumps of sugar, and 20-kopek pieces, and the sorry remnants of a set produced by the restaurant chef, a sympathetic spirit, we just barely made the next train just after finishing the last move.

Jere went with O'C to see [Ivanov's] *The Armored Train* at the First Moscow Art [Theater]. I wrote on my article and went to bed.

Thursday, Jan. 12

Tired after yesterday's strenuousness. Go shopping with Tretyakova, O'C, and Jere, who buys some embroidered blouses etc. I content myself with a peasant spoon, Caucasian cottons, and carved wooden desk bric-à-brac.

Buy some more children's books.

Tretyakova takes us to a shop for photographs of architecture but the confusion is so complete that we leave in disgust.

Hear that the Poles confiscate all printed matter in Russian. Will have to mail our stuff to Paris.

Piotr is very interesting as well as charming. Jere learned from him something of his past. His father was a merchant ship captain whose ship was torpedoed in the Baltic. He shot himself rather than return without his ship. Piotr's sister was killed in Leningrad street fighting during the October Revolution.

I think of Gaisia, who lost her parents and brothers, escaping through Vladivostok with her sister. In the evening Jere and Sheriapin go to a film. Sheriapin was aboard the Aurora (the Potemkin) during the mutiny. He was an officer.

Friday, Jan. 13

I wonder if this journal will ever be worth the time and trouble.

Today we were finally conquered by Russian icons: the superb collection formerly belonging to Ostroukov.[30] We spent two hours going over them again and again. He also had an excellent late Rembrandt.

Wednesday night on the bus coming back from the Yaroslavl, Dana and Jere, sitting behind me, were discussing where the latter should get off for the MXAT [Moscow Art Theater]. A woman seated beside, turned about and, speaking in French, gave them information. A little later she began to read. The title at the

top of the page was in English: *Easy Reading.* Beneath was a paragraph heading: Highland—something. "Aha," I thought, "an excerpt from Scott," and then after much squinting I read *Highland Park,* the Ford Factory. After she got up to leave a man took her place. He heard me talking in English and said, "Did you go to Roberts College?" "No," I answered, "did you?" "Yes, I was educated there. I'm a Greek. I thought you were a Greek, too."

Such is Moscow.

Wrote this bothersome journal all evening while Jere and Piotr went to the movies.

Saturday Jan. 14

To the State Tretyakov Gallery. A barren waste of nineteenth-century story pictures, portraits, and allegories. But in the cellar some fine things by Goncharova, Lentulov, Larionov, Mashkov, and other members of the *Bubnovy Valet* (Jack of Diamonds).[31]

Back for dinner and then with O'C to the Russkino to see Eisenstein. He was extremely affable, humorous in talk, almost a clown in appearance. He studied (we learned later from Tretyakov) architecture at Riga, was an official artist during the war. Worked with Meyerhold for a year, then two years in the Proletariat [Theater] and finally 1924 in the kino. *Potemkin* was his second film.

We saw four reels of *October,* his revolutionary film, which was supposed to be finished three months ago and may be ready by February. His mastery of cutting and camera placement were clearly shown, especially in the July riot scene. We didn't see the storming of the Winter Palace, which is the high point of the film. Certain faults appeared: he seemed to yield to the temptation of the fine shot, viz., the drawbridge scene, the strangling scene. At times, too, the tempo was too fast. The film seems however a magnificent accomplishment.

After *October* we saw his reconstruction film, *The General Line,* intended to show the differences between old and new methods of farming and cattle-raising, dairying, etc. The parts were still uncut and gave us an excellent idea of Eisenstein's raw material: procession with icons, praying in fields, reaping with sickles, wind, rain, airplane propeller. We asked whether much of the excellence of E.'s films did not develop in the cutting rather than in the shooting. He laughed and answered that the critics always wrote of his filming as "always carefully premeditated" and then he himself would write, "always carefully premeditated," having a sense of humor.

He hopes to come to America after *The General Line* is finished, perhaps in June.

From the Russkino we tore by [taxi] to the Vakhtangov Theater to see *Razlom* (*The Break-Up*). It was certainly one of the interesting plays we've seen, better constructed, less caricatured. The Whites are human beings as well as the Reds and this makes possible situations in which one can believe, whereas in *Richi-Kitai* the "opposition" was made up of fools, puppets, and idiots.

We sat with Tretyakov and -kova and O'C. I asked Tretyakov about the

caricature in his *Richi-Kitai.* He replied that it was not in his play but entirely in the directing of Meyerhold. "How soon," I asked, "will it be possible to write objectively of the revolution?" "Objectivity is bad," he answered and went into a long explanation in bad German which I couldn't follow. Yet in his bio-interview on the life of a Chinese boy he illustrates objectivity perfectly. Both he and Meyerhold feel themselves a unit in the new society. While they function in this way I suppose any artistic objectivity is impossible. Prejudice is inevitable.

I cannot get over the fact that O'C, who is intelligent, critical, and a great theatergoer, should not have noticed the impossible characterizations and actions of the English and Americans in *Richi-Kitai* by comparison with the superb realization of the Chinese.

Uncle Tom's Cabin was doubtless the greatest theatrical propaganda ever staged but as a work of art it is of a very low order. Compare *The Persians* of Aeschylus written a few years after the defeat of Xerxes.

Of course there are several October and civil-war plays which show the tragedy and comedy of strife in an impartial manner. One of these, *Days of the Turbins,* was much censored because it created sympathy for the Whites.[32] At the 1st MXAT, *The Armored Train* shows the despair of the defeated Whites without caricature.

To return to *Razlom.* This is hailed as a conspicuous example of the influence of kino on theater. A "triple window" set is used for much of the play, sometimes one room, sometimes two or three being lighted, suggesting the agility with which the scenes change in a film. Furthermore two small 45° sets were used, very strongly suggesting an overhead angle shot. In one of them a four-sided diaphragm opened on a group of officers around a table on which was a map. The whole set was tipped forward at a 45° angle making the map visible to everyone in the audience as well as lending an air of intimate keyhole observation. All the props were nailed or glued and the officers were skillfully braced in order not to slide.

The effect was very striking—but smacks to me of the tour de force. The salvation of the theater lies not in this direction where it can only hobble after the infinitely more nimble kino.

The battleship sets of *Razlom* were very ingenious—but less imposing and hieratic than Meyerhold's Cockchafer in *Richi-Kitai.*

Jan. 15

Back to Vakhtangov's for the *Princess Turandot,* a Chinese Arabian Nights-like fantasy. Excellent sets in an applied cubistic manner with Chinese color. The play was carried through in the best commedia dell'arte tradition. We left after the third act without regret. Two and a half hours' buffoonery suffices when you can't understand Russky. There were many delighted children there.

We got to the Trades Union Hall (formerly a sumptuous club) just in time for a concert of Prokofiev's music played by students at the Conservatory.

A miraculous thing happened. We had asked at the box office for tickets and, after a moment's futile sign language, were about to give up in despair. Suddenly a boy who was standing near came up and asked if we spoke English. He then drew out two tickets saying that his friends could not come and thus he would be glad to sell their tickets at a ruble apiece. As they were very cheap we took them and, as he was very agreeable, we annexed him too. He was just beginning his studies as a mining engineer specializing in mineralogy, but very fond of the theater and music. We found him not only a deus ex machina but a very pleasant companion. We hope to see him again. In the evening Piotr and Jere went to the kino while I stayed in the room to write.

Jere asked Piotr yesterday why he was so small. He answered very simply, "During 1919 and '20 when I was supposed to be growing, I was starving. The doctors said I couldn't possibly recover but I was taken into the country and gradually regained my strength."

Our friend of the concert whose name was Theodore said, when Jere asked what English books he read, that he liked Jack London most but also read much of O'Henry, whom he found difficult because it was written in a New York argot (sic). I asked what modern Russian music he liked the most. "Prokofiev," he said, "and then Stravinsky, but Prok. much more."

I was not much impressed by Prok's music. The things for small orchestra were entertaining and witty but there is little sustained effort in any of his things. He is very clever in his use of percussion-brass-woodwind combinations. Some of his songs were charming and reminded one of Ravel, though less stylish. The piano sonata was very romantic. Underneath the modern harmony one glimpsed Tchaikovsky and Schumann.

Monday Jan. 16

Spent the day writing—with a couple of fruitless hours searching the shops for art books. I know there must be some but I can't find them. Dana arranges with Lunacharsky for a visit on Saturday. We'll try then to crash the Kremlin.

In the evening to the concert of the famous Leaderless Orchestra. We were not greatly impressed, though Rozinsky praised the quality of the strings enthusiastically. The tempo was uneven and tended to slow up especially when the line was thrown from one choir to another. I'm sure they would have played better with Klemperer or Koussevitzky preserving the tempo and putting punch in the fortissimi. Also the program was very poor. Borodin's weak unfinished symphony, a vulgar waltz by Glazunov far inferior to Johann Strauss, and some songs of Glazunov sung by a young bass whose career is very interesting. He was a mechanic and then a chauffeur in Odessa. His union sent him on a scholarship to the Leningrad [Conservatory]. From there the Narkompros sent him to Rome to study with Battistini.

They played *Scheherazade* during the second section of the concert. I had not heard it played by an orchestra since junior year, 1921, when it put me in great ecstasy in Alexander Hall [Princeton]. Tonight, knowing the music so

thoroughly, it failed to move me, except to the greatest admiration. It is so much better than any other Russian orchestral composition of the nineteenth century, not a dead theme in the whole composition, and only occasionally is it repetitious. Its clarity and good workmanship make one think of Mozart, its ingenuity of Strauss. The arrangement of the orchestra was interesting. [He draws a plan of the arrangement of the orchestra.]

Tuesday Jan. 17

To the bank, where they still use the abacus for counting, apparently very efficient and far cheaper than an adding machine, though there is no automatic record possible.

Then to the Museum for Art-Culture, formerly the Stroganov School. Many of the pictures had been moved but we found the best collection of the finest twentieth-century Russian painters, better by far than the Tretyakov except in the *Bubnovy Valet.* The cubists, cubo-futurists, and suprematists were there in serried ranks, also the postexpressionists, reflecting Dix or Grosz or Chirico.

The curator (?), an elderly lady, was very kind to us and gave me a good bibliography and several monographs.

(Got a good letter from Virgil Barker.[33] He seems to like my stuff which pleases me very much.) Spent the evening going over my film article and writing letters. Jere went to see a play with Dana. I was too weary.

Between 5:00 and 6:00 we had a visit from two very entertaining young architects, one a girl. We garbled French and German and had a grand time looking over photographs. The man [Andrei Burov] has done the buildings for Eisenstein's new film *The General Line.* [34] He was delighted to find one of his *esquisses* illustrated in the catalogue of the Machine Age Exposition in New York.

Wed. 18th

To the Museum of Fine Arts. Fine Egyptian things in the Golenishev collection, especially Fayum portraits. We had little time for anything but a survey because our time was taken up with Efros, the curator of painting (and an important critic), a young orientalist, and the curator of the Egyptian things.[35]

More photographs from Louis Simon. Also some snapshots from Lux Feininger.[36]

In the morning we looked over photographs of Rivera's paintings and drawings; very strong and simplified, Egyptian influence and Giotto and Piero.

Thurs. 19th

Off to the School for Art-Culture with Diego and Dana and Piotr. Diego introduced us to Prof. Sterenberg (David Sterenberg) with whom he had worked as a cubist in Paris before the war. Sterenberg is now one of the most influential teachers of painting in Moscow and certainly one of the most interesting painters we've seen. There is scarcely any cubistic hangover in his work at present,

primitivistic portraits and figures, fine postexpressionist still lifes, curious intimate studies of flowers and grass, a decorative screen suggesting the Korin in the Metropolitan.[37]

While we were going through the school we met Falk who had been a leader in the *Bubnovy Valet* and later perhaps the finest of the Russian cubists. He is now professor of painting in the school. We went to his studio to see his later work since only his cubist things which he had long ago passed by were of interest to the director and were included in the exhibition in the gallery.

Falk has passed through many phases in the past *decade:* from crystalline cubism (without disintegration)—flat geometric figures, Rembrandtesque, Cézanne in walnut-stain period, Chardin, then to a solid realistic Speicher-like phase, to a few impressionist experiments, and now a strong carefully composed realism suggesting Marchand in landscape, Segonzac in still life and figures.

To return to the school to which we paid three visits on separate days. It is called the Moscow Higher Workshops for Arts and Crafts and includes a large number of departments: painting, sculpture, architecture, printing (color and various processes), typography, graphic arts, furniture designing, advertising posters, and techniques of materials (*Materialen-Kultur*).[38]

In painting the masters are Sterenberg, Falk, and four or five more. In architecture: Vesnin, Lissitzky, and 3 or 4 more. In metal and cabinet work: Rodchenko and Tatlin. In graphics: Favorsky and Sterenberg.

. etc.

In each art the fundamentals of material, technique, and composition are supposedly thoroughly taught. This seemed successful in furniture and metalwork, where Tatlin's and Rodchenko's constructivism made a thorough knowledge of materials necessary. In architecture there were many compositional problems carried out in clay and cardboard and metal but we saw few signs that the actual problems of construction were being faced. We remember the very bad technics of the Tretyakov apartment house.

In Rodchenko's atelier we saw many interesting and ingenious designs and models for furniture: office desks, filing cases, etc. Tatlin, who spoke as bad German as I did, was very modest and kindly. His work was only two months old but he *had* to show [us] very beautiful metal constructions by pupils.

The sculpture seemed very uninteresting on the whole, clay modeling from a model. The things in wood were much finer. Beginners in stone were chipping away at marble moldings.

The whole institution seemed painfully lacking in organization and equipment but the fine spirit of enthusiasm will conquer these technical difficulties with time and money. It was annoying, though, not to find *any* printed matter about the school, not even a list of professors or courses. The building was disorderly.

They were much interested in the Bauhaus and have evidently learned much from it. I asked Sterenberg what were the chief differences between the two. He replied that the Bauhaus aimed to develop the individual whereas the Moscow

workshops worked for the development of the masses. This seemed superficial and doctrinaire since the real work at the Bauhaus seems as social, the spirit as communistic as in the Moscow school. Kandinsky, Feininger, and Klee have actually very little influence among the Bauhaus students. The important difference so far as I could discern lay in the fact that the aim of the Moscow school was more practical, its technique far less efficient; the aim of the Bauhaus more theoretical, its technique much superior. But with men such as Lissitzky and Tatlin and Falk there is much in the future. The great lack is a Gropius, an organizing genius. A good janitor to direct storage and clean up rubbish would be a boon.

Thursday Jan. 19, afternoon

We tore back from the School for Arts and Crafts to go with O'C to see Rodchenko again. I had prepared a list of questions to ask him. He answered them in a rather disgruntled manner, insisting that the past bored him utterly and that he couldn't remember at all when he had painted this way or that. Fortunately, Stepanova (Meyerhold's assistant), his brilliant wife, was a great help.[39] She also picked out photographs of his paintings and promises to send others of his kino sets, photomontage, photographs, constructions, etc. O'C was very patient but annoyed at R's pouting attitude. Very different from Sterenberg's slippery affability and Falk's simple friendliness.

Jere tore off to the Jewish Theater to see *Benjamin the Third.* I followed in time to see the last two acts. Very theatrical theater, excellently flavored music right out of Chagall's pictures. The Jews in Russia seem to have an extraordinarily vivid and distinctive culture.

Rodchenko showed much satisfaction at having delivered the death blow to painting in 1922. Since then NOZH and OST have thrived.[40]

Stepanova then took more of the Simon photos for my *Kino* article.

Friday Jan. 20

To see Lunacharsky but found him called to a general council. So we went to an exhibition of *Revolutionary Artists.* Most of the painting in various realistic styles—mostly *Neue Sachlichkeit,* some showing influence of photomontage. Some very fine lacquered boxes with scenes from the revolution done in the icon style with gold hatching and schemata.

The graphics were interesting, but the sculpture rather stupid variations on Bourdelle and Metzner and Maillol and Konenkov with U.S.S.R. themes.

In the evening to the first MXAT to see *Days of the Turbins,* their revolutionary play, which seems to us rather counter: the story of a White family of the Ukraine during the stormy Wrangel-Petliura days, superbly acted in purely actualistic manner.

Saturday 21

To the Ostroukov museum to borrow the Muratov *Les icones russes.* [41] We met

Ost. himself, an invalid of about 60, but very interested in our Kondakov volume which we had brought as a hostage. He promised to give us a letter to a friend of his in Novgorod. We wonder, too, if Vladimir should be seen.

We hurry back to go with Dana and Diego to Sterenberg and the school. And from the school to dine with "Prof." Weekstead, who teaches English in the Second (?) Soviet University.

In the evening Piotr and Jere went to the kino. I went through Muratov finding the illustrations very exciting. The text seems a little superficial but will correct much of Kondakov.

22

While eating breakfast, *Potemkin* catches my eye among the kino ads in the *Pravda*. Dana and I rush off for a 12 o'clock special showing (today being the anniversary of the 1905 revolution). Jere had seen it in N.Y. and didn't come. It was magnificently up to expectations. The tension continuous, the shots thrilling, the incidents beautifully directed, and the cutting displaying to the full Eisenstein's mastery. One fault only appeared, a lack of dramatic composition which seemed sacrificed to the emphasis of great episodes, the spoiled meat, the mutiny, the sleeping sailors swinging in the hammocks, the dead seaman on the quay, the Cossacks marching mercilessly down the steps, the Potemkin preparing for action; but the scenes aboard ship and the great step scene were not dramatically related. Nevertheless it is a glorious achievement.

A few hours later we saw an equally great, though not so epoch-making film by Mezhrabpom-Russ, Pudovkin *régisseur,* Gorki's *Mat* (*Mother*). Here there was a much more careful subordination of single sequences to the whole composition. The essential unimportance of most American films, their vulgarity and trivial sentiment was brought home by *Mat.* In the kino at least the revolution has produced great art even when more or less infected with propaganda. Here at last is a popular art; why, one wonders, does the Soviet bother with painters? The film in Russia is more artistically, as well as politically, important than the easel picture.

In the evening (a full day) to the Kamerny to see *Antigone.* [42] Fine cubistic sets, fair costumes, excellent handling of light, but the great theme of Sophocles' play was distorted to fit revolutionary needs. Antigone became a leader of the proletariat dying for her cause. Kreon became the aristocratic tyrant.

Monday Jan. 23

Read Muratov in the morning and evening. To the Narkompros with Dana to see Lunacharsky but he had changed the date to Wednesday, characteristically Russian. I wonder if our third visit will find him available. The walls of the Kremlin are less pregnable than we had thought. After the vain journey to the Narkompros, we returned to the Arts and Crafts School.

Tuesday Jan. 24

Finished Muratov and feel eager to see and talk icons; a great new field is opening up, if only material (books and photographs) were available here. I spent the afternoon in a vain hunt for books. Found a set of Grabar for 40 rubles, but the plates are bad.[43]

In the evening to see an educational film on the mechanism of the brain. Pavlov's experiments on dogs and monkeys, children and idiots and frogs were beautifully shown. There were remarkable shots of children at play, of the head of a woman in child-[birth], of a monkey, whose visual brain had been removed, trying to eat an orange; but a materialistic philosophy based on the conditioned reflex seems absurdly limited. The so-called higher faculties of man can't even be photographed and much less easily explained.

What then is the correct Marxian attitude toward God or, to humanize, toward St. Thomas—and what is the correct Thomistic attitude toward St. Marx?

Elucidate also the debate between the Sts. Marx and Engels and St. Mark and the Angels?

Since Leonardo first explained the conditioned reflex, should we conclude that the conditioned reflex explains Leonardo?

Wednesday Jan. 25

Take the Muratov book back to Ostroukov. He shows us a fine set of periodicals called *Russkaya Ikona*—which Jere orders from the Kniga [Bookshop] on Kuznetzky Most.

Then to the Narkompros for a third attempt to see Lunacharsky, this time successful. He gave us ¾ of an hour—genial conversation, friendly advice but little new information. Most important he wrote us a letter to the Narkomindel[44] about getting us into the Kremlin. This goal seems in sight at last though the recent political disturbances make it very difficult.

In the evening with Piotr to see a pleasant, mediocre film, *The Daughter of the Stationmaster* (Mezhrabpom-Russ)—story by Pushkin. The very beautiful Vera Malinovskaya played the part—she was in *The Waiter at the Palace Hotel* also.

Thursday Jan. 26

Start out with Dana to hunt books on Russian art at the library. No luck. Only the Lenin Library and State Institute for the Study of Fine Arts (Lunacharsky) remain. Go to the Fine Arts Museum to finish our review of the paintings there. Some excellent Magnascos, a curious Grünewaldesque piece (nearer to Baldung it seemed to me), a very André Lhote Cuyp and an extraordinary Francesco Morandini (late sixteenth century) which seemed close to Fuseli.

Then to the Shchukin for a second visit. The Gauguins and Cézannes are certainly inferior to Morosov's, but his half-dozen Rousseaus compensate. Make lists of photographs. After a too-greasy meal at the hotel we go with Tretyakova

to visit a brilliant young architect, Moisei Ginzburg by name. He has written an interesting book on the theory of architecture (illustrations are good). He is perhaps the most [illegible] of Russian architects; though his work lacks the boldness of Lissitzky or Tatlin, it is certainly more concerned with actual problems. He did the apartment house where the Tretyakovs live. He showed us photos of his work, gave us back numbers of *Sovetskaia arkhitectura,* [45] the periodical published by the "left" architects. In his room he had an excellent maquette for a workers' apartment house and club. He explained why it was that several of the big new buildings are so bad—or at least unfortunate—Izvestia and Telegraph, etc. These were done by older architects who had drag but who had only a superficial feeling for the problems of modern design, hence the ludicrous steamboat funnels on Izvestia and the inert weight of the Lenin Institute.

We gave Ginzburg Peter Smith's and Russell Hitchcock's addresses. He wants articles on American architecture and likes Jere's photos. Ginzburg's wife, who gave us tea, remarked that Russian architects and American engineers should combine, after I had told how reactionary our architects are.

In the evening I was both sick and ill—indigestion.

Friday 27

Spent day in bed.

Jere went with Dana to foreign office to see about Kremlin, taking Luna-charsky's letter. It will be difficult. Practically no foreigners are admitted.

Saturday 28

Last night I destroyed this creature [bug taped to page of journal], the second casualty among the companions of my slumber. I have been bitten only once since I adopted my elaborate defences. This is of another species than the bug of December 27th. This seems to belong to the tick family.

This is my birthday [Barr was 26]—to judge from the date—and a long letter from K.G. [Katherine Gauss] which was most welcome.

In the morning I wrote and rested. In the afternoon to the Morosov. Again the Bonnards, van Goghs, Cézannes, Gauguins left their mark, a truly marvelous collection. We saw for the first time the German room: Marc, Campendonck, Grosz, Pechstein, a fine Munch, and two first-rate Klees.

Ternowetz was very kind and showed us the few books he had on Russian painting. He took my list of photographs, which he said are only 75k., if I can get them. Most of them were to illustrate the importance of negro sculpture in the formation of cubism in Picasso's work of 1907–09. We made arrangements to visit Tyschler, the painter who interested us so much at the Exhibition of Revolutionary Artists. Ternowetz likes him too, probably because he is the closest of all the Russians to Chirico.

I wrote and went to bed early being somewhat weakened by fasting.

Jan. 29

To the great market with Piotr. Much rummaging among junk, brass, icons, etc. Jere bought a very good provincial icon triptych for 10 rubles, a great bargain. We also got some small brass icons and I a little panel of the Prophet Elijah being fed.

In the evening, after an hour's search, to see the painter Tyschler, whom Ternowetz had recommended. Found his work refreshingly imaginative, frankly of a fantastic world, rather than of the careful this-worldliness of most Russian painters. Some of his things suggested Chirico by analogy.

Jan. 30–Feb. 9: Written after I'd been ill, brief.

Jan. 30—Last day, can't remember.

Jan. 31 Tues.

Went to hear Roland Hayes in evening. Voice weak but superbly trained— a very fine master. Audience very enthusiastic. Met him afterwards—fine personality.

Most of the day in the library in the Tretyakov Gallery.

Wed. Feb. 1st.

Tretyakova called for us and we went to see the head of Blue Blouses, that remarkable organization which spreads the news of Russia's problems and needs through factory clubs and peasant villages.[46] We received photographs and literature and an invitation to see a show tomorrow night though that will mean giving up a good concert of Prokofiev and Stravinsky music.

The Blue Blouses grew gradually out of a news service during a period when paper was expensive and illiteracy far more general than now. The news was acted instead of read. Gradually a more elaborate program and technique developed until now there are B.B. troupes all over Russia engaging in an excellent and effective form of propaganda, forming at the same time the most natural and spontaneous of Russian theaters.

In the evening to Meyerhold's to see his *Window on the Village,* a delightful revue of village life as it is and was: much dancing and singing, merry-go-round, swings, cinema, etc. We thoroughly enjoyed it, especially the scene in which two reluctant girls are gradually moved to dance by a most seductive accordion.

Thurs. Feb. 2

Got in touch with Victor Midler[47] of the Tretyakov who may help me with my primitive problem; but I haven't much hope of getting any material that I can keep.

To Eisenstein's to see about stills for articles on *October* and *The General Line.* Found him very weary. "Will you go on a vacation after *October* is

finished?"—"No, I'll probably die." We found out through Diego why *October* has been so delayed.

With Piotr to the club of the Transportation Workers to see the Blue Blouses perform. We arrived an hour too early and sat through a long lecture on Russia's natural resources and economy.

The interior of the club was interesting. Various propaganda charts and posters —Darwinian and antireligious, anti-Trotsky. A club "wall" newspaper, etc.

The Blue Blouses were on from about 9:00 to 10:45. The first part of the show was mostly sugarcoated propaganda in the form of song and dance. Very ingenious costume shifts and simple athletic ballet. After an entr'acte they gave a parody on Carmen, very slapstick. Charlie Chaplin's was much funnier.

The whole performance however was hugely and noisily enjoyed by the audience for whom it was carefully studied. They wanted opera in the club and the B.B. provided it. The élan and spontaneity and simplicity of the performance as well as its remarkable functionalism make the B.B. a very important unit of the Russian theater.

Jazz band with combs etc.

Friday

Jere went with Piotr to visit his brother-in-law in the country so I went to the Institute for the Science of Art (*Kunstwissenschaft*) on the Kropotkina to work in the library.[48] I found a fair collection of current periodicals including among the American only the *Theatre Arts, The American Mercury,* and *The Arts* which had my "Dutch Letter" in it.

I worked seven hours straight and got much material for my thesis— especially from the periodicals *Apollon* and *The Golden Fleece.*

After dinner I walked to the Bolshoi for tickets to *Prince Igor* but found the box office closed. To bed early, very tired.

Sat. 4.

To the Tretyakov to see Victor Midler. He was very pleasant, seems to know about the important Russians of my particular problem: Larionov, Chagall, Goncharova, etc. Is going to try to get photographs of paintings I listed. I have little hope.

Came home feeling tired—headache—went to bed.

Feb. 5

In bed—not very sick—gastrointestinal. Jere the perfect nurse. Have a doctor to get advice about medicines and diet.

Feb. 6

Better. Dinner at Litvinov's with Dana and Roland Hayes called off. Hayes ill.

Feb. 7

Better but weak. Dana also ill—also Mary Reed.

Feb. 8

Much better but legs still shaky.

Rozinsky in. He read me an article by the German *régisseur* Erwin Piscator on the class theater full of absurd sophistries and historical misstatements. The only vital theater is the class theater. Whenever a theater ceases to handle a class problem it is decadent, like a class which is not self-conscious. The Greek theater and the medieval theater were class-conscious. The only theater which can exist in Berlin is the Piscator Theater for it is the only class theater, the only proletariat anti-bourgeois theater. Eisenstein's films are class-conscious and therefore excellent, but *Potemkin* is at fault because Eisenstein failed to emphasize the relation between the mutiny and the profound movement of the 1905 revolution, etc. etc. I nearly had a relapse blowing off steam and poor R., who is usually so positive, seemed quite subdued, though he insisted that he agreed with all that Piscator wrote. P. evidently knew the public he was writing for. To distort fact to such an extent in a German paper would have been unwise. I do agree with Piscator, though, about the vitalizing power of a social or political issue in the theater as a relief from eternal woman. No one makes love in *Potemkin*.

Tomorrow if I'm able to stagger we do the Kremlin.

Jere goes to Tretyakov's for dinner. Has argument with Tretyakov about functionalism and choice in architecture. T. believes that any selection in a purely functional building is impossible, a typical error of a man whose logic is superb but who knows nothing about building programs. He seems also to have a hangover from his futuristic days, speaks of razing Moscow completely to build anew.

Feb. 9–17: written in Leningrad between Feb. 22 and Feb. 24

Fri. Feb. 9

The Kremlin at last, though Dana is too sick to go and I stagger. A man from the Narkomindel takes us to the gate where we are met by a Red officer. The two of them stay by us during the whole round. We proceed to the old Armory where a very intelligent woman from the Historical Museum acts as our guide. We go through rooms of marvelous silver and gold plate, embroideries, armor, etc. til I have to sit and rest. Finally we emerge and walk across to the courtyard of the main palace where in the center is the 14th-century church of Our Lord in the Woods. To our great disappointment we can't go in and thus miss the fine *Transfiguration*—perhaps by Rublev. We see part of Ivan's palace above and behind the bad 19th-century stories. Then to the Cathedral of the Archangel which is not especially interesting. The Annunciation *Sobor* (Cathedral) has

much finer icons. The "feast" row in the *tchin*[49] is partially by Rublev or close to him. They seemed very fine through our poor opera glasses. Then to the Uspensky *Sobor* (Dormition)—large but filled with scaffolding. Unfortunately they are cleaning all the accumulated repainting to lay bare the wrecks of 16th-century work of the school of Dionysos. The effect will be ghastly when complete. The uncleaned part is decoratively satisfactory, if poor in style.

Then out past the great bell and the innumerable cannons, having missed two-thirds of what we hoped to see, and disappointed in what we did see, and to cap the climax we were told that the charge for our visit would be 25R., which we refused to pay until further argument with Narkomindel, which had not warned us of this tax.

I rest during much of the day and go to bed early.

Sat. Feb. 10

We wrap our many books. In evening I go to [a] film which Jere and Piotr had seen while I was sick—*Prisoners of the Soil,* Mezhrabpom-Russ—excellent film with a superb brothel scene, as usual the theme of the downtrodden peasant and the decadent aristocrat. Coming back to hotel early I play two games of chess with a waiter and take one; very good fun, a laughing group of waiters and cooks stood about while "Alekhine" of Moscow played "Capablanca of New York."

Sunday Feb. 11

Take an A tram early for the Porcelain Museum, formerly one of the Morosov Palaces. After a not too interesting hour we walk back toward the Kremlin, try to get into Our Lady of Georgia to see the Ushakovs but find it shut, go to the very interesting Dom Boyar, then to the Red Square and into St. Basil's—that marvelous church—which is almost as incredible within as without. It is now a museum with many fine secondary icons. Then to the Historical Museum but find that the rooms with the best icons are closed. Back to our favorite restaurant, very hungry. Buy a Russian book on Picasso, interesting early things illustrated.

Monday Feb. 12

Up early to go to Grabar's and phone only to find that he had been called out of town till Wednesday morning—and he had told us to come without phoning.

So we sally forth with Piotr to buy our tickets for Leningrad but are seduced by the many marvelous photographers' backdrops set up in the Tverskaya Park. We have our photographs taken, and then a backdrop without us, much to the puzzlement of the photographer.

Back for luncheon and then to the Tretyakov Gallery where Curator Midler had promised to have my photographs ready and to show us the icons. At first we were told that he was not there. But while we were being told, he appeared suddenly, having missed his cue, and, after some embarrassment, explained that

no photographs could be taken except at great expense and that the icons could not be seen because other pictures had been stored in front of them. We left in disgust, resenting not so much his inability to oblige as his too facile promises. A typical Russian day of delays and disappointments and wasted time.

In the evening to the Proletcult Theater to see *Along the Road.* Interesting direction, very sparse setting and figure composition, excellent vigorous acting. Skating in the park.

Feb. 13

Finally get tickets to Leningrad—hard class—only $6.00 (12 R).

To the Historical Museum to see the old icon collection under Mme. Kavka's guidance (Anisimov, the curator, being abroad).[50] Several magnificent things, especially the disquietingly beautiful head of an archangel dating from the twelfth century and probably Greek, done in Russia (though Grabar thinks it Russian), the Dormition on the back of the *Donskaya Madonna,* perhaps by Theophanos, the *Riaboushinski Archangel,* the *Novodevichi St. Nicholas,* and many things of less importance. The collection was closed to the public the day after it was opened for fear that it might serve as a religious influence.

Feb. 14

Vain search for photographer to buy icon photos, then to Morosov's to find my French photos ready and very satisfactory, after two weeks delay. Hunted a bookshop recommended by the librarian of the Tretyakov Gallery but found it nonexistent. After dinner (4:30) to Eisenstein's apartment. He received us with his customary comical remarks and pseudo-foot-in-the-grave manner. After we had gone through a vast pile of stills from *October* and *The General Line* (of which he generously gave us several dozen), we looked at his books on Daumier and on the history of the theater, a very fine library with some scarce volumes. He reads all important European languages and talks four of them. And Daumier is his great hobby.

Rush back to hotel to receive a call from Konstantin Umansky, the brilliant young head of TASS (the foreign news commission), and author at the age of 19 of the book *Neue Kunst in Russland.* He too speaks English, German, and French. During the last few years he has not followed painting carefully, finding it of little interest in comparison with architecture, about which he is very sanguine, and, of course, the theater and kino. I asked for his ideas about a proletarian art. He repeated the commonplace that the various modern movements were far beyond the grasp of the proletariat and then suggested that a proletarian style was emerging from the wall newspaper with its combined text, poster, and photomontage—an interesting and acute suggestion.

Certainly the various revolutionary styles—futurism, suprematism, cubism, left-classicism—are far beyond the interests of the ordinary, who prefer the nineteenth-century story-pictures of the Tretyakov.

After Umansky's brief visit we hurried off for a farewell call at the Tretya-

kovs. Olga was especially dressed for the occasion and gave us tea *very* vivaciously. Just as we were leaving, Tretyakov came in so we took off our coats and stayed longer. He gave us each several of his books autographing them with exhortations to found the American *Lef.* [51]

15

Pack books, in morning, only to find them too heavy for the Soviet book post. Unpack and repack. To Grabar's to get our photos of magnificent twelfth-century icons and then to TASS (press *cliché* department) to try to make a last attempt to find photos of modern pictures and architecture. Find two satisfactory, rest bad, two rubles apiece. Back in time for dinner and then to Hermitage Theater to find *Kino* sold out. We go backstage in theater to see maquettes, many excellent; no photos. Jere and Piotr stay for 10:30 projection. I back to pack.

16

Suddenly decide I want one of Diego Rivera's drawings. Find him dressing —but all drawings over at Sterenberg's, whither we go, he having an engagement there. I take back roll of drawings and choose a fine charcoal of men working on railroad tracks (30 rubles).

Take new packages of books to P.O. with Piotr—10 packets, five of them still too heavy. Repack in P.O. Then rush to VOX to find Jere had gone back to hotel with Dana's mail. Finally find Jere and we take a tram, a long 14-kopeck ride to southeast corner of town, to visit Chirikov's icons.[52] He is a friend of Grabar's and has a very fine series of late icons, almost as good as Ostroukov's, all stored in closets. He brought them out one by one. He is the chief cleaner of icons working under Grabar—a very fine craftsman as well as connoisseur and collector. He took us over to see the church of the Uspensky Virgin of . . . [Barr's omission] near his house where there was another very exceptional collection. Back to hotel for final packing. Rozinsky stops in to say good-bye; Dana, Mary Reed sick with her bad heart. Leave for station with Piotr who is going with us to Leningrad to visit his brothers. Very fortunate for us. Piotr and Jere sit up all night but I doze, on an upper shelf—hard class. Air very bad— but only seven fleabites and nothing stolen.

Feb. 17
(written Feb. 28)

Arrive in Leningrad at 10:30—to Hotel Angleterre near St. Isaac's Cathedral—recommended by Eisenstein but rooms cold, expensive, and service bad. We decide to spend the night since Piotr had gone for the day to his sister. We wander streets looking for restaurants but have little luck, gloomiest day in Russia—until we try the Hotel Europe and find not only German but English spoken—very good rooms and beds and adequate service. To bed early.

As to the city, it seems entirely un-Russian in appearance, except one large

and execrable imitation of St. Basil's in Moscow. But it is the most complete and most beautiful eighteenth-century city I have seen—superb composition of squares and *places* and palace facades, the earliest, such as the Winter Palace (now the Palace of Art), in late baroque, but the later in beautifully studied neoclassic. The main artery, the Prospect 25 October,[53] is spacious but very ugly nineteenth-century architecture.

Feb. 18

Move to Hotel Europe from Angleterre, much better and a little more expensive (7.50 R.). No museums open. Piotr appears and we take a long walk past the Russian Museum down by the Neva, past many huge palaces, many of them in disrepair, along the back of the Hermitage and the Winter Palace, then up past the fine Falconet bronze of Peter the Great to the St. Isaac *Sobor* which we enter to find it as cold, heavy, costly, and tasteless as its exterior would lead one to suppose. Then to luncheon in the old Astoria Hotel, now the First Proletariat Restaurant, and a very poor one, dirty as are all the restaurants, and wretched service, the food greasy and heavy. Then back across canals to the *Sobor* of Our Lady of Kazan—a very fine neoclassical church on the plan of St. Peter's in Rome. In the interior, severe and fine, were several beggars and ragged women hugging the stoves. Back to our room for a comfortable tea.

In the evening with Piotr to a small theater to see several excellent one-act plays, one of them satirizing the Russian worship of efficiency and inability to practice it.

19

To Hermitage—truly a marvelous gallery, though the Italian pictures are a little disappointing—the Rembrandts, however, a dozen late portraits and the *Danaë* are very wonderful. The gallery was more crowded than any I have ever seen, many docent groups of workers, peasants, and soldiers.

—In addition to the Rembrandts—Vrel, Duyster, Boorse, de Hooch, Bartolomeo Vivarini, two small Botticellis?, a dugento panel, two large Magnascos, de Witte, Poussin's great *Polyphemus* landscape, a Chardin kitchen scene, Guido's *Childhood of the Virgin,* a Veronese *Conversion of St. Paul,* a late Lotto portrait, Procaccini Madonna, etc. The Titians did not interest me especially— the late Sebastian seemed a bit dull.

In the evening to a rather poor Russian film satirizing American prejudices about Bolshevists, a good subject but handled very badly.[54]

Monday February 20th

To Russian Museum to go over the icons with Smirnov, the Byzantine scholar, and Lessuchevsky, a young Ukrainian, assistant curator and specialist in brasses.[55] The collection is not so fine as the Moscow Historical Museum, nor up to the Ostroukov—a fine Byzantine St. Nicholas, the great Boris and Gleb from Novgorod and many lesser things.

Dinner at the "Bar" Restaurant—food quite good and cheap if you have an *Obyed*—but costly if *à la carte.* [56]

Tuesday

Back to Hermitage, rear entrance. Mlle. Matzulyevitch, who promises to see about photos and to put us in touch with Schmidt, the curator of paintings. In evening to a very interesting Kino retrospective: films dating from 1903 (*Death of Lincoln*), early Max Linder and Chaplin, and ending with the steps scene from *Potemkin.*

Wednesday, 22

Russian Museum again to go over modern painting with Ivan Punin,[57] perhaps the finest of Russian critics of modern art. The collection takes one from the *Bubnovy Valet* through cubism and suprematism to contemporary work. The collection is small—about fifty paintings but well chosen, exactly the sort of collection which we lack in any American gallery except Duncan Phillips's. Punin gave us each a copy of his excellent monograph on Tatlin.

In evening to a good but interminable Russian film of comedy and adventure built around a Conan Doyle Moriarty-like villain with an anti-Soviet complex who is frustrated by a trio of gallant young newspapermen with radical inclinations. The film was intended for boys, Piotr explained, and the action moved breathlessly. We left exhausted at the end of the second hour, two-thirds done.

Feb. 23

After breakfast we walk across the ice on the Neva to the Zoological Museum to see the great stuffed mammoth which I used to dream about in the days when paleontology was to be my career. Then to the Hermitage for an appointment with Schmidt at 12:00. He had not yet arrived—we waited an hour. They phoned—he had a cold—and had apparently not been notified by the suave and cordial Matzulyevitch. Perhaps we can see him next Tuesday—perhaps—perhaps—time wasted—Russia—Russia.

Piotr discovers a good restaurant—a really good one—with real waiters and clean tablecloths and not expensive, 1.25 R for dinner.

In the evening to *Prince Igor* at the opera. The interior is not large but very charming for an opera—but *Prince Igor* was flat, uninteresting music, except for the ballet and a few choruses. Borodin's symphonies and his opera are about on the same level.

The horses and taxis are decked with ribands—a holiday is near.

Fri. 24

Through the Russian Museum—the peasant arts from all over the empire from Kiev to Kamchatka. Many very beautiful things and excellently arranged.

About eleven o'clock Piotr comes and we leave for the train to Novgorod. We go 2nd (soft) class for the first time in Russia in order to save our strength for intensive activity during the next three days. Piotr is embarrassed but secretly, I think, pleased by our bourgeois "softness." It is his first *soft* berth and he has traveled a great deal. . . .

The LEF and
Soviet Art

Barr was first entertained at the home of Sergei Tretyakov, co-founder of *LEF* and *Novyi LEF* (which succeeded the original in 1927), just two days after his arrival in Moscow in December 1927. At the end of that evening, he wrote in his diary, "We'd rather be here than any place on earth." The vivid impression made by Tretyakov colored the rest of Barr's Russian sojourn. (From *Transition,* Fall 1928.)

The word LEF is formed from two Russian words meaning left front.

In Russia the left front is no longer revolutionary. The Third Internationale is now inconspicuous, its program for the time being abandoned. The most strenuous effort is concentrated upon political stabilization and the economic organization of that vast and disparate sixth part of the world, the Soviet Union.

The LEF is a group of individuals who would be described by any but themselves as artists, literary, dramatic, pictorial, critical, cinematographic. Their spirit is rational, materialistic, their program aggressively utilitarian. They despise the word "aesthetic," they shun the bohemian implications of the word "artistic." For them, theoretically, romantic individualism is abhorrent. They are communists.

Among the group are the poets Maiakovsky and Asseyev, the scientific journalist Tretyakov, the *kino régisseur* Eisenstein, the critics Brik, Shlovsky, and Stephanova and Rodchenko who work in many mediums. Meyerhold is also affiliated with, if not actually a member of the LEF.[58]

Tretyakov incarnates more completely than any other the ideal of the group. His personal appearance is significant. He is very tall, clad in khaki shirt and whipcord riding breeches with leather puttees. Through his horn-rimmed spectacles his eyes are owl-like. His face and scalp are clean shaven. He lives in an apartment house built in the severely functional style of Gropius and Le Corbusier. His study is filled with books and periodicals on China, modern architecture, and the cinema. In this laboratory atmosphere, behind this mask of what seems ostentatious efficiency, there is profound seriousness and very real sensibility.

Tretyakov was once a futurist poet. For a period after the revolution he was professor of Russian literature in Peking. In addition to his poetry he has written a very remarkable play *Roar, China!* which has been running in Meyerhold's

theatre for two years with the greatest success. *Roar, China!* is being translated for the Piskator theatre in Berlin and will doubtless be produced if Piskator survives his recent bankruptcy. The play, which is, of course, propaganda, shows the peaceful sobriety of the Chinese coolie outraged by truculent Anglo-American big-business-cum-gunboat. Unfortunately, the Meyerhold production of the play considerably weakens its dramatic force by introducing a childish caricature of the English antagonists who are represented as idiots in whom it is impossible to believe. Tretyakov's intention was otherwise.

More important, both as an expression of the LEF and as a work of art, is Tretyakov's new study on the life history of a Chinese boy. Every day for months Tretyakov talked with the boy, questioning, examining, using as a background his own intimate knowledge of Chinese life. The published result will be called characteristically a *bio-interview*—a term scientific and journalistic in flavor. The first section has already appeared in an edition of 180,000 copies. By such means Russia will be brought to a knowledge of China, while to Russian literature will be added a very careful, probably a great, biographical document.[59]

Now that the Chinese bio-interview is finished Tretyakov is turning his attention increasingly to the kino. He would like to be *régisseur,* but until this is possible he finds partial satisfaction in writing very penetrating criticism of Russian films.

Rodchenko first became known about 1915 as one of the leaders of the *Suprematists,* painters who in a few years were to carry the dialectic and practice of cubism to a pure geometry far more ultimate than the art of M. Gleizes or even of Piet Mondriaan. Today Rodchenko believes that his greatest virtue lies in his having been the first to drop the atrophied art of painting, as one would one's appendix. From this anachronism he turned to many media—wood, metal, cardboard, from which he made "constructions"—newspapers and photographs, from which he composed *photomontages* and posters. His constructivism bore practical fruit, the development in Russia of a modern tradition in designing furniture. Rodchenko's interior of a worker's club at the 1925 exhibition in Paris was conspicuously genuine in the midst of *"arts deco."* confectionery.

In the purely visual arts Rodchenko passed rapidly from *photomontage*—composition with fragments of photographs—to photography itself, with remarkable success. He is also an ingenious designer of books and magazines. Finally, the cinema has drawn him. In 1927 he designed sets for Obolensky's film *Albidum.* At present he hopes soon to become a *régisseur.*

We have seen that both Tretyakov and Rodchenko have been drawn into the movies. Indeed, to distort Walter Pater, all the arts in Russia, including music, tend constantly toward the condition of the cinema. The word *kinomontage*—in the form of cinema—was first used, I think, in Russia. Lenin was a seer when he declared that "for us of all the arts the cinema is the most important." It is

appropriate, then, to mention as a third representative of the LEF, Sergei Eisenstein, the foremost of Russian *kino régisseurs.*

Of himself, Eisenstein writes: "I am a civil engineer and mathematician by training. I approach the making of a motion picture in much the same way that I would the equipment of a poultry farm or the installation of a water system. My point of view is thoroughly materialistic. . . ."

This, like Tretyakov's shaven head and whipcord breeches, is sincere but misleading—for Eisenstein's engineering was primarily architectural and once he painted pictures—was even for a time an official staff artist. After a futurist period, he passed through Meyerhold's theatre to become the *régisseur* of the extremely left Proletkult theatre, in which he developed theatrical "bio-mechanics." Only four years ago, at the age of twenty-six, he made his first film *Strike.* Then came his great triumph *Potemkin,* followed this year by the superior but less popular *Ten Days that Shook the World.* These three films concern the history of revolution: his fourth—to be released this fall—is to prove to one hundred million indifferent peasants the advantages of modern agricultural methods.

In the passage quoted Eisenstein reiterates that sentiment for efficiency and modernity which is so characteristic of the LEF. When he discusses the technique of his films he refers constantly to Freud and Marx and the Russian experimental neurologist, Pavlov. He usually neglects to mention his own remarkable library on the theatre covering three centuries in five languages, or his great love for Daumier whose lithographs he collects. Without doubt, Eisenstein is sincere in his anti-artistic, communist, scientific attitude, yet one suspects a conflict between the natural individualist and the limitations of a Marxian ideal. In spite of an exasperating censorship, it is rumored that *The Ten Days* has not been good propaganda, even in Russia. It is too subtle, too metaphorical, too abstract in its sequences, too careless of narrative clarity; it is, in other words, too fine a work of art.

There is no space to write of the other members of the LEF. Maiakovsky, the greatest of the futurist poets, is better known outside of Russia than the other literary members. The time for his staccato verses is passed, but as editor of LEF, the periodical of the group, he is still a power. Meyerhold, whose theatre has been the world's school for ten years, is now accused of growing old and repeating himself. Stephanova, Rodchenko's wife, rivals him as a photographer and is superior as a designer of stage settings. She composes the adventurous typography of *Sovietskoi Kino,* the foremost of Russian cinema periodicals. Brik was, I believe, the first critic to urge artists to desert the artistic for the practical. Shlovsky's destructive criticism of Tolstoi's *War and Peace* is now appearing in LEF.

The LEF is more than a symptom, more than an expression of a fresh culture or of post-revolutionary man; it is a courageous attempt to give to art an important social function in a world where, from one point of view, it has been prostituted for five centuries. The LEF is formed of men who are idealists of

materialism; who have a certain advantage over the Alexandrian cults of the west —the *surréaliste* wizards, the esoteric word-jugglers, and those nostalgics who practise necromancy over the bones variously of Montezuma, Louis Philippe, or St. Thomas Aquinas.

The LEF is strong in the illusion that men can live by bread alone.

Sergei
Michailovitch
Eisenstein

Eisenstein, "extremely affable, humorous in talk, almost a clown in appearance" (as Barr described him in his diary), became a close friend of Barr's and Jere Abbott's during the Russian trip. Barr viewed footage from *October* (*The Ten Days that Shook the World*) and *The General Line* (*The General Peasant Policy*) before the films were completed, thereby getting "an excellent idea of Eisenstein's raw material. . . ." (From *The Arts,* December 1928.)

Movie critics by and large are not given to superlatives—in fact they tend to sigh with ennui and damn with gusto more habitually than their fellow-sufferers who survey professionally the other arts. Yet last year on one occasion they behaved with the most unwonted lack of restraint. Accustomed to be grateful for any pittance of displayed intelligence, they were suddenly confounded by genius. Eisenstein's *Potemkin* was more than an important artistic experience. In the history of the motion-picture it was obviously epoch-making. And now, after long delay, another Eisenstein film, the eagerly awaited *Ten Days that Shook the World,* has been released in Russia and has recently had its American première at the Little Carnegie Playhouse in New York.

Potemkin or, as the Russians pronounce it, *P'tjumkin,* was great for reasons more complex and considerably more dignified than those which cause the success and failure of American and other European films. For us *Potemkin* was a very moving work of art. For Eisenstein and for his employers and his public it was much more. The Russian Government which supported the now dissolved *Goskino* company required films which should serve to strengthen the revolutionary spirit. The events of the troubled year of 1905, the massacres in Odessa and the successful mutiny aboard the cruiser *Potemkin* afforded a subject commemorative of revolutionary heroism and therefore excellent propaganda. The potential power of such scenes in the hands of a sympathetic régisseur can be estimated when one remembers the usual commercial manipulation in America of super-slapstick and the too eternal triangle.

Furthermore, the Russian public, at least of the five great Russian cities, is more intelligently sophisticated in theatrical matters than the public of any other nation. New York barely supports three or four struggling theatres where experi-

ment and artistic probity are placed above the box office. Chicago is less success-ful. But in Moscow, which is smaller than Chicago, there are over twenty repertory theatres, each of which employs methods of direction and mounting which are so advanced that they would be commercially impossible in America. Yet these are supported largely by the proletariat who also of course support the *kino* and judge it by a comparably high standard.

The stimulating requirements of propaganda, the intrinsic dignity of the subject-matter, the extraordinary critical standards of a public trained in a progressive theatrical tradition—these external factors explain to some extent *Potemkin*—but there is also Eisenstein.

I first met Sergei Eisenstein at the house of the writer Tretyakov.[60] Since Maiakovsky's noisy futurism is no longer an important influence, Tretyakov has become the literary leader of the group called the L E F, which includes Meyerhold, the most important figure in the Russian theatre, Rodchenko, the photographer, Stephanova, stage designer, and Eisenstein himself. The L E F is aggressively utilitarian, materialistic, constructive. They despise the word "aesthetic"; they ignore (theoretically) artistic intuition. Tretyakov, who was once a poet, now refers to himself proudly as a journalist. His nearly finished life-history of a Chinese boy he calls a *bio-interview*. Meyerhold enjoys his function of propagandist extraordinary. Stephanova and Rodchenko were both painters, but they have deserted that "useless" art to work on constructivist stage-settings, *photomontage*, the designing of posters, books, and furniture.

In a similar spirit Eisenstein refers to himself in a statement published last year in the *Nation:* "I am a civil engineer and mathematician by training. I approach the making of a motion picture in much the same way that I would the equipment of a poultry farm or the installation of a water system." This ostentatious utilitarianism loses some force when one learns in conversation that his engineering was architectural, that he was also an amateur painter and during the war served as a staff artist.

Eisenstein has also impressed interviewers by his references to Marx, Pav-lov, and Freud. The social and psychological principles which we connect with these names undoubtedly have much to do with his films, but they have more, possibly, to do with the criticism of them. It is true that he concerns himself with class warfare and that he has eliminated the individual as hero by the substitution of the mass in an orthodox Marxian manner. Yet *Potemkin* was criticised by no less an authority than Erwin Piskator, the conspicuous Berlin follower of Meyerhold, because Eisenstein failed to show clearly the connection between the revolt aboard the cruiser and the great social significance of the 1905 revolution in St. Petersburg, thus weakening his production as propa-ganda. From a Marxian point of view Piskator's criticism is justified, but artisti-cally an elaborate presentation of the social and political issues involved would have greatly diluted the concentration and force of the dramatic issue.

To the influence of Freud may be attributed certain scenes in *The Ten Days,* such as the subtle caricature of Kerensky,[61] the ungallant, pungent satire on the

Battalion of Death, and the mangling of a Bolshevist demonstrator after the July riots. Similarly the terrific physical impact of certain moments in *Potemkin* and *The Ten Days* might well serve to illustrate Pavlov's experiments in the conditioned reflex. No one who has seen *Potemkin* can forget the terrible scene in which the Cossacks march mechanically down the interminable flight of steps firing into the bewildered masses. Eisenstein writes: "By consciously combining the elements of legs, steps, people, blood, we produce an impression—of what kind? The spectator does not imagine himself at the Odessa Wharf in 1905. But as the soldiers' boots press forward he physically recoils. As the baby carriage of the crazed mother goes over the side of the mole he holds on to his cinema chair. He does not want to fall into the water." This is an interesting description of technical method and of behavioristic stimulus and reaction. But there is much more which Eisenstein omits—the superb pictorial composition of the shots, the sense of kinetic and dramatic form in the sequences, the intense characterization of individuals in an agony of fear, these elements contribute to an experience of pity, rage, and beauty which far transcends the initial physical excitement.

Eisenstein's remarks on the theatre further prove the seductions of economic theory. He writes: "The theatre, I believe, is a dying institution. It is the handiwork of the petty artisan. The movie reflects heavy, highly-organized industry." Here again is a pseudo-economic explanation of what on analysis is not a convincing assertion in the first place. For the theatre is almost fabulously vigorous in Russia. Moreover, while the movie, especially outside Russia, may reflect heavy, highly-organized—and usually philistine—industry, Eisenstein's own films reflect and express that very sensitive and gifted individual—Eisenstein.

Marx, Freud, Pavlov—they are parts of Eisenstein but one must also speak of his rare seventeenth-century books on the theatre, of his passion for the lithographs of Daumier, and of his most conspicuous characteristic, a profound sense of humor.

Eisenstein's career has been, of necessity, brief, for he is only thirty years old. His training in a technical school in Riga, his early flair for painting, have been mentioned. Shortly after the revolution he joined Meyerhold, and a little later, while still under twenty-five, became a régisseur and then director of the important Proletcult Theatre, at that time the most advanced in Russia. Here he carried to an extreme the then new experiments in gymnastics and caricature, employing elaborate constructivist settings with pulleys, wires, ladders, inclined planes, trapdoors, multiple levels and the other paraphernalia of theatrical "bio-mechanics." In 1924 he left the Proletcult and entered the *kino. Strike,* his first film, gave him confidence. *Potemkin,* his second film, won him at the age of twenty-eight world-wide recognition. Early in March of this year his third film, *The Ten Days that Shook the World,* or as it is called in Russia, *October,* was released; and this summer he was to complete his fourth, *The General Peasant Policy.* [62]

The Ten Days that Shook the World is based roughly on John Reed's book of the same name. In filming it the story of the July demonstration and the October revolution in Leningrad were in large part re-enacted. The government lent armored cars, guns, sections of the Red Army, and the cruiser *Aurora,* the very ship that had threatened to bombard the Winter Palace in 1917. Five thousand Leningrad workers gave their services and toiled, night after night, to film the storming of the Winter Palace. When a mob was needed, Eisenstein said, the militia had to be summoned to keep away the many thousands of volunteers. *The Ten Days* is thus even more emphatically than *Potemkin* a film made by the masses, with occasional individuals appearing for a moment and then submerged. Kerensky appears as the leading antagonist—the vain, rather weak politician with latent Napoleonic ambitions. And at the end of course there is Lenin in triumph riding on an armored car. In Russia Lenin is now a saint —for many, perhaps, a god.

The Ten Days was to have greeted the delegates to the Tenth Anniversary of the October Revolution but an absolute censorship of all the parts played by the recently exiled members of the opposition required a laborious re-cutting. As a result it was not completed till five months later. Early in March it was released in over two hundred theatres throughout Russia. Reports from Russia indicate that it has not been a great success there. As a monument to the collective effort of communist revolution it is too clearly, one surmises, an expression of individual genius. Such a film is perhaps beyond the appreciation of any general public, for more even than in *Potemkin* Eisenstein has sacrificed propaganda and perhaps even narrative clarity for pure *kino* of the subtlest quality.

In this respect there is an interesting contrast between Eisenstein and Pudovkin, creator of *The End of St. Petersburg,* which has already been shown in this country and has met with a remarkable and well-deserved triumph. Pudovkin, who began his career under the influence of Eisenstein, has now become his chief rival. Similar in technique, his ideals are, however, far less austere than Eisenstein's. Instead of playing with masses of men in an objective, documentary manner, Pudovkin uses the more conventional device of emphasizing the individual personality. His magnificent version of Gorki's *Mat* showed the destruction of an heroic mother and her son in the midst of revolution. *The End of St. Petersburg* recounts the adventures of a young peasant caught in the terrible events of 1917. By his use of the individual as hero Pudovkin obviously possesses a considerable advantage over Eisenstein, who makes no compromise with popular taste.

In contrast to *The Ten Days,* with its thunder of destruction, the *Generalnaya Linya (The General Peasant Policy)* shows a constructive struggle. The Russian government is confronted with the herculean task of educating a hundred million reluctant peasants in modern agricultural methods while at the same time acquainting the unsympathetic city workers with the peasants' problems. This film, a thoroughly modern georgic, is to be an extremely important instrument

of instruction. Village coöperatives, cattle-breeding, hog-farming, dairying, agri-
culture—these are prosaic and earthy subjects but they are handled with all the
technical skill of *Potemkin* and moreover with a most extraordinary sense of
humor, both pictorially and dramatically. In this film no man is hero, nor even
a mass. It is the machine that conquers. The tractor triumphs over the horse;
irrigation supplants prayers for rain. Within a dazzling white ultra-modern dairy
cream separators are enthroned. Thus is unfolded a modern epic—man's techni-
cal victory over the natural world—in that country where at present the strife
is most arduous.

Within the last few years we have come to appreciate the educational film,
the travelogue, the chronicle. *Nanook, Moana, Chang, Samba,* the African films
of Colin Ross and André Gide have been among the finest movies of this type.
Eisenstein's *General Policy* will take its place perhaps as the greatest of these.

What of Eisenstein's future? It is said that Douglas Fairbanks when in
Moscow asked him to come to Hollywood. The Film Arts Guild of New York
has also invited him, but obtaining official permission to leave Russia for such
an extended visit is a very difficult matter. In America the Soviet censorship
which severely injured *The Ten Days* would not hamper him. But he would find
timidity, vulgarity, prudery and other varieties of constraint, as well as severe
temptation to cheapen his art. The results of such a visit would help us to judge
not merely Eisenstein, but America as well.

Otto Dix

Barr wrote to James Thrall Soby in November 1948: "The Dix piece was done in June, 1929, though not submitted to *The Arts* for some time afterward. Amusingly enough, three days after I had finished it I was asked to join the Museum staff and frankly did not want to be identified immediately with a stand which would have seemed to the Museum supporters a very reactionary one. Actually, of course, it was reactionary, and shocked [Albert] Gallatin and Georgie Morris and [James Johnson] Sweeney."[63] (From *The Arts,* January 1931.)

I am a man for whom the visible world exists. GAUTIER[64]

In the church of the Eremitani I have seen some paintings by Mantegna, one of the older painters, and I am struck with amazement. *How keenly and with what certainty an actual present is reproduced in these pictures!*—a real Present—not an effective deceitful apparition appealing solely to the imagination—but a pure, straightforward, clear, consistent, conscientious, delicate, well defined Present, with a leaven of strenuous, enthusiastic and laborious effort in it.

GOETHE in *Italian Journey*

In art as in other human activities violence begets violence, extremes extremes. By 1912 the ideal of *pure spontaneity* in painting had passed through varieties of expressionism to the ultimately amorphous *Improvisations* of Kandinsky. By 1920 the ideal of *pure design* in painting had passed through cubism to Piet Mondriaan's rectangles drawn with a ruler and painted red, yellow, and blue, or to Alexander Rodchenko's circles drawn with a compass, black on black. Romantic "spontaneity" was realized variously in dadaism, *Merzismus,* surréalisme, while classical emphasis on design was carried to the extremes of *Kompressionismus,* neoplasticism, suprematism, *purisme.*

Certain words are still fashionable enough to remind us of these two extremities—distortion, deformation, disintegration, abstraction—to describe the processes of artists who seemed bored with, ashamed of, or even unaware of "nature." Other phrases—organization, crystallization, composition, rhythmic order, significant form—convinced the poor public that in a picture it was not the objects (or subject) which mattered but the "relationships." The "tyranny of subject matter" had been overcome and "actual resemblance to anything in nature" was "no longer essential." In fact, it was rather contemptible. For what had the natural world of things to do with the anarchy of dreams or the discipline of geometries? Since the days of Courbet and Leibl the resolute intensive study of the object itself had failed to interest artists. But the pendulum swings.

The phrase *die neue Sachlichkeit* [65] was invented several years ago by Dr.

G. F. Hartlaub, director of the Mannheim *Kunsthalle,* as a category for a number of European painters who seemed to be turning their backs upon the devious subjective quicksands of expressionism and the arid plateaux of abstract design in order to walk again upon the firm and lucid paths of the objective world. In Paris the recent work of Coubine, Herbin, Kisling, Pierre Roy, Severini, de Chirico (in his portraits), Ivan Baby, Picasso, in the phase begun in 1919 with the portrait of his wife; in Italy the *novecentisti,* Oppi, Casorati, Carrà (before his "Renoir" period); in England Edward Wadsworth, Wyndham Lewis, Charles Ginner; in America Edward Hopper, Charles Burchfield, Charles Sheeler, James Chapin, Stefan Hirsch,—these painters would all fall more or less into the "new objectivism."

In Germany where the *neue Sachlichkeit* first became self-conscious, and where it is strongest relatively and intrinsically, we may analyze it more carefully. Munich is perhaps the quantitative center of the movement. Here work Davringhausen, Kanoldt, Mense, Schulz-Matan and Schrimpf. Georg Scholz of Grötzingen, Karl Rössing of Essen, Carl Grossberg of Würzburg, Gottfried Diehl of Frankfurt, George Grosz of Berlin and Otto Dix of Dresden prove its wide distribution throughout Germany. Without illustrations most of these names will perhaps mean little to American readers but several general characteristics are worth noting. A sense of style and an awareness of design, inherited from cubism, prevent most of these men from falling into the stupid minute descriptive painting of a Meissonier, a Gérôme or a Gerard Dou. Most of them use frank high keyed color, severe continuous contours and highly polished surfaces.

Their sources, in so far as they are discernible, are two: the early 19th century with its similar mixture of polished realism, pseudo-classicism, and primitivism, and the 15th century both in Italy and the North. Because of superficial technical similarities their work seems very much alike, but in sentiment and intention it varies from the elegant sleekness of Alexander Kanoldt, to Georg Scholz's hard exact "verism," to Georg Schrimpf's Bavarian placidity. Many of these painters are talented craftsmen and Schrimpf and Mense have considerable sensibility but none approach the stature of George Grosz, who belongs to the movement by virtue of his portraits, and Otto Dix whose power and originality lift him far above the rather sterile and banal virtues of the group as a whole.

Otto Dix (laconic name) was born in 1891 at Unterhaus near the small Saxon manufacturing town of Gera. His father was an iron worker. The double portrait of his parents, now in the Cologne Museum,[66] tells us much about them as well as about their son. In speaking of cubists we can afford to dispense with their parents. They do not seem to matter. But these two gnarled unlovely human beings, the great hands of the mother, the immodest collar-button and beer-stained mustache of the father, the Biedermeier sofa, the stenciled wall behind them, all these material things help us in a very essential way to realize Otto Dix who has painted them.

At the age of fourteen Dix began his career as a painter, a *Dekorations-maler,*

a thoroughly sub-artistic occupation in pre-war Germany, somewhat less tolerable than ordinary house painting. After five years of this he was able in 1910 to enter the *Kunstgewerbeschule* in Dresden where, studying especially under Richard Müller, he mastered academic draughtsmanship and acquired a love of patient disciplined craftsmanship. A self-portrait of 1913 shows him capable of a vigorous realism very close to that of fifteenth century Italian fresco painters, with firmly if somewhat coarsely modelled sculptural surfaces bound by a wiry contour. His face scowls with youthful overseriousness, self-conscious determination; defiant, a little sullen perhaps but strong as iron. How completely isolated this curious work was from contemporary currents. There is nothing in it of the fashionable brush work of Liebermann or Sargent, or of impressionism, or of the strident angles and primitive dissonance of the *Brücke* group, or of cubism which was just entering its most abstract phase, or of Kokoschka, at that time a power in Dresden, or of the Blue Rider group led by Kandinsky and Marc. Not that Dix was to remain untouched by these movements, for at different times he has painted as an impressionist, a cubist, an abstract purist, but always he has returned to the austere realism of this portrait of 1913.

The war interrupted his studies. For four years he fought in France.

All Quiet on the Western Front, written by Dix's compatriot [Erich Maria Remarque], is frequently named the greatest novel on the war. The memories and sketches which Otto Dix preserved from these years were ultimately made permanent in a folio of etchings and in a single great painting, works worthy to rank with Remarque's novel, for which they might serve as illustrations. They deserve special examination.

Soon after the armistice Dix returned to Dresden and entered the masters' class of the Dresden Academy working with Feldbauer and Gussmann, and receiving special encouragement and sympathy from Professor Sterl. But the spiritual rancour left by the war drove him for a brief period into dadaism. In Dix's *dada* there was however very little of the clever futile trivialities of Schwitters, Picabia, or Max Ernst. He came, rather, under the influence of George Grosz, that most savage of all contemporary artists. In the *Barrikade* of 1920 the obscene chatter of dada is present but its cynicism is elevated to despair, naïvely expressed perhaps but of terrible intensity. The barricade is piled high with wheels, cogs, ratchets, crucifixes, syringe bulbs, Titian's *Tribute Money,* mangled bodies, a cast of the Venus de Milo, placards with pious mottoes —facts, all painted with meticulous fidelity. Only the men who crouch behind this heap of mechanico-domestic debris are monstrous, orgiastic. They are caricatures by a man capable of a great hatred but scarcely of the deliberate and perverse madness of genuine dada.

In the following year Dix outgrew dadaism but not the influence of Grosz. Etchings and drawings of acrobats, seamen, serious-eyed circus folk, prostitutes, baldheaded fat-necked bourgeois, war cripples, pass in parade drawn with racy truculence or washed in with those peculiarly unpleasant *kitsch* colors which Grosz discovered in cheap chromo-lithographs. . . .

To this period also belongs the most widely known of Dix's paintings, perhaps the most famous picture painted in post-war Europe. It is called, simply, *War*. It is a masterpiece of unspeakable horror. From fetid pools in shell holes exude the groping hands and eaten faces of men long dead. Vines of barb wire, the serried teeth of cartridge belts crawl over the sick earth. Half-fleshed skulls are mocked by ogling gas-masks. The very pigment seems to fester horridly, iridescently. Painted with the uncanny verisimilitude of wax works this staggering vision of decay in death lives even more through the spiny wriggling character of its design and the terrific loathing which Dix has concentrated in it. Looking back over the history of painting we cannot find its equal except in that other dreadful masterpiece, the Altarpiece of Isenheim, by the painter who went till recently by the name of Matthias Grünewald.[67] Grünewald's grey, lacerated Christ, the bloated ulcerated monsters that afflict St. Anthony may well have been in part Dix's inspiration.

Huysmans,[68] the discoverer of Grünewald, or Poe, or Baudelaire, might, perhaps, have done justice in words to Dix's war painting and etchings though there is little about his work which suggests the love of the horrible or the decomposed for its own sake. Dix is no decadent taster of gamey delights nor a mere amateur of the macabre, but an artist who has gone through four years of "quiet" on the Western Front and expressed himself subsequently with a certain lack of restraint.

War, the painting, was purchased by that shrine of German mediaeval idealism, the Wallraff-Richartz Museum in Cologne, but the municipal authorities found it unpleasantly strong, and required its removal. Recently it passed into the modern rooms of the Dresden Gallery.[69]

In 1924 Dix purged himself finally of war poison in a folio of fifty etchings bearing the title *Der Krieg* and accompanied by a tribute from Henri Barbusse, the French soldier and pacifist. These are documents in the spirit of the Dresden painting, cumulatively as powerful, and affording, naturally, a far greater variety. They bear prosaic names, they present facts, but seem an anthology of nightmares. *Star-shells lighting the farm at Monacu* shows us shattered walls, an overturned caisson and writhing tree stumps drawn with that sensitive calligraphic delicacy which we find in the whiteline drawings of Altdorfer and Baldung Grien. A *Dead Horse* gestures with stiffened protesting legs. *Grenade crater (Summer, 1916, Champagne), Shellholes before Dontrien lit by rockets, Near Langemarck, February, 1918,* are landscapes as sterile and deathly as lava fields on the moon, or the etchings of Hercules Segers. *Storm troops advancing in gas masks* seem more inhuman than the two cadavers in another print who engage in grotesque conversation while grass sprouts from their skulls.

Goya's *Desastres de la Guerra* of course comes to mind, but Goya is at once more dramatic and more journalistic. He is outside, looking on, an observer and a commentator. But Dix is a survivor, who has participated. Goya thinks in terms of contrived action, of violent forces; Dix depends on eloquent, spectral silence, on documentary precision. Goya, the classicist, the Latin, emphasizes the human

dramatis personae, but for Dix war is a process of organic disintegration, a slow fantastic metamorphosis of life into death in which the human being emerges, as it were, accidentally.

How inadequately equipped artists were to give us a record of the war. *Nature mortisme,* form for form's sake, pseudo-primitive decoration, and then August, 1914. Dix's compatriot, Franz Marc, while in the trenches fills his notebook with a plaintive fairyland of animals. Across the lines are de Segonzac's superficial etchings, Gromaire's concrete machine gunners, Duchamp-Villon's abstractions. The English, naturally more romantic, more patent to the impact of physical reality tell us more. Stanley Spencer grasps the strangeness and humor of sudden novelties, Paul Nash realizes to some extent, especially in his *Menin Road,* the methodical barrenness of the battlefield. But neither passes far beyond picturesque decoration. The unpretentious sketches of our own Captain Thomason are more to the point.

The attitude of the orthodox formalist as soldier is strikingly illustrated by a letter written from the trenches in 1915 by the Franco-Polish sculptor Henri Gaudier-Brzeska. He writes, in part:

"I have been fighting for two months and I can now gauge the intensity of Life. . . . With all the destruction that works around us nothing is changed, even superficially. The bursting shells, the volleys, wire entanglements, projectors, motors, the chaos of battle do not alter in the least the outlines of the hill we are besieging. . . . My views on sculpture are absolutely the same. I shall derive my emotions from the *arrangement* of *surfaces.* I shall present my emotions by the arrangement of my surfaces, the planes and lines by which they are defined. The hill where the Germans are solidly entrenched gives me a nasty feeling *solely* because its gentle slopes are broken by earth works which throw long shadows at sunset."

Could there be a more heroic defence of the ivory tower of "significant form" —magnificent but scarcely war.

Dix is now thirty-eight. Of the works of the last five years his portraits are unquestionably the most important. In them Dix's enthusiasm for the idiosyncrasies of the object, the human face, the hands, the clothing finds most valuable expression. The self-portrait of 1926 illustrates his mature style in its disciplined austerity. The form is modeled by the Florentine method of sculptural light and shade. There is no interest in accidents of light or in brushwork or in "quality" of pigment surface. Detail is emphasized but there is no suggestion of virtuosity in mere illusionistic imitation. Effort is concentrated upon objective fact *characterized* and *intensified.*

For comparison we are carried back a hundred years to so-called neo-classic portraits of the early 19th century, the less formal portraits of David for instance, or particularly to certain German works such as the astonishing self-portrait by Viktor Emil Janssen in the Hamburg *Kunsthalle.* There is also an

obvious relation between Dix and German portraiture of the great period after 1500, not to Dürer so much as to the coarser, more vigorous and direct vision of Cranach and Hans Baldung Grien. Dix's signature, the serpent and bow with the date, is perhaps conscious homage to Cranach who signed his pictures by a tiny winged dragon.

The portrait of Dr. Mayer-Hermann, also of 1926, is a masterpiece.[70] The rotund curves of his hands and body and head are wittily repeated in the shining sphere of the X-ray machine which rises above him like a great metallic busby. The effect is equally reminiscent of the *machinismes* of the dadaists and the beautifully painted paraphernalia in certain pictures by Holbein, especially the *Astronomer* in the Louvre, and the *Two Ambassadors* in London. Such a portrait might have won the approval of Bronzino or even of Ingres.

These two portraits show Dix at his most objective. In the hands of the double portrait of his parents we find him indulging in humorless but potent exaggeration. He departs much further from fact in the extraordinary portrait of the poet Franz von Lücken, who rises up and burns before one like one of Greco's flaming apostles. The sense for the bizarre which informs so many of Dix's war etchings reappears in such fantasies as *The Widow* of the Mannheim Gallery.[71] The curious psychological flavor and the fastidious spiny hand are worthy of Carlo Crivelli. Dix, the protestant, the consciously Marxian naturalist, is seen in the unforgettable *Arbeiter* now in the Museum at Stuttgart.[72] Mercilessly (though a little sentimentally) he presents this myopic worm with sad mustache and too large bowler hat.

Nelly, Dix's small daughter, has proven one of her father's most stimulating subjects. In the painting now, I believe, in the *Kunstgewerbe Museum* of Cologne, she is seen standing in a "prospect of flowers."[73] The pudgy hands, the inflated cheeks and staring eyes, the top heavy head, the puppet-like intentness, those strange inhuman qualities of babies are remarkably expressed. Around her and above her head tower plants drawn with the lovely precision of Dürer's botanical studies but with more vitality and sense of existence. The *Son of the Artist,* another portrait of a baby, has recently been acquired by the National Gallery in Berlin.[74]

Occasionally Dix condescends to still-life. Yet even in this most hackneyed problem of modern painting he introduces remarkable freshness. *The Stilleben mit Oxenkopf* is richer in pigment surface than is usual in Dix's work, it is bold and successful as a formal arrangement, but it is also markedly interesting as an assemblage, a composition, of objects striking in themselves and made more so by juxtaposition and an intense concentration upon essential character. Lilies in a jug, a grisly calf's head, a shredded sack, heads of cauliflower and cabbage: one feels in this picture not merely texture and "form" but a thoroughly romantic interest in *things,* things felt as well as seen. Still-life painting in the 15th century pictures has something of this quality. Zurbaran's still-life has it and Velasquez's before he becomes interested in optical problems. In Rembrandt's and Van Gogh's still-life this feeling is miraculously vivid. Chinese

painters quite consciously devoted themselves to research into the "vitality of things." But in most contemporary painting this feeling is comparatively undeveloped.

Those who are devoted to contemporary French painting or its American imitation will feel their prejudice against German painting strengthened by the work of Otto Dix. It seems so coarse and ruthless, so filled with "extra pictorial" elements, so "realistic." Yet these are the very qualities which have shocked and baffled Germans who are so far ahead of Americans in their acceptance of abstract and expressionistic painting that they regard Dix with suspicion as a man who has denied and betrayed their hard-won achievements in the appreciation, say, of Picasso or Feininger. Older painters also tend to regard Dix as something of an apostate to the generally anti-naturalistic tradition of recent painting. But it is most noteworthy that German museum officials have learned from past experience the value of tolerance and courage in the face of new ideas. Directors who grew up in the faith of Monet and Liebermann or of Munch and Van Gogh, curators who are contemporaries of Léger and Matisse, Schmidt-Rottluff and Paul Klee, have nevertheless purchased Dix's work to such an extent that almost all the great galleries exhibit his paintings, and most of the smaller museums own his prints and water-colors.[75]

Dix's faults are rather those of the romantic. His qualities are excessive. Like those two great German painters who seem his spiritual and artistic ancestors, Matthias Grünewald and Hans Baldung Grien, he is guilty of overemphasis. Their stridency and assertiveness are his, their occasional vulgarities, their dissonant color, their realism carried at times to the verge of the bizarre. But these faults are so positive, so robust that they become virtues which are staunch against any but the most frigid classicist. The future may very possibly reveal Otto Dix as one of the great artists of the middle 20th century but even at present we may estimate him as perhaps the foremost among those who have rediscovered the objective world in all its wealth of individual character and particular detail as worthy of the artist's passion.

Paul Klee:
Introduction

In 1941 the Department of Circulating Exhibitions prepared a memorial traveling exhibition and catalogue of the work of Klee, who had died in June of 1940. The introduction was a revised version of Barr's catalogue essay for a 1930 Klee show at the Museum.

His father a Bavarian, his mother Southern French, Paul Klee was born, with geographical appropriateness, in Switzerland near the town of Berne, in the year 1879. His childhood was passed in an atmosphere of music for his father was a professional musician and conductor of the orchestra in which his son at an early age played the violin. His mother, too, came of a musical family so that for a time he expected to become a musician. However, after much debate, he was sent in 1898 to Munich to study drawing, at first at the Knitt school, and then with Franz Stuck at the Academy. Stuck was an academic painter of bizarre and macabre subjects, at times coarsely banal, but with considerable imaginative power. In 1901 Klee made the orthodox journey to Italy, but quite unorthodoxly he preferred early Christian art to that of the quattrocento, Baroque to High Renaissance painting, and the Naples aquarium to the classical antiquities of the Naples Museum.

For the next few years Klee lived with his parents, producing very slowly a remarkable series of etchings, among them *Perseus* [*The Triumph of Brain over Body,* 1904] which he exhibited in Switzerland and Munich. Though he visited Paris he did not at first become aware of the post-Impressionist and *Fauve* revolutions. He found himself more concerned with drawing and caricature than with painting. Goya's fantastic *Caprichos* interested him as did the other-worldly engravings of Blake and Fuseli. Of more recent draughtsmen he found Kubin's weird humor, the bizarre pathos of James Ensor, and Redon's visionary lithographs most to his taste. He read the tales of Hoffmann and of Poe, the prose and poetry of Baudelaire. His admirations both in graphic art and literature were clearly fantastic.

He moved to Munich in 1906. In the next four years he came to know through exhibitions van Gogh, then Cézanne, and finally Matisse, who opened the eyes of the young artist to the expressive (as opposed to the descriptive) possibilities of color and to the charm of the apparently artless and naive.

In Munich he became acquainted with three other young painters, Kandinsky, a Russian who had also studied under Stuck, Franz Marc, and August

Macke, the last two, both of them men of great promise, lost to German art during the First World War. The four formed the nucleus of the famous group *Der Blaue Reiter* which raised the banner of revolt in staid academic Munich, won a considerable success in Berlin and made the word *Expressionism* known throughout the world. Marc painted compositions of animals, using brilliant, pure color, a line of great style and a Cubistic technique. Kandinsky's abstract *Improvisations* were among the first to disregard entirely all vestiges of representation. But Klee, while he experimented with abstract design, continued his researches in the realm of fantasy.

In 1912 Klee visited Paris, where he stayed for over a year. Guillaume Apollinaire, Picasso, Delaunay, became his friends. A journey to Tunis (Kairuan) in 1914 seems to have been equally important in the discovery of himself.

Shortly after the War, the town of Weimar asked the architect Walter Gropius to reorganize the art school. The Bauhaus, as the new school was called, was primarily a technical school devoted to the study of materials and design in architecture, furniture, typography, and other modern industrial arts. As a "spiritual counterpoint" to these technological and utilitarian activities Gropius invited three painters to live at the Bauhaus and give instruction in drawing and painting. They were the Russian Kandinsky, the American Feininger, and the Swiss Klee, three of the most gifted as well as most adventurous artists at work in Germany. Klee remained as professor at the Bauhaus from 1920 to 1928. In 1926 the Bauhaus moved to Dessau and in the same year Feininger, Javlensky, Kandinsky, and Klee formed the Blue Four which exhibited throughout Germany and America. Klee also sent paintings to the *Société Anonyme* exhibitions in New York and Brooklyn.[76]

Klee was "claimed" by the Surrealist group in Paris but refused to become in any formal sense a member of the movement. His work is, however, perhaps the finest realization of the Surrealist ideal of an art which appears to be purely of the imagination, untrammelled by reason or the outer world of empirical experience.

About 1929 Klee left the Bauhaus and accepted a professorship in the Düsseldorf Academy where he taught for three years. In the spring of 1933 came the Nazi revolution which forced all art in Germany to conform to the timid and vulgar prejudices of Adolf Hitler. Klee left Germany in disgust and returned to Berne. In Switzerland he died seven years later, honored throughout the world wherever the human spirit still retained its freedom.

Klee, when one talked with him, seemed the opposite of eccentric, in spite of his amazing art. When I visited him at Dessau in 1927 he was living in a house designed by Gropius as a *machine à habiter* near the factory-like Bauhaus building. He was a smallish man with penetrating eyes, simple in speech and gently humorous. While one looked over his drawings in his studio one could hear his wife playing a Mozart sonata in the room below. Only in one corner were there significant curiosities, a table littered with shells, a skate's egg, bits of dried moss, a pine cone, a piece of coral, fragments of textiles, a couple of

drawings by the children of his neighbor, Feininger. These served to break the logical severity of the Gropius interior and Bauhaus furniture—and perhaps also served as catalytics to Klee's creative activity.

Much has been written in German and French about Klee's art. Indeed few living painters have been the object of so much speculation. For a work by Klee is scarcely subject to methods of criticism which follow ordinary formulae. His pictures cannot be judged as representations of the ordinary visual world. Usually, too, they cannot be judged merely as formal compositions, though some of them are entirely acceptable to the esthetic purist.

Their appeal is primarily to the sentiment, to the subjective imagination. They have been compared, for this reason, to the drawings of young children at an age when they draw spontaneously from intuitive impulses rather than from observation. They have been compared to the fantastic and often truly marvelous drawings of the insane who live in a world of the mind far removed from circumstantial reality. Klee's work sometimes suggests the painting and ornament of primitive peoples such as: palaeolithic bone carvings, Eskimo drawings and Bushman paintings, the pictographs of the American Indian. Drawings made subconsciously or absentmindedly or while under hypnosis occasionally suggest Klee's devices. In fact, Klee has himself at times made "automatic" drawings with some success. The child, the primitive man, the lunatic, the subconscious mind, all these artistic sources (so recently appreciated by civilized taste) offer valuable analogies to Klee's method.

But there are in Klee's work qualities other than the naive, the artless, and the spontaneous. Frequently the caricaturist which he might have been emerges in drawings which smile slyly at human pretentiousness. Often he seduces the interest by the sheer intricacy and ingenuity of his inventions. At times he charms by his gaiety or makes the flesh creep by creating a spectre fresh from a nightmare.

Of course he has been accused of being a "literary" painter. For the person who still insists upon regarding painting as decorative, or surface texture, or pure, formal composition the accusation is just. But Klee defies the purist and insists as do Chirico and Picasso upon the right of the painter to excite the imagination and to consider dreams as well as still life material for their art.

Klee is a master of line which seems negligent but is unusually expressive. *Couple in the Twilight* [1924] and *The Holy One* [1921] are suggested by the most sensitive calligraphy. *The Shepherd* [1929] presents no earthly beings but creatures of the mind drawn with the finality of hieroglyphics. Equally interesting to the Klee enthusiast are such humorous graphic contrivances as the *Apparatus for Magnetic Treatment of Plants* [1921], *Metamorphosis* [1924], and *The Twittering Machine* [1922].

Klee's abstract designs have little to do with Cubism for they, too, are improvisations rather than abstractions of things seen. *Evening Architecture* [1937] is a subtle arrangement of squares and triangles of color; *Classical Coast* [1931], a mosaic-like composition of horizontal bands. *Three Polyphonic Subjects*

[1931] and *Abstract Trio* [1923] are obviously suggested by music; they seem related to the linear abstractions of Miro, Masson and Ernst.

Klee made a study of masks in theatrical and ethnographic museums, and experimented with their power to startle and bind the imagination. *Actor's Mask* [1925] reminds one of Melanesian ceremonial masks in its startling, hypnotic effect. Comparable as disquieting apparitions are the large *Mask of Fear* [1932], the *Idol for House Cats* [1924], and the *Child Consecrated to Suffering* [1935].

The arrow is a motive which frequently occurs in Klee's compositions. It is used to indicate the movement and direction of forces as in the diagrams from Klee's course at the Bauhaus. In *Dead Cataract* [1930] the arrows point in the direction of the snake's movement. In *Mixed Weather* [1929] the arrow sweeps along the earth like a tempest beneath the dripping moon. In *Wounded Mother Animal* [1923] it is more literally a missile.

Klee has used a variety of media, all of them handled with remarkable skill and inventiveness. He combines watercolor and ink, oil and gouache, using diverse surfaces including paper, canvas, linen, burlap, silk, tin and compo-board. Like the Cubists and Surrealists he has made many experiments with textures.

Nothing is more astonishing to the student of Klee than his extraordinary variety. Not even Picasso approaches him in sheer inventiveness. In quality of imagination also he can hold his own with Picasso; but Picasso of course is incomparably more powerful. Picasso's pictures often roar or stamp or pound; Klee's whisper a soliloquy—lyric, intimate, incalculably sensitive.

Nationalism in German Films

The following two selections were written at Ascona, Switzerland, in May 1933 while Barr was on leave from the Museum. He had just spent four months in Stuttgart and had seen the Nazis come to power. Barr originally intended the report, which he called "Hitler and the Nine Muses," to be published as four articles for a popular magazine, but he could find a willing publisher—his friend Lincoln Kirstein, editor of a "little magazine"—for only one at the time. *(See p. 102.)* (From *The Hound & Horn*, January 1934.)

On April 3 Dr. Göbbels, Reichminister for Propaganda and Popular Enlightenment, spoke in Berlin at the Hotel Kaiserhof before a meeting of German film producers, distributors, theatre owners and executives. He had been investigating the film industry during the previous two weeks and everywhere had found a feeling of uncertainty.

"Let no one think for a moment that the national revolution in government and general culture will not affect the films. One is free to believe that the crisis may be a material one but the film crisis is a spiritual affair and will remain so, *so long as we do not have the courage to reform the German film from its very foundations.*" (The italics are in the press report.)

Minister Göbbels went on to explain that "several films had made an extraordinary impression upon him, for instance *Armored Cruiser Potemkin* which is so marvellously made that it displays an incomparable cinema art. Its distinguishing quality is spiritual. Anyone undecided in his convictions could well be brought to bolshevism by this film. It shows that propaganda can very well be contained in a work of art and that even the worst tendencies can be propagated if the work of art in which they are embodied is sufficiently convincing." As a second film Göbbels mentioned *Anna Karenina* which was marked by the extraordinary art of Greta Garbo. Third, *The Nibelungen*, "a drama taken not from our time, but so modern, contemporary and real that it has profoundly moved those who are fighting for nationalism. Finally a film which must also overwhelm the non-nationalists: *The Rebel.* This example proves that spirit alone cannot make a film unless combined with technical ability. Thus it can be asserted that inner greatness of thought must be given expression through material means. Then can the German film become a world force the limits of which are today not yet visible. The sharper the national contours of a film, the greater will be its possibilities of conquering the world."

Dr. Göbbels concludes his address in a less trenchant manner, explaining

that the Government has no wish to cause difficulties or handicap production, providing the film companies take precautions to avoid anything which might "strike the new times in the face." His closing sentences are most tolerant though not without a final word of warning: "The manufacture of little amusements, the daily requirements for the hours of boredom and worry we wish in no case to interrupt. One ought not to do serious thinking from dawn till night. Art is free and art must remain free, so long as it conforms to certain conventions (*Normen*)."

So conciliating is this peroration that the Minister must have felt that his thunderous "reform the German film from its very foundations" had frightened his listeners more than it had inspired them. But to even the superficial observer the German film of the past two years seems to have needed no spur to its patriotism.

Every one remembers the international deluge of war films which began eight or nine years ago. In America *The Four Horsemen of the Apocalypse, What Price Glory* and *The Big Parade* mingled sentimentality, heroism, humor and the horrors of war in about equal quantities. England produced a long series of historical films, presumably objective in spirit combining documentary film with manufactured scenes. *Mons, Ypres, The Somme, Zeebrugge, Coronel and Falkland Islands, Gallipoli, Jutland* were represented as chronicles with only a sprinkling of humor or gratuitous drama and rarely with any emphasis upon the individual. France followed suit with the conscientious but uninspired *Verdun.* Most of the Russian pictures concerned the post-revolutionary civil and Polish wars rather than the Great War, though the short battle sequences in Pudovkin's *End of St. Petersburg* make a more lasting impression than do many of the rather pedestrian English battle pictures, and Dovzhenko's *Arsenal* must be mentioned— that appalling masterpiece of terror and confusion.

As was to be expected German producers hesitated for some time before they dared attempt the exploitation of a war which had ended in defeat, but the success of foreign war films and of Remarque's novel "All Quiet on the Western Front" encouraged them. *West Front, 1918, Four in the Infantry* were grim affairs, with harrowing long drawn out scenes of front line fighting. They represented war as tedious, filthy, desperate, and one at least was specifically dedicated to the promotion of peace. These films were satisfactory to the pacifist, but the nationalist and military parties found them highly subversive. During the showing of the American film based on Remarque's novel in Berlin, serious disturbances occurred. The brown-shirted Nazis broke up furniture and threw gas bombs. Remarque was a Jew, the film was foreign, and its spirit defeatist. *All Quiet* was withdrawn. The film industry had had its lesson.

Thereafter three new kinds of military films began to appear: operettas with gay uniforms upon gay young officers, military music and applauding women; then elaborate "costume" films of Germany's heroic past; and finally films of the great war in which glory and heroism and even victory were an important element.

The military musical comedies are scarcely worth naming but the subjects of the historical films are significant. In *The Choral Singers of Leuthen* Frederick the Great, fighting against fearful odds, defeats the French on one battlefield and then leads his chanting troops to another victory over the Imperial army. No less than five films have been devoted to the *Freiheitskrieg* against Napoleon. *Yorck* recounts the heroism of General Yorck who disobeyed his king to fight the French. *Marschall Vorwaerts* gives us the story of the unfaltering Blucher who led the Prussians to victory at Leipzig. In spite of Yorck and Blucher the War of Freedom was far from a brilliant affair from the official military point of view. For many years Napoleon was too much for the German army without a Frederick. It is not surprising therefore to find that the guerilla warfare against the French has proved a more fruitful source of material for patriotic movies. In *Schinderhannes* the hero is a kind of German Robin Hood who harries the victorious invader until he is finally caught and executed. Major Ferdinand von Schill of Berlin led a desperate rebellion against the French in 1809. The film *Die Elf Schill'schen Offiziere* tells of the exploits of eleven of his subordinates culminating in their execution on the field of Wesel. Perhaps the best of these films is *Der Rebel,* mentioned by Göbbels in his speech. The hero, played by Louis Trencker, returns from a German University to his Tyrol where he finds his home burnt by the French. He kills a French officer and flies to the mountains where he organizes the Tyrolese into guerilla bands. In actuality the French were aided by the Bavarians but in the film Trencker exhorts his comrades to avoid conflict with men of their own blood while appealing to the Bavarian commander to desert his French allies: "We are all Germans!" The film ends in a magnificent ambuscade of an enemy column. The double theme: resistance to the invader even after the defeat of the military forces (Austerlitz, Jena, Wagram) and the necessity for an *Anschluss* between Germany and Austria against the French—both are policies of the National Resurgence under Hitler, 114 years later. We happened to see *The Rebel* in Innsbruck where it played to an intensely enthusiastic audience. In Germany it has been a great success. Göbbels has good reason to recommend it.

The War of 1870 has strangely enough been little exploited, but films based upon the more glorious episodes of the Great War of 1914–18 have been only less frequent than those concerned with the great war of 1805–13. *Morgenrot* is a melodramatic film of submarine warfare in the North Sea. The *Cruiser Emden,* seen in America last year, also redounds to the glory of the German Navy. *Tannenberg,* more documentary in character, represents Hindenburg's rout of the Russians in 1914, and the *Flaming Mountain,* in America called *The Doomed Battalion,* with Trencker starring, is a stirring picture of Alpine warfare on the Italian front.

Needless to say all these pictures are a complete contradiction of the spirit of *All Quiet* or *West Front, 1918.* Not only do they handle war as a glorious, noble, *pro patria* adventure but the scenes behind the front are for the most part romantic, especially in the "costume" films. In general they have been commer-

cial successes, well calculated to please the changing temper of the German public. But it is doubtful whether they could have been released in such quantities were it not for the fact that Hugenberg, head of the Nationalist party and chief supporter of the Stahlhelm, also has an important interest in the Ufa film company. Heavy industry has rarely been opposed to war.

The Nibelungen, the third film mentioned by Göbbels, was made about 1923 during the great creative period of the German moving picture and at a time when war was too recent and painful a memory to tempt producers. Perhaps as a result of Göbbels' speech it has just been revived with sound under the name of *Siegfried's Tod.* The advertisements and program quote Göbbels' remarks. Fritz Lang, the director of *Siegfried's Tod,* has been placed in a curiously ambiguous position for at the very time his ten year old work is being revived under official sanction as a masterpiece of Kultur, his latest release *The Testament of Dr. Mabuse* has been banned throughout Germany. Lang will be best remembered in America for his Marxian extravaganza, *Metropolis.*

That Dr. Göbbels speaking as Reichminister of Propaganda should have included *Anna Karenina* among his four significant films convinces one of his honesty—it would be unfair to say his cleverness—in view of the fact that neither the theme nor the star is German—and he might easily have mentioned instead a dozen other greater and more purely German films.

Göbbels' praise of the Soviet *Potemkin* does credit to his connoisseurship, for Eisenstein's film is certainly one of the great 20th century works of art. His fear of the propaganda element in *Potemkin* may be somewhat exaggerated, but it is definitely reflected in the fact that Soviet films which had been shown in Germany with the greatest freedom are now forbidden, except, one guesses, when shown for the instruction of German directors. As Göbbels hints, the work of the Russians such as Eisenstein, Dovzhenko, Room, Pudovkin, Ozep will be carefully studied.

Minister Göbbels has recently visited Italy to study Italian methods of propaganda through films and other channels. The Italian fascists have made far less extensive and intelligent use of the films than have the Soviets. It was not till almost ten years after the March on Rome that the government began to sanction propaganda films. *Armata Azzurra* released at the end of 1932 is a military air service film with feeble music, an absurd plot and magnificent shots of air manoeuvres in mass formation. *Camicia Nera* (Black Shirt) celebrates the Fascist Revolution with special emphasis on the *bonifiche,* the recently reclaimed areas in the Pontine Marshes south of Rome. Following the methods of Eisenstein in the *General Peasant Policy,* the subject is ably dramatized. *Black Shirt* has been less of a success in Italy than in Germany where it is advertised with the slogan: *"Deutscher, du musst diesen Film sehen!"*[77] The very recent *Acciaio,* a film of the Italian steel industry, has also been shown in Germany.

Following in Italian and Russian footsteps, the German newsreels are saturated with political matter, but only one official full-length film has thus far been produced. *Bleeding Germany* is a chronicle composed of old newsreel sequences,

official documentary films, prepared speeches and a few studio recreations of historical events. Dedicated to the German people, *Blutendes Deutschland* is advertised as *"Der Film der Nationalen Erhebung."*[78] It is divided into three parts: 1. From the Great Period. 2. Germany in Need. 3. Germany Awake! The film opens with glimpses of the battle of Sedan—German cavalry pursuing the retreating French—the entry into Paris—the founding of the first Reich at Versailles in 1871—Berlin and Potsdam in 1913—the Empress in a magnificent hat stepping into her carriage—the Kaiser reviewing troops—the news of Sarajevo—mobilization placards—the War—glimpses of warships, submarines—Hindenburg bending over maps—spike-helmeted troops marching—zeppelins, airplanes—Baron von Richthofen with an embarrassed smile after having brought down his seventy-fifth enemy plane—Germany's enemies increased through the influence of a "lying press"—1918, Western front—waves of American and English troops melting before German machine gun fire—the Spartacist (communist) uprising—barricades—bombs thrown into trucks of soldiers—German refugees fleeing out of Poland—the occupation of the Rhineland—the Ruhr—double printing showing a smiling French Senegalese guard in helmet superimposed upon the interior of a German factory—armored tanks and cars moving through German cities—a film of the actual execution of Albert Leo Schlageter shot by the French for sabotage—the inflation—glimpses of Italian fascists, of Polish and French troops and artillery—Germany defenceless but not dishonored—End of second part.

Germany Awake! Hitler addressing hatless young brownshirts in shorts like boy scouts—the Ludendorff-Hitler Putsch of 1923—Hitler speaks again—the elaborate funeral of Horst Wessel, writer of the Nazi hymn, shot by the communists—glimpses of slums and the *Arbeitslose*—the Harzburg convention—Hitler reviews the Nazi army—Göbbels in a white raincoat speaks against the Treaty of Versailles, against War guilt, against the Young plan: "Our elders are played out, make way for the young!—new men! new ideas! a new path!"—Hitler speaks: "The failure of the social democrats and the party system—down with the Weimar Constitution"—Goering, Hitler and von Papen seated—Hitler forgets entirely to turn towards von Papen till someone nudges his shoulder—the election of March 5th—Nazis parading on Unter den Linden—the swastika flag flying from the Brandenburg Tor—the day of triumph at Potsdam—Hitler enters the garrison church of Frederick the Great—the Crown Prince and von Mackenzen applaud, wearing busbies of the Death's Head Hussars—a vast banner "Gott mit Uns—Deutschland, Deutschland, über Alles! Finis."[79]

Postscript: On April 27th Minister Göbbels at a meeting held in the Ufa studios at Neubabelsberg near Berlin announced that the Government is to offer a prize of 12.000 marks for the best German film of the subsequent year. In his speech he added that the winning film must be "entirely ruled by the ideas of the New State."

Art in the
Third Reich—
Preview, 1933

See previous headnote. (From the *Magazine of Art,* October 1945.)

I. "THE BATTLE BAND FOR GERMAN CULTURE"

Stuttgart, the capital of Württemberg, is known to most Americans as a railroad center through which one passes on the way from Paris to Munich. It is a city of less than 400,000 people, conservative, prosperous for these times, bourgeois in atmosphere in spite of its only recently untenanted Royal Palace. The foreigner is astonished by its dozen museums, its theatres, its excellent opera, its profusion of concerts and its quantity of good modern architecture. Though Tübingen, the nearest university, is an hour away, Stuttgart is proud of its intellectual as well as of its artistic life. Even for the average citizen, Schiller, Hölderlin, Hegel, Kant, Feuerbach are something more than the names of Stuttgart streets.

Württembergers are traditionally phlegmatic, and Stuttgart took its revolution very calmly. The National Socialist government established itself with little apparent trouble. Only in a few instances was the dispossessed bureaucracy recalcitrant. Many people knew of some acquaintance who had been granted the "protection" of prison for racial or political reasons but no one seemed to know how many had thus been treated. A small quiet crowd gathered outside of the party headquarters; the flag and flagpole merchants did an enormous business; the swastika was everywhere and one saw the sickle and hammer and the triple arrow only upon the walls of back streets. The surviving newspapers resounded with the glory of the National Resurgence. Rathenau Street, named for a Social Democratic statesman murdered by the Nazis in 1922, was renamed Göring Street; postcards of the Leader, grim of face, his arm raised in the fascist salute, spoke from all shop windows; and there were parades by night and day. In the evening one heard from every other house the strained voices of Hitler or Goebbels shouting over a Berlin microphone. But those who recalled the machine guns of St. Petersburg in 1917, Berlin in 1919, Rome in 1922, Munich in 1923,[80] had little fault to find with the efficient disciplined technique of the

Nazis. They were surprised, however, at the thoroughness and rapidity with which the new order invaded every business and profession, every intellectual and cultural activity.

On April the 9th, a little over a month after the National Socialist Revolution, the Württemberg Chapter of the *Kampfbund für deutsche Kultur* held its first public meeting. The *Kampfbund für deutsche Kultur*, literally the "Battle Band for German Culture," is an official affiliate of the National Socialist party. Its headquarters are in Munich but it has organized subordinate groups in every important German city. These local groups work hand in hand with the civic governments and with the state ministers of education who in Germany usually supervise general cultural activities as well as schools and universities. In this way the *Kampfbund* with national, state, and local governmental support is able to dominate to an extraordinary degree almost every phase of the cultural life of Germany.

The meeting was held in the smaller of Stuttgart's two civic theatres. We found the theatre crowded. In the seats of honor were the State President of Württemberg, the State Commissar and the *Kultminister* (Minister of Education). Behind them, row on row, sat painters, sculptors, musicians, architects, teachers, critics and many of the most active amateurs of the arts in Stuttgart. They had been gathered together to hear what was expected of them under the new government.

The orchestra on the stage opened the meeting with Bach's Second Brandenburg Concerto. Then a young man walked out from the wings and stood gravely behind the lectern. He opened a copy of the white pamphlet which many of us had bought on entering the theatre. He was Dr. Otto zur Nedden, who had been till recently on the faculty of the University of Tübingen but was now making his first appearance as the newly appointed head of the Württemberg *Kampfbund*. The pamphlet was the *"Kulturprogramm im neuen Reich"* which he had edited under the direction of the *Kultminister*. He began to read *Kultminister* Mergenthaler's preface:

"It is an important cultural duty of the regime of the new National Resurgence to set free from any foreign, external influence our native creative personalities and by so doing to give them the possibility of increasing their vitality. Then will our people be enriched by those creators who are summoned to bring German art and culture to a new flowering."

The reader stopped and raised his head. There was silence, then hesitant handclapping. He turned the page and in the audience five hundred pages turned:

"Universities

"The universities and technical schools were in the past the special pride of our people. No country in the world can call its own so many centers of true spiritual culture. It belongs to the sorriest chapters of the history of the last fourteen years that our universities and technical schools in a mistaken interpretation of the expression 'academic freedom' have in general given way to the

spirit of liberalism. But now a new day has dawned! Academic freedom shall and must be preserved. It is the right of the free creative spirit. *But it must be a German academic freedom!* It must never again be misused to open the door to insidious foreign influences. If this misuse should continue, it would lead to the end of academic freedom. Therefore, to take steps to guard academic freedom in the *German sense of the word* has been and will be one of the most important duties of the *Kampfbund für deutsche Kultur.*" (The italics in this and other quotations are in the original text.)

This pledge bore the signature of State Counsellor Prof. Dr. Oswald Lehnich of Stuttgart. It was followed with two statements written by Tübingen professors, one on history, another on philosophy. Single sentences convey the import:

"Philosophy, too, is besieged by un-German influences. But now the hour of awakening has struck!" (Prof. Max Wundt.)

"Much more than before it will be the duty of the science of history to grapple with the problem of the German people's adjustment to foreign cultural influence." (Prof. Adelbert Wahl.)

Then in succession came architecture and poetry, and music and the pictorial arts:

"The widely held contemporary belief that art is international is absolutely misleading."

"What does not issue out of the depths of the spirit with conscious responsibility toward German culture, is not art in the German sense of the word."

The reading of the manifesto closed with a section on the theatrical arts by the General Director of the Württemberg State Theatres:

"The National Revolution has stirred the deepest depths (*tiefsten Tiefen*) of our people. The reformation of the political life of Germany to its original condition has been achieved. Now will German art and science carry German culture deep into the spiritual life of our people. To build up this great cultural work, to watch over it, to guard its purest springs, is, as I see it, the function of the *Kampfbund für deutsche Kultur.* So with the coöperation of the *Kampfbund* I wish to announce today the first practical step: a prize competition for a play, to have its first presentation on the stage of the Württemberg Theatre."

The audience followed the recitation of these eleven articles of politico-cultural faith with an almost liturgical solemnity. The handclapping following each statement was sporadic. We watched one row of ten listeners carefully: two clapped regularly after every section, but five never clapped at all.

Kultminister Mergenthaler himself came upon the stage. Professionally, he had been a teacher in a day school near Stuttgart but now he bore his ministerial rank with convincing dignity. Tall, erect, pale, bald-headed, spectacled, he faced his audience for a moment with an air of confident defiance. Then he spoke, harshly aggressive, forcing his voice in Hitler's manner as if addressing ten thousand people in the Town Hall instead of ten hundred in the Kleines Theater:

"It is a mistake to think that the national revolution is only political and economic. It is above all cultural. We stand in the first stormy phase of revolu-

tion. But already it has uncovered long hidden sources of German folkways, has opened paths to that new consciousness which up till now had been borne half unawares by the brown battalions: namely, the awareness that all the expressions of life spring from a specific blood, a specific people, a specific race! The consequences of such a discovery are perhaps the most revolutionary that Germany has experienced in a thousand years. Out of this most profound consciousness shall the new structure of German culture arise. And from this it must follow that art is not detached, that it cannot be built into an Internationale, but must be rooted profoundly in the German people and in the heroic attitude of its soul as illustrated by Dürer's engraving of the 'Knight, Death, and the Devil' or by a song of Beethoven's or the work of Richard Wagner, which could only spring from the very blood of the German people.

"Art is not international. . . . Nor is there any such thing as international science. What are for the German people the deepest questions and greatest secrets of Nature, are perhaps for a foreign race unimportant. . . .

"Therefore, with this conclusion in mind it is inevitable that the Revolution will penetrate just as thoroughly the territories of art, culture and science as it has economic and political activities. If anyone should ask: What is left of freedom? he will be answered: there is no freedom for those who would weaken and destroy German art. Freedom is only for those who carry in themselves the German artistic spirit and a fanatical will to reform.

"The government has no intention of regimenting the creative arts. But on the other hand there must be no remorse and no sentimentality in uprooting and crushing what was destroying our vitals. . . . And if anyone accuses the German Revolution of having no heart then let him take this for an answer: we do what we do because we have a heart for Germans, who have up till now been throttled.

"Upon us falls the holy responsibility to clear for our people the pathways of the cultural realm. For this we live and strive. For this we fight, and we will leave nothing undone in order to make art in Germany German again. To this end we awaken the memory of our great poets. Uhland, Hölderlin, Schiller and Goethe are our invisible comrades and fellow warriors in the battle for the welfare of German art. And come what may, let this alone be our eternal watchword: *Deutschland, nur Deutschland, ganz allein!*"

The hoarse voice of the *Kultminister* of Württemberg cracked with emotion and stopped. He walked from the stage followed by stormy applause.

II. "RETURNING SANITY" IN GERMAN ART—1933

On March 1st the Württemberg *Kunstverein* (Art Society) opened to the public a retrospective exhibition of the works of Oskar Schlemmer in the Stuttgart Civic Gallery. On March 5th the National Socialist party came to power. On March 11th the NATIONAL-SOZIALISTISCHES KURIER published a review of the Schlemmer exhibition. On March 12th the exhibition, which was to have run for a month,

was closed and about the same date two paintings by Schlemmer in the Museum of Modern Württemberg Art were taken down and put into storage. As Schlemmer is the most famous living artist of Stuttgart birth these events are not without significance.

Oskar Schlemmer was born in 1888. He first studied painting in the Stuttgart School of Arts and Crafts, then at the Stuttgart Academy, and later in Berlin, Paris and Weimar. About 1926 he became a teacher at the Bauhaus School at Dessau where he organized the Department of Theatre and Ballet with distinguished success. In 1929 he was called to a professorship in the Breslau Academy and in 1932 to the Berlin United State Schools of Fine and Applied Arts.

Professor Schlemmer is the author of "Bühne im Bauhaus," a book on experimental theatre which is known to students all over the world. He is in addition a sculptor, a choreographer, a costume designer, a designer of furniture and, finally, it may be said without exaggeration, one of the twenty best known German painters. While his canvases are (or were) hung in many German museums, his most extensive work is the fresco decoration in the fountain court of the Folkwang Museum at Essen. In America he is known both through his book and his paintings which have been included in several exhibitions. One of his most important pictures is owned by a New Yorker.[81]

Schlemmer's paintings are for the most part arrangements of rather stiff doll-like figures, sometimes used in silhouette as in an Egyptian frieze, sometimes placed in a precise geometrical perspective like pieces on a chessboard. They are painted in transparent glazed colors, principally in deep purple, vermillion, blue, brown and white. Their subjects are sometimes taken from the schoolroom or theatre but more often the title of the picture is simply *Composition III* or *Figure in Red* or *People and Architecture.* One might say that Schlemmer's art is decorative, possessed of an exact clarity, detached in spirit, conscientious in craftsmanship, original but somewhat limited both in subject and treatment.

The critic of the NATIONAL-SOZIALISTISCHES KURIER wrote:

"The current exhibition at the Württemberg *Kunstverein* is worth while in several ways. There is discussion—so we hear—as to whether the Schlemmer exhibition ought to be hung at all in these times of returning sanity. Very good! Very good on two counts: first because this discussion shows that many responsible circles are not convinced of the value of this 'art'; second because it is giving the *Kunstverein* a troubled conscience, and third (sic) because this exhibition is doubtless the last chance the public will have to see painted *Kunstbolschewismus* at large. Who wants to take these pictures seriously? Who respects them? Who wants to defend them as works of art? They are unfinished in every respect. One may say that in their decadent spiritual attitude they might as well be left on the junk heap where they could rot away unhindered. It is certainly no accident that Oskar Schlemmer belonged to the graveyard of the Dessau Bauhaus and the Breslau Academy.

"Whoever studies this exhibition will discover that Herr Professor Oskar Schlemmer has not had a single new idea since 1931 (sic). All his pictures remain today, just as ten years ago, stuck in the first stages through which any work of art must pass. They are fragments of the most pre-primitive kind, without benefit of organic form or resonant color. And throughout this brutality of form and impossibility of color runs a dissonance of English red and Prussian blue. After the most careful examination there is apparent absolutely no reason why these pictures should be lent to an art exhibition unless it were to show the insolence of the 'artist' who has sent such half baked rubbish out on tour as works of art."

This unequivocal attack was published six days after the Revolution. Almost immediately the *Kunstverein* took the hint, removed the Schlemmer paintings to a gallery in the rear of the building and kept them under lock and key so that they could be seen only upon special request. The Museum of Modern Württemberg Art followed suit by hiding its permanently owned Schlemmers. "Protection of the pictures following unfavorable press notices" was the explanation given by the gallery officials. In other words these paintings were treated much as have been the persons who, politically or racially anathema to the new regime, are put in jail, in *Schutzhaft* (protection by imprisonment).

The parallel is not quite exact, for the new government took no direct steps to close the exhibition; nor had the *Kampfbund für deutsche Kultur* any official part in the affair, for it was not yet a controlling power in Stuttgart. Nevertheless the decisive attack was made in the local Nazi paper and in the light of events in other German cities there can be little doubt but that the officials of the *Kunstverein* and Museum were moved to protect themselves more than the pictures.

This affair provokes several questions the answers to which throw some light upon art in relation to the National Resurgence. What is there about Schlemmer's pictures which caused their hasty withdrawal from public exhibition? Had the officials of the two galleries any justification for their caution? Were there any public or official protests? And finally is the affair an isolated accident or is it characteristic of what is happening elsewhere in Germany?

It is very difficult to find anything of the slightest political significance in the subject matter of Schlemmer's pictures. Their style, however, certainly offended the critic of the Nazi KURIER who proceeds further to the assumption that a picture because it seems radical in style is therefore radical politically. Such equations as cubistic-equals-bolshevistic are fairly familiar even in America. He insists too that the paintings are "unfinished" and their colors "impossible" (i.e. "not natural") but it may be noted in passing that these adjectives are very similar to those used by people who were offended by the impressionists in the eighteen seventies, by Manet and Whistler in the 'sixties, by Turner in the 'forties and Constable a century ago. That a similar attack should be made against Schlemmer in 1933 is all the more remarkable when one realizes that he is a post-cubist painter whose work is far easier for the inexperienced person to understand than are the works of the cubists painted twenty years ago.

Schlemmer's career, however, may seem somewhat tarnished from the National Socialist point of view. The Bauhaus where he taught for several years was the center of radical experiment in architecture, photography, ballet, furniture, typography and other arts, and for a short interlude after Schlemmer had left, it had a communist director. But Schlemmer since 1929 has been a professor at the respectable Civic Art School in Breslau and during the past year at the State Art School in Berlin.

Following the closing of his exhibition several serious and courageous protests were made, one of them by the liberal highly respected critic of the STUTTGARTER NEUES TAGEBLATT. He avoided carefully any direct criticism of the new order of things but maintained that Schlemmer was neither bolshevist nor un-German. A Stuttgart art dealer who is also a doctor of the University of Vienna published a long article exhorting the German museums and *Kunstvereine* to seek the coöperation of the new régime before abandoning their interest in modern art. A third and more weighty protest was made by an official who was at the time a Nazi of good standing. He wrote a letter directly to Hitler, another to Goebbels and a third to the headquarters of the *Kampfbund für deutsche Kultur* in Munich. He received no direct reply but was warned that in the future he must watch his step very carefully.

Apparently these letters had little effect in reassuring museum authorities or in restraining the zeal of the new bureaucracy. For shortly afterwards, early in April, the large State Gallery of Art also suffered censorship. Paintings by five of the best known modern artists in Germany have been removed from the walls. Schmidt-Rottluff, Kirchner and Otto Müller belonged to the Bridge Group of expressionists founded about 1906. Paul Klee was one of the Munich Blue Riders of 1912. Otto Dix is the leader of the post-war realists. The work of each of the five has been seen again and again in American exhibitions. Of the removed pictures only one is questionable in subject matter: Otto Dix's *Arbeiter* is not flattering to the German factory worker nor to the system which produced him.

At first the hiding of these pictures and the closing of the Schlemmer exhibition seemed pusillanimous, but the newspapers began to publish announcements which suggested beyond a doubt that the German museum director who has concerned himself in any way with modern art must act with extreme circumspection. The writer cannot give complete statistics but these events which are doubtless well known in America must have been suggestive to the directors of the Stuttgart art institutions. The museum of Ulm boasted a more advanced group of modern pictures than the Stuttgart museum. The Director of the Ulm Museum has been dismissed. Dr. G. F. Hartlaub of the Mannheim Museum invented the term *Neue Sachlichkeit* (New Objectivity) which was applied to the most advanced group of German painters in the decade after the war. He has also made his museum an important center for those who wish to study modern French as well as modern German art. Dr. Hartlaub has been given an indefinite leave of absence. The directors of the Karlsruhe Gallery, the

Düsseldorf Museum, the Cologne Museum of Decorative Arts, the Hamburg Museum of Decorative Arts, the Cologne Museum of Oriental Art have all been given "vacations." The director of the Chemnitz Gallery has been supplanted by a pupil of Professor Pinder of Munich, long conspicuous for his zealous patriotism in the interpretation of art history. One of the great German scholars, Prof. Zwarzenski, formerly General Director of the Frankfort museums, has been demoted and his place taken by an academic painter.

As I write, Dr. Max Friedländer, director of the Kaiser Friedrich Museum in Berlin, and Dr. Ludwig Justi, director of the National Gallery in Berlin, have both been dismissed.[82] Dr. Friedländer, a Jew, is one of the foremost living authorities on Netherlandish and German painting of the 15th and 16th centuries. Dr. Justi, who organized the museum in the former Kronprinzen Palais in Berlin, has been distinguished for his interest in modern German art.

These changes in museum personnel appeared one by one in tiny news items. But the changes in museum installation did not receive even as much notice. One read for instance of the removal of the director of the Nürnberg Civic Gallery but one had to visit the gallery itself to discover what had happened to the objectionable pictures. In Stuttgart we have told how pictures were taken down from the walls of two museums. This occurred on a larger scale in Leipzig and Dresden, while in Frankfort certain galleries of modern German art are simply locked. But in several cities a more ingenious method is used to express the National Socialists' disapproval of the last twenty years' development in German painting. In the Nürnberg Civic Gallery one passes through the galleries of the 19th century painting without noticing anything unusual. On the second floor two or three conspicuous placards appear beneath paintings. They bear in large black letters the words "For This 'Art' 2500 marks were paid in 1924." The amount varies but the word "Art" is always in quotation marks. On the third floor where most of the recent acquisitions are shown, the labels occur more frequently until in the last room all the pictures are labeled and above the door is an inscription: "Art of the fourteen years system acquired under ex-burger-master Luppe and ex-museum director Schultz." But certain curious discrepancies are noticeable. A small drawing of Berlin slums by George Grosz is placarded but on the floor below a large portrait of the artist's mother escapes. Otto Dix's portrait of the sinuous dancer Anita Berber is placarded but in the next room a water color of his baby son is passed without comment. Doubtless the explanation in these cases lies not in the style but in the subject matter: babies and mothers are approved subjects; slums and sinuous dancers are not approved.

Such is the fate of some of the directors of German museums who bought and hung too modern pictures; and such is the fate of the pictures themselves. But what of the painters? Their income from sales is of course drastically cut off but some of them have been dealt with more directly. Before the Revolution civic art schools throughout Germany in contrast to those in the rest of the world had enlisted the services of the most advanced artists, rather than depending entirely upon more academic teachers. But this policy has now rendered the

progressive painter peculiarly vulnerable for, having a job, he is now liable to lose it. For example, Paul Klee and Oskar Moll have been removed from the Düsseldorf Academy, Otto Dix from the Dresden Academy, the architect Hans Poelzig and the painter Carl Hofer from the Berlin United State Schools of Fine and Applied Art, the same school in which Oskar Schlemmer had been teaching. Schlemmer's fate was somewhat more elaborate. National Socialist students accused him of being a Jew (although he is of pure Suabian blood). His classes became so difficult that finally he asked for some official confirmation of his position. Instead he has been granted along with Hofer and Poelzig a "vacation."

There is abundant and concrete evidence of what kind of German painting draws upon itself official censure. But exactly what kind of painting is to receive official sanction is not yet quite clear. What seems most thoroughly German to the foreign eye, the expressionism of Schmidt-Rottluff or Klee, the exaggerated realism of Dix and Grosz has been as we have seen discouraged in every practical way. The pictorial art section of the *Kampfbund* manifesto, while it does not answer this question, illustrates the spirit of the artists who are now being raised to positions of official power. It was written by Professor Waldschmidt, President of the Stuttgart Academy:

"The widely held contemporary belief that art is by and large international is absolutely misleading. Apart from the fact that the great artists of all time were unacquainted with this point of view, this slogan works towards the destruction of the nation's imaginative powers, its noble thoughts and its heroic spirit. Under such a theory all creative art could be centralized under an international dealers' dictatorship which would dominate its spirit entirely.

"For thirty years, in fact, this dictatorship has ruled. Art historians, museum directors, dealers and, to their shame, a large number of artists have reached out their hands to one another in order to bring about a so-called international art language.

"National Socialism has the courage and the will-power to uproot this sorry lack of character which has been based only upon opportunism. That some few better talents may be swept away during the process is quite beside the point. Any halfway measure at this time would be a crime against German culture which can only be built anew from the ground up."

Professor Waldschmidt's own painting is less nationalistic than his oratory if one may judge by his *Plowman* in the Museum of Modern Württemberg Art. So far as its style is concerned were one to see this large picture in the Carnegie International Exhibition one might take it for Belgian work or Polish or Swedish or Canadian. Plowing is international and as neither the plowman nor his beast wear any clothes there is really almost nothing save Professor Waldschmidt's signature to suggest the German origin of his picture.

To accomplish the purpose set forth by Professor Waldschmidt, to "build anew from the ground up," *Kultminister* Mergenthaler has appointed the *Kampfbund* leader, Dr. zur Nedden, to act as official art supervisor. To coöperate with him an art commission of five has been named which has for artist members

Professor Schmidt, a sixty-six-year-old academician, and the sculptor Professor Habich whose work shown in the Museum might have been done anywhere in Europe or America were it not for the subject. It is a portrait of *Reichspresident* von Hindenburg.

In this museum where the works of Professors Waldschmidt and Habich are to be seen and from the walls of which the two paintings of Schlemmer were removed an event occurred which may serve as a tail piece for this chapter. Early in May Stuttgart painters and sculptors received an invitation to attend a reception in honor of the *Kultminister* who had then been two months in office. On the invitation was written: "Attendance obligatory." Those who happened to pass by the museum at the appointed hour witnessed an interesting spectacle. Lining the steps on either side of the portal were brown-shirted troops of the National Socialist *Sturmabteilung* standing with rifles in their hands. Between their ranks the artists filed.

III. "ATTENTION TO ARCHITECTURE"—1933

Baedeker's "Southern Germany" gives about thirty pages to Stuttgart. The Weissenhof suburb on a hill overlooking the town is described in two lines as "an interesting colony of ultra-modern flat-roofed houses with wide windows, large verandas and roof gardens." But in the history of post-war modern architecture the Weissenhof suburb is perhaps the most important group of buildings in the world. More than that, the Weissenhof is an extraordinary monument to the courage of the Stuttgart city fathers who in 1927 authorized the Württemberg section of the *Deutscher Werkbund* to build the suburb as an exposition of modern architecture, not in mere plans and models, but in full-scale houses which were subsequently to be rented by the city. Mies van der Rohe of Berlin, the director of the exposition, invited sixteen architects of Holland, France, and Germany to furnish designs. Among them were the pioneers who are now famous even in America as the leading architects of the International Style. Le Corbusier and Jeanneret of Paris built two houses, one of them the famous double house with cantilevered second storey; J. J. P. Oud, city architect of Rotterdam, built a group of small row houses. Walter Gropius, at that time Director of the Bauhaus at Dessau, designed two private dwellings and Mies van der Rohe a large apartment house which has been imitated all over Germany.[83]

The exposition had an extraordinary success. The visitors during the first year were estimated at nearly a million which included architects from all over the world as well as many thousands of tourists and casual sightseers. Even now when the novelty and some of the stucco have worn off and the houses have become dwellings the suburb attracts more visitors—and photographers—than any other sight in Stuttgart.[84]

The conservative town received to her bosom this anthology of advanced architecture with very mixed feelings. It became known that the city fathers had been persuaded only after a long campaign to authorize such a radical venture.

The pillars of Stuttgart society while acknowledging that the Weissenhof was a powerful magnet to visitors felt a strong dislike for the architecture itself. Although the inexpensive apartments and row houses filled up quickly the larger houses did not attract the well-to-do burgers who preferred the ornate *art nouveau* houses of the 1890's and early 1900's which line the more respectable streets. Finally a cleverly faked postcard of the Weissenhof appeared showing camels and Arabs wandering through the white-walled flat-roofed houses of "Stuttgart's Moroccan Village."

Nevertheless the influence of the Weissenhof architecture began to make itself felt. The year after its completion, Stuttgart's first skyscraper was built in the International Style (four years before the same style began to be used for American skyscrapers). Department stores and shops, factories and the civic power plant followed suit. Richard Döcker, one of the two Stuttgart architects of the Weissenhof, built at nearby Waiblingen the most modern hospital in Europe. Alfred Daiber designed the huge office building of the Civic Health Insurance Bureau. A dozen private houses in the new style went up and during the past two or three years the majority of the new houses in Stuttgart have been compromises between the new style and conservative tradition. More important still, the architectural division of Stuttgart's Institute of Technology gained the reputation of being the most liberal and advanced of all the officially recognized architectural schools in Germany.

Before the National Socialist Revolution opposition to the new style was primarily personal. But since March 5th there has been ample evidence of official hostility which now amounts practically to suppression.

The most recent Stuttgart building in the International Style is a church designed by the architect Alfred Daiber and actually completed after the Revolution, but before the new régime was sufficiently organized to assert its power over architects. Architecturally and in its location the church is an extension of the Weissenhof development which doubtless contributes a considerable proportion of its congregation.

The church is a long white-stuccoed two-storied building with a flat roof relieved by a bell tower. At the left of a long façade facing a park is the main entrance surmounted by a simple, very large copper cross applied to the wall. The lower floor is a Sunday school room with smaller committee and kindergarten rooms adjoining. The church auditorium occupies the floor above. To the rear of the church is a small block of living apartments. On March 24th, a few days after the church opened, Stuttgart's largest paper, the *Neues Tageblatt* printed the following statement, issued by the Stuttgart Chapter of the *Kampfbund für deutsche Kultur*. The *Kampfbund*, as has been explained, is an official organization of the National Socialist party.

"The evangelical Church Council has given its sanction to a church with community house which has now been completed upon the Kochenhofgelände under the name of the Brenz Church. German piety and German cultural sensibility will be deeply wounded by this building. In the name of all who have

preserved a pure feeling for the spiritual fundamentals of our Christianity and our society, warning must be given against the appearance here of a betrayal of these fundamentals. Neither the principle of efficiency in the combination of church and community house, nor the principle of artistic 'freedom' excuses the completion of this public offense. That the board of governors of an evangelical church and an architect in our time of religious and cultural danger should carry through such a building fills every culture-loving German with sorrow. Such occurrences must confirm in the minds of the public the resolution to prevent the reappearance of an art foreign to our people and the irresponsible indifference of our public opinion that could heretofore permit such manifestations to take place.

"We have faith that the State Minister for Education who has already publicly taken measures to support German culture will also direct his attention to architecture."

Four points may be noted in this document: (1) The *Kampfbund* has exaggerated a dislike for a certain architectural style until it becomes "an offense against the spiritual fundamentals of Christianity and society"; (2) It insists upon the "foreign" character of the architecture; (3) It attacks both the architect and the Church council; (4) It recommends that an official of the Württemberg Government take precautions against future offenses.

A fortnight later it was disclosed that the conservative architect Paul Schmitthenner was the principal architectural advisor and spokesman of the *Kampfbund* in Stuttgart. On the morning of April 9th the Stuttgart *Kampfbund* held its first public meeting at which was read a long manifesto on the various arts in relation to the National Socialist Revolution. The section on architecture was written by Schmitthenner.

"Architecture"

"The architecture of a period is the best gauge of its general cultural level. The nature of German architecture reveals itself at its most significant in tradition. The more we removed ourselves from tradition and thus from the fulfillment of our duty towards history, manners, and people, the more have we emphasized the utilitarian which in the words of Karl Friedrich Schlegel becomes obnoxious when it is handled without that grace or dignity which alone can make the useful beautiful. Tradition is not the taking over of exterior forms but the keeping alive of the natural; it is the cultivation and increase of what is characteristic in a significant development. The New Objectivity (*Neue Sachlichkeit*) in architecture is nothing but the utilitarian become form, that very utilitarian spirit which has dominated the contemporary period to such an extent that grace and dignity have been readily sacrificed to an international[85] phantom. But tradition is the foundation of every culture and it can only be born from the very heart of a people. The achievement of a new German architecture depends decisively on the spirit cultivated in our architectural schools. It is, therefore, necessary that our youth be educated in the spirit of a sound tradition."

It is, of course, Schmitthenner's political affiliations which make him a

powerful antagonist. But he is also a good architect, one of the best reactionary architects in Germany. Reactionary is an exact adjective, for the best known Germanic architects of before the War: Behrens, Bonatz, Moser, Wagner, Hoffman[n], Berlage, were already working in a style which would seem advanced in present day America. Schmitthenner's architecture on the contrary is a refined imitation of what was the international style of about a hundred and twenty years ago. He is an Alsatian and his larger private houses if they have any local flavor suggest the Empire châteaux of Alsace and Burgundy. He uses brick covered with light grey, carefully antiqued stucco, occasionally with heavy stone coigns. He has a fine sense of proportion demonstrated by his interiors and carefully symmetrical façades. He prides himself on his craftsmanship and shows a fondness for capricious ironwork. His placing of windows on the side and rear walls would be considered extremely slovenly by the modern architects whom he opposes. All in all his work is well calculated to please the wealthy conservative client; it would not be out of place in Southampton or Brookline but it is definitely neither national nor socialist nor even traditional in any living sense of the word. Nevertheless, Schmitthenner was mentioned by Commissar Hinkel of the Prussian Ministry of Education in a recent interview[86] as one of the three architects whose work the National Socialists hold up as an example. His reputation is already nation wide.

Schmitthenner is not, however, content with a passive rôle. He was probably not responsible for the *Kampfbund's* attack upon Daiber's church, but in addition to his share in the *Kampfbund's* general art manifesto he has assaulted the International Style in a series of public letters written against the *Werkbund's* proposed 1933 Exposition of Wooden Houses. Called in as a consultant by the National Socialist Community Council which was to have passed upon the *Werkbund's* project, he has succeeded in having the Exposition placed under reactionary control.

The spokesman for the *Werkbund* in this controversy was the architect Richard Döcker who it will be remembered built one of the houses in the Weissenhof Exposition of 1927 and subsequently the large Waiblingen hospital. At the moment of writing Döcker is working on two private houses, both of course in the International Style. One of them is nearly finished but the other was only half built when he was summoned to the office of the Civic Supervisor of Building and told that he must change the design, abandon the roof terrace and build a gable roof. He protested that his client as well as he himself wanted a flat roof but their objections were overridden. The gabled roof which is quite out of harmony with the rest of the building is now under construction.

Italian Sources of Three Great Traditions of European Painting

In 1939 a collection of Italian paintings and sculpture from the fifteenth through the eighteenth century was shown at the San Francisco World's Fair; a showing in Chicago was arranged by Daniel Catton Rich, Director of The Art Institute. The Italian government offered the Metropolitan Museum the opportunity to show them, as they passed through New York on the way back to Italy, at a fee of $5,000 a week. Although the Met declined, MoMA agreed, with a predictably surprised public reaction. In the catalogue preface, Barr justified the exhibition's place at MoMA by invoking the "great tradition of European art and its American branches" and recalling Cézanne's desire to paint "something solid and enduring like the art of the museums." Barr also charted the ancestry of modernism.

The chart that appears here is an adaptation of Barr's original.

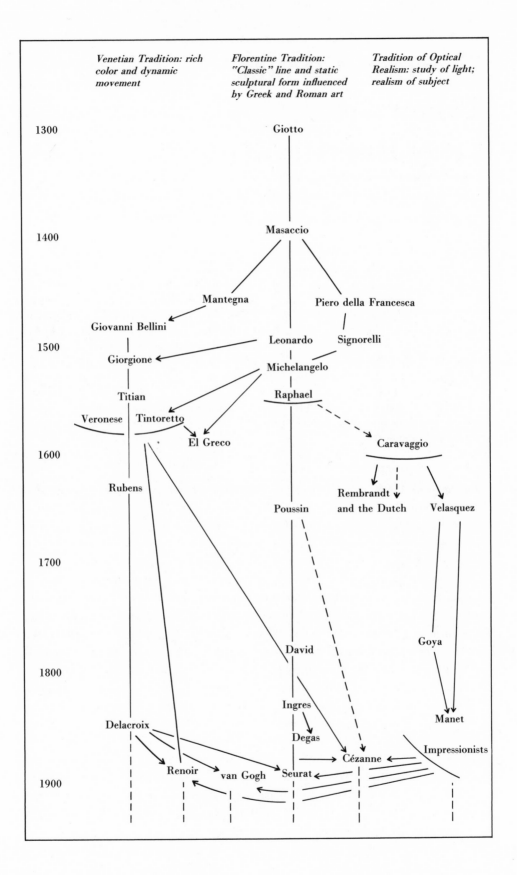

Twentieth-Century
Italian Art:
Early Futurism

The 1949 show of *Twentieth-Century Italian Art* was organized by James Thrall Soby (Assistant Director of the Museum in 1943, Director of Painting and Sculpture 1943–45, Chairman of the Department of Painting and Sculpture in June 1947, and a trustee since 1942), with Barr choosing the works for the Futurist section, collaborating with Soby on the others, and helping, through his influence and diplomacy, to arrange loans. Soby had counted on him to write the Futurist section of the catalogue, but Nelson Rockefeller, President of the Museum, did not want Barr's work on a revised edition of *Cubism and Abstract Art* interrupted. Ultimately, Soby persuaded Rockefeller that Barr's name would "mean much to the prestige of the Italian catalogue." Barr asked for, and got, Rockefeller's "personal approval as president," and wrote the following, with "some misgivings. . . . I am horribly muscle-bound in the actual writing."[87] A revised edition of *Cubism and Abstract Art* never did appear.

In the year 1909, dreaming of her past, Italy slumbered—or so it seemed to certain young Milanese. In politics, Premier Giolitti was ingeniously balancing Parliament, labor, business, the Church; compromising, conciliating, effecting a certain material prosperity in spite of social unrest; weaving an intricate path between reaction on the right, anarchism and syndicalism on the left. In philosophy, the Neapolitan school flourished under Croce and Gentile, systematic, scholarly, history-minded. In literature honors were divided between Pascoli, a sensitive lyric poet, traditional in spirit and like his master, the pessimistic Carducci, a professor at the University of Bologna; and d'Annunzio, erotic melodramatist, celebrant of Italy's Middle Ages and Renaissance and, above all, of Venice. In music the vacillating Boito lingered for the forty-seventh year over his opera *Nero;* Puccini, five years after *Madame Butterfly,* was at work on *La Fanciulla del West;* and Busoni was in Berlin emulating Liszt by rearranging Bach.[88] Italian films led the world but they were "epics" of Antiquity which were to culminate shortly in *Quo Vadis, The Last Days of Pompeii* and finally, *Cabiria,* a superfilm of the Punic Wars. Among painters of reputation Mancini held the field in Rome, recalling late Titian and Rembrandt with rich virtuosity; Boldini in Paris was out-Sargenting Sargent; Sartorio admired d'Annunzio and painted like Böcklin; the languid "pittori lirici" looked back to the English Pre-Raphaelites; and the last of the *Macchiaioli* remembered Fattori and other

Italian equivalents of Manet or Winslow Homer. The successful sculptors were clever modelers like the aging Gemito who had flourished since his *Fisherboy* had been bought by Meissonier; but Medardo Rosso, revolutionary precursor of Rodin at his boldest, was officially neglected. Neglected, too, were the most modern painters of the period, the divisionists, who worked in a style parallel to French neo-impressionism of the 1890's. Their leader, Segantini, had been dead ten years.

Yet in this easy-going, unambitious, retrospective, peninsular Italy of 1909, there were already rumblings and cracklings of an aggressive modernism. The year before, in Florence, Prezzolini had founded the periodical *La Voce* which published brilliant, modern, internationally-minded criticism by Giovanni Papini and Ardengo Soffici, the latter a young painter just back from Paris. And in Milan, Filippo Tommaso Marinetti, wealthy, educated at the Sorbonne, a poet and dramatist, a declaimer of French and Italian poetry, the founder and editor of *Poesia,* was preparing an explosion. On the 20th of February, 1909, his play, *Le Roi Bombance,* a burlesque *à la* Jarry, opened in Paris at the Théâtre de l'Oeuvre. On the same day, Marinetti published in *Figaro,* the Paris newspaper for which he was the Italian literary correspondent, the first

MANIFESTO OF FUTURISM

We shall sing the love of danger, energy and boldness. . . .

We declare that the world's splendor has been enriched by a new beauty: the beauty of speed. A racing motor-car, its hood adorned with great pipes like snakes with explosive breath . . . a roaring motor-car, which runs like a machine gun, is more beautiful than the *Winged Victory of Samothrace.*

We stand upon the topmost crest of the centuries! . . . Why should we look behind us, when we have to smash in the mysterious portals of the Impossible? . . .

We wish to glorify War—the only health giver of the world—militarism, patriotism, the destructive arm of the Anarchist, the beautiful Ideas that kill, the contempt for women. . . .

We wish to destroy the museums, the libraries, to fight against moralism, feminism and all opportunistic and utilitarian meannesses. . . .

It is in Italy that we launch this manifesto of violence, destructive and incendiary, by which we this day found Futurism, because we would deliver Italy from its plague of professors, archaeologists, tourist guides and antique dealers. . . .

The oldest amongst us is thirty; we have, therefore, ten years at least to accomplish our task. When we are forty, let others, younger and more valiant, throw us into the wastebasket like useless manuscripts!

We stand upon the summit of the world and once more we cast our challenge to the stars!

Marinetti's call to arms aroused considerable interest in Paris and, as he had hoped, it electrified the youthful Milanese. The band of Futurist writers grew and was soon joined by three young painters, Boccioni, Carrà and Russolo. They had known each other for over a year and were already united in revolt against the stale air of artistic Milan where the Lombard divisionists were still considered too radical for academic tolerance. Carlo Carrà, born in 1881, had worked with the two best painters in Milan, the realist Tallone and the poetic Previati. Umberto Boccioni, born in Calabria in 1882, had studied with the most advanced painter in Rome, the divisionist Giacomo Balla. In 1904, with his master Balla and his fellow student Gino Severini, Boccioni had helped organize the first Roman *salon des refusés.* In 1907, he settled in Milan and in January, 1909, conspired with Carrà and Luigi Russolo to put on a rebel section in the staid annual exhibition of the society *Famiglia artistica.*

About a year later, after discussions with Marinetti, Boccioni, Carrà and Russolo began work on their own manifesto. Boccioni wrote his friends Balla in Rome and Severini in Paris and got them to join with the Milanese trio in signing their proclamation, dated February 11, 1910:

MANIFESTO OF THE FUTURIST PAINTERS

To the young artists of Italy!

By associating our ideals with those of the futurist poets we are launching a cry of rebellion. . . .

We want rabidly to fight the fanatical, lifeless and snobbish cult of the past which is fed by the deplorable existence of museums. . . .

For other countries Italy still seems the land of the dead, a huge Pompeii white with graves. But actually Italy is coming alive and her political rebirth is now followed by her intellectual rebirth. In the country of illiterates schools multiply; in the country of *dolce far niente* countless factories roar; in the country of traditional esthetics inspirations sparkling with novelty are taking flight today. . . .

Art is vital only when it is grounded in its environment. Our ancestors drew their artistic material from the religious atmosphere that weighed upon their souls and in the same way we must draw our inspiration from the tangible miracles of contemporary life, from the iron net of speed that envelops the earth, from ocean liners, from dreadnoughts, from marvelous flights that plough the skies, from the dark daring of underwater navigators, from the anguished struggle in the conquest of the unknown. And can we remain insensitive to the frenzied activities of great capital cities, to the new psychology of night life, to the hectic figures of the *viveur,* the *cocotte,* the *apache* and the intoxicated? . . .

We propose:

. . . To exalt every form of originality even if reckless, even if over-violent. . . .

To consider art critics useless and harmful. . . .

To rebel against the tyranny of the words "harmony" and "good taste," expressions so elastic that with them one might easily demolish the work of Rembrandt, Goya and Rodin. . . .

To render and glorify the life of today, incessantly and tumultuously transformed by the victories of science. . . .

A month later, March 8, 1910, at the big Chiarella theatre in Turin, the three Milanese painters took part with Marinetti in their first "Futurist Evening." Boccioni read their new Manifesto to an outraged public which had already hissed verses from Dante's *Divine Comedy* under the mistaken impression that they too were Futurist poetry. Carrà then denounced the Italian critics "who didn't know the difference between Cézanne and Ettore Tito" and the evening ended in a riot. Other evenings followed in Milan and other cities. At Bologna, Carrà was nearly struck by the back of a bench hurled from a balcony. In Treviso the Futurists were rescued from a furious citizenry by the police. Marinetti bearded the Austrians in Trieste, and, with the three painters, assaulted d'Annunzio's Venice in the manifesto *Contro Venezia Passatista*. (D'Annunzio countered by making the hero of his new novel an airplane pilot.)

A month after the Turin riot, the five artists signed an explanatory statement, dated April 11:

TECHNICAL MANIFESTO OF FUTURIST PAINTING

. . . Our thirst for truth can no longer be assuaged by traditional form and color!

A gesture for us will no longer be an *arrested moment* within the universal dynamism: it will be, definitely, *dynamic sensation* itself. . . .

Everything is moving, everything is running, everything is whirling. A figure never stands passively before us, but appears and disappears constantly. Thanks to the persistence of images on the retina, forms in movement are multiplied, deformed, follow one another like vibrations in the space through which they pass. Thus a running horse does not have four legs: he has twenty and their movements are triangular. . . .

The sixteen people around you in a moving tram are one, ten, four, three: they are still and they move; they come and go, they rattle along the street, they are devoured by a patch of sunlight, they sit down again—persistent symbols of universal vibration. And sometimes on the cheek of the person we are speaking to on the street we see a horse passing by at a distance. Our bodies penetrate the couches on which we sit, the couches penetrate us, just

as the tram going by enters the houses which, in their turn, fall upon the tram and become amalgamated with it.

... Painters have always shown us figures and objects arranged in front of us. We are going to put the spectator at the center of the picture.

We proclaim ... that universal dynamism must be rendered as dynamic sensation; that movement and light destroy the substance of objects.

We are fighting . . . against the superficial and elementary archaism based on flat tints which reduces painting to an impotent synthesis, infantile and grotesque; against the nude in painting which has become as boring and nauseating as adultery in literature.

We are the primitives of a new and completely transformed sensibility.

After reading these manifestoes so full of youthful bombast, Bergsonian metaphysics, reckless iconoclasm and defiant patriotism, the early paintings of the Milanese Futurists—at least what is left of them—seem an anticlimax. Almost all the Carràs and Russolos of 1910 have, in fact, disappeared. There are a few Boccionis of Milanese industrial suburbs or small excited crowd scenes painted in a meticulous, neo-impressionist, or divisionist dot technique. And there is *The City Rises,* Boccioni's panorama of building construction, the energies of modern technology symbolized not by machines as one might expect from the Futurist manifestoes, but by two colossal horses and their drivers straining at their work. The . . . forms in this painting seem fused in a kind of flowing radiance, as if painted with an electric brush.

The *Street Pavers,* somewhat later in style, combines divisionist breaking up of light into color spots with cubist breaking up of form into angular planes.

After more demonstrations which included a riotous evening in Rome, the trio held their second show in Milan at the Ricordi Pavilion in the early summer of 1911. A list of the exhibition is not available, but the show probably included two large works by Boccioni, *The City Rises* and *The Laugh,* a garish night-life scene in which the round gaping face of a belly-laughing woman seems to shatter tables, shirt fronts, glasses and bright gowns into a fantasmagoria of color sliced by light rays. Boccioni's chief new work comprised three canvases illustrating *States of Mind.* The large preliminary drawings reveal a rather obvious and naïve use of abstract lines for symbolic and emotional effects. In *The Farewells,* whirling, twisting lines amplify the figures and gestures of the leave-takers. In *Those Who Go,* sharp blade-shaped lines streak across the surface veiling half-seen fragments of the faces of the travelers, while telegraph poles, trees and houses flicker by, merging with the inside of the train along the lines of the paragraph in the *Technical Manifesto* which describes the interior-exterior of a tram in motion. In the third drawing, the figures of those left behind walk slowly away from the station through curtains of drooping, dejected lines.

The canvases themselves were repainted after a trip to Paris in the fall. By comparison with the drawings, the paintings in their revised version are more developed and less obvious. They well demonstrate the Futurist effort to pre-

sent simultaneously subjective feeling and the complex sensations of movement or flux.

Carrà's large Futurist painting, the *Funeral of the Anarchist Galli,* was also finished in 1911. In his autobiography he describes how, in 1904, he was watching the funeral of the assassinated radical on its way to the Musocco Cemetery. A riot broke out against the squadron of mounted police protecting the procession. "Without wishing to, I found myself in the center of the struggle. I saw the bier covered with the red flag careening on the shoulders of the pallbearers. I saw the horses rear skittishly, canes and lances clashing, so that it seemed to me that the coffin would fall at any moment and be trampled by the horses." It was this experience which led him, six years later, to contribute to the *Technical Manifesto* the phrase, "we are going to put the spectator at the center of the picture"—though Boccioni also claims credit for this idea. The Futurist use of broken silhouettes, interpenetrating lights and shades and the flickering fan-shaped patterns of flailing weapons contributes to the frenzied kinesthesia of the painting. Yet, fundamentally, in its main lines and masses Carrà's *Funeral* is as classically organized as a fifteenth-century battle piece by Paolo Uccello.

Somewhat later in 1911 Carrà painted *The Tram,* which he originally called, *What the Tram Said to Me.* Again the sense of the simultaneity of movement and the sensation of inner and outer space are fused by the fragmentation of forms, lines and color surfaces.

The exhibition at the Ricordi Pavilion produced some blunt criticism by Soffici in *La Voce.* The Florentine, with seven years of Paris behind him, said the Futurists grossly exaggerated their own importance and called their paintings half-baked in comparison with the work of contemporary French masters whose work he accused them of garbling. The Futurists—Marinetti, Boccioni, Russolo and Carrà—took the next train to Florence and found Soffici, Papini and the rest of *La Voce* at the Café Giubbe Rosse. Boccioni hit Soffici and started a fight. They were all taken to the police station, but were released only to renew the brawl in the station the next morning as the Futurists boarded the train back to Milan.

Soffici's criticisms were confirmed by Severini who came down from Paris a few months later. Though he had signed the 1910 manifestoes at Boccioni's persuasion, he found the paintings of the Futurists pretentious, literary and uncertain in style. He insisted that they must come to Paris to make themselves *au courant* with modernism at its source. Together they persuaded Marinetti to pay for the trip, and later in the fall they all arrived in Paris for a reconnaissance. In Severini's company they saw cubist pictures and their painters first hand. At the same time they made arrangements with Félix Fénéon, the manager of the important Bernheim Jeune Gallery, for a great exhibition to be held early in the new year. When they returned to Milan they painted furiously to prepare for the crucial test.

The exhibition opened February 5, 1912, with a stormy oration by Marinetti

before a large gathering of the Paris *avant-garde,* many of whom had previously read the various Futurist manifestoes. The French were aware that the Futurists were mounting a frontal assault on French hegemony in the arts; and they were offended by the aggressive belligerence of the Italians. Apollinaire and [André] Salmon took the Futurists fairly seriously, but other critics were condescending or hostile. Modigliani was outraged; Picasso, contemptuous. Yet the general uproar gave the Milanese a sense of success. Carrà's *Funeral of the Anarchist Galli* was reproduced on the front page of *Le Journal* and the publicity was considerable. Severini, however, was embarrassed by what seemed to him provincial chauvinism on the part of his friends, but he found their paintings better integrated in style than those he had criticized in Milan.

Besides the *Funeral,* Carrà showed *The Jolting of a Cab, What the Tram Said to Me, The Milan Station* and several paintings which seemed more static and cubist than Futurist. Boccioni showed the repainted *States of Mind, The Street Enters the House, The City Rises, Forces of the Street,* and *Simultaneous Vision.* Russolo exhibited *A Tram in Motion,* and his most famous work, *The Revolt.* The largest painting in the show was the *Pan-Pan at the Monaco* by Severini himself, who for the first time was showing with his fellow Futurists. He had been working for two years on this kaleidoscopic panorama of a night club, using flat, angular fragments of color. He also showed *Recollections of the Voyage,* a composite picture of trains, trams and buildings, and the *Boulevard,* which well illustrates his early Futurist style.

Although the Paris exhibition was not received with critical enthusiasm, it aroused popular curiosity throughout Europe. From Paris it went to London, accompanied by Boccioni and Marinetti. On the 10th of March, an hour before the press review of the London show, Boccioni wrote to his friend Vico Baer in Milan: "The Paris show has proved to all Europe the existence of a new movement animated by a formidable enthusiasm. . . . My preface to the catalog aroused so much interest that 17,000 copies were printed. The English catalog is fine too. They have added explanations of every painting . . . which will be useful to these *bestie di Inglesi*—these stupid Englishmen—as Benvenuto Cellini used to call them. Anyway, the public is imbecile in all countries, and just as it does not understand in Italy, it does not understand here, and it does not understand in France.

"Those here abroad who know Italy and the infantile, ignoble, vulgar condition of its esthetic standards, cannot understand how we have been able to escape from the mud puddle, and thereby, with one leap, put Italian art side by side with French."

From London the exhibition went to Berlin under the auspices of the Sturm Gallery. In Berlin all the remaining paintings were sold, but the exhibition, totaling thirty-four canvases, was kept together for subsequent showings in Brussels, Hamburg, Amsterdam, The Hague, Munich, Vienna, Budapest, Frankfort, Breslau, Wiesbaden, Zurich and Dresden. In the middle of the tour, the Futurists were invited to take part in the "Armory Show" in New York, held

early in 1913, but they refused because they wanted separate galleries with a separate box office. Their work was not to be shown in America until the San Francisco Exposition of 1915.

Boccioni did not accompany the exhibition on its grand tour, but returned from Berlin to Paris where he renewed his interest in sculpture. By the end of spring he had gone back to Milan in spite of Severini's insistence that all the Futurists should leave Italy to seek their artistic fortunes in the great competitive arena of the French capital. Marinetti, meanwhile, had gone east to enjoy the Balkan War which inspired his most famous poem, *Zang-tumb-tumb or The Siege of Adrianople.*

Back in Milan, the Futurists found that their international renown had not deeply impressed their fellow countrymen. Soffici, perhaps a little jealous of the Paris show, wrote another attack in *La Voce,* accusing the Futurists of charlatanism, professional vulgarity and of using Belgian and American publicity methods. Yet the article was kinder than the piece of a year before which had led to the battle of the Café Giubbe Rosse. Though he proclaimed that the Paris show was mostly a *succès de scandale,* he admitted that it had helped break down the legend of Italy's living in her cultural past. Severini, who had been introduced to Soffici by Picasso, now renewed their acquaintance in Tuscany, and before the end of the year a coalition between the Milanese and Florentine vanguards had taken place, thanks partly to Severini's diplomacy. Papini and Soffici actually deserted *La Voce* and founded a new magazine, *Lacerba,* which passed rapidly from tolerance of Futurism to enthusiastic participation. Thereafter, for a year and a half, *Lacerba* was the chief Futurist organ.

In February, 1913, the combined Milanese and Florentine forces put on an exhibition in Rome, and a Futurist Evening at the Costanzi Theatre where they were greeted with a "nutritious shower of missiles *più o meno alimentari.*"[89] The Roman exhibition, one of the best of all Futurist shows, included the mature work of Severini, the three Milanese and, for the first time, Balla and Soffici.

Boccioni showed six canvases including *Materia,* his major work of 1912, a complex painting in which the imposing figure of his mother, sitting with colossal folded hands, dominates, and at the same time is absorbed into her environment, the interior of the room, the window, the balcony and a row of houses across the street beyond. *Elasticity,* with its cantering horse and rider seen against a background of factories and high-tension poles, is less ambitious but better integrated.

Carrà's paintings of 1912 grew closer to the static analytical cubism of Picasso and Braque, though his Futurist masterpiece, *The Milan Galleria,* involves some suggestion of orthodox Futurist commotion. The quality and restraint of Carrà's painting of this time quite belie the Futurist rebellion against "harmony" and "good taste." Soffici, the new recruit, also contributed work which seems more cubist than Futurist. Russolo showed *The Fog,* Balla, the *Girl* × *Balcony* and the *Leash in Motion.*

Balla, although he had signed the 1910 manifestoes, had developed his style

in the comparative isolation of Rome. The *Girl × Balcony* shows that he had not yet freed himself from Signac-like neo-impressionist spot painting. The study for the feet in the *Girl × Balcony* suggests that his technique of kinetic suggestion is derived directly from the "geometrical chronophotographs" of figures in motion such as were made by E. J. Marey in Paris as early as 1883 and widely publicized. Balla's kinetic researches are clarified in the *Leash in Motion,* one of the most famous, original and entertaining of all Futurist paintings.

Among Severini's six pictures was his masterwork, the *Dynamic Hieroglyphic of the Bal Tabarin,* painted in Faenza in the summer of 1912. In it are still a few passages which seem naïve and out of style, but on the whole the *Bal Tabarin* wonderfully assimilates and expresses the tinsel whirl of a Paris cabaret. The sequins glued to the canvas, Severini writes, had a respectable precedent in the jewel-encrusted halo of a fourteenth-century Saint Peter in the Brera, which Apollinaire mentioned to him. Severini's sequins themselves may have anticipated cubist collages by several months. Two years before, however, the cubists had begun to use isolated words and letters in their compositions. Severini, of course, knew their work but with typically Futurist concern for subject matter he scatters such words as VALSE, BOWLING, POLKA through his *Bal Tabarin* as integral and positive elements in the representation of the scene. Later, words and images are used in almost equal balance by Severini and Carrà in some of their war pictures and by Marinetti in his war poems.

The exhibition in Rome marks a high point in the development of Futurist painting, indeed of Futurism as an art movement. The show traveled as a whole to Rotterdam and selections from it were shown in Berlin and elsewhere, including Balla's *Leash in Motion* and Severini's *Bal Tabarin* which was sold in London. Many young artists of talent and some older men were attracted to the Futurist standard, and Futurism's influence grew stronger throughout Europe. Even the French critics and artists were now not only more respectful, they even borrowed Futurist critical and pictorial ideas, usually without giving credit. All through 1913 *Lacerba*'s pages were full of new manifestoes and polemical articles by Boccioni, Carrà, Marinetti, Soffici and Papini. Russolo published his manifesto on the *Futurist Art of Noises* and followed it with performances on his noise-machine in Paris and London as well as in Italy. Pratella, whose manifesto of Futurist music had appeared in 1910, conducted a Futurist symphony in Rome. Carrà was asked by Diaghilew and Strawinsky to design a ballet. Severini had a successful one-man show in London. Most important of all, Boccioni held his first exhibition of Futurist sculpture in Paris. The Futurists staged violent evenings at Genoa, Venice, Mantua, Padua, the series coming to a climax in Florence on December 12 at the Teatro Verdi where Carrà's "smoking" was soiled by a direct hit of *"pasta asciutta."*

Among the memorable Futurist paintings of 1913 are Severini's train compositions. . . . The use of chevron or wedge-shaped forms to suggest speed and force had however been initiated by Russolo in 1911 in his striking *Revolt.*

Throughout 1913 Balla also experimented successfully with the suggestion of speed in a series of automobile pictures which began with the earlier *Speeding Automobile.* Balla's *Swifts,* sub-titled *Paths of Movement + Dynamic Sequences,* combines exterior and interior, moving and static objects by fusing kinetic series of birds in flight with the window frame and suggestions of roof tiles and gutters.

Boccioni painted the *Dynamism of a Cyclist . . .* and the *Dynamism of a Human Body.* To these may be added the best known of his drawings, *Muscular Dynamism.* These three pictures belong fundamentally to the long series of studies of the human figure in action, striding, running, cycling, which pre-occupied Boccioni more than any other subject. In painting, these researches are climaxed by the huge *Football Player* of 1913. More notable, however, than any of these pictures is the series of striding figures in sculpture which he completed in the same year.

Boccioni's theories of sculpture, announced in the *Technical Manifesto of Futurist Sculpture,* April 11, 1912, were just as elaborate as his painting theories. They were also more prophetic of future developments, far more than he himself could realize in his two short years of work as a sculptor. In the manifesto he condemns, of course, the oppressive weight of the Greeks and Michelangelo upon the contemporary sculpture of France, Belgium and Italy. He scorns the archaistic and primitivist tendencies in Central European sculpture. He rejects the academic insistence upon the nude human figure and proposes sculpture which would integrate the complex elements and emotions of contemporary life. He dismisses his older contemporaries Meunier, Bourdelle, Rodin, but praises with real sympathy the plastic fluidity and freedom of Medardo Rosso. He proposes a sculpture of movement and atmosphere, the abolition of the silhouette, the extension of natural forms into space and the use of *polimateria,* that is, the abandonment of the traditionally "noble" materials of bronze and marble for glass, wood, cardboard, concrete, horsehair, leather, cloth, mirrors, electric lights, in various combinations. He foresees sculpture not only of forms in movement but sculpture itself mechanically mobile.

Boccioni's own sculpture falls into two periods, before and after his visits to Paris in the winter of 1911–12. The early work is ambitiously complex. *Head + House + Light,* now destroyed, was very closely related to the painting *Materia,* but the fusion of the woman's figure with a balcony and a house across the street together with rays of light results in a grotesque conglomeration, courageous but too doctrinaire. In Paris in March of 1912 Severini had taken him to the studios of Archipenko, Brancusi and Duchamp-Villon. Although his own ideas were more radical than theirs, their more traditional and less pictorial sculpture may have persuaded Boccioni to return to more manageable problems.

Back in Milan, he began the series of striding figures. The first, *Synthesis of the Human Dynamism,* still includes miscellaneous fragments of environment such as window mullions. In 1913 he abandoned these accessories, clarifying his forms in three successive figures, the *Spiral Expansion of Muscles in Movement,* the *Muscles in Velocity* and the climactic *Unique Forms of Continuity in*

Space. This last figure well embodies Boccioni's theory that "sculpture should bring to life the object by making visible its prolongation into space. The circumscribed lines of the enclosed statue should be abolished. The figure must be opened up and fused in space." The muscles of the *Continuity* figure are forced into streamlined shapes as if under the distorting pressure of supersonic speed. The sense of gravity is further diminished by the flaming spiral of the figure when seen from the front.

A still life of 1912, the *Development of a Bottle in Space,* demonstrates Boccioni's dictum that "there is more truth in the intersection of the planes of a book with the corners of a table . . . than in all the twisting of muscles in all the breasts and thighs of the heroes and venuses which inspired the idiotic sculpture of our time."

Boccioni took his ten pieces of sculpture and twenty drawings to Paris for a show at the Galerie La Boëtie in June, 1913. At the opening he spoke in faltering French which Severini helped to interpret to an audience more sympathetic and respectful than that which had greeted Marinetti at the general exhibition of Futurist painting fifteen months before. Though influenced somewhat by cubism, [the *Bottle* and the *Continuità*] seem more advanced than any sculpture of the period in which they were done; and the *Continuità* remains one of the brilliant achievements of early twentieth-century art.

Futurism as a movement continued to gain ground in Italy during 1914. Adding still another art to the movement, the architect Antonio Sant' Elia published his manifesto *L'Architettura Futurista* in *Lacerba* of August 1, 1914, together with remarkably prophetic projects for skyscrapers with terraced setbacks several years before the zoning law brought about similar designs in New York. And Boccioni published his *Pittura, Scultura Futuriste,* the authoritative source-book on early Futurist art.

In his paintings Boccioni, abandoning the expression of violent movement, worked on the traditional theme of the figure seated at a café table, adding light rays and psychological atmosphere which were lacking in cubist paintings of similar subjects. Severini began a series of highly abstract compositions painted in a whirl of gay, rainbow colors, among them the *Dancer—Helix—Sea.* Carrà and Soffici, however, were more and more influenced by cubism. They assimilated collage techniques with greater skill and sensibility than any but the best Paris cubists. Indeed Carrà recalls that in the spring of 1914 he was offered a contract by Kahnweiler, discriminating dealer of Picasso, Braque and Gris.

The outbreak of the European war in August, 1914, aroused the Futurists to even more violent activity. Boccioni had written in the catalog of the Paris exhibition of February, 1912, "If our paintings are Futurist, it is because they represent the result of ethical, esthetic, political and social concepts which are absolutely Futurist." To the faithful, Futurism was a way of life devoted, among other things, to the patriotic aggrandizement of Italy. The Futurists were anti-German and, of course, anti-Austrian. They were pro-French politically and through strong personal associations, particularly in the cases of Marinetti,

Soffici and Severini. Consequently they threw themselves with the utmost energy and enthusiasm into the cause of Italian intervention on the side of the Allies. As a result of public demonstrations, they were several times arrested and jailed (once with Mussolini, in Rome) and when Italy finally entered the war in April, 1915, most of the Futurists responded wholeheartedly and courageously to the call to arms. Russolo and Boccioni enlisted in the artillery. Marinetti was wounded and twice decorated. Sant' Elia was killed.

Boccioni's letters from the front reveal the natural conflict between Futurist romanticism and military reality. To Vico Baer he writes: "At last I have received the baptism of fire . . . I counted seventeen shots, four explosions a few steps away which covered us with leaves and earth. Fortunately Marinetti and I were flat on the ground." And again, "Here we are fighting against the wind, the hard rocks and the bugs. Excuse me, it is hard to believe it, but war is made up also of this: bugs, boredom and unsung heroism." But he could also write with true Futurist *élan:* "We have been shelling for four days to open the road . . . it is marvelous. 149 shells going over like express trains. It is beautiful and terrible. Tomorrow we move forward. I shall write you. At least I hope to. . . ."

But, on that tomorrow or perhaps a little later, Boccioni was hit and invalided to a base hospital at Verona. There, one day in the summer of 1916, before he was fully recovered, and under circumstances of extreme romantic irony, he was killed in a riding accident.

"The War is a motor for art," Carrà proclaimed in his book *Guerrapittura* published in 1915 and signed Carrrà``—with one extra consonant, two extra accents and a growl. And between political demonstrations and military service, the Milanese Futurists produced a number of drawings such as Carrà's *Cannon at a Gallop* or Boccioni's *Charge of Lancers,* brushed on a collage of war news clippings. But it was Severini who made the best Futurist pictures of the war, perhaps because he took no active part in it. During 1915 he lived near a station on the outskirts of Paris where he could see ammunition and Red Cross trains moving to and from the front. The *Armored Train* was probably painted at this time. The drawing, *Flying over Rheims,* must be one of the first air-view pictures by a well-known modern artist. Earlier in his life Severini had wanted to be an aviator.

Yet, in spite of the stimulation of the War, the original group of Futurist artists was disintegrating. By the end of 1914, Boccioni had begun to desert Futurism for a more static and traditional technique. His last important work, the portrait of his friend the great pianist Busoni, was completed in 1916 not long before his death, in a style very close to Cézanne. Carrà's ardor as a Futurist painter was also cooling. In 1915 he forsook Futurism in his painting; in 1916 he contributed articles in praise of Giotto and Uccello to *La Voce* which had revived as a rival to *Lacerba;* and early in 1917 he became a collaborator of de Chirico in *pittura metafisica,* a movement entirely anti-Futurist in spirit. In 1915, Papini, the publisher of *Lacerba,* and Soffici, too, formally repudiated

Futurism, going back, as Marinetti scornfully expressed it, to *"passatismo."*[90] However, Balla remained faithful; and Rosai and then Sironi . . . joined the movement briefly. In Paris, after his Futurist war pictures of 1915, Severini accompanied Picasso back to a kind of neo-classic style, at least in his figure painting. It is true that as late as 1917, Carrà and Severini signed themselves as Futurists in one-man shows, the former in Milan, the latter in Alfred Stieglitz' Gallery in New York. But their allegiance was vestigial. When Marinetti emerged from the war to ally himself with his fellow interventionist, Mussolini, none of the original band of artists was with him save only Balla.

Futurism undoubtedly involved some of the same elements as Fascism: chauvinism for instance, admiration for war and military courage, enthusiasm for technology and machinery—"modernolatry"—to use Boccioni's word. But, fundamentally, Futurism was anarchic, not Fascist. Once Fascism was in power, the love of freedom, of perpetual revolt against the stale and conventional which had characterized early Futurism, was no longer politically valuable within the discipline of the totalitarian state. A second generation of Futurists grew up around Marinetti, painted, wrote manifestoes, demonstrated and were accorded some official recognition. A few of them were men of talent but their activities seem marginal and their achievements minor in quality beside those of the original Futurists. More congenial to the Fascist régime—and far better rewarded by it—were the *Novecentisti* who, as Mr. Soby recounts, rode the general wave of reaction and isolationism by painting old-masterish figures and landscapes, often with solemn references to the Italian Renaissance or Imperial Rome.[91]

Throughout Europe, however, the influence of early Futurism was perhaps greater than that of any movement save cubism. Often dismissed by the French as a rather tasteless and provincial back eddy of cubism, Futurism was in principle, a repudiation of the static, puristic and quasi-academic elements in the Paris movement. Quite deliberately Boccioni insisted upon the importance of subject matter and overt emotion which the *fauve* and cubist movements had almost eliminated in favor of an art of pure esthetic values. A number of Paris artists and critics felt the impact of Futurism. In 1913 Apollinaire himself contributed a manifesto, *L'Antitradizione Futurista,* to *Lacerba.* And the Dadaists of 1916 turned to the Futurists for valuable precedent in iconoclastic agitation and as well for their later rejection of the dogmas of the *Section d'Or* cubists. Through the Dadaists, the irrational element in Futurism passed on to Paris Surrealism in the early 1920's. Futurism also influenced the Berlin *Sturm* group before 1915, the Berlin Dadaists such as George Grosz after 1917, the British Vorticists of 1914, the Central European Activists, and Americans such as Weber and Stella.

Marinetti had lectured in Moscow in 1914 and it was in Russia both before and after the Revolutions of 1917 that Futurism flourished most vigorously. The kinetic effects in Malevich's painting of 1912–13 and later in the work of Burliuk, the dynamic-mechanical, multimaterial esthetics of Tatlin's construc-

tions, the general machinolatry of the theatre, the poetry of Mayakovsky, all were in large part latently or avowedly Futurist in inspiration. But Futurism soon shared the fate of other modern movements in the U.S.S.R. As in Nazi Germany ten years later, they were discouraged and then suppressed by a régime which feared any sign of individual freedom or of nonconformity with popular taste as exploited by authoritarian politicians.

The year 1949 marks the fortieth anniversary of Italian Futurism. Conceived in a spirit of cultural rebellion, born as an instrument of international rivalry, nourished in the rumor of war, discolored by subsequent political associations, Futurism and its works are not easy to appraise. Even its name or, rather, the adjective "futuristic," has been misapplied by the general public to almost everything new and modern that has emerged in the art of the past four decades. Yet it should be possible now to wipe the dust of age and battle from these paintings and drawings and sculptures and look at them with fresh interest and a certain objectivity. However we may ultimately judge the quality of their work and whatever mischievous ideas we may deplore in their doctrine, we may conclude that few ventures in the history of art have been conducted with more energy, courage, and enthusiasm than that of the early Futurists.

Matisse, Picasso, and the Crisis of 1907

By May 1951, Barr had already written *Picasso: Fifty Years of His Art*; *Matisse: His Art and His Public* would appear later that year. This article was based on two chapters from the latter book. (From the *Magazine of Art,* May 1951.)

In the year 1907 the fauve group, which had held the Paris vanguard for three years, disintegrated, and a new movement which might be designated Cézannism began to form. The Cézannists were divided: Derain, Vlaminck, Friesz led the conservative wing; Picasso, followed by Braque, was far more radical. Learning something from primitive art, as well as from Cézanne, and encouraged by certain popular echoes of space-time physics, they gradually developed cubism, the most important innovation of the period.

Matisse, the leader of fauvism, the movement which was being superseded, had already been profoundly interested in Cézanne for almost a decade. By 1907, at the very moment the other painters were discovering Cézanne, Matisse was ready to move in a new and quite different direction. Consequently a crisis in leadership occurred which deeply affected the course of modern painting.

Though other personalities were involved, the protagonists in the drama were Matisse and Picasso, and though what they produced in their studios was of course essentially important, the chief arena where they happened to meet as personalities was the apartment of Leo and Gertrude Stein on the rue de Fleurus.

The rivalry between Matisse and Picasso has sometimes been oversimplified or overdramatized. Actually neither was temperamentally inclined to controversy, and neither had serious ambitions to figure as the leader of a coterie or movement. Both were highly individualistic, and the influence each exerted on others, though very great, was incidental to the development of his own art.

Matisse's role as a leader of his fellow artists had begun almost a decade before 1907 during what might be called his second student period. In 1897, after a brilliant début as an academic still-life painter, he abandoned a safe and conventional career to follow the difficult path of the creative artist. In 1899 he returned to Paris after a year spent in Corsica and Southern France, where he experimented with a personal variation of impressionism. Back in Paris, Matisse

went to school again—not to learn from teachers, however, but to work out his own problems while drawing from the model. First he went to the studio of his old teacher, Gustave Moreau, at the Ecole des Beaux-Arts. But Moreau had died, and his successor Cormon was so alarmed by Matisse that after several weeks he asked him to work elsewhere. Yet his brief stay left such an impression that two years later, when Raoul Dufy entered the same studio, he could still hear echoes of Matisse and his theories. After leaving Cormon's, Matisse tried the Académie Julian, but the students, Beaux-Arts bound, heckled him so that he moved on to the studio supervised by the liberal Carrière. In that less academic atmosphere, Matisse rapidly assumed a position of influence among his fellow students, who included Derain, Biette and Jean Puy.

This leadership was due to factors of personality, ability and circumstance. Born in 1869, Matisse was older than his companions and had already made two false starts—first as a law student, then as an academician. To the advantage of superior age, he added exceptional critical intelligence, courage, talent, extraordinary pertinacity and a profound seriousness of purpose. Yet in spite of the radical character of his art, Matisse was so dignified and conventional in appearance that when Derain's bourgeois parents objected stubbornly to his becoming a painter, Matisse drove out to Chatou to call on them, and his respectability so impressed them that they were persuaded to relent.

Doubtless—and fortunately—they did not know Matisse's art, for by 1900 he was already painting pictures so bold in color and drawing that they might be called "proto-fauve." In fact, his friend Marquet and his disciple Derain were later to testify that fauve painting was definitely foreshadowed by Matisse's work of around 1900.

The fauve painters—the "wild beasts" whose bold deformations and brilliant, "unnatural" colors so shocked the public at the Salon d'Automne of 1905—had known each other for some years. Matisse had studied together with Rouault, Marquet and Manguin in Moreau's studio in the early 1890's. At Carrière's in 1899, as we have seen, he met other future fauves, including Derain, who introduced him to Vlaminck in 1901. During his dark period, while Derain was in military service and Vlaminck was working in isolation around Chatou, Matisse was the central figure of the group who exhibited at Berthe Weill's gallery. Friesz, Dufy and van Dongen showed there, too, and had come to know Matisse and his friends by 1904.

At the Salon des Indépendants early in 1905, the loosely associated group showed its strength to conspicuous advantage—partly, it may be, because Matisse was chairman of the hanging committee. His own "bathers" composition, *Luxe, calme et volupté,* was the most notable painting by a younger artist in the show. It was condescendingly criticized by the somewhat older leader of the Nabi-Symbolist painters, Maurice Denis, but the young Raoul Dufy found it a "revelation of the possibilities of modern art."

Later in that same year, at the Salon d'Automne, Matisse, Rouault, Marquet, Puy, Manguin, Friesz, Derain, Vlaminck and van Dongen all exhibited. Rouault

and Vlaminck were strong, independent figures who owed little to Matisse, but the others, though very talented, looked to him as their leader. It was Matisse, too, who bore the chief brunt of critical attack. His *Woman with the Hat* offended older painters and outraged the general public, but fascinated a minority— among them the young Americans, Leo Stein, his sister Gertrude, and especially his sister-in-law Sarah, wife of Michael Stein. Though Leo found the *Woman with the Hat* "the nastiest smear of paint" he had ever seen, it was bought and hung with the Cézannes and Renoirs in the studio-apartment which he and Gertrude shared in the rue de Fleurus. Soon afterwards all four of the Steins got to know Matisse, who became a frequent visitor both at the rue de Fleurus and at the rue Madame where the Michael Steins lived.

During the months after the Salon of 1905, Matisse toiled on his most ambitious fauve painting, the *Bonheur de vivre,* a very large composition of arcadian figures in a landscape. Matisse sent the *Bonheur de vivre* to the Salon des Indépendants in the spring of 1906. Again the artist was dismayed by the hostility of the public. Even Leo Stein was repelled at first, but he returned again and again to the Salon to study it. Finally, after announcing to his friend Maurice Sterne that it was "the most important painting done in our time," he proceeded to buy this work, too.

During 1906 and 1907 the fauves flourished. They dominated the Salon des Indépendants in the spring and the Salon d'Automne in the fall. They even had some material success. Vollard bought out the studios of Vlaminck and Derain and sent the two of them on a painting trip to London. The youthful Braque, who joined the group at the Indépendants of 1907, sold every one of his six pictures—they were rather mild by comparison with those of Matisse and Vlaminck. At the Salon d'Automne of 1907, the fauves exhibited in full force: Matisse, Marquet, Manguin; Vlaminck and Derain who were nicknamed the "school of Chatou"; Friesz, Dufy and Braque, the three painters from Le Havre; and the Dutchman, van Dongen. And there were new recruits. In his critique of the show, Jean Puy, one of the old guard, adds Metzinger, Le Fauconnier and Czobel, who was virtually a pupil of Matisse. Puy might have added the young American fauve, Alfred Maurer, who like Matisse had abandoned a safe conservative career.

The group's lack of inner cohesion was not yet clearly apparent, and Matisse still reigned not only as the *roi des fauves* but as the most influential younger master in Paris. Painter-critics of the slightly older generation, such as the classicist Denis and the realist Vallotton, could not like Matisse's art; but they respected him and accepted the fact of his leadership among the young. Yet before the end of the year, Guillaume Apollinaire, who was emerging as the new champion of the *avant garde,* in a famous article described Matisse not as a wild beast, nor a leader of the "cult of the ugly," nor a renegade seduced by the exotic delights of the Orient, but as a student of the great masters of European painting and a pillar of their tradition.

Within the next few years, Matisse's reputation was to grow enormously

throughout the world until he became its most famous living painter. But early in this period it gradually became clear that his position as the generating power at the very heart of the school of Paris was threatened. The rival star—or, better, dynamo—was Pablo Picasso.

During 1906–07, the Steins had continued to be Matisse's foremost supporters, far outdistancing their nearest French rival, Marcel Sembat, or the young German enthusiast, Hans Purrmann. The Michael Steins in fact bought most of Matisse's best paintings during the later fauve years, including the first version of the *Young Sailor,* the *Pink Onions,* the powerful *Self-Portrait* [1906] now in the J. Rump Collection, State Art Museum, Copenhagen, the magnificent *Blue Still-Life* and the monumental *Coiffure.* Sarah Stein and Purrman[n], who were already studying with Matisse, even began to talk of forming a class.

About 1907, however, Leo Stein's enthusiasm for Matisse's painting began to wane. Two more Matisses of that year, *Music* and the formidable *Blue Nude,* were to be added to the crowded walls at the rue de Fleurus, but they were the last. Leo began to feel that Matisse's art was "rhythmically insufficient." At the same time he was becoming even more skeptical about his other principal protégé, Picasso. Picasso was painting his big *Demoiselles d'Avignon,* which initiated cubism[92]—and cubism Leo was later to condemn as "godalmighty rubbish." Gertrude Stein, on her part, now grew more and more deeply interested in Picasso, though both she and Leo continued to welcome the Matisses to their Saturday evenings on the rue de Fleurus. Leo Stein, however, within two years from the time that he had first come to know Matisse and Picasso, began to turn his back on them—not socially, but esthetically. Nevertheless, as he himself has pointed out, he was the critic who first felt that Matisse *and* Picasso were the two important artists of his time.

Picasso was twelve years younger than Matisse. As a child he had had, it is said, his first one-man show in the doorway of an umbrella-maker in Corunna. That was about 1890—the very year Matisse, as an amateur, painted his first still-life. After an academic success as a youthful prodigy and a few brilliant years in Barcelona's bohemia, Picasso had come to Paris towards the end of 1900 to see the same World's Fair that a few months before had provided Matisse with a badly needed decorator's job. Within a few weeks Berthe Weill had sold some of his pictures, and in June, 1901, Vollard gave him a show, almost three years before he was to pay Matisse the same attention.

It is a curious coincidence that Picasso in 1901 was just entering his "blue period," a year or more after Matisse had begun his famous series of "blue" studies from the model. And just as Matisse had retired in discouragement to his home town of Bohain in 1902, Picasso in the same year, and in spite of Berthe Weill's efforts, starved and went back defeated to Barcelona, to return to Paris permanently only in 1904. Later in 1905 the minor dealer Clovis Sagot recommended Picasso to Leo Stein, who bought one of his circus pictures. A little later, guided by Pierre Roché, Stein went to Picasso's studio on the rue Ravignan, and soon the painter and his mistress, Fernande Olivier, began to

come to the rue de Fleurus. This happened shortly after the Steins had met Matisse as a result of buying his *Woman with the Hat* at the Salon d'Automne of 1905.

In his book *Appreciation* Leo Stein, after describing Picasso's shabby and disorderly room, and the artist himself as "more real than most people without doing anything about it," compares him with Matisse:

> The homes, persons and minds of Picasso and Matisse were extreme contrasts. Matisse—bearded, but with propriety; spectacled neatly; intelligent; freely spoken, but a little shy—in an immaculate room, a place for everything and everything in its place, both within his head and without. Picasso—with nothing to say except an occasional sparkle, his work developing with no plan, but with the immediate outpourings of an intuition which kept on to exhaustion. . . .
>
> Matisse was a social person rather than a convivial one. Picasso was more convivial than social. Matisse felt himself to be one of many, and Picasso stood apart, alone. . . . Matisse exhibited everywhere. He always wanted to learn, and believed there was no better way than to see his work alongside the work of everybody else. Picasso never showed with others. . . .[93]

During the early months of 1906, Picasso worked on the portrait of Gertrude Stein, now in the Metropolitan Museum, and in the summer went to Gosol in the Pyrenees where he developed his rose or "pink" style. Matisse, who at the beginning of the year had completed his *Bonheur de vivre,* then visited North Africa and spent the summer as usual at Collioure, not far, as it happened, from Gosol across the border. Back in Paris in the fall, at the rue de Fleurus, Matisse and Picasso met for the first time.

Fernande Olivier, closer of course to Picasso, yet fairly objective in her memoirs, *Picasso et ses amis,* describes this historic moment:

> The type of the great master with his regular features and vigorous red beard, Matisse was a sympathetic character. At the same time, behind his big spectacles, he seemed to mask the exact meaning of his expression. Whenever he began to talk about painting, he chose his words deliberately.
>
> He argued, affirmed, wanted to convince. Clear, of an astonishing lucidity of spirit, precise, concise, intelligent. Perhaps much less simple than he wished to appear.
>
> He was already forty-five years old.
>
> Very much the master of himself at his meeting with Picasso who was always a bit sullen and restrained at such encounters, Matisse shone imposingly.
>
> They were the two artists one paid the most attention to.[94]

Actually, Matisse was thirty-seven at the time, but Picasso was only twenty-five. They seem to have respected each other uncomfortably from the first and, as time went on, to have learned considerably from each other. Gertrude Stein states—and Matisse himself confirms her story—that not long after they met,

Matisse showed Picasso the first piece of African sculpture he had seen, and later Picasso learned a good deal about color and something about sculpture from Matisse, just as Matisse was at times strongly influenced by Picasso's cubism during the next ten years.

Picasso had to thank Matisse for one extremely important and generous gesture: the older painter brought Sergei Shchukin, the foremost collector of modern painting then active, to Picasso's studio for the first time, and Shchukin became by far Picasso's greatest patron, buying in all over fifty paintings from him during the succeeding six years. That was in 1908. Not long before that, Matisse and Picasso had even exchanged pictures, Picasso choosing the quasi-childlike portrait of Matisse's daughter, Marguerite (a selection which the gossips, I think mistakenly, suppose was made to reveal the donor's weakness as a painter). Yet they were too different in age and temperament to become intimate. Fernande Olivier concludes, "Matisse . . . did not have the same ideas as Picasso. 'North Pole' and 'South Pole,' Picasso would say, speaking of the two of them."

The same metaphor might have been used to contrast the two remarkable pictures by which the two masters most completely expressed themselves at this period. If by some chance Picasso did not see Matisse's *Bonheur de vivre* at the Salon des Indépendants in the spring of 1906, he surely saw it often at the rue de Fleurus during the following autumn and winter. Very possibly it inspired him to emulation or at least to the concentration of his resources in a single great effort. Leo Stein tells with amusement how Picasso had the huge canvas relined as if it were already a classic work, even before he began to work on it. In any case, early in 1907, after months of preparation he began to paint a figure composition larger and more elaborate than any he had attempted before, at least since his student days. Many years after it was finished, someone gave it the troubadour title *Les Demoiselles d'Avignon,* an ironic reference to the gay inmates of a house on the Carrer d'Avinyó—Avignon Street—in Barcelona.

Although *joie de vivre* may be said to have inspired both pictures, the connection is tenuous, for Matisse's nymphs lolling in a bosky meadow or dancing a Dionysian round in the distance could scarcely be further removed from Picasso's *filles de joie* in their curtained interior. Matisse's figures are scattered sparsely over a perspective as wide and deep as a vast ballet stage; Picasso's loom like giantesses on a shallow, crowded, cabaret-like platform. Matisse's style is spacious, easy, curvilinear, flowing; Picasso's rectilinear, cramped, angular, rigid. Lastly, the effect of Matisse's *Bonheur de vivre*—enjoyment of the good life—fulfils its title, but the effect of *Les Demoiselles d'Avignon* is forbidding, formidable, even frightening.

Yet there are certain significant resemblances, minor and major. As preliminary sketches prove, the format of Picasso's original composition was much closer to that of the *Bonheur de vivre* than the final compressed proportions of the *Demoiselles* reveal. The general lines of the setting are similar: for instance, the enclosing curtain at the left of the *Demoiselles* not only follows the contour

of the trees at the left of the *Bonheur de vivre* but, like them, is warm in color by contrast with the cold tones of the right-hand "scenery" in both pictures. More important is the experimental and synthetic character of both canvases. Matisse's inconsistencies of style in the *Bonheur de vivre* are numerous, his borrowings from such disparate sources as Ingres and Islamic art evident. Picasso in the *Demoiselles* suggests that, without completely assimilating them, he has learned from sources as various as the archaic bronzes of prehistoric Spain, the masks of West African Negroes and the mannerist altarpieces of El Greco. But it is Cézanne's bather compositions which, above all, lie back of both pictures; and in relation to Cézanne Picasso had, as will be seen, the curious advantage of a Johnny-come-lately.

Whatever the similarities and differences between the two paintings, they represent moments of climactic achievement in the careers of the two artists, and they are both landmarks in the history of modern painting. Both are signposts pointing in the same general direction, towards abstraction, but by very different routes: Matisse, with the brilliant, singing color and organic, curving, fluid forms of the *Bonheur de vivre* opens the way to Kandinsky and, after him, to Miro and the more recent masters of color-cloud-and-flowing-line abstraction; Picasso's austere, stiff, angular structure leads on to cubism—in fact the *Demoiselles* has justly been called the first cubist picture—and beyond cubism to Malevich, Mondrian and "geometric" abstraction.

The histories of the two pictures during their period of greatest influence differ as dramatically as the paintings themselves and the personalities of their makers. The *Bonheur de vivre* was scarcely dry before it was publicly and conspicuously exhibited at the Salon des Indépendants. It was bought very soon after and hung in the most influential collection of the moment—that of the Steins on the rue de Fleurus. By contrast—and contrary to the fond philistine illusion that Picasso always paints with his eye on sensational publicity—*Les Demoiselles d'Avignon* was never publicly exhibited until 1937;[95] apparently it was never even reproduced in a European publication until the early 'twenties. Instead, during its first dozen years, it remained in the artist's studio, part of the time rolled up or turned to the wall. Yet artists saw it, studied it, were perturbed and then influenced by it and by its author. Among them were Derain, Matisse's most important follower, and Braque, the youngest recruit to fauvism. These conversions, catalyzed by Picasso, occurred during 1907. But even before that year, Matisse himself was painting certain pictures, notably his own *Self-Portrait,* which anticipate a return to a more structural style.

There were two principal factors at work in this new concern for structure: first, a reaction against the excessive color and spontaneous but often flimsy design of fauvism; second, the rapidly rising influence of Cézanne. Cézanne, thanks largely to Pissarro, had of course been known and admired by Gauguin and van Gogh in the 1880's and by the Nabis in the 1890's. Vollard had shown him at length in 1895 and 1899, and at the Salon des Indépendants of 1901

Denis had exhibited his own *Hommage à Cézanne,* a portrait group of the Nabis and Symbolists gathered reverently around a Cézanne still-life.

Matisse had come to know Cézanne's painting about 1897 and had been encouraged to study the master of Aix by Camille Pissarro himself. In 1899, in spite of real financial difficulties, Matisse bought a small Cézanne bathers composition from Vollard. Many years later, in 1936, when he came to give this picture to the Museum of the City of Paris, he wrote to his old friend Raymond Escholier, the director of the Petit Palais: "I have owned this canvas for thirty-seven years and I know it fairly well, I hope, though not completely; it has sustained me spiritually in the critical moments of my career as an artist; I have drawn from it my faith and my perseverance." Even during one of his worst periods of crisis, the dark years of worry and poverty from 1901 to 1904, Matisse clung to this Cézanne and, staunchly confirmed by his wife, refused to sell it, in spite of the pressure brought to bear by some of his commonsensical friends.

Jean Puy, while confirming Matisse's role as an innovator among the fauves, recalls especially how he helped his fellow students at Carrière's to gain a new sense of structure in their work by clarifying for them the importance of Cézanne. Matisse continued to look to Cézanne as his chief guide through his years of somber discipline following the turn of the century. As late as the summer of 1904, the *Saint Tropez: Place de Lices* and *Still-Life with a Spanish Decanter* are obviously Cézanne school-pieces. And Matisse's neo-impressionist *Luxe, calme et volupté,* which so impressed Dufy at the Indépendants of 1905, is essentially a Cézannesque bather group done in a pointillist technique. Cézanne's drawing, color and composition continued to inspire Matisse subtly or patently during his entire fauve period from 1905 through 1907. Matisse looked to Cézanne—especially to his watercolors—for guidance in construction through color planes, as the *Woman with the Hat* demonstrates. In fact, even in the midst of his fauve period, Matisse was painting the *Self-Portrait* of 1906 and the *Blue Still-Life* of 1907—pictures more Cézannesque than anything by his fauve colleagues or Picasso. And such powerful studies as the *Walking Model* of 1907 anticipate much of the dark, rather heavy-handed Cézannism which both the ex-fauves and the budding cubists were to adopt in the following years.

Matisse has recently informed me that in 1899 he had at first been tempted by a van Gogh *Arlésienne* which he had seen at Vollard's, but on second look had found the small Cézanne *Bathers* more to his liking. This is significant, for in the ensuing years it was van Gogh and Gauguin who chiefly influenced the future fauves such as Vlaminck, Derain, Friesz and Dufy. The big van Gogh shows at Bernheim-Jeune's in 1901 and at the Indépendants of 1905, the Gauguin memorial show of 1903 at the first Salon d'Automne and the even larger exhibition at the 1906 Indépendants served to strengthen the influence of these two important but, by comparison with Cézanne, somewhat more superficial and therefore easily understood masters.

Cézanne, who had been obscured first by his fellow impressionists and then by van Gogh and Gauguin, began to rise in the esteem of the whole new generation of artists only in 1904. At the Salon d'Automne of that year, forty-two paintings by Cézanne were included—his first public one-man show—and ten more were in each of the Salons of 1905 and 1906. His death in 1906 was followed in 1907 by a show of seventy-nine watercolors at Bernheim-Jeune's, a memorial exhibition of forty-eight paintings at the Salon d'Automne and the publication of a number of articles and letters. Among them was the famous sentence Cézanne had written three years before to Emile Bernard, a former Symbolist and Gauguin pupil: "You should see in nature the cylinder, the sphere, the cone. . . ."

By 1905, Charles Morice had found that Cézanne was the chief subject of argument in the studios of the younger artists. And in his review of the Salon d'Automne of the same year—the fauve Salon—Maurice Denis had noted among various other groups a "school of Cézanne." Within two or three years most of the fauves themselves, Vlaminck, Derain, Friesz and the youthful Braque, had become enthusiastic Cézannists or, more or less under the influence of Picasso, had pushed a single aspect of Cézanne into various forms of early cubism.

As was true of the fauves, Picasso himself had paid little serious attention to Cézanne until late 1906. But in 1907, as we have seen, he painted the *Demoiselles d'Avignon,* which, with all its admixture of primitivism and El Greco, was a far more creative *hommage à Cézanne* than had been Maurice Denis' pious portrait group of 1901. The early cubism of Picasso and Braque through 1909, the early post-fauve pictures of Vlaminck, Friesz, Derain and others, all owe more to Cézanne than to any other artist.

Matisse in 1907 thus found himself in the curious position of having been a "premature Cézannist"—to paraphrase a recent political epithet. For eight years or more he had been studying Cézanne and undoubtedly understood his work more profoundly than did Picasso, Derain or Braque. But Matisse's relationship to Cézanne was not apparent to his critics nor clearly understood by his colleagues, who in fact did not clearly understand Cézanne as a whole.

Most of Matisse's Cézannesque pictures of 1906–07, however, though excellent in themselves, were comparatively personal reactions against fauve license; they were recurrent exercises in formal discipline. The main course of his art lay in a post-Cézannesque direction of ever bolder use of brilliant decorative color in comparatively flat design, such as is indicated by the second version of *Le Luxe* painted late in 1907. Thus by 1908 he found himself no longer the captain of the vanguard in Paris, but a figure against whom a new vanguard—many of them his own followers—had already begun to react. Maurice Denis, reviewing the Salon des Indépendants of 1908 in an essay tendentiously titled *Liberté, épuisante et stérile,* noted with satisfaction that "it is apparent that there is much less influence of Matisse here than of Cézanne." (In 1910, Guy Pène du Bois, far from the scene of action, was to write an angry article in the *New*

York American proclaiming that "a great injustice is being enacted today. It is the widespread publicity given to the name of Henri Matisse, who, in reality, far from being the head of a new movement in art is simply a disciple of Cézanne. . . ." Ironically, Max Weber remembers how in 1908 Matisse would speak of Cézanne to his pupils as *"le père de nous tous."*)

Matisse was not unaffected by the turn of the tide. Fernande Olivier says he threatened to "get" Picasso, and, though a man of extraordinary fair-mindedness and objectivity, he was in fact a member of the jury of the Salon d'Automne of 1908 which rejected Braque's early cubist landscapes of Cézanne's own Estaque country. Matisse denies the story that while the jury was reviewing Braque's new paintings, he had exclaimed impatiently, *"Toujours les cubes!"*— thereby initiating the word which soon developed into cubism, the name of the movement about to eclipse fauvism. Yet he could scarcely have viewed those angular, pale green and tan compositions without reflecting that only a year before, Braque had been the bright new star of fauvism.

On the other hand, Matisse had won his position of leadership not through ambitious schemes for grasping power, but through the combined strength of his art, his mind and his character. The inconsistent and sometimes unsubstantial methods of fauvism were exhausted for him as well as for more overt deserters of the movement. But Matisse would not join the other ex-fauves and Picasso in their youthful, somewhat belated and at times naive discovery of Cézanne. Nor could he follow, except casually and at a distance, the radical, epoch-making development of cubism.

Yet, though during 1908 Matisse was losing his dominant position in the Paris *avant-garde,* he was to have many and great compensations on many different levels of achievement and satisfaction. Before the year was over, students from the United States, Germany, Eastern Europe and Scandinavia were flocking to the class which Sarah Stein and Hans Purrmann had persuaded him to open; Shchukin was surpassing the Steins in buying quantities of his most daring paintings; he exhibited for the first time abroad, in New York, Moscow, Berlin and London; he wrote and published *Notes of a Painter,* one of the most influential statements ever made by an artist; and, most important of all, he was developing his art with greater courage, confidence and originality than ever before. His greatest decade lay ahead of him. Before it was over, he was to be generally recognized throughout the world as the foremost painter of his generation.

3. THE STATESMAN

By the second half of the 1940s, The Museum of Modern Art and Alfred Barr began to take on a new personality. Where earlier, the tone was one of agitation, increasingly it became one of tact. Where before, the Museum was on the offensive, breaking new ground, increasingly it found itself on the defensive—legitimating its own history and realm. Where earlier, dissenters could grumble about the irreverent upstart, critics now had a substantial, influential target.

However, there were two specific reasons, in addition to the general ones of growing maturity and institutional entrenchment, that encouraged Barr's more statesman-like posture. His firing as the Museum's director in 1943 was a psychological blow of stupendous magnitude. If it didn't dim his fervor and commitment (and it surely didn't), at least it made him more restrained in the expression of it, even more modestly careful than before to justify his judgments and defuse opposition. His almost immediate reinstatement—as Director of Research in Painting and Sculpture—and subsequent naming as Director of the Museum Collections (1947) only confirmed his indispensability, and dignified his new voice—in effect transubstantiating him, turning him from quotidian superintendent into *éminence grise*.

The second reason for Barr's emergence in a new role was the fact that in the political and social climate of the postwar years a cultural statesman (as opposed to spokesman) was needed, and Barr naturally assumed the role. Modern art was being attacked as subversive by the popular press, by conservative intellectuals and academic artists, and by members of the Congress (see "Artistic Freedom"). Barr responded to these sloppily reasoned attacks (what he called a "campaign of muddleheaded reaction"[1]) with his characteristic zeal for the precise presentation of facts and brilliance at adapting his delivery to the subject and audience addressed. But, now, in addition, there was an unmistakable awareness of his authoritative stature.

That stature Barr was ambivalent about. He certainly expected to influence opinion on significant issues, and spent enormous amounts of time and energy preparing and arguing his cases; yet he was publicly uncomfortable with the popular image of himself as "tastemaker," and never missed an opportunity to correct that designation ("Tastemaking" is only one instance). In fact, Barr continually wrestled with numerous conflicts—conflicts that are still (especially)

vexing to today's art community, and were, in a sense, fathered by him: The museum as temple dedicated to quality versus the museum as cultural carnival and department store; recognition of the intellectual demands made by art versus a desire to involve the widest possible public; the relative status of regional styles versus an international style, of "mainstream" versus "peripheral" styles, and of a European versus an American style; museum scholarship versus university scholarship; and the artist's and critic's obligations to art versus their obligations to society. These questions were never resolved for Barr, nor are they ever likely to be for most thoughtful people. What is certain is the sacred importance he attached to the inquiry—for Barr these were literally issues of his faith. In 1953, corresponding with Dwight Macdonald, who was preparing a *New Yorker* profile of him, Barr wrote: "I enjoy looking at pictures sufficiently to think enjoyment important. At the same time, in our civilization with what seems to me a general decline in religious, ethical and moral convictions, art may well have increasing importance quite outside of aesthetic enjoyment. . . ."[2] And, to be sure, Barr's noted "certainty" in matters appeared, to Macdonald, "to come from moral and intellectual convictions rather than from aesthetic reactions of the sort that involve enthusiasm, disgust, delight, and other unkempt feelings." Barr's uneasy conflation of the burdens assumed by art with those of religion can at least partially explain his insistence that good art is "difficult" art.

In the public's mind, Barr's identification with The Museum of Modern Art, and the Museum's with him, is nearly total. Barr took frequent notice of this and, embarrassed, decried it as unjust to the Museum—to the founding "Ladies," to the presidents and trustees, to the large, dedicated staff. But in a sense it was equally unfair to Barr, making him larger, but much paler, than life. There were other subjects that absorbed him nearly as much as art—ornithology, botany, military history, chess strategy, music. Throughout his life he devoted considerable energy to causes of social justice and civic responsibility. He waged letter-writing campaigns to support the Child Labor Amendment, the Federal Theatre Program in New York, the Lend-Lease Bill, and automobile-safety legislation, and to oppose dam sites on consecrated Indian land in New Mexico and the encroachment of concrete into the bird-refuge Ramble in Central Park. As a member of the American Civil Liberties Union's Committee on Censorship he fought tirelessly against the ban of Roberto Rossellini's film *The Miracle* in the early fifties. It seems only reasonable to include a small selection of Barr's numerous letters to the editor in this anthology.

A. N.

Research and Publication in Art Museums

The following is a transcript of a paper read at a conference on "The Future of the Art Museum as an Educational Institution," held in Chicago, March 24–25, 1944, under the auspices of The Art Institute of Chicago and the University of Chicago. (From *The Museum News,* January 1, 1946.)

When I was asked to speak on Research and Publication in Museums I hesitated. The Museum of Modern Art is so untypical in its field and in much of its work that I cannot pretend to speak with authority about the research and publication problems of other art museums, especially our vast museums of historic art.

I like to think that in these great museums with their large curatorial staffs and comparatively leisurely schedules a great deal of research is going on— research which will meet the dictionary definitions of "diligent investigation" and "careful or critical inquiry in seeking facts or principles." In our own museum I know that research is sometimes a matter of hand-to-mouth, last minute effort to meet an exhibition or catalogue deadline. This frenzy does however produce results, at least of a quantitative nature, even though the research involved may be hasty and superficial. I do not underestimate these results. They are timely and serve their purpose. But they should be recognized for what they are—a kind of superior journalism produced too often in the atmosphere of a newspaper office. I do not think our museum is unique in this. I suspect that in many other museums, especially those in which the staffs are small, something of the same sort of hurry and strain prevails.

The truth is that our museums have not yet caught up with themselves. The new and often justified demands which have been made upon them by the depression and the war, and by the recent but intensive pressure to popularize themselves all tend to conflict with research. This conflict is not intrinsic, but a matter of time, money, and energy. In most museums some desirable activities have to be sacrificed and research is too often one of them. Serious psychological handicaps are active, too, for during the depression when men were hungry and even more during the war when men are dying it is hard to concentrate on any

work which requires patience and reflection and which does not bring immediate results or hasten victory.

Yet American art museums cannot blame the war for their rather low reputation as centers of research. In 1939, before the war, Laurence Vail Coleman in his book *The Museum in America*[3] states that "Only four public museums of art are thought of for research." Science museums are generally superior and, in the field of art, universities also surpass public museums. In the same year Paul Sachs[4] writes that "scholarship falls short in American museums, when appraised by any reasonable international standards of performance." Among American art museum scholars he names only Winlock as worthy to enter the lists with Bode and Friedlaender, Kenneth Clark and C. J. Holmes, Swarzenski, Ganz, Jamot and others.[5]

On the one hand pressure is brought to bear on museums to earn their way by making themselves into popular community centers; and on the other, to raise their standards of research and publication. Both can be done under the same roof providing we have enough faith to believe in the value of both and enough skill to persuade others to agree with us. These are of course questions of general museum policy and strategy but they are so urgent that they must be kept in mind whenever we attempt to reexamine the intellectual side of our work.

In order to clarify the problems of research and publication in our museums I should like to compare them with corresponding problems in university art departments.

I intend to apply the term research a little more broadly than the dictionary sanctions. The word publication also I should like to use in the broadest possible sense. When scholars use the verb "publish" they usually have in mind writing a *catalogue raisonné,* a definitive monograph, or a learned article for a learned periodical—works of research intended for other scholars or for the boldest and most inquisitive laymen. By publication I mean not only the scholarly treatise but also the popular article or book, the classroom or public lecture, the gallery talk, publicity releases, various kinds of reproductions, the film, the museum label, the broadcast and the telecast. Some of these channels of publication are shared by both university and museum—though the museum as a rule uses the greater variety. Whatever means of publication we may use, all are based on research if the publication is to be sound and true and at the same time effective —effective, that is, upon the museum public which is so much more various and uncontrolled than that of the university.

Occasionally the university faces this general public. The University of Chicago Roundtable broadcasts are I think a notable instance.[6] But the university's primary public—the consumer of its publications—is the student body, undergraduate and graduate. Perhaps the university student body may seem varied and undisciplined to their teachers but actually they constitute a homologous body of exceptionally intelligent and eager men and women of about the same age and at the height of their intellectual energy and esthetic sensibility. The museum by contrast is confronted by consumers aged four to four score

years, from every class and calling and in every state of mind from passionate and erudite interest to the most casual indifference.

This radical contrast between the university and museum suggests one of the most important and least considered differences between research in the two kinds of institutions. I am speaking now of the research which makes publication *effective* more than that which makes it true, of what might be called the pragmatic rhetoric of education rather than its data. This rhetoric should be based on research as well as intuition and experience. In our universities such research is practiced upon the student body as a matter of traditional routine and with the utmost care. For although we do not usually think of it in this way every examination or test or conference is research—an elaborate and time-consuming effort to find out whether or not the teacher's efforts at publication have been effective. So, the university teacher does research on his public as well as on his subject. Again and again he examines his students and, in so doing, himself.

How much more difficult is this kind of research in a museum! Not only is the public a chaos of mind and feeling, inattentive, undisciplined, and irresponsible; it is almost unexplored. There has, it is true, been some careful research on the behavior of the museum public with some startling conclusions as to how many seconds the average visitor looks at an average picture.[7] This is like statistics of how many hours the average college student spends studying the average course. Such behavioristic analyses have a certain value, but what we in museums need far more is research on what goes on in the visitor's head during those brief seconds. Of course the intelligent and sensitive docent or gallery lecturer can after a period of years gain some insight into the public mind, but this knowledge must remain superficial by comparison with the results obtainable through the precise instrument of the college examination.

How much we need this kind of research is suggested by an examination given the public at the Museum of Modern Art, though, as it happens, in a field interesting to most museums of older art. You will remember the exhibition of work by Italian masters which was shown in San Francisco, then in Chicago, and finally in New York.[8] As an experiment intended both to stimulate active critical judgment on the part of the public and to serve as research into the quicksands of public taste, we asked every writer to check in the order of his personal preference a list of the works exhibited. Three hundred thousand people saw the exhibition in New York, many of them entering an art museum for the first time in their lives. Considering this, we assumed condescendingly that their first choice would be the sweet, prettily colored Raphael *Madonna of the Chair,* familiar to everyone on Christmas cards, with the Botticelli *Venus* as a possible runner up. To our immense surprise the ballots proved that our public preferred Titian's austere and ruthless portrait of Paul III. We felt confused and humbled by our bad guess—and then very much encouraged.

Perhaps research on the heterogeneous public mind is too difficult to be profitable. Perhaps it has been tried far more than I know. I confess I have no

series of ingenious devices to propose and I realize that we cannot subject our public to elaborate tests. But I do suggest that museums in comparison with universities will continue to waste much time on research and publication until more research is done *on the public itself.*

I have considered the public first because, in connection with research in museums and universities, the public is usually thought of last or not at all. I come now to a second important difference between research and publication in the two kinds of institutions. If this difference seems too obvious to be worth mentioning, you must forgive me for it seems to me one of the crucial distinctions upon which the museum should base its general research policies. I refer to the simple fact that museums own and exhibit original works of art whereas university art departments usually do not.

I can remember as a graduate student my year's study at one of our leading universities. Although my courses carried me into four distinct fields in the history of art I never once in connection with my researches was led to examine an original work of art; nor was I aware during the same period that my instructors had any direct contact with original works of art, except outside their scholarly pursuits. These men loved art and believed profoundly in its importance but as university art historians they and their students could work for long periods with books and photographs alone. The scholarly discipline was excellent, but led at times to a certain over-confidence. I remember a story of a graduate student at another college who wrote a thesis on a sculpture in a nearby museum. So used was he to working with photographs that only after months of research did he take the trouble to travel a few miles in order to examine the original figure which he had discovered to his consternation had once been seriously damaged and incorrectly restored. As a result he had to scrap much of his work. Of course no mature university scholar would have fallen into this error and in justice to our academic training I must add that I have since heard how a forgery in the same museum was first revealed by a university graduate student.

I think that almost all museum men would agree in theory that the chief focus of their research and publication should be the works of art in their collections. In practice there are of course notable exceptions. No one would criticize Fiske Kimball[9] for his superb studies in 18th century architecture and decoration even though his material lies largely outside the Philadelphia Museum. And we can look forward to the publication of Francis Taylor's history of collecting and Lloyd Goodrich's book on Winslow Homer.[10] But it may be better in the end for most of us to concentrate our researches upon the vast wealth of material of which we are custodians, at least until we have begun to publish it adequately.

This is a colossal task, especially if we are willing to accept research and publication in the broad sense I have suggested. We shall need all the help we can get from universities—and this I hope will be more than we have had in the past.

Barr, 1947, photographed by Irving Penn. The picture appeared in *Vogue*, in an article on ten American "Influences," along with John Dewey and Walter Lippmann

In April 1950, the "advanced" artists who had participated in the Friday evenings held by the "Subjects of the Artist" school and "Studio 35" held a closed three-day session. Barr was the only nonartist present. Upper photograph (left to right): Seymour Lipton, Norman Lewis, Jimmy Ernst, Peter Grippe, Adolph Gottlieb, Hans Hofmann, Barr, Robert Motherwell, Richard Lippold, Willem de Kooning, Ibram Lassaw, James Brooks, Ad Reinhardt, Richard Pousette-Dart. Lower photograph (left to right): Brooks, Reinhardt, Pousette-Dart, Louise Bourgeois, Herbert Ferber, Bradley Walker Tomlin, Janice Biala, Robert Goodnough, Hedda Sterne, David Hare, Barnett Newman, Lipton, Lewis, Ernst

Barr, Museum President William A. M.
Burden, and René d'Harnoncourt on the
roof of the Museum, 1953

In Barr's office, spring 1953

Philip Johnson, Frank Lloyd Wright
(back to camera), and Barr in the
mid-1950s

The jury for the "Unknown Political Prisoner" International Sculpture Contest, 1953. Left to right: Sir Herbert Read; Giulio Carlo Argan; Jorge Romero Brest; Will Grohmann; and (rear right) Barr

Barr, Pablo Picasso, Jacqueline Roque, and Margaret Scolari Barr in June 1956 during preparations for *Picasso: 75th Anniversary Exhibition*

Winners of Brandeis University's 1965 Creative Arts Awards. Left to right: composer Elliott Carter, painter Mark Rothko, Barr, playwright Tennessee Williams, poet Stanley Kunitz. Barr received a special medal for "Notable Creative Achievement"

Esquire magazine picked New York's "decisive dozen" in July 1960. Left to right, first row: Kermit Bloomgarden, Sol Hurok, Barr, Alfred A. Knopf; second row: Robert Sarnoff, Henry Heald, Jessica Daves, Philip Johnson; third row: Ford Frick, Carmine De Sapio, Arthur Krim, Joe Glaser

James Johnson Sweeney, late 1940s

Henry-Russell Hitchcock, c. 1937

Paul Sachs at the Museum's twenty-fifth
anniversary celebration in 1954

Thomas B. Hess, 1950s

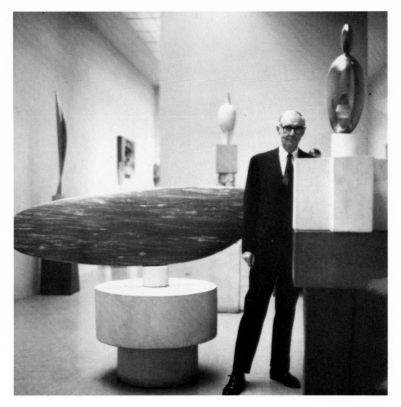

Barr in the Museum's Brancusi gallery, c. 1960—an installation he personally planned

1958 installation of *The New American Painting*, at the Galleria Civica d'Arte Moderna in Milan

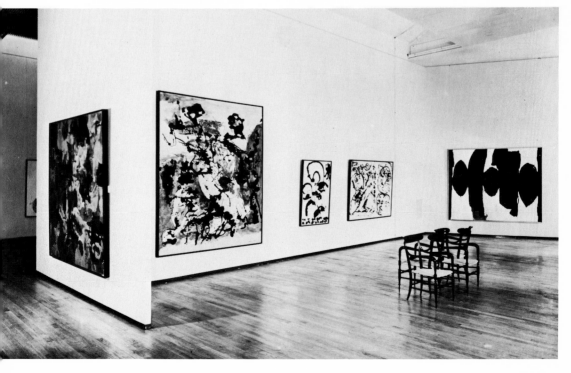

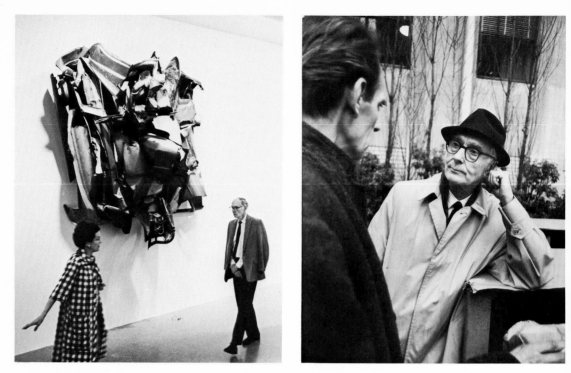

Barr in the late 1960s: with Dorothy C. Miller and John
Chamberlain's *Essex* during the installation of *The 1960s: Painting
and Sculpture from the Museum Collection;* and in the Sculpture
Garden with Ronald Bladen

William Rubin, then Curator of Painting and Sculpture, soon to be
Director of the Department, with Barr in early 1973

A work of art is an infinitely complex focus of human experience. The mystery of its creation, its history, the rise and fall of its esthetic, documentary, sentimental, and commercial values, the endless variety of its relationships to the other works of art, its physical condition, the meaning of its subject, the technique of its production, the purpose of the man who made it—all these factors lie behind a work of art, converge upon it, and challenge our powers of analysis and publication. And they should be made accessible to other scholars and intelligible to the man off the street.

I know that what I say may seem irrelevant to some of you. You may feel that the works of art in our care should be allowed to live their own lives undisturbed by research or other educational activity. Yet I believe that works of art, like human beings, thrive on the attention paid them.

Consider, for instance, a newly acquired painting. It enters the museum collection on a wave of excitement. It has been shipped on approval, committees have debated its merits, the bargain has been sealed. Preliminary studies have been made of its condition, authenticity, history, and iconography. It is announced in the newspapers, mentioned on the local radio, and reproduced in the bulletin. The *Art News* praises it, the *Art Digest* damns it. It is hung with honor in a special gallery, perhaps accompanied by a persuasive label. Other museums want to borrow it, and painters want to copy it. Thus for a time it leads a gala life to which research and publication have contributed their share all along the line. But usually this initial research is superficial and only first results are published. A little later the new painting takes its normal place in gallery 34 B and the honeymoon is over.

Whether the work of art subsequently lives or dies depends partly on its intrinsic qualities, partly on the attention we are able to give it by our continued interest. Take for example what I suppose to be the most valuable object in the Art Institute of Chicago, Seurat's *Grande Jatte*. It is for some of us one of the great works of European art. It would be absurd to suggest that its life depends upon research and publication. Yet I believe that Mr. Rich's monograph on this picture has added so greatly to our knowledge and understanding of it that, ten years after its accession, he may be said to have helped renew and enrich its life.[11] One felt that the little book in which he published not only his information but also his enthusiasm was in fact the homage of a scholar for a great work of art.

The differences between research and publication in art museums and university art departments, the difference in the character of their material and the nature of their consumers, are far less important than the common purposes and dangers which should draw them together. I have mentioned the tension under which museum people must work during these war years. So far as I can ascertain universities are under an even more critical strain. After the war I believe this may be partly reversed. The universities, even if their accelerated schedules are maintained, may resume a comparatively normal existence while our art museums, as Francis Taylor has recently said and eloquently pointed out,

may have to bear heavy responsibilities in salvaging European cultural material and works of art. "It is our duty," he writes, "so to perfect our own institutions as centers, not merely of popular recreation, but of scientific study and research, that they may form the cornerstone of the reestablishment abroad."[12] I agree with him that our debts to Europe should be paid but I foresee a real danger that our attention and energies may be diverted abroad to such an extent that we shall weaken our already insecure position in this country.

Whether or not we believe in the century of the common man the inexorable fact remains that eight or nine million of our fellow citizens will return to civilian life with fresh and critical eyes. And among these millions an elite by the hundred thousand will have missed their normal higher education, with the tolerance and cultural maturity which that helps to bring. They are likely to be afraid of civilian life, impatient with what does not seem immediately useful or intelligible to them. At the same time and often without being aware of it they will need what museums have to offer more than ever. This is an overwhelmingly important challenge to our capacity for popular education but it will put an even greater strain upon the integrity and intellectual quality of our work.

It is not therefore from a desire to lower the standards of scholarly research and publication that I have suggested a broadening of their scope. On the contrary, these standards should be raised: but they should also be integrated at their best with a more serious study of our public and a bold, unprejudiced acceptance of the modern channels of reaching and teaching that public.

This is, in a sense, a stratagem of defense, for it may help to convince a sceptical public that scholarly research in museums is not some recondite game but an essential and fundamental activity. In another and more important sense this broadening of scholarly purpose would be more than a stratagem. It would be I believe a means of confirming our faith in our own usefulness to a democratic republic during the critical mid-century years.

A Symposium: The State of American Art

Because he recognized that the war years had produced an unprecedented atmosphere in American art, Robert Goldwater, then editor of the *Magazine of Art,* surveyed a group of writers and critics on three questions: 1. "Is there a well-marked trend or direction of style" in American art today? Is it of "sufficiently marked character to warrant being called 'American'?" How does American art today stack up "against the Old World in quality of individual accomplishment and vigor of general activity?" 2. Is it true, as Herbert Read suggested, that "the extremes of 'abstraction' and 'naturalism' no longer apply to current creativity" and that "these two tendencies are equally strong within the individual and correspond to divergent emotional directions—so that they can be practiced simultaneously by the same artist, his (unconscious) choice of style depending upon his mood of the moment?" And, this being "but an intensification of the broader problem of an 'eclecticism of styles' in artists' practice and public taste . . . [can] all 'styles' of art . . . be equally well carried out by different artists, success depending only on the quality of the individual work?" 3. "Does it appear to you that the separation of literature and the visual arts, unfortunately characteristic of this country's taste since at least 1900, is being broken down?" (From the *Magazine of Art,* March 1949.)

I do not think there is a single "well-marked trend or direction" in American art today. There is, however, a strong, broad and diversified movement towards abstraction, often highly original in character and affecting many older, well established artists as well as younger ones. This is the third wave of abstraction in American art during the past thirty-five years. There are also several other trends and reactions: one towards minutely rendered detail, whether realistic, neo-classic or fantastic in subject matter; another towards a revival of traditional romanticism. Expressionism seems to be the most common style of the 1940s, having succeeded the academic impressionism of the first quarter of our century.

I would say that whatever is produced by American painters or sculptors is American; but almost all Americans work within the varied traditions of the Western World so that their art, except when obviously American subject matter is used, is usually not distinguishably American. Even the more conservative and popular styles which the ignorant suppose, or the reactionary assert, are peculiarly American have their counterparts in most European and Latin American countries, above all in the U.S.S.R. where "modern art" was strangled twenty years ago.

From superficial impressions gained during three recent months in Europe I would say that American painting "stacks up against the Old World" very well indeed. In fact, with the very important exception of the work of a few painters in France of the generation now over sixty-five, American painting seems to me more vigorous and original than that of any single European country. The best painters selected from the "Old World" as a whole would however surpass the Americans. American sculpture may possibly be somewhat inferior to that of France, Italy or (because of Henry Moore) Great Britain.

A few extremely versatile and inventive painters such as Picasso, Klee and Ernst have been able to make many rapid changes in the style of their work, even from picture to picture. They seem to me exceptions. Many other artists have changed their art gradually or abruptly, but for longer periods of time and for different reasons than is suggested by your phrase "mood of the moment." An artist may temporarily change his style from abstraction to realism, or the reverse, primarily for purposes of discipline or refreshment; or, as in the cases of Erni or Bayer, he may produce a dazzling variety of styles to order; but these changes are not the consequence of urgent inner necessity.

Abstraction and realism are crude and ambiguous terms but they have a present usefulness as indications of polarity.

The second paragraph of your question shifts the point of view from artist to public. For the public, too, freedom of choice among many styles I believe to be a good, not a bad thing. "Success" then depends not only upon "the quality of the individual work" but upon the needs of the individual "consumer" and the quality of his sensibility.

An actual "battle of styles," as for instance between realism and abstraction, is desirable only to those who thrive on a feeling of partisanship. Both directions are valid and useful—and freedom to produce them and enjoy them should be protected as an essential liberty. There are, however, serious reasons for taking sides when one kind of art or another is dogmatically asserted to be the only funicular up Parnassus or, worse, when it is maliciously attacked by the ignorant, the frightened, the priggish, the opportunistic, the bigoted, the backward, the vulgar or the venal. Then those who love art or spiritual freedom cannot remain neutral.

No, I'm afraid the unhappy blindness of most American writers and editors towards the visual arts, especially in their more modern forms, is not being broken down. The relationship of the French literary world towards painting and sculpture, not only in the nineteenth century but recently too, has been friendly, enlightened and even symbiotically effective. The same was true in the Germany of the Weimar Republic and seems to be true in contemporary Belgium, Switzerland, Brazil, Mexico and, possibly, Britain.

Most American painters I believe have a real interest in modern literature, or at least a great respect for it. But comparatively few American novelists and poets seem to be interested in the visual arts—and those that are all too rarely write about them, to the real loss both of art and literature. As for magazine

editors, columnists, caption writers and popular essayists, with laudable exceptions, they seem less concerned with enlightening their readers about modern art than with the easy and profitable confirmation of popular prejudice. This they do with a complacent conscience because, for the most part, they themselves have never really taken the trouble to correct their own inadequate education in the visual arts. Most artists can read—but few writers can see—and thus the blind continue to mislead the blind.

Is Modern Art Communistic?

Starting in 1947, when the State Department canceled the government-supported, interna-
tionally touring exhibition *Advancing American Art* under pressure from Congressman
George A. Dondero and others, avant-garde art was increasingly attacked as subversive and
anti-American by the politically right. Barr had a long-standing interest in the relationship
between art and government—particularly since his visits to Russia in 1927–28 (he returned
in 1956 and 1959) and Germany in 1933—and he frequently wrote and spoke on the
subjects of art under dictatorships, censorship, and creative freedom. (From *The New York
Times Magazine,* December 14, 1952.)

Modern political leaders, even on our side of the Iron Curtain, feel strongly
and express themselves eloquently against modern art. President Truman calls
it "merely the vaporings of half-baked lazy people" and believes "the ability
to make things look as they are is the first requisite of an artist." After looking
at an abstract mural at the United Nations building, General Eisenhower re-
marked: "To be modern you don't have to be nuts." Prime Minister Churchill
has been quoted as proposing assault, hypothetical but violent, on Picasso. Many
others go further. Because they don't like and don't understand modern art they
call it communistic. They couldn't be more mistaken.

Whatever a Western leader's point of view on artistic matters may be, he
would not want to impose his taste upon his countrymen or interfere with their
creative freedom. The totalitarian dictators of Nazi Germany and Soviet Russia,
on the contrary, did want to: the modern artist's non-conformity and love of
freedom cannot be tolerated within a monolithic tyranny and modern art is
useless for the dictators' propaganda, because while it is still modern, it has little
popular appeal. The dictators wanted to impose their artistic convictions. They
could. They did and the Russians still do. Let's look at the record in Russia and
Germany.

In the early days of the Soviet revolution the artists of the vanguard wel-
comed the toppling of the old order and threw their energies into building the
new with fervent idealism. Yet it was Lenin himself who said to his biographer
Clara Zetkin: "I have the courage to appear a barbarian. I cannot appraise the
works of expressionism, futurism, cubism and other 'isms' as the highest mani-
festations of artistic genius. I do not understand them. They give men no joy."

Lenin also said that "every artist claims, as his proper right, to work freely
according to his ideal whether it is any good or not. There you have the ferment,

the experiment, the chaos. Nevertheless," he went on, "we are Communists, and must not quietly fold our hands and let chaos bubble on as it will. . . . Art belongs to the people. It must have its deepest roots in the broad masses of the workers. It must be understood and loved by them and no others. . . . On their behalf let us learn a prudent administration . . . in the sphere of art and culture."

Some of us will respond to Lenin's very human confession of philistine feeling toward the "isms"; others, to his democratic assertion that "art belongs to the people." But the crux of his dialectic lies in his insistence that art must be loved by "them and no others." That would be a dictatorship of the proletariat more absolute than any foreseen by Marx and Engels.

Nevertheless, at first, "experiment" and "chaos" did "bubble on." In 1920 Pevsner and Gabo published their manifesto of constructivism and taught abstract painting and sculpture in the State Art School at Moscow. In Petrograd the constructivist Tatlin built a huge model for a far huger spiral monument to the Third International. Malevich, who had proclaimed suprematism in 1913, sent his famous canvas "White on White" to the big Moscow exhibition of 1919.

Chagall, back in Russia after success in Berlin and Paris before 1914, now became the head of the academy in his native Witebsk and later painted murals for the Jewish Chamber Theatre in Moscow. Kandinsky, who in pre-war days had won fame throughout the world for his abstract paintings, was appointed to important posts in universities and academies and founded twenty-two museums in the U.S.S.R.

In 1921 the U.S.S.R. was at peace for the first time since the revolution, but it was in desperate economic straits. During the same period that Lenin was putting through the New Economic Policy it became apparent that a return to the nineteenth-century tradition of academic realism in the arts would be more useful to the new state than constructivism and futurism. Gradually some of the academic artists of the old regime plucked up courage, offered their talents and began to recover their prestige.

Conversely, about the same time Chagall concluded that his work would be more appreciated in the West than in Moscow: he left for Berlin in 1922; and so did the disillusioned (and secretly forewarned) Kandinsky. One morning Pevsner found his studio at the academy locked and his class disbanded. By 1923 he and Gabo had also left Russia. Malevich departed quietly for a now provincial Leningrad. His fame has survived only in the West. Tatlin and Rodchenko, under pressure, turned to applied art. Burliuk, the futurist leader, had already arrived in the United States, where, in a free country, he could paint as he wanted to. Within five years Shadr's "Cobblestones—the Weapon of the Proletariat" and Katzman's "Lacemakers" had become typical of Soviet sculpture and painting. Deineka's "Textile Workers" also of 1928 was soon, however, to be considered too abstract in style.

Finally, in 1932, the dogma of Socialist Realism was proclaimed by Pravda and the formation of the Union of Soviet Artists was decreed by the Central Committee of the Communist party. The critic Milyutin wrote: "Art, the object

of which is to serve the masses, cannot be other than realistic. The attention of artists is concentrated on socialist construction . . . our struggles . . . the enemies of the people . . . the heroes of the Soviet land. . . ."

Abstraction or stylization of form, idealism or fantasy of subject were anathematized with such terms as formalism, Western decadence, leftist estheticism, petty-bourgeois degeneracy. Even realism that was too honestly factual was damned as naturalism. To practice these vices was to risk denunciation, isolation and starvation. To defend them involved more overt dangers.

One of the most frightening and shameful documents of our time is quoted at length in Kurt London's "Seven Soviet Arts." It records the inquisition conducted by a committee of fellow-painters upon the young artist Nikritin after he had submitted his canvas "Old and New" to the Art Commission for the annual exhibition. The picture was not a great work but it was a sincere, thoughtful and loyal effort to paint an allegory of a changing world. Two of Nikritin's friends, subway workers, posed for the youthful figures and had admired it. They had even made suggestions about the composition. But to Gerassimov, Deineka and the other successful artists on the jury the picture was a "defamation," "derived from the Italian Fascists," "deeply erotic, pathological," "individualistic," a "nightmare," a "catastrophe," a "terrible picture." The painter Lecht disclosed the jury's feelings: "Comrades, we have here a sample of the works about which Pravda warned us. . . . What we see here is a calumny . . . a class attack, inimical to Soviet power. The picture must be removed and the appropriate measures taken."

Nikritin's reply was courageous, even desperate. He rejected the jury's attacks and expressed his belief that shortly there would be a demand for paintings "actually realistic and contemporary and not photography like those which you assessed yesterday. . . . Those works follow the line of least resistance. I confess what I think—perhaps I am speaking for the last time."

The Committee did, however, approve another girl-and-boy-worker picture, Ryangina's "Higher and Higher" of 1934, which shows an artist's acceptance of Milyutin's assertion: "Life in the U.S.S.R. is full of purpose, bright hopes, obvious progress, growth of culture and security for the masses. . . . All this makes for buoyancy and cheerfulness and brightness in the creative work of Soviet artists." By 1934 the objective, unsmiling realism of Katzman's "Lacemakers" of 1928 would have been accused of naturalism. Ryangina, six years later, was insistently bright and cheerful and so was Deineka (one of Nikritin's accusers) in his "Future Flyers" of 1937. He had made commendable progress since his "formalistic" "Textile Workers" of 1927.

The heroism of the Red Army during the Civil Wars and, later, World War II, has been a very popular theme.

During the first twenty years of the U.S.S.R., pre-revolutionary triumphs of Russian arms were generally ignored but since the late Thirties Alexander Nevsky, Ivan the Terrible, Peter the Great, Suvarov and other imperial victors have often been celebrated by painters as well as in films. The patriotic painter,

however, wisely found his favorite subject in the dictator himself. Every year, in the big exhibitions, Stalin appears in scores of paintings, Lenin in dozens, the two together in half-dozens. Alexander Gerassimov's twelve-foot-long "Stalin and Voroshilov on the Walls of the Kremlin" of 1938 is characteristic. Three years earlier the painter had served as one of Nikritin's inquisitors. Favorite painter of the Red Army, Gerassimov is today perhaps the most influential artist in the U.S.S.R.

Russian artists who accommodate their art to the dictates of authority are well-paid and greatly honored. Their exhibitions are attended, we hear, by vast crowds and many of their works are bought for museums, factory club rooms, town halls, railroad stations, army barracks and museums.

Museums of historic art are also much visited and paintings of the past studied and admired, particularly such realistic history paintings of the late nineteenth century as Repin's "Cossacks Sending a Jeering Message to the Sultan." Colossal, quasi-photographic canvases by Repin and Surikov are held up as models to young painters.

Yet the most famous museum in Moscow is closed. The Museum of Modern Western Art comprises the collections of Morosov and Shchukin, assembled by those two great enthusiasts before 1914. Expropriated in 1919, it remains the greatest collection in the world of French painting of the post impressionist and early twentieth century schools. During the Twenties and Thirties the museum served as bait for foreign tourists. But apparently such formalistic canvases as Cézanne's still lifes, Gauguin's Tahitian scenes, and van Gogh's "Walk in Arles," not to mention a hundred Matisses and Picassos, seemed too powerfully subversive. The museum is barred, but Pravda continues to rage against the persistence of "worshipers of bourgeois decaying art who regard as their spiritual teachers, Picasso and Matisse, cubists and artists of the formalist group."

Painting and sculpture were perhaps the first arts to succumb to cultural tyranny but the theatre, movies, literature and music followed little by little. (Curiously, the recurrent heresies and pathetic repentances of the musicians Shostakovich and Prokofiev are far better known to the general public abroad than are the parallel but far more tragic cases of Mayakovsky, the greatest Russian poet of the Nineteen Twenties; Meyerhold, probably the most brilliant theatre director of our age, or Eisenstein, the master film régisseur.[13])

Architecture, too, succumbed. The designs of Tatlin and other constructivists were, of course, soon dismissed as impracticable fantasies without popular appeal, but during the Twenties a considerable number of buildings were designed under the influence of Le Corbusier and Gropius. This International Style architecture, however, was condemned during the Nineteen Thirties as "formalist" and "Western." Instead, Russian architects were enjoined to look backward to the great public buildings, first of imperial Rome, then of imperial Russia. Yofan's revised design for the Palace of the Soviets, of about 1935, marked the victory of academic reaction. The celebrated Moscow subway stations confirmed

it: they form a suite of expensive period galleries (though who wouldn't trade them for the shabby bleakness of our New York equivalents?). The new Government palaces and big apartment houses of Moscow, 1950, emulate the baroque or neo-classic American skyscrapers of 1920 at their worst—and all in the name of Socialist Realism!

Modern art was to fare no better in Nazi Germany. Though the Nazi revolution of 1933 was anti-Communist and anti-Slav, Goebbels had made a careful study of Soviet techniques; and by 1939 the Nazi-Soviet pact suggested that even their ideological differences might not be too irreconcilable. Now, in 1952, the nationalistic arrogance of the Russians and the imperialistic achievements of the U.S.S.R. might well make Hitler writhe in his grave with envy and chagrin.

Lenin personally disliked modern art, and so does Stalin, but Soviet art policies are based more on a dialectic of power than on personal feeling. Hitler did not merely dislike modern art, he hated it as only a frustrated academic artist could. And he found plenty of company among his brown-shirted battalions and considerable numbers of the general public who were smugly delighted to hear that the new art (which they had never troubled to study or understand) had, in fact, been foisted on them by a conspiracy involving an international cartel of Jewish dealers, corrupt art critics, irresponsible museum officials and artists who were spiritually un-German, bolshevistic, Jewish and degenerate. The fact that none of the dozen foremost German artists were Jews and only two were Communists made no difference. The Big Lie triumphed.

Immediately after the revolution the Nazis took action. The *Kampfbund für deutsche Kultur,* which already had its skeleton corps of academic artists well-posted throughout Germany, now formed local committees with power to act.[14] Modern painters and sculptors were everywhere denounced, their exhibitions closed, their works removed from museums, their teaching positions forfeited to reactionary successors. Critics and museum officials who had favored their work lost their jobs. A few were retained on evidence of good behavior.

Not only the works of the living "degenerate" artists but also those of the dead were banned. Van Goghs . . . , Gauguins, Ensors, Lautrecs, Munchs were stripped from museum walls and sold abroad. And so were the works of Matisse, Beckmann, Kokoschka, Feininger, Picasso, Klee, Barlach and many others, including Chagall and Kandinsky, who were already exiles from Moscow. Probably the most famous of all German sculptures, Lehmbruck's "Kneeling Woman," passed from the National Gallery in Berlin to the Museum of Modern Art in New York. Meanwhile Hitler himself was collecting dozens of elaborate and vulgar historical paintings by the nineteenth century artist Hans Makart.

If the various expressionist and abstract styles of painting and sculpture were anathema to the Nazis, the flat roofs and uncompromising lines of the "International Style" in the architecture of such internationally renowned persons as Gropius and Mies van der Rohe were equally so. Conservative architects flocked to join the *Kampfbund* and catered to Hitler's tastes. The Nazis even forced

modern architects to construct gabled roofs on houses which had been designed with flat ones so that they might appear more *echt deutsch.*

Meanwhile the Nazi academicians painted idealized figures of Luftwaffe and S. A. troopers such as Eber's "The Call to Arms," heroic scenes of German wars, old and recent, *gemuetlich* German peasants such as Baumgartner's canvas, tempting Nordic nudes, Aryan allegories, pretty German landscapes, generals, the Nazi ringleaders, and above all the Fuehrer.

Such is the painting of Hitler declaiming to his followers in the early Munich beer cellar days, which was included in the great exhibition at the opening of the *Haus der deutschen Kunst* in 1937.[15] Perhaps its title, "In the Beginning Was the Word," contributed to its considerable success!

The subject, style and spirit of Thorak's "Prometheus" epitomizes Nazi sculpture, which was largely confined to heroic nudes, mostly male, single or in comradely pairs. To the same degree the pompous, neoclassic *Haus der deutschen Kunst* at Munich illustrates Nazi architecture. Hitler personally supervised its design and spoke for two and a quarter hours at its opening in 1937.

Nazi art had a history only one-third as long as has its Soviet counterpart. During their coincident period—that is, 1933 to 1945—they grew more and more alike in subject-matter, thanks largely to increasing Russian nationalism.

At the *Haus der Kunst* there was more slick, academic neo-classicism in evidence, at the All-Russian Artists' Annual[16] more of the huge, incredibly elaborate, historical paintings of, say, Stalin proposing a toast at a party banquet, or Ivan the Terrible entering a conquered Polish town. Nazi architects at least knew clearly what Hitler wanted but "Socialist Realism" has not proved a very clear beacon for Soviet architects no matter how eager they may be to conform to the party line.

It is obvious that those who equate modern art with totalitarianism are ignorant of the facts. To call modern art communistic is bizarre as well as very damaging to modern artists; yet it is an accusation frequently made. Most people are merely expressing a common dislike by means of a common prejudice. But this is a point of view which is encouraged by the more reckless and resentful academic artists and their political mouthpieces in Congress and elsewhere. It was given voice in the recent attack on the Metropolitan Museum by the National Sculpture Society, in the ridiculous but sinister debate in the Los Angeles City Council late in 1951,[17] and in the well-coached speeches of Representative George A. Dondero of Michigan. Those who assert or imply that modern art is a subversive instrument of the Kremlin are guilty of fantastic falsehood.

Artistic
Freedom

In October 1954, the full board of trustees of the American Federation of Arts approved a "Statement on Artistic Freedom" that was intended, a press release stated, to "guide the national art organization's activities in relation to contemporary art." The statement said, "Freedom of artistic expression in a visual work of art, like freedom of speech and press, is fundamental in our democracy. This fundamental right exists irrespective of the artist's political or social opinions, affiliations or activities. The latter are personal matters, distinct from his work, which should be judged on its merits. . . . in opposing anti-democratic forces throughout the world, the United States should do so by democratic methods, and give no cause for accusation that it is adopting the methods of its opponents. . . ."

Barr was a member of the American Federation of Arts Committee on Artistic Freedom, the committee that drafted the statement. Barr is here responding to a letter by William Ainsworth Parker, of the American Council of Learned Societies, who wrote, in part: "Because those who are criminals of some sort or Communists do hold identifiable socio-political opinions, it seems to me that when using public money the AFA, or any other contracting organization, can not operate on the policy that 'artistic expression must be judged solely on its merits as a work of art and not by the political or social views of the artist.' This appears to me to be particularly applicable to safeguards which must be maintained in connection with artists who may be sent abroad, or whose works may be exhibited in other countries, under the sponsorship of our Government." (From the *College Art Journal,* Spring 1956.)

Sir:

May I confess my astonishment that a letter signed above the initials of the American Council of Learned Societies should urge the American Federation of Arts and other art organizations to compromise their principles in order to accommodate the United States Information Agency. Yet this is what Wm. Ainsworth Parker proposes in his letter on page 57 of your Fall 1955 (XV, 1) issue under the heading "Artistic Freedom."

In its *Statement on Artistic Freedom,* first published, I believe, in the College Art Journal, Winter 1955 (XIV, 2, inside rear cover) the American Federation of Arts maintained the artist's right to freedom of expression and the corresponding rights of institutions and individuals to use his work with, of course, due respect to the laws against libel, obscenity, treason and political crimes. The *Statement* insisted upon judging works of art on their merits and not by the political implications of the artist.

The American Federation of Arts' statement was stimulated by a number of incidents in this country, some of them local, some of them involving censorship by national agencies such as the State Department and the United States Information Agency.

Broadly speaking, there were two kinds of censorship. One had to do with the style of art; the other with the artist's political inclinations.

In his speech before the A.F.A. in October, 1953, A. H. Berding of the U.S.I.A. stated that his Agency was interested in art exhibitions only insofar as they provided a "medium of communication, a means of interpreting American culture to other peoples." He asserted that "our Government should not sponsor examples of our creative energy which are non-representational," and added, "We are not interested in purely experimental art." In word and deed the U.S.I.A. made clear it did not want abstract art, for example, included in its exhibitions, in spite of the fact that abstract art was the most vigorous current movement in this country, and indeed throughout most of the Western world.

For an "information agency" in the stricter sense of the term, the U.S.I.A.'s policy was logical, but as our chief national agency for circulating art exhibitions abroad, the U.S.I.A.'s position was unrealistic. Mr. Berding's statement that "governments are notoriously conservative" in matters of art was and is not necessarily true, particularly as regards exhibitions sent to other countries. The U.S.A. is conservative, the U.S.S.R. even more so, and so, perforce, are its satellites, and Communist China. But Britain, France, Italy, do send the work of their advanced artists abroad. In proportion to the quality and timeliness of their exhibits, their *avant-gardes* win prizes and prestige. These countries also send abroad work by artists whose political associations, or even commitments, are radical—and this leads us back to our other category of censorship.

Though not stated in Mr. Berding's speech in 1953, a second kind of restraint or censorship practiced by the U.S.I.A. involved the political associations of the artists. So far as I know, the first published statement of the U.S.I.A. policy concerning this kind of censorship appeared in an article by Leslie Portner in the *Washington Post and Times Herald* on March 6, 1955. Mr. Parker quotes its key sentence: the U.S.I.A. will not exhibit "works of avowed Communists, persons convicted of crimes involving a threat to the security of the United States, or persons who publicly refuse to answer questions of congressional committees regarding connection with the Communist movement."

This statement of policy, contrary as it is to the A.F.A.'s statement of principle, actually represented a marked relaxation of censorship as previously practiced by Government agencies which had banned or tried to ban the work of artists obviously less implicated than those who were "avowed Communists" or convicts or had remained publicly silent under congressional questioning. Unfortunately practice has not always been as liberal as policy.

The article in which the U.S.I.A. permitted Mrs. Portner to quote its policy was the sequel and in effect a rebuttal to a previous piece in which Mrs. Portner reported a lecture which I had been honored to give at the Corcoran Gallery

under the auspices of the Institute of Contemporary Arts and the Phillips Gallery. In this lecture, I reviewed the policies and some of the incidents I felt illustrated the behavior of the State Department and U.S.I.A. in reference to exhibitions sent abroad over the previous decade.

I described how in the Fall of 1946 the Hearst papers initiated an attack on the State Department's *Advancing American Art* exhibition and ran illustrations of some of the paintings in the show by Stuart Davis, John Marin, Ben Shahn, Yasuo Kuniyoshi and others with abusive quotations by Dean Cornwell, Charles R. Knight, Eugene Speicher and other conservatives; how *Look* Magazine published a spread of the American pictures to show how the taxpayers' money had been spent; and finally, how Secretary Marshall, under pressure, ordered the shows withdrawn for the good, as he said, of the State Department. I questioned whether it was good for the country to withdraw an exhibition of American art from Prague where it had won enthusiastic applause during the very period when the U.S.S.R. was well on the way toward the Communist conquest of Czechoslovakia. The show was effective in advancing American prestige not because it exhibited agreeable scenes of American life and landscape, but because it contained good work by many of the best American non-academic painters.

I said that the attacks were for the most part on the radical style of the pictures, but the radical politics of some of the artists was also mentioned. After the shows were withdrawn, Congressman Busbey[18] attacked them elaborately, publishing a list of 24 of the 45 artists with citations from the files of the Committee on Un-American Activities as evidence that they were subversive. I added that after studying these citations carefully and from other knowledge, I believed that half a dozen of the 45 artists were or had been Communists or loyal Party-liners. At the same time, I said that I was pretty sure that Congressman Busbey could not possibly have picked out which pictures were painted by the half dozen most plausible suspects.

I remarked that the traumatic effect of Busbey's attack had been lasting, followed as it was by Congressman Dondero's irresponsible tirades and Senator McCarthy's[19] damaging assaults on the morale of our foreign services. Up to 1955 the U.S.I.A. generally attempted to exclude not only the work of certain artists associated with subversion, but also abstract art in general, in spite of the fact that radical styles of art are even more anathema to Communists than to congressmen. I then spoke of the "black list" or "gray list" which I had heard was used to blackball the work of artists. I gathered that these "lists" had nothing to do with works of art themselves, but simply with the artists' pasts as presented in some security dossier or on some list in the Congressional Record. I also guessed that the blackballing proceeded without any independent effort to check on whether the dossiers contained true information or not. I noted that no one on the outside had been permitted to see the lists, but that we knew from experience how they worked.

I then gave some examples:

1. In 1952 John Baur, now Curator of the Whitney Museum, had been asked by the State Department to do an article on recent American sculpture for publication in Europe. Baur naturally included William Zorach in his survey and also in the seven illustrations he was asked to recommend. He was astonished to receive a phone call from the State Department saying that Zorach's marble torso of a woman entitled *Victory* could not be illustrated because, Baur gathered, Zorach had been accused by Congressman Dondero of having been a member of the John Reed Club in the early 1930's. About the same time, Zorach (probably the best American sculptor of his generation) lost an important government commission after he had already completed the model—it appeared that he had been denounced by some academic sculptor. Zorach emphatically denied Congressman Dondero's accusation and had his denial read into the Congressional Record by his own congressman, but the results for the sculptor were loss of work, and for Baur's article, censorship.

2. Ben Shahn first won fame through his Sacco-Vanzetti series of 1931. He was associated during the thirties with several artist organizations which were Communist dominated. In 1947, in Congressman Busbey's denunciation of the State Department exhibitions, Shahn was listed among 24 painters who were supposed to have subversive records. Some of the 24 had as many as three fine-print columns of citations. Shahn had only one citation: he had contributed a drawing to the *New Masses* art auction in March, 1942, a time when our Communist ally, the U.S.S.R., was winning general American sympathy in its desperate struggle against the Nazi invaders.

Shahn worked for Wallace in 1947, as did many gullible liberals. Perhaps the Communist subversion of Wallace's Progressive Party disillusioned Shahn. In any case, he was later to speak with extreme bitterness of the Communist infiltration and corruption of liberal movements and with equal vigor against Soviet art policies. (Later in my lecture I quoted Shahn twice. In describing the predicament of the liberal, Shahn wrote in *Art News*, September 1953: "To the left of the liberal stands the Communist contingent, ever alert to move in upon his good works, always ready to supply him with its little packages of shopworn dogma, to misappropriate his words, his acts and intentions. The liberal has long suffered such Communist invasion of his organizations. It has been his cross, and it has, over a period of years, thoroughly demoralized the great American liberal tradition." In the previous year, at the University of Buffalo, Shahn had paid his respects to totalitarian art policies as well as to their curious parallels in this country. Of art in the U.S.S.R. Shahn said: "Communist doctrine, again, holds art to be a weapon and has harnessed it to the uses of the State. Neither the formulae of commissars, nor inducements of honor, nor pretentious awards have yet succeeded in breathing life into Soviet art. Its deadly procession

of overdrawn generals and over-idealized proletarians bears sharp testimony to the fact that there is no conviction in the artists' hearts, and that the search for truth has been stalled.")

During the very period of these two statements, Shahn had been nominated by a committee of leading American museum officials as the American painter most worthy to be represented in an important foreign exhibition. This nomination, however, though approved by an overwhelming vote, was vetoed by a spokesman for the State Department.

3. The Museum of Modern Art received through the State Department a request from a foreign government to assemble an exhibition of American painting to be shown abroad. The Museum agreed to do this with the usual provision that it should be free to make its own selections. When the State Department was told of the artists included, the Museum was asked to omit a work by Franz Kline, one of the most notable of the younger American abstract painters, from the exhibition. It appeared that the artist was on some "list." The Museum refused. (Though the following P.S. is beside the point, it should be added to the credit of the State Department that not long afterwards the Museum was informed that the charge against Franz Kline was the result of mistaken identity!)

During the intermission in my lecture at the Corcoran I was approached by a member of the U.S.I.A. to say that I had been mistaken in thinking that the Agency used a "black list" or "gray list" and that, on the contrary, it no longer tried to eliminate artists against whom only minor charges had been leveled. When I resumed speaking, I made these corrections. A couple of weeks later in Mrs. Portner's article a spokesman for the U.S.I.A. stated its three official categories of exclusions as quoted above and explained that this policy had been established in 1953.

I am now convinced that there are no mimeographed "black lists" or "gray lists" in the desks of the U.S.I.A. employees. However, I gather that lists of artists whose works are proposed for exhibition are submitted to some sort of security office for clearance, an operation which results both in censorship and the accumulation in the minds of the staff of names associated with supposed subversion or, at least, risk to the U.S.I.A.

Perhaps it is this apprehensive state of mind which still results in occasional efforts to eliminate the work of artists whose political errors are not grave enough to fit any of the three official categories of proscription. Quite recently a representative of the U.S.I.A. cautioned a committee of the College Art Association against the inclusion of a work by one of the best and internationally most admired American painters in an exhibition to be sent abroad. The ban was preliminary and, one hopes, casual; perhaps it will not be confirmed; but the intention was clear.

This was a disquieting incident. Nevertheless, the U.S.I.A. is apparently relaxing. We have heard that certain artists are no longer blackballed and one may note with relief that an exhibition, *Sport in Art,* with work by the four artists

who have recently been accused in Dallas of having been aligned with the "Communist-socialistic-international groups of subversives" (Kroll, Kuniyoshi, Shahn and Zorach), will be shown abroad by the U.S.I.A. *Sport in Art* was originated and sponsored by *Sports Illustrated* (a Luce publication), organized by the American Federation of Arts, and is scheduled to be sent by the U.S.I.A. to Australia "where the exhibition will represent this country during the Olympic Games in the fall of 1956." (Even while this show was still on view at the Corcoran Gallery in Washington, the Dallas County Patriotic Council— the American Legion, D.A.R., et cetera—was training its heaviest artillery on the Dallas Museum to force it to remove the works by the four accused artists before the exhibition was shown in Dallas.[20]) We are also assured, through Mrs. Portner's article and later reports, that the U.S.I.A. no longer intends to exclude all abstract art from its exhibitions.

In conclusion, let us not underestimate the anxieties and difficulties of the U.S.I.A. staff. Often the very works of art most likely to enhance American prestige abroad are also most likely to offend congressmen and thereby arouse the fears of superior officers in the Administration. For their well-justified departures from current procedures or even for candid criticism of them, U.S.I.A. staff members have, it appears, been heavily penalized. Yet to follow Mr. Parker's call to compromise would not, I believe, help the U.S.I.A. in the long run as much as the vigilant, out-spoken defense of American principles of freedom on the part of the very organizations Mr. Parker's letter involves. I mean the American Federation of Arts, the American Council of Learned Societies and the College Art Association.

Above all, let us keep our eyes on the two chief enemies of American freedom, the Communists and the fanatical pressure groups working under the banner of anti-communism. The Communists are still active, still trying to influence or take over artists' organizations, still taking their theories of art from Moscow and savagely attacking modern art that does not conform to Party-line realism, still trying to involve liberals in defending them when they get in trouble. On their part, the fanatical vigilante groups, waving the American flag, but reckless of our traditional liberties, and usually allied with academic artists, are trying to put pressure on museums, exhibition organizers and public officials by repeated attacks on works of art and their makers. It is hard to say which faction is actually the more subversive of our civilization and culture.

ALFRED H. BARR, JR.
New York City

The Museum of Modern Art's Record on American Artists

In the fifty-fifth anniversary special issue of *Art News,* Executive Editor Thomas B. Hess's editorial commented on the previous five years, 1952–57. "Ten years ago," he wrote, "most of the leading New York School artists were famous in their art world—to the small professional public which inevitably grew around them—but were either unknown or suspect to the officialdom of museums, collectors, critics and to the registered museum-visiting attendance. . . ." However, in "the past five years, the situation has altered; a characteristic symptom of the change is the Museum of Modern Art's inclusion of Jackson Pollock, in a context of 'introductions,' in its '15 Americans' exhibition, 1952, *vis-à-vis the undertones of catalogued History in its Pollock retrospective show of last winter* [italics added]. And, in its peculiar way, the Museum of Modern Art speaks *for* rather than to its enormous public. . . ."

Barr, in this letter to the magazine, incompletely quotes Hess, somewhat altering the terms of the discussion. In fact, Hess responded in the same issue to Barr's letter by saying: "Mr. Barr is probably the most informed, courageous and efficacious champion modern art has had since Apollinaire. But . . . the Museum does not express his identity. It is a complex Organization with a monolithic, widely publicized national (and increasingly international) presence. It was this presence—the Museum as a force—that was referred to. . . . The Museum is the sum of its Christmas-cards and upholstery-fabric competitions, Mondrians, automobiles and Pollocks, Latin-American watercolors and Picassos . . . no one part can discount another. . . ." (From *Art News,* September 1957.)

Sir:

In his editorial in your Summer issue, T[homas] B. H[ess] states that "ten years ago most of the leading New York School artists . . . were either unknown or suspect to the officialdom of museums, collectors, critics. . . . Encouragement . . . came from only a handful of sympathizers." He then observes that "In the past five years, the situation has altered; a characteristic symptom of the change is the Museum of Modern Art's inclusion of Jackson Pollock in a context of introductions in its '15 Americans' exhibition, 1952. . . ." However, he warns, "the fact that the Museum of Modern Art finally accepted a representative work by Hans Hofmann for its collection does not mean that its collective bureaucratic

stereotypes have become flexible. It will be just as tough as it ever was for moderns. . . ." These remarks are virtually a confirmation of the same writer's otherwise very friendly editorial of November 1954 in which he complains of the Museum's "baffling lack of recognition of postwar American abstract painting and sculpture," a lapse "prevented from becoming a scandal" only by "Dorothy Miller's exhibitions of American artists in 1946 and 1952."[21]

It has indeed been "tough for the moderns" and much honor is due the "handful of dealers, critics and collectors" who stood by them ten years ago. But is it really true that ten years ago the "New York School" ("avant-garde" or "Abstract-Expressionist") was "unknown or suspect to the officialdom" of the Museum of Modern Art (not to mention the Whitney and the Art Institute of Chicago) and that it was only in 1952 that the Museum took a half-hearted turn for the better? Let's look at the Museum's record before that date as it concerns the six painters mentioned in the editorial, Gorky, Pollock, Tomlin, Hofmann, de Kooning and Motherwell, to which I should like to add Baziotes since ten years ago, as it happens, it was he who was the most bitterly maligned of all the avant-garde.

First, Gorky: three of his paintings were first shown by the Museum in 1930 during its first season, and again in 1936 and 1938 (in Paris). Paintings were not acquired until 1941 and 1942 because his work seemed too derivative. *Agony* [1947], possibly his best picture, was bought in 1950. Ten paintings were shown in "Fourteen Americans," 1946: the *Art News* critic dismissed them as "decorative meanderings."

In 1944 the Museum bought Pollock's *She Wolf* [1943], his strongest work up to that time but later surpassed by the big abstract canvas, *Number 1* (1948) bought in 1950. Though Pollock's *Number 1* and Gorky's *Agony* are generally considered to be among the best paintings of the "New York School," *Art News* (January 1951) mentioned neither of them even as a runner-up in its deliberations on nominating "the most important modern American painting acquired by an American public collection" in 1950. Instead, it tentatively named a Ben Shahn. *Art News* (March 1949) gave only a single paragraph to the extraordinary Pollock exhibition out of which *Number 1* had been bought and later (January 1950) named Balthus, Peter Blume, Shahn, Gatch and Arp as the five artists with the best one-man shows of the year.

Because three excellent paintings by Tomlin had already been acquired by trustees with the intention of giving them to the Museum Collection, the Museum did not buy a picture until 1952: that was the very large *Number 20* of 1949, perhaps his masterpiece.

The Museum bought its first Motherwell in 1944, others in 1946 and 1950, and exhibited thirteen pictures in "14 Americans," 1946, when like Gorky, he received dispraise from *Art News*.

The Museum showed a de Kooning in 1936 and bought his superb black abstraction in 1948. Four more were bought in 1949 and 1951 by a trustee. I mention our trustees' purchases because most of them were loyally made with

the Museum's collection in mind and because I suppose the purchasers would surely be included by T.B.H. within the disparaged "officialdom . . . of collectors." *Before* "1952" at least sixteen paintings by Tomlin, Motherwell, Pollock, Baziotes, Gorky and de Kooning had been acquired by four trustees of the Museum.

Hofmann, the great teacher of the "New York School," was not represented in the Museum Collection until 1952, a delay which may have been an error of judgment but was not the result of indifference.

The Museum's first Baziotes was bought in 1947. Before 1952 three trustees had also bought his paintings.

Early in 1948 the Museum showed the Baziotes along with recently acquired works by other avant-garde painters such as Gottlieb, Stamos, Donati and Tobey. The February *Art News* listed but gave no critical support to this group of acquisitions generally condemned elsewhere as "extremist." Though it does praise a current Baziotes show in the same issue, one also notes a long laudatory review of a book by an art critic conspicuous for her caustic contempt for Baziotes *et al.*, and an unsigned paragraph on an exhibition by Pollock whose work is summarized as "lightweight, somehow."

A month later, March 1948, the Museum published a catalogue of its painting and sculpture collections in which "Gorky, Matta and Pollock" are singled out as the younger exemplars of that "lyrical spontaneity of line, form and color" in which "freedom of imagery and metaphor matches freedom of technique"—to which might be added J. T. Soby's eloquent and discerning remarks on Pollock in his *Contemporary Painters,* published by the Museum the same year.

In January 1949, when the Museum put on a full scale show of its American painting collection, *Art News* grouped "Baziotes, Pollock, Motherwell, de Kooning, Gorky" as the "fond hopes of the Modern Museum" and noted that "its encomiums" were "unequivocally placed on abstraction." Paintings by those five artists and several others in the movement were in fact shown together as the climax of the exhibition, a gesture made with enthusiasm and conviction but greeted without the slightest approbation by the *Art News* critic who recommended that the Museum acquire more works of a more realistic or at least more "legible" character. (Let us recall that besides the disparagement of the American avant-garde by the newspapers and news weeklies during the previous year, F. H. Taylor's "Art and the Dignity of Man" had just been published in the December 1948 *Atlantic,* Lincoln Kirstein's "State of Modern Painting" in the October 1948 *Harper's;* George Biddle's "Modern Art and Muddled Thinking" in the December 1947 *Atlantic.* In March 1948 the Boston Institute of Modern Art had penitently repudiated the word "Modern" in its name as having been contaminated by "double talk, opportunism and chicanery," "obscurity," "extremism" and "the cult of unintelligibility.")

In 1950 the Editor of *Art News* asked the Museum to collaborate in the American show at the Venice Biennale. The Museum chose three of the nine artists and assembled their work: they were Gorky, de Kooning and Pollock. In

the preface published in the Biennale catalogue I wrote: "After World War I, painting in the Western world went through a period of retrospection. . . . The spirit of painting after World War II seems by contrast much bolder. . . . There are, it is true, reconsiderations of meticulous realism or romantic scenery, but everywhere in the United States as well as in Western Europe many strong young artists and a number of talented older men are engaged in renewed exploration and adventure. In America several names have been used to describe this predominant vanguard: 'symbolic abstraction,' 'abstract expressionism' . . . three of the younger leaders have been Gorky, de Kooning and Pollock." This preface incidentally was re-published by *Art News,* Summer 1950.

After 1950 but before the *15 Americans* show in 1952 (when according to T.B.H. the Museum belatedly turned over a new leaf) paintings by Rothko and Kline were added to the collection; and Andrew Ritchie directed the Museum's "Abstract Art in America" exhibition, wrote the most thorough account of the subject published up to that time and arranged and published an important symposium on the subject.

The Museum's record is far from perfect. Sometimes it was handicapped by lack of money, always by lack of time and space; occasionally it was retarded by differences of opinion, more often, I know, by lack of vision. Furthermore —*pace* the partisans—the Museum has not, and I hope will not, commit itself entirely to one faction: at the Venice Biennale of 1954 it presented a one-man show of Shahn as well as de Kooning; in the galleries of its painting collection it will continue to exhibit Hopper as well as Tobey, Peter Blume as well as Mark Rothko, Carroll Cloar as well as Helen Frankenthaler. Some of the Museum's friends have questioned this policy, urging that the Museum align itself exclusively with the current avant-garde. Its bitterest enemies insist that the Museum has already done exactly that. Be that as it may, the Museum welcomes, and ponders, thoughtful, informed criticism.

Alfred H. Barr, Jr.
Director of the Museum Collections
Museum of Modern Art
New York, N.Y.

The New American Painting as Shown in Eight European Countries 1958-1959: Introduction

"The New American Painting" show was assembled by Dorothy C. Miller to travel to eight European countries. The artists included were: William Baziotes, James Brooks, Sam Francis, Arshile Gorky, Adolph Gottlieb, Philip Guston, Grace Hartigan, Franz Kline, Willem de Kooning, Robert Motherwell, Barnett Newman, Jackson Pollock, Mark Rothko, Theodoros Stamos, Clyfford Still, Bradley Walker Tomlin, Jack Tworkov. In most cases, this was the audiences' first exposure to Abstract Expressionism.

"We are now committed to an unqualified act, not illustrating outworn myths or contemporary alibis. One must accept total responsibility for what he executes."
CLYFFORD STILL 1952

"Voyaging into the night, one knows not where, on an unknown vessel, an absolute struggle with the elements of the real." ROBERT MOTHERWELL

"There is no more forthright a declaration, and no shorter a path to man's richness, nakedness and poverty than the painting he does. Nothing can be hidden on its surface—the least private as well as the most personal of worlds."
JAMES BROOKS 1956

"Art never seems to make me peaceful or pure. . . . I do not think . . . of art as a situation of comfort." WILLEM DE KOONING 1951

"The need is for felt experience—intense, immoderate, direct, subtle, unified, warm, vivid, rhythmic." ROBERT MOTHERWELL 1951

"Subject is crucial and only that subject matter is crucial which is tragic and timeless." MARK ROTHKO

"What happens on the canvas is unpredictable and surprising to me. . . . As I work, or when the painting is finished, the subject reveals itself."

WILLIAM BAZIOTES 1952

"Usually I am on a work for a long stretch, until a moment arrives when the air of the arbitrary vanishes and the paint falls into positions that feel destined. . . . To paint is a possessing rather than a picturing." PHILIP GUSTON 1956

"The function of the artist is to make actual the spiritual so that it is there to be possessed." ROBERT MOTHERWELL

Of the seventeen painters in this exhibition, none speaks for the others any more than he paints for the others. In principle their individualism is as uncompromising as that of the religion of Kierkegaard whom they honour. For them, John Donne to the contrary, each man is an island.

Though a painter's words about his art are not always to be taken at face value, the quotations preceding this preface—like the statements printed further on—suggest that these artists share certain strong convictions. Many feel that their painting is a stubborn, difficult, even desperate effort to discover the "self" or "reality," an effort to which the whole personality should be recklessly committed: *I paint, therefore I am.* Confronting a blank canvas they attempt "to grasp authentic being by action, decision, a leap of faith," to use Karl Jaspers' Existentialist phrase.

Indeed one often hears Existentialist echoes in their words, but their "anxiety," their "commitment," their "dreadful freedom" concern their work primarily. They defiantly reject the conventional values of the society which surrounds them, but they are not politically *engagés* even though their paintings have been praised and condemned as symbolic demonstrations of freedom in a world in which freedom connotes a political attitude.

In recent years, some of the painters have been impressed by the Japanese Zen philosophy with its transcendental humour and its exploration of the self through intuition. Yet, though Existentialism and Zen have afforded some encouragement and sanction to the artists, their art itself has been affected only sporadically by these philosophies (by contrast with that of the older painter, Mark Tobey, whose abstract painting has been deeply and directly influenced by Tao and Zen).

Surrealism, both philosophically and technically, had a more direct effect upon the painting of the group. Particularly in the early days of the movement, during the war, several painters were influenced by André Breton's programme of "pure psychic automatism . . . in the absence of all control exercised by reason and outside of all aesthetic and moral preoccupation." Automatism was, and still is, widely used as a technique but rarely without some control or subsequent revision. And from the first Breton's dependence upon Freudian and Marxian

sanctions seemed less relevant than Jung's concern with myth and archaic symbol.

The artists in the exhibition comprise the central core as well as the major marginal talent in the movement now generally called "Abstract Expressionism" or, less commonly, "Action Painting." Both terms were considered as titles for this exhibition.

Abstract Expressionism, a phrase used ephemerally in Berlin in 1919, was re-invented (by the writer) about 1929 to designate Kandinsky's early abstractions that in certain ways do anticipate the American movement—to which the term was first applied in 1946. However, almost to a man, the painters in this show deny that their work is "abstract," at least in any pure, programmatic sense; and they rightly reject any significant association with German Expressionism, a movement recently much exhibited in America.

Action Painting, a phrase proposed in preference to Abstract Expressionism by the poet-critic, Harold Rosenberg, in an important article published in 1952,[22] now seems to overemphasize the physical act of painting. Anyway, these artists dislike labels and shun the words "movement" and "school."

The briefest glance around the exhibition reveals a striking variety among the paintings. How could canvases differ more in form than do Kline's broad, slashing blacks from Rothko's dissonant mists, or Pollock's Dionysiac *perpetuum mobile* from Newman's single, obsessive, vertical line? What then unites these paintings?

First, their size. Painted at arm's length, with large gestures, they challenge both the painter and the observer. They envelop the eye, they seem immanent. They are often as big as mural paintings, but their scale as well as their lack of illusionistic depth are only coincidentally related to architectural decoration. Their flatness is, rather, a consequence of the artist's concern with the actual painting process as his prime instrument of expression, a concern which also tends to eliminate imitative suggestion of the forms, textures, colours and spaces of the real world, since these might compete with the primary reality of paint on canvas.

As a consequence, rather than by intent, most of the paintings seem abstract. Yet they are never formalistic or non-objective in spirit. Nor is there (in theory) any preoccupation with the traditional aesthetics of "plastic values," composition, quality of line, beauty of surface, harmony of colour. When these occur in the paintings—and they often do—it is the result of a struggle for order almost as intuitive as the initial chaos with which the paintings begin.

Despite the high degree of abstraction, the painters insist that they are deeply involved with subject matter or content. The content, however, is never explicit or obvious even when recognizable forms emerge, as in certain paintings by de Kooning, Baziotes, and Gottlieb. Rarely do any conscious associations explain the emotions of fear, gaiety, anger, violence, or tranquillity which these paintings transmit or suggest.

In short these painters, as a matter of principle, do nothing deliberately in

their work to make "communication" easy. Yet in spite of their intransigence, their following increases, largely because the paintings themselves have a sensuous, emotional, aesthetic and at times almost mystical power which works and can be overwhelming.

The movement began some fifteen years ago in wartime New York. American painting in the early 1940's was bewilderingly varied and without dominant direction. The "old masters" such as John Marin, Edward Hopper, Max Weber, Stuart Davis, were more than holding their own. The bumptious Mid-Western regionalism of the 1930's, though still noisy, was dying along with its political analogue, "America First" isolationism. Most of the artists who during the decade of the Great Depression had been naïvely attracted by Communism had grown disillusioned both with the machinations of the party and with Socialist Realism. There were romantic realists who looked back nostalgically to the early nineteenth century, and "magic realists," and painters of the social scene such as the admirable Ben Shahn. The young Boston expressionists Hyman Bloom and Jack Levine had considerable success in New York, while from the Pacific coast came the visionary art of Mark Tobey and Morris Graves, reflecting Oriental influence in spirit and technique. There was also a lively interest in modern primitives, but no one discovered an American *douanier* Rousseau.

Late in the artistically reactionary 1930's, the American Abstract Artists group had stood firm along with their allies, *Abstraction-Création* in Paris and Unit One in England. Working principally in rather dry cubist or non-objective styles, they did not seem much affected by the arrival in the United States of Léger, Mondrian and several Bauhaus masters. Quite other young painters, not yet identified as a group, were however strongly influenced by the surrealist refugees from the war, notably Max Ernst, André Masson, Marcel Duchamp (who had been the leader of New York Dadaism during World War I), the poet André Breton, and the young Chilean-Parisian painter Matta Echaurren. Equally important was the influence of the former surrealist associates, Picasso, Miró and Arp, who had stayed in Europe.

Chief among the supporters of the surrealist group in New York was Peggy Guggenheim whose gallery, "Art of This Century," opened in the autumn of 1942 and served as the principal centre of the *avant-garde* in American painting until the founder returned to Europe in 1947. Her brilliant pioneering was then carried on by the new galleries of Betty Parsons, Charles Egan and Sam Kootz. "Art of This Century" gave one-man shows to Motherwell, Baziotes, Rothko and Still, and no less than four to Jackson Pollock. Arshile Gorky, the most important early master of the movement, showed at another (and prior) surrealist centre, the Julien Levy Gallery, with the poetic blessing of Breton.

The work of certain older American painters, notably Ryder, Marin and Dove, interested some of the artists, and for a time Rothko, Pollock, Gottlieb and Still were influenced by the symbolic imagery of primitive art, especially of the American northwest coast. All during this early period and afterwards, Hans Hofmann, a Parisian-trained German of Picasso's generation, taught the

young inspiringly and became their *doyen* colleague, though with little obvious effect on the leaders.

Before 1950 most of the artists in this show had hit their stride. And they had won general, though usually reluctant, recognition as the flourishing vanguard of American painting, thanks to the courageous dealers just mentioned, enthusiastic critics such as Clement Greenberg, a handful of editors, teachers, collectors, and museum officials, and above all to their own extraordinary energy, talent, and fortitude.

They were not, however, a compact phalanx. Gorky had been a quite well-known but rather derivative painter for fifteen years before he found himself about 1943. Pollock and Baziotes, both born in 1912, worked in obscurity until 1942–3, when they emerged along with the youthful and articulate Motherwell. Pollock exhibited his first highly abstract pictures about 1945 and invented his "drip" technique in 1947. By 1947, Rothko and Still, working some of the time in California, were developing their characteristic styles, Gottlieb was turning away from his "pictographic" forms, and Stamos, twenty years younger than they, had had his first show. In 1948, de Kooning, then forty-four, publicly entered the movement and quickly became a major figure; Tomlin was nearly fifty. Kline, Newman, Brooks and Guston, all mature painters, also transformed their art, Guston after having relinquished a brilliant success in a more realistic style. Since 1950, hundreds upon hundreds of American artists have turned to "abstract expressionism," some of them, like Tworkov, in mid-career, others like Hartigan and Francis while they were still students. Sam Francis is unique as the only expatriate in the show and the only painter whose reputation was made without benefit of New York, having moved directly to Paris from San Francisco where Still and Rothko had been honoured and influential teachers. Sculptors related to, and sometimes closely allied with, the painters' movement should be mentioned, notably Herbert Ferber, David Hare, Ibram Lassaw, Seymour Lipton, Theodore Roszak and David Smith.

The movement, after several tentative early years, has flourished in its maturity since about 1948, roughly the starting point of this show. Naturally, because of its dominance, it has aroused much resistance in the United States among other artists and the public, but it has excited widespread interest and even influenced the painting of some of its most stubborn adversaries. Others are staunchly resisting what has inevitably become fashionable. There will be reactions and counter-revolutions—and some are already evident. Fortunately, the undogmatic variety and flexibility inherent in the movement permits divergence even among the leaders; a few years ago, for instance, both Pollock and de Kooning painted a number of pictures with recognizable figures, to the dismay of some of their followers who had been inclined to make an orthodoxy of abstraction.

For over a dozen years now, works by some of these artists have been shown abroad, first in Europe, then in Latin America and the Orient. They have met

with controversy but also with enthusiasm, thanks in part to artists working along similar lines, and to other champions.

To have written a few words of introduction to this exhibition is an honour for an American who has watched with deep excitement and pride the development of the artists here represented, their long struggle—with themselves even more than with the public—and their present triumph.

Tastemaking

In his *New York Times* column of September 11, 1960, critic John Canaday quoted a statement Barr had made in an issue of *Esquire* magazine during the previous summer.[23] In part, it said: "The vigor and quality of this movement [Abstract Expressionism] is bound to generate a reaction—but where we are going to go I'm not willing to prophesy. What I see is a new concern with figure, and a movement toward a new severe style." Calling Barr "without any question at all the most powerful tastemaker in American art today, and probably in the world," Canaday referred to the enormous impact he felt what he termed Barr's "obituary" for Abstract Expressionism would have. (From *The New York Times*, September 25, 1960.)

To the Art Editor:

In your requiem for Abstract Expressionism (Sunday, Sept. 11) you involved me to my double embarrassment. It is true that I have said over the past several years that Abstract Expressionism, partly because of its dominant position, was bound to generate reactions and that some of these reactions were obvious. For instance, a new concern with figure painting, a resurgence of geometrical or "hard-edge" abstraction, new developments of dada techniques and spirit. (Incidentally, these tendencies have been generously represented in exhibitions at the Museum of Modern Art organized during the past two years by my colleagues —"Recent Sculpture U. S. A.," "New Images of Man," "16 Americans"—and by myself in Recent Acquisitions shows.)

You quoted (correctly) a rather garbled remark of mine and then eagerly misinterpreted it as an "obituary" for Abstract Expressionism. It was not. A number of the leading Abstract Expressionists seem to me to be painting as well or better than ever. And there are some able young recruits. I believe that in spite of highly interesting countercurrents—and, I might add, in spite of the generally hostile attitude of the head critics of the leading New York newspapers throughout the fifteen years since the movement began—American Abstract Expressionism, in its robust middle age, is going strong.

I suppose I should be pleased by your calling me "the most powerful tastemaker in American art today." Actually, I am more than embarrassed, I am dismayed. Any influence I may have is largely dependent upon the institution where I work, an institution with 250 other employes, devoted working committees and a Board of Trustees unequaled in the world for their generosity, enthusiasm and knowledge.

Now it is true that the Museum of Modern Art has a few times set out

deliberately to be a "tastemaker." It may even have succeeded. I think that our "Modern Architecture" show of 1932 did a good deal to accelerate revolutionary changes in American architecture. The museum probably affected the design of American furniture, too, even though unfortunately it failed in its repeated attempts years ago to influence the design of American automobiles.

But it has never been the museum's policy to try to influence painters, sculptors, printmakers, photographers, film makers or their entrepreneurs. The artists lead: the museum follows, exhibiting, collecting and publishing their work. In so doing it tries to act with both wisdom and courage, but also with awareness of its own fallibility.

The museum is also aware of its power, whether exercised deliberately as in a few of its architecture shows, or with embarrassment as in its painting shows or purchases. Especially in strictly contemporary art the risk of error is great and some unfairness inevitable. When a museum buys the work of one young artist, nine others and their ninety friends are disappointed. And the effects on "taste" and the art market (which you so amusingly exaggerate in personal terms) may indeed occur. But what should museums do? Abandon their concern with recent art? Would you abandon yours? You are the art critic in chief of the most powerful and respected newspaper in the United States with about 1,400,000 copies sold every Sunday. Surely you do not suppose that you have no influence on artists, dealers, collectors, museum trustees, foundation officials and the general public. Does this cause you no anxiety?

At the Museum of Modern Art we propose a partial answer to the dilemma: we must show the many disparate, even contradictory, yet significant kinds of art our complex civilization has produced, and show them continuously in permanent galleries so that the public may have at all times a panoramic perspective of the visual arts of our period (and incidentally will not suppose that the museum is exclusively committed to the one kind of art which happens to be on display at the moment in a temporary exhibition). To do this, whatever wisdom, courage and humility we can summon will not be enough. We must find the means to provide space, adequate space, to show our collections which we believe are, within their fields, the most comprehensive and representative in the world. This is one of the principal purposes of our current effort to raise $25,000,000.

In conclusion, may I propose that reluctant "tastemakers" like me and those like you who exaggerate the power of "tastemakers" both ponder Aesop's fable of two flies who, perched upon the axletree of a chariot, complacently remarked to each other: "What a dust we do raise!"

ALFRED H. BARR JR.
Director of the Museum Collections
The Museum of Modern Art
New York

Letters

"Alfred always had to write that letter to the paper,"[24] Dorothy Miller told Dwight Macdonald in 1953. Following is a sample of the more than fifty-five letters to the editor that were published.

THE PIED-BILLED GREBE

(From *Art News,* September 1947.)

Sir:

May I be among the dozens who have written you to protest your unintentional slight to the Pied-billed Grebe alias *Podilymbus podiceps* (*linnaeus*) alias Dabchick; Waterwitch; Dipper; Didapper (sic); Hell-diver who appears on the cover of your August issue by calling him a "nonchalant little duck." However "intricately webbed foot" is just, for no duck is so podiceps, though the waving is pure exhibition technique; nor can even a dabchick ride so high as Mark Catesby has drawn him, but he can most amazingly and gradually submerge himself and then go swimming along with only his bill and eye above water, thereby providing a prodigy which might have pleased Queen Carolina in 1725.

Yours, etc. ALFRED H. BARR, JR.
Greensboro, Vt.

THE LOYALTY OATH

(From the *Princeton Alumni Weekly,* April 13, 1951.)

Dear Sir:

Nothing is more nauseating than an American Communist appealing to "academic freedom" when he—and we—know what has happened to professors and liberal intellectuals generally in the U.S.S.R. On the other hand, it seems to me that Albert Covolo's insistence that Princeton impose a loyalty oath on its faculty (PAW, March 23, 1951) is naive. His comparison of a university staff member accused of disloyalty with a bank clerk indicted for embezzlement proves my point. The bank president might indeed fire the clerk, as Mr. Covolo assumes, but would he thereupon suppose that he could protect his depositors by insisting that the remaining employees take an *honesty* oath? Of course it's true that if he then caught another embezzler he could prosecute him for perjury!

Since Mr. Covolo is interested in the subject of forcing faculties to take loyalty oaths, he might read "The Year of the Oath," a book about some recent and disintegrating occurrences at the University of California. It's by a famous —and non-communist—Princetonian, George R. Stewart '17 (see ALUMNI WEEKLY of October 6, 1950).

New York City ALFRED H. BARR JR. '22

THE MIRACLE

Il Miracolo was half of a two-part film, *L'amore,* directed by Roberto Rossellini in 1948. Anna Magnani portrayed a simpleton who is seduced by a passing shepherd (played by Federico Fellini). She believes that he is Saint Joseph, and that the child she conceives is a second Holy Child. The ban against which Barr protested was ultimately rescinded. (From the *Magazine of Art,* May 1951.)

Sir:

I believe your readers will be interested in some of the sequels and consequences of Otto L. Spaeth's editorial, *Fogged Screen,* published in your February issue—many weeks before any other article on the subject appeared in a monthly magazine. The editorial deplored the censorship, under Catholic pressure, of early Chaplin comedies and of *The Miracle,* an Italian film directed by Roberto Rossellini. Between the writing and actual publication of the editorial Cardinal Spellman, bishop of the New York diocese, had denounced *The Miracle*

as "vile and harmful . . . a despicable affront to every Christian . . . a mockery of our faith . . . a vicious insult to Italian womanhood . . . a divisive act" employing "the technique of the greatest enemy of civilization, atheistic communism," etc., etc. He enjoined Catholics and "all people with a sense of decency" to boycott the film and "unite to change and strengthen Federal and State statutes" (*New York Times*, January 8th).

Thereupon the Paris Theater in New York, where *The Miracle* was being shown, was picketed by Catholic War Veterans, performances were interrupted by anonymous threats of bombing and, for the first time in its history, the theater was charged with a breach of fire regulations, Lieutenant Edward Coughlan serving the summons. Late in December, as stated in the editorial, New York's License Commissioner, Edward T. McCaffrey, a Bronx Democratic politician and former State Commander of the Catholic War Veterans, had temporarily forced *The Miracle* from the screen by threatening the theater with cancellation of its license. The film was reinstated temporarily, thanks to court action, but in spite of protests of the Protestant clergy and various lay groups, it was finally banned on February 16th by the Board of Regents, which as the supreme educational authority in New York State considered that it had the power to reverse the action of the State Education Department's Division of Motion Pictures in originally granting the license. This was the first time that a film license, once granted, had been revoked. Catholic pressure also prevented the Radio City Music Hall from acting as host to the New York Film Critics on the occasion of their publicly announcing their award to *Ways of Love*, of which *The Miracle* was a part, as the "best foreign-language picture of the year." On February 16th, the day *The Miracle* was banned the second time, a council of the Knights of Columbus accompanied by their chaplain, Father Finnegan, marched on a Queens theater and forced the withdrawal of another film, Vittorio de Sica's *Bicycle Thief*, on the patently absurd charge that it "glorified a thief." Unlike *The Miracle, The Bicycle Thief* is a masterpiece.

When the February *Magazine of Art* was published, both the *New York Times* and the *Herald Tribune*, which had already printed editorials against the suppression of *The Miracle*, quoted at length from Mr. Spaeth's statement. The whole article was printed *in toto* with enthusiastic commendation in the February issue of the *ADA World*, monthly magazine of Americans for Democratic Action. The April issue of *Harper's Magazine*, in its own long editorial, remarks, "In fact the most eloquent and persuasive comment . . . appeared in the *Magazine of Art*. . . . It came from Otto L. Spaeth, Director of The American Federation of Arts, past president of the Liturgical Arts Society, and delegate to the First International Congress of Catholic Artists in Rome last year."

The April *Atlantic Monthly* also published an extended analysis of *The Miracle* affair, but of even greater significance are two long articles in Catholic papers. The *Commonweal* of March 16th published "The Catholic as Philistine" by William P. Clancy of the University of Notre Dame, who notes that "A group

of Catholics, headed by Mr. Otto L. Spaeth, president of The American Federation of Arts, gave *The Miracle* unanimous approval as a deeply moving, profoundly religious film." Professor Clancy states that he is "profoundly disturbed" by "crusades which we feel can result only in great harm to the cause of religion, of art, and of intelligence. . . . These appeals to mass hysteria, these highly arbitrary invocations of a police censorship . . . are a most deplorable violation of the human spirit. . . . The end result, in each case, has been a semi-ecclesiastical McCarthyism with its appeal to prejudice. . . . It is a spectacle which many of us, as Catholics, can view only with shame and repulsion, for we know that neither art nor prudence, religion nor country, intelligence nor morality can be served by such means. . . . If art and the integrity of the artist mean anything at all, they mean that final judgment on them must be reached quietly, prayerfully and intelligently by those who are morally, intellectually, and aesthetically qualified to speak on them."

On March 22nd the *Catholic Messenger,* a diocesan newspaper published by Bishop R. L. Hayes in Davenport, Iowa, devoted a whole page to the suppression of *The Miracle* and *The Bicycle Thief.* Its film critic, Frank Getlein, deplores the kind of censorship imposed by the Catholic Legion of Decency and asserts that the Paris Theater "consistently shows better, and, for that matter, more overtly Catholic, films than any of the big houses in the Times Square area, the gaudy palaces specializing in wholesome and harmless, odorless, colorless, tasteless, lifeless native American fare."

The *Catholic Messenger* concludes: "The worst point about this whole affair —the bitter personal attacks on Rossellini, the violence and threats of bombing, the madness in Queens—is that once again the Church has been viciously misrepresented, and, as so often, by the spokesmen of the Church themselves.

"Christ wants the free love of all men; so often, as here, Christians demand the unwilling conformity of all. The Church is the Religion of Love. So often it seems to speak with the voice of hatred."

On May 7th the New York Supreme Court, Appellate Division, Third Department, reconvenes in Albany. It will consider the argument in the brief filed by the film's distributor, Joseph Burstyn, Inc., and the New York City Civil Liberties Committee and the National Council on Freedom from Censorship (affiliates of the American Civil Liberties Union) as friends of the court, that the action of the State Board of Regents in revoking the license of *The Miracle* on the ground "that it is sacrilegious would be to violate the First and Fourteenth Amendments of the Constitution." These amendments concern the separation of church and state, religious liberty, and freedom of speech and press. The film's distributor and the affiliates of the American Civil Liberties Union have expressed their intention of carrying the case on up to the Supreme Court, if necessary.

On Wednesday evening, May 9th, at 8.15 p.m. the National Council on Freedom from Censorship is holding a meeting at Town Hall in New York on

"Freedom vs. the Censors." There will be speakers representing films, publishing, radio, theater and art. All persons interested in this problem are invited to attend.

<div align="right">

ALFRED H. BARR, JR.
New York City

</div>

CITY'S RESORT FOR WILD FOWL

(From the *New York Herald Tribune,* March 26, 1953.)

To the New York Herald Tribune:

There are precious few birds around these parts during the winter," you say in your editorial "Redpolls to the South" (March 19). Steamer-voyaging redpolls and occasional flocks of evening grosbeaks in remotest Jersey or Long Island make news in your columns but I wonder if your readers are aware of the wealth of winter bird-life right here in the heart of Manhattan. I refer to the concentration of water birds to be found on that neglected inland sea, the Central Park Reservoir.

Almost any winter's day you will see a great raft of maybe 200 herring gulls yelping and mewing in the middle of the lake. Serene in the midst of this plebeian bedlam there are always a few great black-backed gulls, thirty-inch-long giants riding high in the water like miniature galleons.

Tame black duck and mallard, who live in Central Park the year 'round, ordinarily form the bulk of the duck population but they are outnumbered for a few days now and then by white-saddled scaup. Almost always, too, there is a flotilla of handsome, rakish American mergansers which you can follow with your binoculars cruising in single file as far out from shore as possible.

The less common ducks usually congregate in the northwest corner of the reservoir. There, this New Year's Day, I saw three pairs of baldpates and a half-dozen green-winged teal besides the usual scaup, mergansers, blacks and mallards—all together over 300 ducks of six different species.

A few days later, to my great delight, I found that the baldpates had been joined by three of their cousins, the European widgeon, a rare visitor from Norway. The color of the male widgeon is both striking and subtle with his gray, black-and-white body, salmon-pink breast, cinnamon cheeks, cream-white forehead and pale blue, black-tipped bill. There he was, a winter wanderer scarcer than your much-publicized evening grosbeak, swimming along with his two brownish consorts about thirty feet from the shore path (and three minutes' walk

from the Independent subway station at 96th St. and Central Park West!).

Manhattan's lake is a winter resort for other wild fowl besides gulls and ducks. Two years ago, at the end of February, I saw diving and swimming near the outlet, a Holboells grebe with his strange snake-like head and neck. He stayed for over a week and was followed later in March by another expert diver, the red-throated loon. And last year for several weeks in mid-winter you could see a dozen stately Canada geese swimming along the eastern shore, at times scarcely 100 feet from the swish and rumble of Fifth Ave. traffic.

Of course there are land birds, too, to be found in Central Park—jays, woodpeckers, sparrows, robins, long-eared owls—but their winter sparseness makes melancholy hunting by comparison with the teeming excitement of the reservoir.

ALFRED H. BARR, JR.

New York, March 24, 1953

AMERICAN CONFORMITY

(From *The Hartford Courant,* December 23, 1964.)

To the Editor of The Courant:

J udging from the *New York Times'* calm account, the suspension of a Westbrook, Connecticut high school boy because he combed his hair in bangs may well be one of the silliest demonstrations of American conformity on record. By their petty tyranny, the teacher, the Superintendent of Schools, the Board of Education, the State Education Commissioner have made themselves ridiculous.

Let us hope the boy's parents will win their fight to let their son comb his hair the way he wants to, even if Beatle-browed. After all, Connecticut is a part of our free country—or isn't it?

New York A. H. BARR

Notes
to the
Introduction

Writings that appear in this anthology are indicated by the following line in *italics: See p. 000.*

Material from The Museum of Modern Art Archives: Alfred Barr Papers that carries an AAA designation is available at the Archives of American Art.

1. See Russell Lynes, *Good Old Modern* (New York: Atheneum, 1973), Chapters I–II.
2. Ibid., p. 20. Even after Barr became Director of The Museum of Modern Art, during the early, most hectic years, he found time to attend meetings of a circle of art historians that included Meyer Schapiro.
3. Alfred H. Barr, Jr., "A Modern Art Questionnaire," *Vanity Fair,* August 1927. *See p. 56.*
4. Paul J. Sachs, in a letter to Alfred H. Barr, Jr., Rome, November 3, 1925, Museum of Modern Art Archives: Alfred Barr Papers: From Miscellaneous (5½″ box of unmicrofilmed items), thanked him for pointing out that Sachs devoted too little time to the twentieth century in his course on prints.
5. William Phillips, in "Our Country and Our Culture: A Symposium (I)," *Partisan Review,* May–June 1952, p. 589.
6. Philip Johnson, Statement, in *A Memorial Tribute: Alfred H. Barr, Jr.* (New York: The Museum of Modern Art, 1981), n.p. Johnson characterized "three aspects of his [Barr's] character that made it what it was . . . passion . . . stubbornness . . . loyalty." No wonder Barr hated the notion of being called a tastemaker, which implied trivial fashion-mongering instead of existential commitment.
7. It was Charles Rufus Morey's course that inspired Barr to choose art history as a calling over literature and paleontology, which were its close rivals.
8. Barr learned about modern Russian art from Louis Lozowick's *Modern Art in Russia* (New York: Société Anonyme, 1925) and Konstantin Umanskij's *Neue Kunst in Russland* (Potsdam: Gustav Kiepenheuer; Munich: Hans Goltz, 1920). He subsequently searched out Umanskij in the Soviet Union. (See "Russian Diary 1927–28," *October* 7 [Winter 1978], p. 46; *see p. 133.)* "A Modern Art Questionnaire" *(see p. 56)* indicates Barr's awareness of the Bauhaus.
9. Alfred H. Barr, Jr., "Lionel Feininger Eulogy," January 17, 1956, p. 1, Typescript. Museum of Modern Art Archives: Alfred Barr Papers; Archives of American Art Microfilm roll 3150, frame 480. Henceforth referred to as: MoMA Archives: Alfred Barr Papers; AAA 0000:000.
10. Sam Hunter, Introduction to *The Museum of Modern Art, New York: The History and the Collection* (New York: Harry N. Abrams in Association with The Museum of Modern Art, 1984), p. 11.
11. Philip L. Goodwin, Preface, *Built in U.S.A.,* exhibition catalogue (New York: The Museum of Modern Art, 1944), p. 8.

12. Alfred H. Barr, Jr., Introduction to *Masters of Modern Art* (New York: The Museum of Modern Art, 2d ed., 1955), p. 9.

13. Barr, "Russian Diary 1927–28," p. 36. *See p. 125.*

14. Ibid., p. 19. *See p. 112.*

15. Alfred H. Barr, Jr., "Mrs. Cresson Draws Fire" [Letter to the editor], *American Artist*, January 1955, p. 13.

16. Alfred H. Barr, Jr., "Sergei Michailovitch Eisenstein," *The Arts*, December 1928, pp. 317–18. *See p. 143.*

17. Ibid., p. 320. *See p. 145.* With reference to Erwin Piscator's criticism of Eisenstein's film *Potemkin* as being deficient as propaganda, Barr wrote on p. 318: "From a Marxian point of view Piscator's criticism is justified, but artistically an elaborate presentation of the social and political issues involved would have greatly diluted the concentration and force of the dramatic issue."

18. Barr, "Mrs. Cresson Draws Fire," p. 55.

19. Dwight Macdonald, "Profiles: Action on West Fifty-third Street—I," *The New Yorker*, December 12, 1953, p. 82.

20. Alfred Hamilton Barr, Jr., "Notes on Russian Architecture," *The Arts*, February 1929, p. 103.

21. Alfred H. Barr, Jr., "Plastic Values," *The Saturday Review of Literature*, July 24, 1926, p. 948.

22. Post-modernism was ushered in by the publication of Robert Venturi, *Complexity and Contradiction in Architecture* (New York: The Museum of Modern Art, 1966). *See p. 42.*

23. Alfred H. Barr, Jr., "Otto Dix," *The Arts*, January 1931, p. 237. *See p. 148.*

24. Alfred H. Barr, Jr., "In Defense of Kokoschka" [Letter to the editor], *The Art Digest*, October 1, 1949, p. 4.

25. Barr, "Dix," p. 235. *See p. 147.*

26. Barr's "Dix" was written in June 1929 but was not published until January 1931, because Barr did not want to seem too reactionary at the time when he assumed the directorship of The Museum of Modern Art. Alfred H. Barr, Jr., to James Thrall Soby, November 1, 1948. *See headnote, p. 147.* MoMA Archives: Alfred Barr Papers: *9b. Roob/AHB Bibliog. material.*

27. Goodwin, Preface, *Built in U.S.A.*, p. 8.

28. Alfred H. Barr, Jr., "A Brief Survey of Modern Painting," *The Carnegie Magazine*, March 1933, p. 313.

29. Alfred H. Barr, Jr., Introduction to *Paintings from the Museum of Modern Art*, exhibition catalogue (New York: The Metropolitan Museum of Art, 1956), n.p.

30. A. H. Barr, Jr., "Modern and 'Modern,' " *The Bulletin of the Museum of Modern Art*, May 1934, p. 4. *See p. 83.*

31. Alfred H. Barr, Jr., Confidential Notes on " 'Modern Art' and the American Public," by James S. Plaut; sent to William A. M. Burden, March 3, 1948, p. 4. MoMA Archives: Alfred Barr Papers; AAA 2171:216.

32. Alfred H. Barr, Jr., to Mrs. John D. Rockefeller, Jr., January 15, 1947. MoMA Archives: Alfred Barr Papers; AAA 3264:1339.

33. Barr remained interested in religion throughout his life; he was the founding president of an organization called Art Religion Culture.

34. " 'Boston Is Modern Art Pauper'—Barr: Wellesley Critic Sees Former Center of Seven Arts Barren and Dreary: Fogg Museum Excepted," *Harvard Crimson*, October 30, 1926, p. 1. *See p. 52.*

35. Alfred H. Barr, Jr., to Forbes Watson, January 9, 1927. Archives of American Art, Forbes Watson Archive, Microfilm roll D47, frame 117. *See headnote, p. 52.*

36. " 'Boston Is Modern Art Pauper,' " p. 1. *See p. 52.*

37. "Great Modern Artists Neglected by Boston," *Boston Evening Globe,* October 30, 1926, sec. 1, p. 3; "Boston Lack of Interest," *Boston Evening Transcript,* November 3, 1926, sec. 2, p. 14; Editorial, *Boston Evening Transcript,* November 6, 1926, sec. 6, p. 8.

38. F. W. Coburn, "In the World of Art," *Boston Herald,* November 7, 1926.

39. Alfred H. Barr, Jr., "Postwar Painting in Europe," *Parnassus,* May 1931, p. 20.

40. Forbes Watson, Editorial, *The Arts,* December 1926, p. 306. *Art News,* November 27, 1926, also ran an article, "Boston Art Desert," to which Barr objected in a letter to the editor, December 18, 1926, p. 8, because he had referred only to Boston's neglect of modern art, not premodern art, particularly Oriental and Classical, with which the city was richly endowed.

41. The Museum of Modern Art's second show, *Paintings by Nineteen Living Americans,* December 13, 1929–January 12, 1930, consisted of works by Charles E. Burchfield, Charles Demuth, Preston Dickinson, Lionel Feininger, George Overbury ("Pop") Hart, Edward Hopper, Bernard Karfiol, Rockwell Kent, Walt Kuhn, Yasuo Kuniyoshi, Ernest Lawson, John Marin, Kenneth Hayes Miller, Georgia O'Keeffe, Jules Pascin, John Sloan, Eugene Speicher, Maurice Sterne, and Max Weber.

 The Museum's ninth loan exhibition, *Painting and Sculpture by Living Americans,* December 2, 1930–January 20, 1931, included painters Gifford Beal, Paul Burlin, Vincent Canade, Arthur Carles, James Chapin, Merton Clivette, Andrew Dasburg, Stuart Davis, Paul Dougherty, Arthur Dove, Guy Pène du Bois, Ernest Fiene, Arnold Friedman, William Glackens, Marsden Hartley, Childe Hassam, John Kane, Morris Kantor, Carl Knaths, Benjamin Kopman, Leon Kroll, Sidney Laufman, George Benjamin Luks, Henry Lee McFee, Boardman Robinson, Harry Schnakenberg, Charles Sheeler, Niles Spencer, Augustus Vincent Tack, and Mark Tobey; and sculptors Alexander Calder, Hunt Diederich, Anna Glenny, Gaston Lachaise, Robert Laurent, Dudley Vail Talcott, and William Zorach.

42. James Thrall Soby, "Statement in Reference to 'The Fur-Lined Museum' by Emily Genauer, *Harper's Magazine,* July, 1944." Typescript for "internal consumption only," The Museum of Modern Art, August 18, 1944, p. 1. MoMA Archives: Alfred Barr Papers; AAA 2173:356.

43. *The Bulletin of the Museum of Modern Art,* November 1940.

44. Alfred H. Barr, Jr., "Re: Bulletin on what the Museum has done in field of American Art," Memorandum to Miss [Dorothy C.] Miller, October 10, 1940. MoMA Archives: Alfred Barr Papers: *9b. Roob/AHB Bibliog. material.*

45. See Thomas Craven, "The Degradation of Art in America," 1948, typescript in a file labeled "Art—20th Century—Reactionary Criticism," Library of The Museum of Modern Art, pp. 2, 11–12, 13.

46. Sidney Finkelstein, "Abstract Art Today: Doodles, Dollars and Death," *Masses & Mainstream,* September 1952, pp. 24, 31.

47. Soby, "Statement in Reference to 'The Fur-Lined Museum,' " p. 9. MoMA Archives: Alfred Barr Papers; AAA 2173:364.

48. Helen Searing, "From the Fogg to the Bauhaus: A Museum for the Machine Age," in *Avery Memorial: Wadsworth Atheneum,* edited by Eugene R. Gaddis (Hartford: Wadsworth Atheneum, 1984), p. 21.

49. Barr met Henry-Russell Hitchcock in 1926 or 1927. He reviewed Hitchcock's first book on architecture; see Alfred H. Barr, Jr., "Modern Architecture," *The Hound & Horn,* April–June, 1930. Barr met Philip Johnson in 1929. He was influential in interesting Johnson in modern architecture and provided him with an itinerary for his trip to Europe in 1929.

50. See Johnson, Statement, *A Memorial Tribute: Alfred H. Barr, Jr.,* n.p. Barr had the International Style of 1400 in mind when he used the label with regard to twentieth-century architecture.

51. Alfred H. Barr, Jr., Foreword to *Modern Architecture: International Exhibition*, exhibition catalogue (New York: The Museum of Modern Art, 1932), p. 15. *See p. 80.*

52. Ibid., p. 13. *See p. 78.*

53. Robert A. M. Stern, in Philip Johnson, *Writings* (New York: Oxford University Press, 1979), p. 44. Stern, in *George Howe: Toward a Modern American Architecture* (New Haven: Yale University Press, 1975), p. 151, n. 31, writes that the sandwichmen's posters read: "See Really Modern Architecture, Rejected by the League, at 903 Seventh Avenue." On p. 152, n. 32, Stern remarks that the League officials were so enraged by the actions of the dissident young architects and their supporters that they tried to have the picketing sandwichmen arrested a number of times.

54. Philip Johnson, "Rejected Architects," *Creative Art*, June 1931, pp. 433, 435.

55. Barr, Foreword to *Modern Architecture: International Exhibition*, p. 13. *See p. 78.*

56. Henry-Russell Hitchcock, Jr., and Philip Johnson, *The International Style: Architecture Since 1922* (New York: W. W. Norton, 1932).

57. Stern, in Johnson, *Writings*, p. 44.

58. Stern, *George Howe*, p. 156.

59. Stern, in Johnson, *Writings*, p. 44.

60. Richard Guy Wilson, "International Style: the MoMA exhibition," *Progressive Architecture*, February 1982, p. 92. Wilson went on to say that the International Style "set the standard against which all other types of Modernism—Functional, Decorative, Neo-Traditional, Stripped Classical, Streamlined, Wrightian, and Expressionist—would be measured and found wanting."

61. See Rosemary Haag Bletter, "Modernism rears its head—the twenties and thirties," in *The Making of an Architect 1881–1981*, edited by Richard Oliver (New York: Rizzoli International Publications, 1981), pp. 103–18. As early as 1930 Howe remarked: "Traditionalism has failed, not in the eyes of the public but in the eyes of the architects. The road has come to a dead end. The pioneers of the modern movement have pointed the way out." Quoted in Stern, *Howe*, p. 135.

62. Nevertheless, Barr's inclusion of housing development in *Modern Architecture: International Exhibition* is evidence of his interest in the social usefulness of the International Style.

63. Alfred H. Barr, Jr., Foreword to Henry-Russell Hitchcock, *Painting Toward Architecture*, (New York: Duell, Sloan and Pearce, 1948), p. 9.

64. Alfred H. Barr, Jr., Preface, in Hitchcock and Johnson, *The International Style: Architecture Since 1922*, p. 14.

65. Barr, Foreword to Hitchcock, *Painting Toward Architecture*, p. 9.

66. Rona Roob, "1936: The Museum Selects an Architect: Excerpts from the Barr Papers of the Museum of Modern Art," *Archives of American Art Journal*, vol. 23, no. 1 (1983), p. 27. Alfred H. Barr, Jr., to Philip Goodwin, July 6, 1936.

67. Ibid., p. 29. Alfred H. Barr, Jr., to Tom Mabry, August 1, 1936.

68. Goodwin, Preface, *Built in U.S.A.*, p. 8.

69. Alfred H. Barr, Jr., "What Is Happening to Modern Architecture? A Symposium at the Museum of Modern Art," *The Museum of Modern Art Bulletin*, Spring 1948.

70. Ibid., pp. 5, 6.

71. Barr, Foreword to Hitchcock, *Painting Toward Architecture*, pp. 9–10.

72. Barr, "What Is Happening to Modern Architecture?" p. 21.

73. Alfred H. Barr, Jr., "Museum," *Charm*, November 1929, p. 15.

74. "Machine Art," *The Bulletin of the Museum of Modern Art*, November 1933, p. 1.

75. Alfred H. Barr, Jr., Foreword to Philip C. Johnson, *Machine Art* (New York: The Museum of Modern Art, 1934), p. 10.

76. Hilton Kramer, "On Art: The MoMA of Us All," *The New Leader*, May 25, 1964, p. 29.

77. Alfred H. Barr, Jr., *Cubism and Abstract Art* (New York: The Museum of Modern Art, 1936), pp. 11, 13–14. *See pp. 85, 86, 87.*

78. See for example Alfred H. Barr, Jr., Letter to the editor, *The New Republic,* December 6, 1933, pp. 104–5. As evidence of Barr's formalism, critics have pointed to his charts, the most famous of which was on the cover of *Cubism and Abstract Art.* In actuality, these artistic genealogies were less a matter of formalism than an urge to see how things fit together. Margaret Scolari Barr, in Notes, July 1979, attached to an interview with Paul Cummings, New York, February 22, April 8, and May 13, 1974, Archives of American Art, recalled that

> in all things of the mind he wanted discipline and neatness; this accounts for the charts in the catalogue of the Italian exhibition (1939) and the one in *Cubism and Abstract Art.* Actually his layout of the permanent collection in its successive hangings depended on his demand for intellectual discipline. When we spent some months in Rome in 1932–33 he was intent on arranging the whole course of Italian baroque painting in his mind and as we looked and looked in museums and churches I could see the restlessness and searchings that would lead up to another logical chart of dates and influences. With stamps, butterflies and birds as well as with works of art his mind was tidy.

79. Barr, *Cubism and Abstract Art,* p. 15. *See pp. 87 and 258.*

80. Meyer Schapiro, "Nature of Abstract Art," *Marxist Quarterly,* January–March 1937, p. 79.

81. Ibid., pp. 94, 97.

82. Meyer Schapiro, "The Social Bases of Art," *First American Artists' Congress 1936,* New York, Conference Proceedings, p. 31.

83. Barr, *Cubism and Abstract Art,* p. 18. *See p. 90.*

84. Schapiro, "The Social Bases of Art," p. 37.

85. See Schapiro, "Nature of Abstract Art."

86. Schapiro, "The Social Bases of Art," pp. 36–37.

87. Leon Trotsky, " 'Art and Politics' (A Letter to the Editors of *Partisan Review*)," *Partisan Review,* August–September 1938. André Breton and Diego Rivera, "Manifesto: Towards a Free Revolutionary Art," *Partisan Review,* Fall 1938. "Leon Trotsky to André Breton," *Partisan Review,* Winter 1939. Trotsky endorsed the Breton-Rivera manifesto.

88. Barr had met Rivera in 1928 in Russia, where they became friends, and Barr purchased a work by Rivera. In 1931 Barr gave Rivera a show at The Museum of Modern Art. In 1932, probably on the advice of Barr, the Rockefeller family commissioned Rivera to paint a mural for Rockefeller Center. The mural generated a great deal of controversy because it expressed the artist's Marxist views, and it was subsequently destroyed.

89. Trotsky, "Art and Politics," p. 7. In his article Trotsky hailed Rivera as the greatest of revolutionary artists.

90. Clement Greenberg in *Art and Culture: Critical Essays* (Boston: Beacon Press, 1961), p. 230, wrote that American vanguard art would be illuminated when it was explained "how 'anti-Stalinism,' which started out more or less as 'Trotskyism,' turned into art for art's sake." Greenberg exaggerated the role of Marxist polemics, since he did not take into account the significant number of abstract artists who had maintained the autonomy of art long before the Trotsky-Breton-Rivera statements, although these bolstered their stance.

91. Alfred H. Barr, Jr., "Dutch Letter," *The Arts,* January 1928, pp. 48–49.

92. Barr, "Otto Dix," pp. 235–36. *See p. 147.*

93. Alfred H. Barr, Jr., Letter to the editor, *The New Republic,* December 6, 1933, p. 104.

94. Ibid. Barr wrote that formalism "has generated new reactions . . . [among them] Superrealism which embraces a variety of values from the spontaneous scrawls of automatic drawing to the laborious hallucinations of Salvador Dali." Barr, in "A Brief Survey of Modern

Painting," *The Carnegie Magazine*, March 1933, p. 313, wrote: "Superrealism, the most conspicuous movement in post-War painting, came as a violent reaction to the Cubists' exclusive interest in the problems of esthetic design and color. The Superrealists asserted the value of the astonishing, the fantastic, the mysterious, the uncanny, the paradoxical, the incredible." Barr went on to say: "Superrealism is only one of many currents active in the early 1930s. A gradual but widespread return to the realistic representation of nature has been in progress since the War, especially in Germany, Italy, and America. An interest in mural painting on the part of advanced artists has also developed remarkably during the last decade in Mexico, and to a less extent in England, Germany, and in the United States."

95. Barr, Letter to the editor, *The New Republic*, p. 104.
96. Alfred H. Barr, Jr., "Modern Art," *The Wellesley College Literary Review*, February 1930, p. 6.
97. Alfred H. Barr, Jr., Statement, in *Homage to New York: A self-constructing and self-destroying work of art conceived and built by Jean Tinguely* (New York: The Museum of Modern Art, [1960]). The statement was delivered in the Sculpture Garden March 17.
98. Barr, *Cubism and Abstract Art*, p. 19. *See p. 91.*
99. Alfred H. Barr, Jr., *A Brief Guide to the Exhibition of Fantastic Art, Dada, Surrealism* (New York: The Museum of Modern Art, January 1937), n.p. *See p. xxx.*
100. Barr, *Cubism and Abstract Art*, p. 200.
101. See Alfred H. Barr, Jr., "Surrealists and Neo-Romantics," *The Saturday Review of Literature*, September 14, 1935.
102. *Abstract Painting in America*, Whitney Museum of American Art, March 26–April 29, 1935.
103. George L. K. Morris, "The American Abstract Artists," *American Abstract Artists 1939*, exhibition catalogue (New York: American Abstract Artists, 1939), section II.
104. Barr's formalist treatment of abstract art was close to that of American Cubist-related abstract artists. He did not esteem their art, but he may have responded nevertheless to their ideas, Morris's, for example (and through his catalogue introduction provided cachet for them). In *American Abstract Artists*, exhibition catalogue (New York: American Abstract Artists, 1938), a number of the participants wrote statements. Under the heading of "The New Realism," Section VII, artist Rosalind Bengelsdorf wrote of a picture "as a thing in itself. The shapes that compose the picture belong to nothing else but the picture. There is no other story than its own story—a tale of form related to other form." Charles Shaw in "A Word to the Objector," Section I, agreed that "stripped of sentimental, familiar, or literary garniture, a work of art . . . remains a work of art . . . [which deals with "fundamentals," such as] rhythm, composition, spacial organization, design, progression of color, and many, many other qualities in any aesthetic work. Indeed it is the perfection of these very qualities that constitute an aesthetic work." The following year, Morris, in *American Abstract Artists 1939*, section IV, summed it up: "American abstract art has been free to concentrate on the structural properties of esthetics, until its works have become things that can be looked at, complete in themselves."
105. Morris, op. cit.
106. Carl Holty, "Letter to Alfred H. Barr, Jr.," November 23, 1937. On file and on microfilm with the Archives of American Art, Washington, *American Abstract Artists Society*, microfilm roll NY 59–11.
107. Alfred H. Barr, Jr., "Letter to the American Abstract Artists," November 30, 1937. On file and on microfilm with the Archives of American Art, *American Abstract Artists Society*, microfilm roll, NY 59–11.
108. *Italian Masters*, The Museum of Modern Art, January 26–April 7, 1940. *See p. 176.*

109. American Abstract Artists, "How Modern Is the Museum of Modern Art?" (New York: Privately Printed, April 15, 1940). Typography by Ad Reinhardt.

110. Wall label, in the exhibition *"Primitivism" in 20th Century Art: Affinity of the Tribal and the Modern*, at The Museum of Modern Art in 1984: "Pollock saw several exhibitions of tribal art at the Museum of Modern Art: African sculpture in 1935, American Indian art in 1941, and Oceanic art in 1946. His love for such art was deep and wide-ranging. In a 1946 letter to a West Coast artist friend, he declared that 'The Pacific Islands show at the Museum of Modern Art tops everything that has come this way in the past few years.' "

111. Lynes, *Good Old Modern*, p. 101.

112. Ibid., p. 153.

113. Ibid., p. 72.

114. "The Museum Collection, Gallery 1: Modern Primitives, Artists of the People," *The Bulletin of the Museum of Modern Art*, October 1941, p. 6.

115. Alfred H. Barr, Jr., Foreword to Sidney Janis, *They Taught Themselves: American Primitive Painters of the 20th Century* (New York: The Dial Press, 1942), p. xix. The Museum of Modern Art had acquired Hirshfield's *Girl in a Mirror* (1940) and *Tiger* (1940) in 1941.

116. *Art Digest*, July 1, 1943, p. 3; Emily Genauer, "Exhibit by Museum Cuts Sorry Figure," *New York World Telegram*, June 26, 1943, p. 4.

117. Emily Genauer, "The Fur-lined Museum," *Harper's Magazine*, July 1944, p. 130. Genauer delighted in Barr's firing. Her article, as an editorial in *Art News*, August 1944, remarked, was a "violent personal attack on Alfred Barr, filled with unpleasant irrelevancies . . . so pointed and in such poor taste" as to call into question her motives. Indeed, her entire article was tainted by "a constant undercurrent of *a priori* animosity and, even more, by an all too obvious intent to smear the Museum's director" (p. 7). Peyton Boswell, in *The Art Digest*, July 1, 1944 (p. 3), supported Genauer; Grace L. McCann Morley, director of the San Francisco Museum, in *The Art Digest*, August 1, 1944 (pp. 25, 27), came to the defense of Barr.

118. See Lincoln Kirstein, "The State of Modern Painting," *Harper's Magazine*, October 1948.

119. See Douglas Crimp, "The Art of Exhibition," *October* 30 (Fall 1984), p. 68.

120. Alfred H. Barr, Jr., "Chronicle of the Collection of Painting and Sculpture," in *Painting and Sculpture in the Museum of Modern Art: 1929–1967* (New York: The Museum of Modern Art, 1977). Under 1943, there appeared a "Report of the Subcommittee on the Museum Collection," chaired by James Johnson Sweeney, which listed, as one of five reasons for the "unbalanced, spotty condition of the Museum Collection today," "The unwillingness of the Acquisitions Committee to make certain purchases because of personal dislikes for certain forms of contemporary expression, which nevertheless have a historical place" (p. 629).

121. Margaret Lynne Ausfeld, "Circus Girl Arrested: A History of the *Advancing American Art* Collection, 1946–1948," *Advancing American Art: Politics and Aesthetics in the State Department Exhibition, 1946–48*, exhibition catalogue (Montgomery, Ala.: Montgomery Museum of Fine Arts, 1984), p. 20.

122. Ibid.

123. Kirstein, "The State of Modern Painting," pp. 47–48. Among "the permanent Philistia," Kirstein listed Thomas Craven, Peyton Boswell, Jr., George Biddle, T. H. Robsjohn-Gibbings, and The Institute of Contemporary Art in Boston. Robsjohn-Gibbings, in *Mona Lisa's Mustache* (New York: Knopf, 1947), attacked modern art as a Fascist conspiracy of the elite. George Biddle, in "Modern Art and Muddled Thinking," *The Atlantic Monthly*, December 1947, p. 59, attributed modern art to "war neurosis, a dealer-rigged market, snobbism, and an association of Modernism with up-to-dateness." He called for art to involve itself with life: "those arts which appeal to the greatest number of people and which

deal with basic human emotions will survive the longest and exercise the most influence" (p. 60). "Extreme Modernism . . . *offers nothing by way of content other than technical experimentation.*"

There were a few articles favorable to modern art published in popular magazines. See Daniel Catton Rich, "Freedom of the Brush," *The Atlantic Monthly*, February 1948, pp. 47–51.

124. Kirstein, "The State of Modern Painting," p. 51.

125. Francis Henry Taylor, "Modern Art and the Dignity of Man," *The Atlantic Monthly*, December 1948, pp. 30, 31, 36.

126. Barr, Confidential Notes on " 'Modern Art' and the American Public," p. 4. MoMA Archives: Alfred Barr Papers; AAA 2171:216.

127. James S. Plaut, " ' "Modern Art" and the American Public,' a Statement by The Institute of Contemporary Art, formerly The Institute of Modern Art," leaflet (Boston: February 17, 1948), excerpt in *Modern Artists in America I* (New York: Wittenborn, Schultz, 1951), p. 147.

128. Alfred H. Barr, Jr., Letter to John Hay Whitney, copies to Nelson Rockefeller, René d'Harnoncourt, and Thomas Braden, May 17, 1949, p. 2. MoMA Archives: Alfred Barr Papers; AAA 3156: 0988–89.

129. Alfred H. Barr, Jr., to Nelson A. Rockefeller, March 5, 1948. MoMA Archives: Alfred Barr Papers; AAA 2171:208.

130. William Burden asked Barr for an analysis of Plaut's " 'Modern Art' and the American Public." Barr sent it to him March 3, 1948. MoMA Archives: Alfred Barr Papers; AAA 2171:210–11. A copy was sent to Nelson A. Rockefeller the following day. Barr wanted the memorandum kept confidential "because while I have nothing to retract in [it], I do not want to increase hard feelings."

131. Barr, Confidential Notes on " 'Modern Art' and the American Public," p. 8. MoMA Archives: Alfred Barr Papers; AAA 2171:223.

132. "Revolt in Boston," *Life*, February 21, 1949, p. 84.

133. Alfred H. Barr, Jr., Personal letter formulated for John Hay Whitney and Nelson A. Rockefeller, which was sent to Henry R. Luce, publisher of *Life*, March 24, 1949, pp. 3, 4. MoMA Archives: Alfred Barr Papers; AAA 2171:167–68.

134. Alfred H. Barr, Jr., Telegram to James Plaut, New York, February 21, 1949. MoMA Archives: Alfred Barr Papers; AAA 2171:205.

135. James S. Plaut to Lloyd Goodrich, March 1, 1949. MoMA Archives: Alfred Barr Papers; AAA 2171:200.

136. Alfred H. Barr, Jr., to John Hay Whitney, May 17, 1949, pp. 1–2. MoMA Archives: Alfred Barr Papers; AAA 3156:0988–89.

137. "Letters to the Editor: 'Revolt in Boston,' " *Life*, April 25, 1949, p. 25.

The museum directors and associate directors were Bartlett H. Hayes, Addison Gallery of American Art; Daniel Catton Rich, The Art Institute of Chicago; Perry T. Rathbone, City Art Museum of St. Louis; Hermann Williams, Jr., Corcoran Gallery of Art; William M. Milliken, Cleveland Museum of Art; John Coolidge, Fogg Museum of Art, Harvard University; Alice W. Kendall, Newark Museum; Fiske Kimball and Henri Marceau, Philadelphia Museum of Art; Duncan Phillips, Phillips Gallery; and Hermon More and Lloyd Goodrich, Whitney Museum of American Art.

138. James S. Plaut, Frederick S. Wight, René d'Harnoncourt, Alfred H. Barr, Jr., Andrew C. Ritchie, Hermon More, and Lloyd Goodrich, "A Statement on Modern Art," by The Institute of Contemporary Art, Boston; The Museum of Modern Art, New York; and the Whitney Museum of American Art, New York, March 1950.

139. See Irving Sandler, *The Triumph of American Painting: A History of Abstract Expressionism* (New York: Praeger Publishers, 1970; Harper & Row, 1976), p. 213.

140. Bernard Karpel, Robert Motherwell, and Ad Reinhardt, A Statement, in *Modern Artists in America I,* p. 6.

141. James S. Plaut, " 'Modern Art' and the American Public."

142. Barr, Confidential Notes on " 'Modern Art' and the American Public," p. 7. MoMA Archives: Alfred Barr Papers; AAA 2171:219–20.

143. Alfred H. Barr, Jr., to John Hay Whitney, May 17, 1949. MoMA Archives: Alfred Barr Papers; AAA 3156:0988–89.

 On an undated piece of notepaper (MoMA Archives: Alfred Barr Papers; AAA 3155: 1287), Barr jotted down adjectives presumably used to attack modern art: "Foreign," "Childish," "Jewish," "Communistic," "Queer," "Dealers' conspiracy," "Insane."

 In March–April 1949, Congressman Dondero let loose with such speeches as "Communists maneuver to control art in the United States" (April 19); "Communism in the Heart of American Art—What to Do About It" (August 19); "Modern Art Shackled to Communism" (October 13). The attacks grew in intensity during the fifties. See Barr's attack on Dondero in an editorial, "It Can Happen Here," *The Art Digest,* August 1, 1949, pp. 3, 23.

144. See William Hauptman, "The Suppression of Art in the McCarthy Decade," *Artforum,* October 1973. See also Alfred H. Barr, Jr., to Lawrence H. C. Smith, April 11, 1952, p. 2. MoMA Archives: Alfred Barr Papers; AAA 3155:1147.

145. American Federation of Arts, *Art Newsletter,* December 1953.

146. Alfred H. Barr, Jr., "Artistic Freedom," *College Art Journal,* Spring 1956, pp. 184–88. *See pp. 220–25.*

147. Meyer Schapiro, "The Liberating Quality of Avant-Garde Art," *Art News,* Summer 1957, p. 42.

148. Lynes, *Good Old Modern,* p. 352.

149. Thomas B. Hess, "Eros and Agape Midtown," *Art News,* November 1954, p. 17. Dorothy C. Miller, at The Museum of Modern Art from 1934 to 1969, began as Assistant to the Director, and retired as Senior Curator of Painting and Sculpture. She is best known for her shows of American artists between 1942 and 1963, including *Fourteen Americans, Fifteen Americans,* as well as *The New American Painting.*

150. Thomas B. Hess, "Fifty-fifth Anniversary," *Art News,* Summer 1957, p. 27.

151. Alfred H. Barr, Jr., "Editor's Letters," *Art News,* September 1957, pp. 6, 56–57. MoMA Archives: Alfred Barr Papers; AAA 2189:431.

 Barr was rather more chagrined than this letter to *Art News* revealed. In a private letter to Alfred M. Frankfurter and Thomas B. Hess, of *Art News,* July 29, 1957, he wrote that he was "deeply concerned over the Museum's responsibility, past and present, toward the American avant-garde. . . . Tom, I think your remarks on the Museum's record (in an area in which we are both greatly interested) are inaccurate and unfair as well as damaging. The Museum and some of its staff, particularly Dorothy [Miller] and myself, have taken quite a beating because of our support of the very movement you are now championing. This was *particularly* true ten years ago, though that was the very period when in your retrospect you implicitly (but clearly) relegate our institution and ourselves to the unknowing or suspicious 'Officialdom of museums.' "

152. See Alfred H. Barr, Jr., "Gorky, De Kooning, Pollock," *Art News,* Summer 1950.

153. Alfred H. Barr, Jr., in a letter to Thomas B. Hess, May 23, 1961 (MoMA Archives: Alfred Barr Papers; AAA 2189:398–99), wrote that he was not "influenced by Clem [Greenberg] until his Pollock pieces of the late '40s. . . . [I was] impressed *and* influenced by his praise of Newman and Gottlieb in the late '50s."

154. Barr acquired Motherwell's *Pancho Villa, Dead and Alive* (1943) in 1944; Gottlieb's *Voyager's Return* (1946) in 1946; Stamos's *Sounds in the Rock* (1946) in 1947; Baziotes's *Dwarf* (1947) in 1947; de Kooning's *Painting* (1948) from his first one-person show in

1948; Gorky's *Agony* (1947), Motherwell's *Western Air* (1946–47), Pollock's *Number 1, 1948,* and Pousette-Dart's *Number 11, A Presence* (1949) in 1950; and Kline's *Chief* (1950), Pollock's *Full Fathom Five* (1947) and *Number 12* (1949), Hofmann's *Ambush* (1944), Rothko's *Number 10* (1950), and Tomlin's *Number 20* (1949) in 1952.

155. Thomas B. Hess, Response to Barr's letter, *Art News,* September 1957, pp. 57–58.

156. Alfred H. Barr, Jr., to Hess, May 23, 1961. MoMA Archives: Alfred Barr Papers; AAA 2189:399.

Barr's involvement with Abstract Expressionism went back to the time when he was an adviser to Peggy Guggenheim's Art of This Century gallery, which first showed Pollock, Rothko, Still, and Hofmann. Barr's acquisition of a Baziotes in 1947 was venturesome; that was the year of the scandal over Baziotes's winning The Art Institute of Chicago's big annual purchase prize, which was the first major recognition of an Abstract Expressionist.

157. Alfred H. Barr, Jr., Statement in "A Symposium: The State of American Art," *Magazine of Art,* March 1949, p. 85. The other participants were Walter Abell, Jacques Barzun, John I. H. Baur, Holger Cahill, Alfred Frankenstein, Lloyd Goodrich, Clement Greenberg, George Heard Hamilton, Douglas MacAgy, H. W. Janson, Daniel Catton Rich, James Thrall Soby, Lionel Trilling, Devolvy, and Patrick Heron. *See pp. 211 and 212.*

158. See Robert Goodnough, ed., "Artists' Sessions at Studio 35," *Modern Artists in America I.* The other participants were William Baziotes, Janice Biala, Louise Bourgeois, James Brooks, Willem de Kooning, Jimmy Ernst, Herbert Ferber, Adolph Gottlieb, Peter Grippe, David Hare, Hans Hofmann, Weldon Kees, Ibram Lassaw, Norman Lewis, Richard Lippold, Seymour Lipton, Robert Motherwell, Barnett Newman, Richard Pousette-Dart, Ad Reinhardt, Ralph Rosenborg, Theodoros Stamos, David Smith, Hedda Sterne, and Bradley Walker Tomlin.

159. Among the artists associated with *Reality* were Milton Avery, Isabel Bishop, Charles Burchfield, Guy Pène du Bois, Philip Evergood, Edward Hopper, Leon Kroll, Yasuo Kuniyoshi, Reginald Marsh, and Raphael Soyer.

160. "Statement," *Reality* 1 (Spring 1953), p. 1.

161. "Letter to Museum of Modern Art," Ibid., p. 2.

162. René d'Harnoncourt, Alfred H. Barr, Jr., and Andrew C. Ritchie, "An Open Letter to 'Reality' Magazine," issued by The Museum of Modern Art, April 24, 1953, p. 1. MoMA Archives: Alfred Barr Papers; AAA 3157:0754.

163. Barr, "Editor's Letters," *Art News,* September 1957, p. 57.

164. Alfred H. Barr, Jr., Introduction to *The New American Painting as Shown in Eight European Countries 1958–1959,* exhibition catalogue (New York: The Museum of Modern Art, 1959), p. 19. *See p. 235.*

165. "Has the Situation Changed?" Panel discussion at the Club, New York, January 1958. The participants were Alfred H. Barr, Jr., Thomas B. Hess, and Harold Rosenberg. Notes taken by the author.

166. Alfred H. Barr, Jr., "Witness," in Gilbert Millstein, ed., *New York: True North* (New York: Doubleday, 1964), p. 182.

167. See Irving Sandler, "Modernism, Revisionism, Pluralism, and Post-Modernism," *Art Journal,* Fall/Winter 1980.

168. Carol Duncan and Alan Wallach, "The Museum of Modern Art As Late Capitalist Ritual: An Iconographic Analysis," *Marxist Perspectives,* Winter 1978.

169. Timothy Clark, "The Myth of Modernity," lecture, in symposium, "The Presence of Myth in Contemporary Life," New School, New York, October 12, 1984.

170. This is particularly true of Serge Guilbaut, *How New York Stole the Idea of Modern Art: Abstract Expressionism, Freedom and the Cold War* (Chicago and London: The University of Chicago Press, 1983).

171. Max Kozloff, "American Painting During the Cold War," *Artforum,* May 1973, pp. 43–47.

172. Eva Cockcroft, "Abstract Expressionism, Weapon of the Cold War," *Artforum,* June 1974, p. 41. Cockcroft misrepresented Barr. Nowhere in his article did he condemn social realism or imply that it and totalitarianism went together. However, he did consider the suppression of the International Style by Communists and Nazis reactionary. Barr's point was that the Russian Communists had anathematized abstract art and had imposed Socialist Realism on artists. To paint otherwise "was to risk denunciation, isolation and starvation," and a bullet in the back of the head, but Barr did not know of that then. His report was rigorously objective, although the facts were heartrending.

173. Deirdre Robson, "The Market for Abstract Expressionism: The Time Lag Between Criticism and Commercial Acceptance," paper delivered at the College Art Association Annual Meeting, New York, February 13, 1986.

174. Duncan and Wallach, "The Museum of Modern Art," p. 44.

175. See Carol Duncan, "Who Rules the Art World?" *Socialist Review,* July–August 1983, p. 106. Duncan implied that in capitalist society freedom was in the main "ideologically useful" and otherwise illusory. To Barr it was very real, fundamental to authentic being and authentic art, which prompted him to speak out vigorously on behalf of freedom whenever and wherever it was threatened.

176. Duncan and Wallach, "The Museum of Modern Art," pp. 36–37.

177. Formalism, as it was commonly defined, was identified with Clement Greenberg's criticism. Therefore, it was necessary for neo-Marxists to link Greenberg and Barr. This was done by Guilbaut in *How New York Stole the Idea of Modern Art,* pp. 6–7. He wrote that the histories written by Sam Hunter, Barbara Rose and myself "subscribe to the formalist analysis proposed by Alfred Barr . . . an analysis championed by Clement Greenberg throughout his career."

178. Alfred H. Barr, Jr., Introduction to *The New American Painting as Shown in Eight European Countries 1958–1959,* exhibition catalogue (New York: The Museum of Modern Art, 1959), p. 17. *See p. 232.*

179. Guilbaut, *How New York Stole the Idea of Modern Art,* p. 200.

180. Ibid. See also p. 4.

181. Guilbaut's thesis is based primarily on the assertion by Greenberg in March 1948 that American art was foremost in the world. Greenberg was an exception among critics, but his announcement prompted Guilbaut to conclude on p. 172: "In the war against communism, America now held all the trumps: the atom bomb, a strong economy, a powerful army, and now artistic supremacy, cultural superiority." The avant-garde had introduced painting into "the list of weapons in the cultural arsenal . . . the weapon that the avant-garde had been working to forge since 1943" (p. 174).

182. In establishing Abstract Expressionism as a weapon in the Cold War, Cockcroft began with the involvement of the Museum in American foreign policy in the forties. But the Museum's efforts then were minor compared to those in the fifties. "In 1952 . . . MoMA's international program was launched with a five-year grant of $625,000 from the Rockefeller Brothers Fund," p. 40.

183. "Our Country and Our Culture: A Symposium," *Partisan Review* May–June, July–August, September–October 1952.

184. Alfred H. Barr, Jr., "Report of the Director," in: *The Year's Work: Annual Report to the Board of Trustees and the Corporation Members of the Museum of Modern Art for the year June 30, 1939–July 1, 1940* (New York: The Museum of Modern Art, 1941), p. 10.

185. See the introduction to *The New American Painting. See pp. 234–35.*

186. Barr, "Witness," in Millstein, ed., *New York: True North,* pp. 180, 182.

187. Ibid., p. 180.

188. Alfred H. Barr, Jr., to Lawrence H. C. Smith, New York, April 11, 1952, pp. 1–2. MoMA Archives: Alfred Barr Papers; AAA 3155:1146–47.
189. Dwight Macdonald, "Action on West Fifty-third Street—I," p. 61.
190. Ibid., p. 77.

Notes to
the Texts

Writings that appear in this anthology are indicated by the following line in *italics: See p. 000.*

Material from The Museum of Modern Art Archives: Alfred Barr Papers that carries an AAA designation is available at the Archives of American Art.

For identifications of artists, film directors, and architects cited in the texts, see Index.

THE VISIONARY

1. [Alfred H. Barr, Jr.], *A New Art Museum* (New York: The Museum of Modern Art, [August 1929]), n.p. *See p. 70.*
2. MoMA Archives: Alfred Barr Papers; AAA 2171:216.
3. Alfred H. Barr, Jr., "The Museum of Modern Art," *Fortune*, December 1938, p. 73.
4. MoMA Archives: Alfred Barr Papers: *9b. Roob/AHB Bibliog. material.*
5. Archives of American Art, Forbes Watson Archive, microfilm roll D47: frame 117.
6. Originally known as the Farnsworth Museum, the gallery was founded in 1889 in the Farnsworth Building on the Wellesley campus. In 1958 when it moved into the new Jewett Arts Center building, it was renamed the Wellesley College Museum.
7. *See* "The Necco Factory," *pp. 62–66.*
8. George Antheil (1900–59), American composer and pupil of Stravinsky. The *Ballet Mécanique* (1925) was played by one mechanical piano, ten pianos, four bass drums, two wind machines, eight xylophones, electric bells, an alarm clock, and a metronome.
9. *Metropolis* (1927), directed by Fritz Lang, was a futuristic depiction of social and political systems.
10. [A. H. B., Jr.], "Wellesley and Modernism," *Boston Evening Transcript*, April 27, 1927. *See p. 54.*
11. There were no photographs in the *Vanity Fair* layout.
12. Royal Cortissoz, conservative critic for the *New York Herald Tribune*.
13. Ernest Newman (1868–1959), English music critic.
14. Ernest Renan (1823–92), French philosopher, historian, and scholar of religion.
15. William Richard Lethaby (1857–1931), English architect and influential theorist.
16. "Listen to the advice of American engineers, but fear their architects."—Le Corbusier-Saugnier.
17. [Author's note: The Roman concrete vault was constructed upon elaborate arches and cells of brick which served both as centering and reinforcement.]
18. Fred F. French Building (1927), 551 Fifth Avenue. Built by the Fred F. French Company, H. Douglas Ives, architect.
19. Woolworth Building (1913), 233 Broadway. Designed by Cass Gilbert.
20. Ritz Tower (1925), Park Avenue and Fifty-seventh Street. Designed by Emery Roth and Carrère & Hastings.

21. Symphony Hall (1893–95). Designed by McKim, Mead & White.

22. Widener Library, Harvard (1915). Designed by Horace Trumbauer.

23. [Author's note: Engineers are often unorthodox in their architectural terms.]

24. The date of this lecture was changed to May 14. MoMA Archives: Alfred Barr Papers: *9b. Roob/AHB Bibliog. material.*

25. Alfred H. Barr, Jr., "Chronicle of the Collection of Painting and Sculpture," in *Painting and Sculpture in the Museum of Modern Art: 1929–1967* (New York: The Museum of Modern Art, 1977), p. 620.

26. The collection of modern art in the Kronprinzen Palast was purged by the Nazis in 1937, and the removed works were sold at auction; the building itself was totally destroyed during World War II, and a new Nationalgalerie was designed by Mies van der Rohe (1967). The Neue Staatsgalerie in Munich was the part of the Bavarian State Collections of Paintings that comprised modern art (painting *and* sculpture), including Impressionist, Post-Impressionist, and German Expressionist works. The latter were purged during the Third Reich, but a portion of the collection was reassembled and is now in the Haus der Kunst.

27. The first show (November 8–December 7, 1929) actually contained 35 works by Cézanne, 26 by Gauguin, 17 by Seurat, and 27 by Van Gogh.

28. See n. 26 above. In Moscow, Barr is referring to the Museum of Modern Western Art (formerly the Shchukin and Morosov collections; see "The Critic/Historian," n. 18 below), the Tretyakov Gallery of Russian nineteenth- and twentieth-century art, in which Barr saw "some fine things by Goncharova, Lentulov, Larionov, Mashkov, and other members of the *Bubnovy Valet . . .*" (*see* "Russian Diary," *p. 120*), and the Museum for Art Culture, which, Barr wrote in 1934, "contain[ed] recent experimental art of the extreme left" ("A Museum of Modern Art in New York" [New York: The Museum of Modern Art, 1934]). The last existed from 1919 to 1929, when its collections went to the Tretyakov.

29. [Author's note: See also *Modern Architecture: Romanticism and Reintegration* by Henry-Russell Hitchcock, Jr. New York: 1929.]

30. [Author's note: *The International Style: Architecture Since 1922* by Henry-Russell Hitchcock, Jr., and Philip Johnson. New York: 1932.]

31. Barr is referring to the Daily News Building (1930), 220 East Forty-second Street ("in the vertical style"), and the McGraw-Hill Building (1931), 330 West Forty-second Street ("with a horizontal emphasis").

32. "Housing," in the same catalogue, *Modern Architecture: International Exhibition,* pp. 179–89.

33. [Author's note: According to Professor Erwin Panofsky.]

34. John Ruskin (1819–1900), English writer, critic, and artist, wrote *Modern Painters,* the first volume of which was published in 1843, to extoll the art of J. M. W. Turner.

35. The Surrealists.

36. The exhibition, a dry run for the 1936 surveys, included Bauer, Bérard, Berman, Bonnard, Braque, Cézanne, de Chirico, Dalí, Degas, Derain, Ernst, Friesz, Gauguin, Gris, Hélion, Hofer, Hugo, Kandinsky, Klee, La Fresnaye, Laurencin, Léger, Masson, Matisse, Mauny, Miró, Modigliani, Moholy-Nagy, Mondrian, Pascin, Picasso, Redon, Renoir, Rouault, Rousseau, Roy, Schlemmer, Segonzac, Seurat, Soutine, Tchelitchev, Tonny, Toulouse-Lautrec, Utrillo, Van Gogh, Vlaminck, Vuillard.

37. Herbert Read, *Art Now* (New York: Harcourt Brace, 1934).

38. Franz Roh, *Nach Expressionismus, magischer Realismus* (Leipzig: Klinkhardt & Biermann, 1925).

39. [Author's note: "Notes from a diary," *Transition* N. 21, Paris, 1932. Quoted in Sweeney, Bibl. 93, p. 30.] James Johnson Sweeney, *Plastic Redirections in 20th Century Painting* (Chicago: University of Chicago Press, 1934).

40. [Author's note: For an interesting commentary on this passage see A. Philip McMahon: *Would Plato find artistic beauty in machines? Parnassus,* vol. VII, 6–8, February 1935. Prof. McMahon emphasizes Plato's dislike for art and esthetic delight in geometry.]

41. [Author's note: In spite of the fact that the Cubists themselves and their most ardent admirers attached little importance to subject matter, Meyer Schapiro of Columbia University advances an interesting theory that consciously or unconsciously the Cubists through their subject matter reveal significant preoccupation with the bohemian and artistic life. It is possible of course that the things in a Cubist still-life: bottles, playing-cards, dice, violins, guitars, pipes, which Dr. Schapiro calls "private instruments of idle sensation," may be a direct rather than a symbolic inventory of objects in the cubist's studio; and the painting of letters, introduced by Braque into Cubism, may be, like his use of imitation wood and marble textures, merely a reminiscence of his early apprenticeship as a house painter, rather than a symbol of the art of literature; and the repetition of such word-fragments with artistic connotations as *Etude, Bal, Bach* and so forth may be balanced by the names of daily newspapers, *Figaro, L'Intran, Journal*—and "Hennessy" by "Baker's Cocoa." Nevertheless, the continual repetition of figure paintings called *Pierrot, Guitarriste, Clarinettiste, Harlequin,* in later Cubist pictures suggests a concern with the world of art instead of the world of life and may consequently be taken as a symbol of the modern artist's social maladjustment—which is, however, not limited to Cubists. In any case the iconography of Cubism should not be ignored.]

42. [Author's note: For example, nine of the artists represented in this exhibition have left Germany since 1933. Only one of them is a "non-Aryan."]

43. [Author's note: As this volume goes to press the United States Customs has refused to permit the Museum of Modern Art to enter as works of art nineteen pieces of more or less abstract sculpture under a ruling which requires that sculpture must represent an animal or human form. . . . They are all considered dutiable as plaster, bronze, stone, wood, etc., and have been entered under bond. The hand-painted canvases in the exhibition were, however, admitted free, no matter how abstract.]

44. MoMA Archives: Alfred Barr Papers: *3.C.4.*

45. Georges Hugnet, "Dada" and "Surrealism," *The Bulletin of the Museum of Modern Art* 4 (November/December 1936), pp. 3–32.

46. Erich Mendelsohn's Einsteinturm or Potsdam observatory (1919–21) was a sculpturesque concrete tower; Ernst Toller (1893–1939), German dramatist, poet, and political activist whose play of social protest *Masse-Mensch* (1920) appeared in English as *Man and the Masses* (1923); Robert Wiene's influential film (1919) used distorted perspective and grotesquely angled lighting to achieve psychological effects.

47. Barr is referring to the establishment of the National Socialist government. *See* "Art in the Third Reich—Preview, 1933," *pp. 163–75.*

THE CRITIC/HISTORIAN

1. MoMA Archives: Alfred Barr Papers; AAA 2181:332–33.
2. MoMA Archives: Alfred Barr Papers; AAA 2164:1137.
3. MoMA Archives: Alfred Barr Papers; AAA 2174:633.
4. Margaret S. Barr's note: Prof. Jay Leyda of New York University, for three years assistant to Eisenstein, gave invaluable help in the publication of this diary, thanks to his knowledge of the history of Russian film; he provided the key to most of the Russian acronyms. I am also grateful to Prof. John Bowlt of the University of Texas at Austin for his interpretation of difficult words and passages. [All the notes to the "Russian Diary" first appeared in *October.*]
5. Margaret S. Barr's note: Jere Abbott also kept a journal of this trip; he gave his manuscript

to the Smith College Museum. It differs considerably from Barr's because, thanks to energy and good health, he covered more ground. He systematically listed the most important works in the Shchukin and Morosov collections, as they stood separately and intact at that time.

6. The exchange was two rubles to the dollar.

7. Throughout the diary "kino" is used for films or movies. *Kino* is a film periodical.

8. International Workers Relief. It maintained the second largest film studio in Moscow.

9. Dom Gertsena (Herzen House)—a writers' club named after Alexander Herzen.

10. Within the Barr diary this young interpreter is sometimes mentioned as Piotr, at other times as Peter. It seemed best to preserve his Russian identity throughout the diary. His signature at the back of [a] photograph is Petia Likhatchew. He was wellborn; his father had been a sea captain; with his mother he spoke French; he also knew English.

11. Sergei Tretyakov (1892–1939) was one of the more radical members of the postrevolutionary futurist movement. He played a leading role as a critic and literary theoretician and cofounded *Lef* (1923–25) and *Novyi lef* (1927–28). No connection with the Tretyakov Gallery. [*See* "The LEF and Soviet Art," *pp. 138–41.*]

12. *October* was first released abroad as *Ten Days that Shook the World; The General Line* was retitled *The Old and the New*.

13. S. Tretyakov, *Den Shi-Hua, Bio-interview* (Moscow: Molodaia Gbardiia, 1930). Cover and layout by Rodchenko. Translated into English as *A Chinese Testament* (New York: Simon and Schuster, 1934).

14. The reference is to a book of cartoons called *Samozveri* (Self-Animals) which Tretyakov projected in 1926, but which was not published. Alexander Rodchenko and his wife Varvara Stepanova worked on the photographic illustrations for this book. Some of these appeared in *Novyi lef*, no. 1 (Moscow, 1927), between pp. 18 and 19.

15. Barr saw the original version of the Lenin mausoleum, i.e., the wooden structure designed by Alexei Shohusev in 1924. This was replaced by the stone version (still standing) in 1930.

16. The identity of Pronov has not been established.

17. Barr is presumably confusing two events: the sailors' mutiny portrayed in Eisenstein's *Potemkin*, an event of the 1905 revolution; and the participation of the crew of the Aurora in the opening assault on the Winter Palace during the October Revolution of 1917, portrayed in Eisenstein's *October*. See also diary entry for January 12.

18. In 1918 both the Shchukin and the Morosov collections were nationalized and became the First and Second Museums of New Western Painting. In 1923 both were amalgamated into a single Museum of New Western Painting. In the early 1930s many of the Museum's works were transferred to the Hermitage in Leningrad, and in 1948 all the holdings were distributed between the Hermitage and the Pushkin Museum of Fine Arts in Moscow.

19. Louis Lozowick, *Modern Russian Art* (New York: Museum of Modern Art/Société Anonyme, 1925). Konstantin Umanskij, *Neue Kunst in Russland, 1914–1919* (Potsdam: Kiepenheuer; and Munich: Goltz, 1920).

20. See Lunacharsky's review and defense of this production in *October* 7 (Winter 1978).

21. VOKS—Society for Cultural Relations with Foreigners.

22. The article in *Kino* is in the AHB Archive [in The Museum of Modern Art].

23. The first Soviet production of Fernand Crommelynck's farce *The Magnanimous Cuckold* was by Meyerhold in 1922. The constructivist sets and costumes were designed by Liubov Popova.

24. Anatoly Alexandrov (b. 1888); Nikolai Myaskovsky (1881–1950); Mikhail Ippolitiv-Ivanov (1859–1935); Reinhold Glière (1875–1956).

25. The Cockchafer was a British gunboat in the Yangtzekiang.

26. The Habima was one of the two main Jewish theaters in Moscow.

27. Boris Ternowetz (1884–1941) was a critic and sculptor. From 1919 onwards Ternowetz was in charge of the Museum(s) of New Western Painting.

28. *Dina Dza-Dzu*, Mezhrabpom-Russ, 1926.
29. See Alfred H. Barr, Jr., "Russian Icons," *The Arts*, XVII (February 1931).
30. Ilya Ostroukov (1858–1929), painter and collector. From 1905–13, Ostroukov was a trustee of the Tretyakov Gallery. His remarkable collection of icons later formed the basis of the icon collection at the Tretyakov Gallery.
31. *Bubnovy Valet* (Jack of Diamonds) was the name of a group of artists that exhibited together from 1910 to 1918. The group included at varying times Falk, Goncharova, Larionov, Lentulov, Malevich, Mashkov, and others.
32. Translated in English as *The Days of the Turbin Family*.
33. Virgil Barker, contributing editor of *The Arts*.
34. Andrei Burov designed the model farm in *The General Line*.
35. Abram Efros (1888–1954) was the author of *Dva veka russkogo iskusstva* (Moscow, 1969), an examination of 18th- and 19th-century art.
36. These youthful snapshots of the photographer Lux Feininger are in the AHB Archive.
37. There is no painting by Korin now in the Metropolitan Museum.
38. Barr is referring to the Moscow art school known as Vkhutein (abbreviation for Higher State Art-Technical Institute).
39. She designed sets and costumes for Meyerhold.
40. NOZH stands for New Society of Painters. Founded in Moscow in 1922, it was a conservative group that favored figurative painting. It existed formally until 1924 when it joined with another realist group called Bytie (Life). OST means Society for Easel Artists, an exhibition group which advocated expressionism and was active between 1925 and 1928.
41. It is important to mention here the book *Drevne-russkaia ikonipis v sobranii I.S. Ostroukhova* (Moscow, 1914), by Pavel Muratov (1871–1947). Muratov used some of this material for a later monograph, *Les icones russes* (Paris: Editions de la Pléiade, 1927), to which Barr is referring.
42. Alexander Tairov first produced *Antigone* at his Kamerny (Chamber) Theater on October 1, 1927.
43. Igor Grabar, *Istoriia russkogo iskusstva* (Moscow: Knebel, 1910–15).
44. Narkomindel was the People's Commissariat for Foreign Affairs.
45. Barr means *Sovremennaia arkhitektura (Contemporary Architecture)*, the magazine edited by Ginzburg and A. A. Vesnin from 1926–30. It was superseded in 1931 by *Sovetskaia arkhitektura*.
46. The idea of a theatricalized newspaper called *The Blue Blouse* first arose in Moscow in 1923. The title derived from the image of the traditional blue coverall worn by workers.
47. Victor Midler (b. 1888) was a painter as well as a museum worker. He was much influenced by the Jack of Diamonds group.
48. Barr is referring to the Russian (or State) Academy of Artistic Sciences (RAKhN or GAKhN) which had been founded in 1921 by Vassily Kandinsky et al.
49. *Tchin* means the correct disposition of images, especially in connection with the Deësis in the iconostasis.
50. Alexander Anisimov (1877–1939) was a specialist in old Russian icons and a member of the Central State Restoration Studios.
51. *Lef,* periodical of the Left artists' and writers' revolutionary movement (1923–25). [*See* "The LEF and Soviet Art," *pp. 138–41.*]
52. Gregory Chirikov (dates unknown) was an icon restorer as well as collector of icons.
53. The Nevski Prospect of Gogol fame had been renamed Prospect 25 October.
54. *The Extraordinary Adventures of Mr. West in the Land of the Bolsheviks* by Lev Kuleshov (Goskino, 1924).
55. Vladimir Lessuchevsky (1898–1941) was interested in 18th-century Russian portraiture as well as in brasses.

56. *Obeed—prix-fixe* dinner.
57. Barr means Nikolai Punin (1888–1953).
58. Vladimir Vladimirovich Mayakovsky (1893–1930), leading poet of the Russian Revolution and early Soviet period; Nikolai Nikolaevich Aseev (1899–1963), Futurist poet; Tretyakov (see note 11 above); Eisenstein (*see* "Sergei Michailovitch Eisenstein," *pp. 142–46*); Osip Maksimovich Brik (1888–1945), literary and art critic; Viktor Borisovich Shklovsky (1893–1984), formalist critic and writer.
59. See n. 13 above.
60. See n. 11 above.
61. Aleksandr Fedorovich Kerensky (1881–1970), moderate Socialist revolutionary who served as head of the Russian provisional government from July to November 1917.
62. This is the same film as that Barr called *The General Line* in "Russian Diary" (see n. 12 above).
63. MoMA Archives: Alfred Barr Papers: *9b. Roob/AHB Bibliog. material.*
64. Théophile Gautier (1811–72), French poet, novelist, critic, and journalist.
65. [Author's note: Concerning the "New Objectivity," Dr. Hartlaub writes in a letter of July 8, 1929: "The expression *Neue Sachlichkeit* was in fact coined by me in the year 1924. A year later came the Mannheim exhibition which bore the same name. The expression ought really to apply as a label to the new realism bearing a socialistic flavor. It was related to the general contemporary feeling in Germany of resignation and cynicism after a period of exuberant hopes (which had found an outlet in expressionism). Cynicism and resignation are the negative side of the *Neue Sachlichkeit;* the positive side expresses itself in the enthusiasm for the immediate reality as a result of the desire to take things entirely objectively on a material basis without immediately investing them with ideal implications. This healthy disillusionment finds its clearest expression in Germany in architecture. In the last analysis this battle cry is today much misused and it is high time to withdraw it from currency."]
66. Barr is probably referring to the *Portrait of Parents* (1924), now in the Kunstmuseum Hannover mit Sammlung Sprengel.
67. "Grünewald" was added to the painter's name in the seventeenth century on no known grounds. Later the surnames Nithart and Gothart were discovered, but the artist is still commonly referred to as Grünewald.
68. Joris-Karl Huysmans (1848–1907), French author and art critic.
69. According to Brigid S. Barton, *Otto Dix and Die neue Sachlichkeit 1918–1925* (Ann Arbor: UMI Research Press, 1981), p. 135, *War* (also known as *Trench Warfare*) is now missing. H. H. Arnason, *The History of Modern Art* (New York: Harry N. Abrams, 1977), p. 320, says it was destroyed around 1943–45.
70. Now in the collection of The Museum of Modern Art.
71. Barr is probably referring to *Die Witwe* (1925), now missing (Barton, op. cit., p. 151).
72. This painting was removed by the Nazis in April 1933. (*See* "Art in the Third Reich—Preview, 1933," *p. 169.*)
73. Currently in the collection of Frau Martha Dix at Hemmenhofen, West Germany (Barton, op. cit., p. 147).
74. Missing (Barton, op. cit., p. 147).
75. For the subsequent fate of Dix, *see* "Art in the Third Reich—Preview, 1933," *p. 169.*
76. The Société Anonyme was organized in 1920 by the painter and collector Katherine Dreier, advised by Marcel Duchamp, for the purpose of buying and exhibiting examples of the most advanced European and American art. It organized Klee's first exhibition in the United States in 1924, and included him in its international surveys in 1926 and 1927.
77. "Germans, you must see this film."
78. "The film of the national awakening."

79. "God is with us—Germany, Germany over all! Finis."

80. St. Petersburg, 1917: The Russian Revolution; Berlin, 1919: "Bloody Week," when the regular German army defeated the uprising by the Communist Spartacists, who were led by Rosa Luxemburg and Karl Liebknecht; Rome, 1922: when the Fascist leader Benito Mussolini led a march on Rome and was made premier, with sweeping powers, by King Victor Emmanuel III; Munich, 1923: the "Beer Hall Putsch," when Adolf Hitler attempted to seize control and proclaim a National Government.

81. Barr is probably referring to Schlemmer's *Bauhaus Stairway* (c. 1929), which he persuaded Philip Johnson to purchase from the exhibition. The painting is currently in the collection of The Museum of Modern Art, a gift from Johnson.

82. Friedländer left Germany in 1933 and settled in Holland. Justi, Director of Berlin's National Gallery from 1909 to 1933, returned in 1946 as General Director of the Berlin museums in the Russian sector.

83. Both Gropius and Mies van der Rohe emigrated to the United States in the late 1930s. Gropius headed the School of Architecture at Harvard University until 1952, and Mies van der Rohe headed the School of Architecture at the Armour Institute (now the Illinois Institute of Technology) in Chicago until 1958.

84. The Weissenhof project was bombed during World War II. Some of the buildings were reconstructed in altered form, and more recently, some have been reconstructed in their original forms.

85. [Author's note: The *"sachlich"* or rational style in which the flat roof is a conspicuous element has been associated either with the dwellings of workmen (the proletariat), erected by social democratic civic governments, or with the more expensive houses of the liberal intellectual or professional men. Both these classes are suspect to the solid citizen who in any case usually looks askance at anything new in art or architecture. The German nationalist feels that the gabled roof is *echt Deutsch* and that the flat roof is "un-German," "bolshevistic" and "international." The hundred per cent German is quite right in asserting that the new style is international but he forgets that almost every European architectural style of the past thousand years has also been international. The romanesque, gothic, renaissance, baroque, neo-classic, the various revivals of the nineteenth century and the post-war international style have spread with more or less strength in most of the important countries of Europe. The joke, however, is on the German nationalist for of all these styles not a single one can be said to have had its origin and its most vigorous expansion in Germany except the last named, the very International Style which he so much resents. The earliest building definitely in the Style was designed by the German architect Walter Gropius and there are probably ten times as many buildings in the Style in Germany as in any other country.

 [In America one often hears the Style referred to as German. In Italy the Style, which has made immense progress in the last year, when not called Fascist is termed *"lo stile tedesco"*—the German style. Three years ago when searching for a new house by Le Corbusier near Paris the writer asked the way, giving a description of a house with white walls, a flat roof and much glass. The Frenchman was puzzled for a moment and then exclaimed, *"Ah, vous voulez dire la maison dans le style allemand!"*]

86. [Author's note: *Völkischer Beobachter*, South German Edition, Munich, April 6, No. 97, *Beiblatt*. The other two architects mentioned by Commissar Hinkel are Kreiss and Schultze-Naumburg. Schmitthenner was later appointed director of the United State Art Schools in Berlin in place of the social democratic Poelzig.]

87. MoMA Archives: Alfred Barr Papers; 3154:64; 3153:1163.

88. Benedetto Croce (1866–1952), philosopher, historian, humanist; Giovanni Gentile (1875–1944), idealist philosopher, politician, educator, and editor, called the "Philosopher of Fascism"; Giovanni Pascoli (1855–1912), classical scholar and poet; Giosuè Carducci

(1835–1907), poet, winner of the 1906 Nobel Prize for literature; Gabriele d'Annunzio (1863–1938), poet, novelist, dramatist, journalist, military hero, political leader; Arrigo Boito (1842–1918), poet and composer; Giacomo Puccini (1858–1924), composer, proponent of operatic realism; Ferruccio Busoni (1866–1924), musician and composer.

89. "more or less edible."

90. "traditionalism," "passé-ism."

91. James Thrall Soby, "Painting and Sculpture since 1920," *Twentieth-Century Italian Art* (New York: The Museum of Modern Art, 1949).

92. For more recent scholarship on this point see William Rubin, "Cézannisme and the Beginnings of Cubism," *Cézanne, the Late Work* (New York: The Museum of Modern Art, 1977), pp. 151–202.

93. [Author's note: Leo Stein, *Appreciation,* New York, Crown Publishers, 1947, pp. 170–72.]

94. [Author's note: *Picasso et ses amis,* Paris, Stock, 1933, p. 107.]

95. Subsequent research has shown that it was exhibited in July 1916 in Paris, in a show organized by André Salmon.

THE STATESMAN

1. Alfred H. Barr, Jr. [Statement] in *Tenth Anniversary Exhibition:* April 13–May 10, 1949 (Cincinnati: The Cincinnati Modern Art Society, [1949]), [p. 2].

2. MoMA Archives: Alfred Barr Papers; AAA 2180:792.

3. [Author's note: Vol. II, pp. 369 ff. By "research" Coleman means adding to the sum of human knowledge, a narrower definition than the speaker's.]

4. [Author's note: *Bulletin of the Museum of Modern Art,* July, 1939, pp. 6, 7.]

5. Herbert Eustis Winlock (1884–1950), archaeologist and Director of the Metropolitan Museum of Art 1932–39; Wilhelm von Bode (1845–1929), German art critic and writer, and Director General of the Royal Museums of Prussia 1905–20; Max J. Friedländer (1867–1958), German art historian and Director of the Kaiser Friedrich Museum in Berlin 1929–33; Kenneth Clark (1903–83), English art historian and Director of the National Gallery in London 1934–45; Sir Charles John Holmes (1868–1936), Director of London's National Portrait Gallery 1909–16 and National Gallery 1916–28; Georg Swarzenski (1876–1957), Director General of the Frankfurt museums 1928–39; Paul Ganz (1872–1954), Swiss art historian and administrator, President of the Association of Swiss Art Museums 1908–19; Paul Jamot (1863–1939), Curator of the Department of Paintings at the Louvre.

6. The broadcasts, which took place in the 1940s and '50s, were a weekly series of programs on which a panel of University of Chicago professors discussed a variety of issues.

7. [Author's note: *The Behavior of the Museum Visitor* by Edward S. Robinson assisted by Irene Case Sherman and Lois E. Curry. American Association of Museums, Washington, 1928.]

8. "Italian Masters, lent by the Royal Italian Government," in New York January–March 1940. *See* "Italian Sources of Three Great Traditions," *p. 176.*

9. Sidney Fiske Kimball (1888–1955), architectural historian and Director of the Philadelphia Museum of Art from 1925 to 1955.

10. Francis Henry Taylor, *The Taste of Angels* (Boston: Little, Brown, 1948); Lloyd Goodrich, *Winslow Homer* (New York: George Braziller, 1959).

11. Daniel Catton Rich, *Seurat and the Evolution of "La Grande Jatte"* (Chicago: University of Chicago Press, 1935).

12. [Author's note: "Beauty for Ashes" in *The Atlantic Monthly,* March, 1944, p. 88.]

13. Mayakovsky (see "The Critic/Historian," n. 58, above) grew increasingly disillusioned with Soviet life and committed suicide in 1930; Vsevolod Meyerhold, a member of the Bolshevik Party who produced propaganda plays but opposed Socialist Realism, was a

victim of the Soviet purges; Sergei Mikhailovich Eisenstein *(see pp. 142–45)* was lecturing and working in Europe, the United States, and Mexico (1929–32) when the direction of artistic policy in the Soviet Union changed from post-revolutionary experiment to Socialist Realism. Upon his return, his position was downgraded and he was the subject of official harassment. His last film, *Ivan the Terrible* (1942–46), planned as a trilogy, aroused Stalin's disfavor and was never completed.

14. *See* "Art in the Third Reich—Preview, 1933," *pp. 163–75.*

15. The House of German Art, the earliest architecture commissioned by Hitler, was a museum in Munich designed by Paul Ludwig Troost.

16. Barr is probably referring to the annual All-Union exhibitions, which began in 1939.

17. Calling modern art aesthetically left, some members of the National Sculpture Society accused the Metropolitan Museum of promoting political leftism by showing advanced work in the exhibition "American Sculpture 1951." In Los Angeles, a City Council–sponsored survey of contemporary art in Griffith Park was attacked by some commercial artists and illustrators who questioned the political backgrounds of some of the participants. Although initially a City Council committee decided that some modern artists were unconscious tools of the Kremlin, ultimately the whole council voted that there was no evidence to support such a charge.

18. Fred Ernest Busbey (Republican, Illinois) served in Congress on and off between 1943 and 1953.

19. George Anthony Dondero (Republican, Michigan) served 1933 to 1957. Joseph McCarthy (Republican, Wisconsin) served 1947 to 1957.

20. [Original editor's note: For an account of the Dallas situation, see Aline Saarinen's article, Art page, *New York Times*, Sunday, February 12, 1956, and a letter from three trustees of the Dallas Museum of Fine Arts in Art page, *New York Times*, Sunday, February 19, 1956.] The Dallas Art Association, which had been the object (along with other art-support groups in Dallas) of long-standing pressure by those opposed to the showing of modern art, responded that it would not ban any works and that it believed that the "fundamental issue at stake is that of Freedom and Liberty." Nevertheless, because of the bad publicity, the show, which was to have toured further (it was shown at the Boston Museum of Fine Arts before the Corcoran), was cancelled by the USIA after its Dallas preview.

21. See Introduction, n. 149.

22. [Author's note: Harold Rosenberg, "American Action Painters," *Art News*, Vol. 51, December 1952.]

23. Martin Mayer, "Decisive Dozen," *Esquire*, July 1960, p. 50.

24. MoMA Archives: Alfred Barr Papers; AAA 2180:692.

Chronology
COMPILED BY JANE FLUEGEL

1902

January 28: Birth of Alfred Hamilton Barr, Jr., in Detroit, to Alfred Hamilton Barr, Sr. (1868–1935), and Annie Wilson Barr (1868–1961).

1905

April 8: Birth of Andrew Wilson Barr, Alfred's brother.

1911

Family moves from Detroit to Baltimore.

1915

Barrs begin to spend summers in Greensboro, Vermont.

1918

Graduates first in class from Boys' Latin School.
September: Enters Princeton University.

1919–21

Takes Charles Rufus Morey's course in medieval art; Frank Jewett Mather's in modern art; Christian Gauss's in Dante. Subscribes to *Vanity Fair.* Takes up birdwatching.
Summers: In 1919 and 1921 works as counselor at camp in Vermont. In 1920 contracts typhoid and remains in Greensboro.

1922

Graduates Phi Beta Kappa from Princeton with high honors in art and archaeology. Enters graduate school at Princeton.

1923

June: Granted Master of Arts degree from Princeton. Writes thesis on Piero di Cosimo.
September: Becomes instructor in art history at Vassar College.

1924

Summer: Travels in Europe with childhood friend Edward S. King.
Fall: Named Thayer Fellow at Harvard University and teaching assistant in Department of Fine Arts. Takes European drawings course with Paul J. Sachs. Completes courses toward Ph.D.

1925

September: Becomes instructor in Department of Art and Archaeology at Princeton.

1926

July: Meets German avant-garde art dealer J. B. Neumann at his gallery, New Art Circle, in New York. Neumann introduces him to Bauhaus concept and contemporary German art.
Fall: Appointed Associate Professor, Department of Art History, Wellesley College. Enrolls in Sachs's museum course at Fogg Art Museum. Classmates include Henry-Russell Hitchcock, architectural historian, A. Everett ("Chick") Austin, future director of Wadsworth Atheneum, Hartford, and Jere Abbott, fellow student of art history from Princeton.

November: Organizes exhibition of modern art at Fogg, borrowing works from collections of fellow Harvard students.

1927

January: At Wellesley, begins teaching course in modern art, first of its scope at any college in country: covers architecture, graphic design, photography, music, and film, in addition to painting and sculpture.

Spring: First correspondence with Katherine Dreier. Requests loan of Société Anonyme exhibitions for showing at Wellesley and in Boston. Plans fail to materialize.

April 11–30: Organizes *Exhibition of Progressive Modern Painting* at Farnsworth Museum, Wellesley.

July 28: Carrying letters of introduction from Dreier, Neumann, and Sachs (who arranges traveling scholarship), arrives in London for twelve months in Europe.

October: Joined by Jere Abbott in London. They depart for Holland to see architecture of J. J. P. Oud and art collections.

December 4: Arrives Dessau to spend four days at Bauhaus. Meets Gropius, Klee, Moholy-Nagy, Bayer, Schlemmer, Albers, and Feininger.

Mid-December: Reaches Berlin.

December 26: Arrives in Moscow. Remains almost two months, keeping detailed diary.

1928

February 16: Departs with Abbott for Leningrad.

February 24: Leaves for Novgorod. Takes train to Vienna after three days. Visits collectors and museums of modern art in Munich, Stuttgart, Frankfurt, Darmstadt, Mannheim, and Basel.

May: In Paris. Returns to America late in July.

September: Resumes teaching at Wellesley. Mounts exhibition of posters from Russia.

1929

Spring: Awarded Carnegie Fellowship. Plans to spend academic year 1929–30 completing thesis on Cubism and abstract art under A. Philip McMahon at New York University.

April 17–May 22: Delivers five lectures on contemporary art at Wellesley.

June: At Wellesley graduation ceremony meets Philip Johnson, classics scholar at Harvard. They have common interests in modern art and architecture.

June: Approached by Sachs to head projected new modern museum in New York.

July: Barr is named Director and Abbott Associate Director of new institution. Barr drafts new museum's prospectus, proposing multidisciplinary approach based on Wellesley course.

August: For opening exhibition proposes American show, but founding trustees Mrs. John D. Rockefeller, Jr., and Miss Lillie P. Bliss prefer "joint French-American" or all-French show.

October 29: Stock market crash, beginning of Great Depression.

November 8: Museum of Modern Art officially opens with exhibition *Cézanne, Gauguin, Seurat, Van Gogh,* 101 works from international collections. In month, show attracts 48,000 visitors.

Meets Margaret Scolari-Fitzmaurice, Italian art historian who has been teaching Italian at Vassar and has been awarded Carnegie Fellowship to study at New York University.

December 12: Opening of second exhibition, *Paintings by 19 Living Americans.*

1930

May 8: Marries Margaret Scolari at New York's City Hall. A daughter, Victoria Fitzmaurice, is born of this marriage.

End of May: In London and Paris to request loans for forthcoming Corot and Daumier and German painting and sculpture exhibitions.

Early July: Embarks on tour of Germany and Switzerland, accompanied by J. B. Neumann.

1931

March 12: Death of Lillie P. Bliss. Bequeaths Museum 21 Cézannes and important works by Gauguin, Matisse, Modigliani, Picasso, Redon, and Seurat.

March 12: Opening of *German Painting and Sculpture,* major exhibition of twentieth-century work from European and American collections.

Spring: With Philip Johnson, organizes *Rejected Architects* in Sixth Avenue storefront, showing work excluded from Architectural League exhibition.

June 4: Barrs arrive in Paris to prepare Matisse exhibition.

After July 10: Travel to Berlin. Meet Johnson, who attends Berlin Building Exhibition.

November 3–December 6: *Henri Matisse Retrospective Exhibition* at Museum, first major Matisse show in U.S.

December 22, 1931–January 27, 1932: Diego Rivera exhibition at Museum. Abby Aldrich Rockefeller commissions Rivera to paint 7 frescoes.

1932

February 10–March 23: *Modern Architecture: International Exhibition,* directed by Philip Johnson with close collaboration of Henry-Russell Hitchcock and Alfred Barr. Museum's first circulating exhibition, it travels in various versions until 1938.

May 3: Museum moves to townhouse at 11 West 53rd Street. First exhibition in new quarters, *Murals by Painters and Photographers,* organized by Lincoln Kirstein, is also first exhibition to feature photography.

July: Museum announces formation of Department of Architecture, with Philip Johnson as Chairman.

July: Writes *A Brief Survey of Modern Painting,* notes on modern art to accompany exhibition of reproductions circulating to New York City high schools.

Fall: Exhausted from rigorous schedule of exhibitions, granted year's leave of absence. Spends three months in Italy, traveling to Zurich to see Picasso retrospective.

Christmas: Skis at Saint Anton in Austrian Alps with Mrs. Barr. Makes plans to see Stuttgart doctor for treatment of persistent insomnia.

1933

January 30: Adolf Hitler is named Chancellor of Germany.

Early February: Barrs arrive in Stuttgart, remaining through end of May.

March 5: Election day. Nazi party gains control of Reichstag. Throughout Germany, modern art and architecture come under increasing attack. Closely follows course of events, and upon reaching Switzerland in late May, writes series of articles tracing Nazi repression.

July 2: Returns from year's leave of absence. British film critic Iris Barry becomes Museum Librarian.

1934

March 6–April 16: *Machine Art,* selected and installed by Philip Johnson, inaugurates Museum's Design Collection.

March 12: Museum becomes permanent institution: endowment of $600,000 raised.

November: Dorothy C. Miller, who assisted Acting Director Holger Cahill with American shows during Barr's leave of absence, joins staff as Assistant to the Director.

November 21: Opening of *Modern Works of Art,* celebrating fifth anniversary.

1935

Spring: Plans under way for exhibition *Cubism and Abstract Art.* Nazi threat to artists and abstract art in Germany lends urgency to plan. In Hanover meets Alexander Dorner, Director of Landesmuseum, and sees El Lissitzky's *Abstract Cabinet;* also sees Malevich material in Dorner's care. Acquires 2 Suprematist oils and 2 drawings. Visits Schwitters's Merzbau and acquires collage *Merz: Santa Claus* (1922). To Amsterdam to make arrangements for Van Gogh exhibition. Also selects Mondrians for *Cubism and Abstract Art.*

November: Announces formation of Film Library. Names Iris Barry Film Librarian.

November: Beaumont Newhall appointed Museum Librarian.

November 5: Van Gogh show opens. Lines extend to Fifth Avenue.

1936

March 2–April 19: *Cubism and Abstract Art* exhibition.

May 12: Sails for Europe to plan Surrealist show. In Paris, enlists aid of André Breton, Paul Eluard, Man Ray, Marcel Duchamp, and Christian Zervos.

June: Sets out to engage great modern architect to assist Philip Goodwin in design of new Museum building. Also authorized by Harvard to seek out candidates for professorship in School of Architecture.

June 16: Arrives in Rotterdam to meet J. J. P. Oud, who declines both invitations.

June 20: Calls on Mies van der Rohe in Berlin, who is open to both offers.

June 25: Arrives in London to speak to Gropius, who ultimately accepts position at Harvard. Attends *International Surrealist Exhibition.*

July: In Paris talks with Louvre regarding American show at Jeu de Paume in 1938.

December 2–January 17: *Fantastic Art, Dada, Surrealism* on view at Museum.

1937

March 17–April 18: *Photography: 1839–1937,* encyclopedic exhibition organized by Beaumont Newhall, Museum's most ambitious exhibition of photographs to date.

June: Museum moves to underground concourse at Rockefeller Center, 14 West 49th Street, to permit construction of new and larger building at 11 West 53rd Street.

Summer: Completes summer cottage in Greensboro.

November 1–20: Picasso's *Demoiselles d'Avignon* (1907) exhibited in New York at Jacques Seligmann & Co. Begins two-year negotiation to deaccession Degas from Bliss Bequest and acquire *Demoiselles.*

December 6: Announces acquisition of Picasso's *Girl Before a Mirror* (1932), gift of Mrs. Simon Guggenheim, first of her many purchases for Museum.

1938

May 24: Opening of first exhibition abroad, *Trois siècles d'art aux Etats-Unis* at the Musée du Jeu de Paume, Paris. Painting, sculpture, photography, film, and architecture represented.

Summer: To Switzerland to borrow Rousseau's *Sleeping Gypsy* for tenth anniversary show. Enters collection in 1939.

December 7: Opening of *Bauhaus 1919–1928* exhibition.

1939

May 5–29: Picasso lends *Guernica,* which had been exhibited at Spanish Pavilion at Paris International Exposition, and related studies to American Artists' Congress for benefit of Spanish Refugee Relief campaign. Tours U.S. before returning to New York in November for Picasso retrospective at Museum.

May 8: Museum reopens to public at 11 West 53rd Street in new building designed by Philip Goodwin and Edward Durell Stone, with sculpture garden designed by John McAndrew. Opening exhibition, *Art in Our Time,* attracts visitors attending New York World's Fair.

President Roosevelt addresses nation in radio broadcast (May 10) on occasion of opening.

May 8: Nelson Rockefeller replaces A. Conger Goodyear as President. Stephen C. Clark is elected Chairman.

Summer: Travels to Paris to assemble Picasso exhibition.

September 1: Germany invades Poland.

September 3: Britain and France declare war on Germany.

November 15–January 7: *Picasso: Forty Years of His Art*, organized in collaboration with Art Institute of Chicago. First major Picasso retrospective in America; includes newly acquired *Demoiselles d'Avignon* as well as important loans from artist. *Guernica* remains at Museum until 1981.

1940

January 4: Elected to Board of Trustees and named Vice President.

January 26–April 7: *Exhibition of Italian Masters*, major loan show organized with Italian government.

April: American Abstract Artists picket Museum, criticizing exhibition of Italian old masters ("How Modern Is the Museum of Modern Art?").

June 15: Fall of Paris.

September: Mrs. Barr, on behalf of Museum, cooperates with American Aid Center set up in Marseilles by Varian Fry to rescue European artists. Assists Ernst, Chagall, Lipchitz, Mondrian, and Masson in reaching America.

December: Department of Photography founded. Beaumont Newhall named Chairman.

1941

Nelson Rockefeller, appointed Coordinator of Inter-American Affairs, resigns as Museum President. John Hay Whitney replaces him, but joins Air Force following year. Chairman Clark then assumes Presidency, as well.

Spring: Reassessment of Museum collection begins. Trustee Advisory Committee recommends sale of Cézannes to finance acquisitions and calls for addition of American avant-garde art.

Acquires Van Gogh's *Starry Night* from Paul Rosenberg by exchanging three Bliss Collection pictures.

December 7: Pearl Harbor bombed. America enters war.

1942

January: Issues *Painting and Sculpture in The Museum of Modern Art*, first general catalogue of collection (listing 693 works).

January: Dorothy Miller, now Assistant Curator, organizes *Americans 1942: 18 Artists from 9 States*, first of 6 "Americans" exhibitions.

December 22: Opening of *Joe Milone's Shoe Shine Stand*, controversial exhibition that outrages trustees.

1943

January: Increasing friction between Barr and trustees, who appoint James Thrall Soby as Assistant Director, granting him authority over "artistic activities." Barr directed to focus on writing.

June 22: Opening of *The Paintings of Morris Hirshfield*. Clark offended by Brooklyn artist's naïve paintings; press reviews exhibition unfavorably.

October 15: Asked to step down as Director of Museum and accept post of Advisory Director. Gives up administrative and curatorial responsibilities.

October 26: Soby named Director of Painting and Sculpture and Dorothy Miller named Curator.

November: Completes *What Is Modern Painting?*, brief introduction to modern movement that

is revised and reprinted in 11 more editions in English (and Japanese, Spanish, and Portuguese editions) during next 40 years.

December 8: Advisory Committee issues report describing Collection as "spotty" and "unbalanced"; charges that Museum has missed opportunities to buy important paintings.

1944

February 3: Delivers eulogy at Mondrian's funeral in New York. Acquires for Museum Pollock's *She-Wolf,* first of his works to enter public collection.

October: Provides trustees with detailed list of suggested acquisitions, collectors, prices, and insurance values.

Named Director of Research in Painting and Sculpture. Works in small office adjacent to Library.

René d'Harnoncourt named Vice President of Museum.

1945

January 1: Soby resigns as Director of Painting and Sculpture; replaced by James Johnson Sweeney.

May 8: End of war in Europe.

June: Installs Museum Collection of painting and sculpture (355 works) on second and third floors; on view through following February. At November trustees meeting, Clark declares Museum acquisitions policy "strikingly vindicated" and commends Barr for his efforts.

1946

Fall: Publishes *Picasso: Fifty Years of His Art,* expanded version of catalogue of 1939 exhibition. Dedicates book to Mrs. Barr, assistant in "Picasso campaigns of 1931, 1932, 1936, 1939."

Granted Ph.D. from Harvard for work on Picasso.

November 16: Sweeney resigns as Director of Painting and Sculpture.

At suggestion of Kenneth Clark, appointed editor of books on American art for Penguin Modern Painters Series.

1947

February: Appointed Director of the Museum Collections. René d'Harnoncourt named Director of Curatorial Departments.

1948

April–July: First postwar trip to Europe. Borrows paintings for Futurist section of forthcoming Italian exhibition. In Paris, sees Matisse and widow of Hector Guimard. In London meets with Roland Penrose and Peter Gregory, soon to found Institute of Contemporary Art.

1949

June: Granted honorary degree by Princeton University.

June 28–September 18: *Twentieth Century Italian Art,* exhibition directed by James Thrall Soby and Barr. Acquires 6 Futurist works for Museum from show.

October: René d'Harnoncourt named Director of Museum.

Acquires Matisse's *Red Studio* (1911) and Picasso's *Three Musicians* (1921) with funds from Mrs. Simon Guggenheim.

Opening of Abby Aldrich Rockefeller Print Room; William S. Lieberman, also former student of Paul J. Sachs, appointed first Curator.

1950

April 21–23: With Richard Lippold and Robert Motherwell, moderates symposium organized by the Club at Studio 35 (35 East Eighth Street). Participants include all major Abstract Expressionists.

Museum acquires Gorky's *Agony* (1947), Motherwell's *Western Air* (1946–47), and Pollock's *Number 1, 1948.*

1951

Spring: Attends opening of *Ninth Street Show,* assembled at 60 East Ninth Street by members of the Club. Group applauds as he enters.

November 13: Publication of *Matisse: His Art and His Public* coincides with opening of exhibition *Henri Matisse* (141 items), directed by Margaret Miller.

1952

January 29–March 23: Installs *Masterworks Acquired Through the Mrs. Simon Guggenheim Fund.*

April 9–July 27: Dorothy Miller's exhibition *Fifteen Americans.*

Summer: Attends Venice Biennale. Travels to Vallauris to visit Picasso and Françoise Gilot. Calls on Matisse at Cimiez. Acquires cut-paper maquettes (1950–52) for red chasuble used in Vence Chapel.

December 14: Article "Is Modern Art Communistic?" published in *New York Times Magazine.*

1953

February 27: At invitation of British Arts Council, departs for London to jury "Monument to Unknown Political Prisoner" competition. Acquires prize-winning maquette by Reg Butler for Museum.

Spring: Opening of Abby Aldrich Rockefeller Sculpture Garden designed by Philip Johnson.

March: Selects for Museum collection De Kooning's *Woman, 1* (1950–52) from exhibition at Janis Gallery.

December 12, 19: Profile by Dwight Macdonald appears in 2 issues of *The New Yorker.*

1954

Summer: Attends Venice Biennale, where Museum organizes exhibition at United States Pavilion, recently acquired by Museum's International Council.

October 19: With Dorothy Miller, installs *25th Anniversary Exhibition,* 495 paintings and sculptures from Museum collection. Edits *Masters of Modern Art* (356 illustrations) on all Museum collections.

1955

May 31–September 5: Organizes *Paintings from Private Collections,* another twenty-fifth anniversary exhibition.

1956

January 17: Delivers eulogy at Lyonel Feininger's funeral.

June 9: Visits Picasso and Jacqueline Roque at La Californie. Selects paintings for Picasso retrospective following year.

1957

May 22: Organizes *Picasso: 75th Anniversary* (171 paintings, sculptures, and drawings from 98 public and private collections).

August 28: Departs for South America to attend São Paulo Bienal. Writes catalogue for U.S. section, organized by Museum.

October 31: Participates in panel on censorship at meeting of American Civil Liberties Union.

1958

January: Attends Jasper Johns's first one-man show at Leo Castelli Gallery. Selects 4 works for Museum; buys 3, and Philip Johnson donates fourth, *Flag* (1954–55), in honor of Barr.

April 15: Disastrous fire in construction on Museum's second floor destroys Monet mural and several smaller canvases. Museum remains closed through end of summer.

April 19: Opening in Basel of *The New American Painting,* first exhibition in Europe devoted to Abstract Expressionism. Organized by Dorothy Miller, with catalogue by Barr, it travels to

Milan, Madrid, Berlin, Amsterdam, Brussels, Paris, and London before returning to New York for showing in summer 1959.

June: Publishes third edition of *Painting and Sculpture in the Museum of Modern Art* (listing 1,360 works).

October 7: Celebrates reopening of Museum with exhibitions of promised gifts and selections from collection of late Philip Goodwin.

1959

May 31: At invitation of Soviet government, makes three-week trip to Russia. Welcomed by cultural community, among whom *Cubism and Abstract Art* is known. At Friendship House, Moscow, delivers slide lectures on modern art and on Museum. Travels to Leningrad to deliver same lectures at Hermitage to overflow audiences. Repeats talks in Tiflis and Yerevan.

August 1: Arrives in Kassel for Documenta 2. American section, organized by Museum, represents 22 Abstract Expressionist painters and 8 sculptors.

October 16: Awarded Grand Cross of German Order of Merit for recognition of modern German art.

1960

September 17: Death of Stephen C. Clark. He bequeaths his collection to Yale University Art Gallery and Metropolitan Museum of Art, New York.

1962

January 28: Sixtieth-birthday celebration at Philip Johnson's Glass House, New Canaan, Connecticut, and Rockefeller Guest House, New York.

October 22: Cuban missile crisis erupts. Within 24 hours many of Museum's most valuable paintings are sent to storage far from city. As Russian ships back off, works quietly restored to original places.

November 28: Museum breaks ground for another addition. Philip Johnson designs East Wing Galleries, East Garden Terrace, and Garden Wing.

1963

March 29: Attends Rauschenberg opening at Jewish Museum, New York. Selects *First Landing Jump* (1961), which Philip Johnson buys and places in Museum on extended loan.

Nelson Rockefeller acquires for Museum Matisse's *Dance (First Version)* (1909) in honor of Alfred Barr.

1964

May 27: Reopening of Museum in newly expanded quarters; Barr installs painting and sculpture collection on second and third floors, his last major installation.

1965

Elected to Board of Overseers, Harvard University, serving until 1970.

1966

Spring: Alexander Calder invites Barr and Dorothy Miller to make selection of his sculpture for Museum collection; 13 sculptures chosen, among them *Gibraltar* (1936).

1967

January: Attends great Picasso retrospective in Paris. Calls on Picasso in Mougins for permission to show sculpture from retrospective at Museum later that year. He agrees. It is their last meeting.

Early in year: Philip Johnson invites Museum to select potential gifts from his collection. Almost 50 works by contemporary artists chosen.

June 30: Retires from Museum and elected Councilor to Board of Trustees. On same date, James

Thrall Soby retires as Chairman of Trustee Committee on Museum Collections and Monroe Wheeler retires as Director of Exhibitions and Publications.

1968

June 30: René d'Harnoncourt retires as Director of Museum.

1972

Receives Art Dealers' Association Award for Excellence in Art History.

1973

April 8: Death of Picasso. Barrs bring bouquet of white flowers, tied with black ribbon with artist's name and dates of birth and death written in gold letters, and place it on pedestal in Museum lobby.

1975

May 13: Attends celebration of renaming of galleries in Museum in his honor. Also honored is late René d'Harnoncourt. Vice President Nelson Rockefeller addresses guests.

1977

Fall: Publication of *Painting and Sculpture in The Museum of Modern Art, 1929–1967* (listing 2,622 works), catalogue of collection at his retirement in June 1967 and chronicle of its assembling.

1980

February: College Art Association establishes Alfred H. Barr, Jr., Award for Museum Scholarship.

1981

August 15: Death of Alfred Hamilton Barr, Jr., in Salisbury, Connecticut.

October 21: Memorial tribute at Museum. Eulogists include Meyer Schapiro, Beaumont Newhall, and Philip Johnson.

Alfred H. Barr, Jr.:
A Bibliography of
Published Writings

COMPILED BY RONA ROOB

INTRODUCTION

This bibliography lists 339 published writings by Alfred H. Barr, Jr. Entries are arranged chronologically in three categories: I. Books and Exhibition Catalogs; II. The Bulletin of the Museum of Modern Art; and III. Periodicals. Barr's writings span some fifty years: the earliest was written when he was a student at Princeton in 1919; the latest, *Painting and Sculpture in the Museum of Modern Art,* was published by the Museum in 1977.

At the time of the Museum's twenty-fifth anniversary, Barr wrote: "The understanding of modern visual art has been greatly helped by the publications of the Museum of Modern Art. . . ." In a letter of October 1943, he noted: "During the first dozen years of the Museum I edited practically everything that the Museum published. . . . I have, through prefaces, reports, bulletin articles, editing and Museum Collection labels . . . tried to present the Museum's policies and achievements, the continuity of its exhibitions and publications, the importance of its collections with precision and enthusiasm. . . . [A]s Director I . . . had general responsibility for the standards of the Museum's publications." Of the 180 citations in sections I and II written after 1929, only 25 were not connected with the Museum. These writings reflect the disciplined thought of a man who was endeavoring to put modern art in order.

In addition to being a scholar, Barr was a fighter, a man of public conscience. The 150+ entries in section III were printed in 83 different periodicals, 13 of these foreign. Many of these letters and articles are polemic in tone—Barr's undeniable aim was to proselytize. In 1953 Barr wrote to René d'Harnoncourt, then Director of the Museum: "Some people are against answering attacks, others such as myself feel that they should be answered, not in a spirit of contentiousness but as a part of our educational function and indeed an obligation. . . ." Barr wrote in order to explain modern art, and the role of the Museum to an unsympathetic public. He defended artists, works of art, art movements, Museum policy, and Museum exhibitions. He was a man of political integrity, and intolerance made him bristle: in 1933 he observed firsthand the Nazi threat and tried to publish his observations. These articles were turned down by six American publishers. Only Lincoln Kirstein was brave enough to publish the section devoted to film in his magazine *The Hound & Horn.* Again, in the 1950s Barr was infuriated by accusations that modern art was "communistic," and by the loss of freedom in the arts and even censorship. His support of individual and civil rights in the 1960s is reflected in several of the entries.

Too few of these citations affirm his great love of nature (ornithology was his avocation). Included, however, are published letters lashing out at those who would destroy the "cover,"

as he would say, of Central Park. Similarly, only one of his poems was published (on Kiesler's *Galaxy*); however, his prose description of Roszak's *Spectre of Kitty Hawk* has the richness of verse.

Two kinds of "published" material have not been entered; "one-liners" or short statements written for purposes of publicity, usually at the request of friends, such as Alexander Calder, Alexander Liberman, Erle Loran, Roland Penrose, and Paul J. Sachs; and television interviews or appearances that have not been transcribed.

The works cited below are accessible in The Museum of Modern Art Library; the form of each entry adheres to that set forth in the *American National Standard for Bibliographic References* (New York: ANSI, c. 1977). The wording of each entry is recorded as it appears in the original.

R. R.

January 1986

Note: Each of the sections is arranged by date of publication.
 c. = copyright.
 Brackets [] indicate that the bibliographer has determined the information from an outside source.

I. BOOKS AND EXHIBITION CATALOGS

1. "A Drawing by Antonio Pollaiuolo." In: *Art Studies: Medieval Renaissance and Modern.* Cambridge: Harvard; 1926: 73–78.

2. [A.H.B., Jr.] *Exhibition of Progressive Modern Painting: from Daumier and Corot to Post-Cubism.* The Art Museum of Wellesley College. 1927 April 11–30: unpaginated. [Note: a published list of works exhibited; typewritten wall labels can be found in the AHB Papers, MoMA Archives; see also Bibliography #187.]

3. [A.H.B., Jr.] [selected reviews for art books.] In: *Bookshopping.* Poughkeepsie, NY: Vassar Co-operative Bookshop; 1928–29: 15, 16, 17.

4. *A Course of Five Lectures on Modern Art.* Wellesley, MA; 1929. [Note: description of lectures to be delivered at Farnsworth Museum, Wellesley College, April and May 1929.]

5. [A.H.B., Jr.] *A New Art Museum: an institution which will devote itself solely to the masters of modern art.* New York: The Museum of Modern Art; first edition [1929 August]: unpaginated. Second edition (retitled *The Museum of Modern Art*), revised, [1929 November]. [Note: this four-page brochure was the Museum's first publication.]

6. "Foreword." In: *First Loan Exhibition: Cézanne, Gauguin, Seurat, van Gogh.* New York: Museum of Modern Art; 1929: 11–27. Second edition; 1929: 11–27. New York: Arno Reprint; 1972.

7. "Foreword." In: *Paintings by Nineteen Living Americans.* New York: Museum of Modern Art; 1930: 9–10. New York: Arno Reprint; 1969 (In: *American Art of the 20s and 30s*).

8. "Foreword" [and catalog notes]. In: *Painting in Paris from American Collections.* New York: The Museum of Modern Art; 1930 January. Second edition, 1930 February: 11–16.

9. [A.H.B., Jr.] "Introduction." In: *Max Weber: retrospective exhibition 1907–1930.* New York: Museum of Modern Art; 1930: 7–12. New York: Arno Reprint; 1969 (In: *Three American Modernist Painters: Max Weber, Maurice Sterne, Stuart Davis*).

10. "Introduction." In: *Paul Klee.* New York: Museum of Modern Art; 1930: 7–10. New York: Arno Reprint; 1968 (In: *Paul Klee: three exhibitions*).

11. "Introduction." In: *An Exhibition of Painters and Sculptors under 35 Years of Age.* New York: Museum of Modern Art; 1930: 2–3.

12. [A.H.B., Jr.] "Introduction." In: *Charles Burchfield: early watercolors 1916 to 1918.* New York: Museum of Modern Art; 1930: 5–7. New York: Arno Reprint; 1969 (In: *Three American Romantic Painters: Burchfield, Stettheimer, Watkins*).

13. "In 1930." In: *Sixth Loan Exhibition: Winslow Homer, Albert P. Ryder, Thomas Eakins.* New York: The Museum of Modern Art; 1930: 6–7. New York: Arno Reprint; 1969 (In: *Four American Painters: Bingham, Homer, Ryder, Eakins*).

14. "Introduction." In: *Eighth Loan Exhibition: Corot, Daumier.* New York: The Museum of Modern Art; 1930: 11–21. Second edition; 1930: 11–21.

15. "Foreword." In: *Ninth Loan Exhibition: Painting and Sculpture by Living Americans.* New York: Museum of Modern Art; 1930: 5.

16. "Introduction" [and catalog notes]. In: *German Painting and Sculpture.* New York: Museum of Modern Art; 1931: 7–14 (passim). [Note: also co-published with New York: W. W. Norton as *Modern German Painting and Sculpture,* n.d. (1931).] New York: Arno Reprint; 1972 (retitled: *Modern German Painting and Sculpture*). [Note: see also Bibliography #218.]

17. "Miss Bliss Collection." In: *Memorial Exhibition. The Collection of the late Miss Lizzie P. Bliss, Vice-President of the Museum.* New York: Museum of Modern Art; 1931: 11–13 (passim).

18. [A.H.B., Jr.] *An Effort to Secure $3,250,000 for the Museum of Modern Art: Official Statement, April 1931.* New York: Museum of Modern Art; 1931: 5–10, 35–41. [Note: pages 5–10, 37–39 reprinted in Bibliography #38, where they were signed by AHB.]

19. "Introduction." In: *Modern French Painting.* Detroit, MI: The Institute of Arts; 1931: 6–10. [Note: this catalog is a reprint of Bibliography #8 omitting references to pictures shown only in New York.]

20. "Introduction." In: *Henri Matisse Retrospective Exhibition.* New York: The Museum of Modern Art; c. 1931: 9–28. [Note: also published by Museum with W. W. Norton in trade edition entitled *Henri Matisse.*]

21. "Plans for the Future." With Goodyear, A. Conger. In: *Museum of Modern Art Annual Report 1931–32.* (New York: The Museum of Modern Art); n.d.: 9–11. [Note: "This brochure prepared for the meeting of the Corporation, November 19, 1931."]

22. "Special Quiz—Art." In: Leonard, J. N. *Ask Me Again! The Third Question Book.* New York: Viking; c. 1932: 127–128, 183–184. New York: Blue Ribbon Reprint; 1938.

23. *A Brief Survey of Modern Painting: Notes . . . on the Museum's Circulating Exhibition of Color Reproductions of Modern Paintings.* New York: The Museum of Modern Art; c. 1932. [Note: see also Bibliography #219.]

24. "Preface." In: Hitchcock, Henry-Russell; Johnson, Philip. *The International Style: Architecture since 1922.* New York: Norton; 1932: 11–16. New York: Norton Library Reprint; 1966 (retitled: *The International Style*).

25. "Foreword." In: Barr, Alfred H., Jr.; Hitchcock, Henry-Russell, Jr.; Johnson, Philip; Mumford, Lewis. *Modern Architects.* New York: Norton, Museum of Modern Art; 1932: 12–17. [Note: text is identical to Bibliography #26.]

26. "Foreword." In: Hitchcock, Henry-Russell, Jr.; Johnson, Philip; Mumford, Lewis. *Modern Architecture: International Exhibition.* New York: Museum of Modern Art; 1932: 12–17. [Note: text is identical to Bibliography #25.]

27. "Foreword." In: *Modern Masters from the Collection of Miss Lizzie P. Bliss.* Indianapolis, IN: John Herron Art Institute; 1932: [3–4].

28. [A.H.B., Jr., ed.] *The Public as Artist.* New York: The Museum of Modern Art; 1932.

29. "Edward Hopper." In: *Edward Hopper Retrospective Exhibition.* New York: The Museum of Modern Art; 1933: 9–15.

30. "Painting and Sculpture." With Helen M. Franc. In: *National Encyclopedia.* New York: Collier; 1933: 76–79.

31. [biographical notes.] In: *Painting and Sculpture from 16 American Cities.* New York: The Museum of Modern Art; c. 1933.

32. A.H.B., Jr., co-ed. *Art in America a complete survey.* With Holger Cahill. New York: Reynal & Hitchcock; c. 1934. [later printing c. 1935.]

33. A.H.B., Jr., co-ed. *Art in America in Modern Times.* With Holger Cahill. New York: Reynal & Hitchcock; c. 1934. Freeport (NY): Books for Libraries Reprint; 1969. [Note: this text was basis for a series of radio programs aired over WJZ in October 1934–January 1935.]

34. *A Brief Survey of Modern Painting.* New York: The Museum of Modern Art; c. 1934. [Note: revised and expanded version of Bibliography #23.] Second edition, emended; 1936: 11–19.

35. "Foreword." In: Johnson, Philip. *Machine Art.* New York: The Museum of Modern Art; W. W. Norton; c. 1934: [7–10]. New York: Arno Reprint; 1970. [Note: passage from Plato to which AHB refers in this foreword expanded upon, at AHB's suggestion, by A. Philip McMahon in "Would Plato find artistic beauty in machines?" (*Parnassus.* 7[2]: 6–8; 1935 February).]

36. "The Lillie P. Bliss Collection." In: *The Lillie P. Bliss Collection: 1934.* New York: Museum of Modern Art; 1934: 5–7 (passim).

37. "Modern Works of Art." In: *Modern Works of Art: Fifth Anniversary Exhibition, November 20, 1934–January 20, 1935.* New York: Museum of Modern Art; c. 1934: 11–19. Second edition, emended; 1936: 11–19.

38. *A Museum of Modern Art in New York.* [New York: The Museum of Modern Art; 1934; unpaginated.] [Note: this text originally appeared on pages 5–10, 37–39 of Bibliography #18; it was not signed by AHB in the 1931 publication.]

39. "Painting and Sculpture." With Van Hook, Katrina. In: *National Encyclopedia.* New York: Collier; 1934: 79–82.

40. [acknowledgements.] In: Kirstein, Lincoln. *Gaston Lachaise: retrospective exhibition.* New York: The Museum of Modern Art; c. 1935: 6. New York: Arno Reprint; 1969 (In: *Five American Sculptors*).

41. *Vincent van Gogh.* New York: The Museum of Modern Art; c. 1935 November. Second edition, emended; 1935 December. Third edition, emended; 1936 March. New York: Arno Reprint; 1966 (retitled: *Vincent van Gogh: A monograph by AHB, Jr.*).

42. [A.H.B., Jr., ed.] *Catalog of selected color reproductions prepared for Carnegie Corporation of New York.* New York: Raymond and Raymond; 1936.

43. *Cubism and Abstract Art.* New York: The Museum of Modern Art; c. 1936; paperbound edition, 1974. New York: Arno Reprint; 1966. Cambridge, (MA): Harvard University Press, 1986 (Paperbacks in Art History reprint edition with foreword by Robert Rosenblum).

44. "Foreword." In: Cahill, Holger. *New Horizons in American Art.* New York: The Museum of Modern Art; c. 1936: 7. New York: Arno Reprint; 1969.

45. "Preface and Acknowledgement." In: McBride, Henry; Hartley, Marsden; Benson, E. M. *John Marin: watercolors, oil paintings, etchings.* New York: The Museum of Modern Art; c. 1936: 9–10. New York: Arno Reprint; 1966.

46. A.H.B., Jr., ed. *Fantastic Art, Dada, Surrealism.* New York: The Museum of Modern Art; c. 1936. Second edition, revised and enlarged, c. 1937. Third edition, c. 1947. New York: Arno Reprint; 1968. [Note: AHB responsible for the "Preface," "Introduction," "Catalog," "Brief bibliography," and, with Elodie Courter, the "Brief Chronology."]

47. *A Brief Guide to the Exhibition of Fantastic Art, Dada, Surrealism.* New York: The Museum of Modern Art; [1937 January]: unpaginated. [Note: this was included as introduction in Bibliography #46 Second edition.]

48. "Preface and Acknowledgement." In: *Prehistoric Rock Pictures in Europe and Africa: from material in the Archives of the Research Institute for the Morphology of Civilization, Frankfurt-on-Main.* New York: The Museum of Modern Art; c. 1937: 9–11.

49. "Catalog of the exhibition." In: *Quintanilla: an exhibition of the war in Spain.* New York: The Museum of Modern Art; c. 1938 [4].

50. "Preface and Acknowledgement." In: *Masters of Popular Painting: Modern Primitives of Europe and America.* New York: The Museum of Modern Art; c. 1938: 9–11. New York: Arno Reprint; 1966.

51. "Tables chronologiques comparatives" and "Painting and Sculpture in the United States." In: *Trois siècles d'art aux États-Unis: exposition organisée en collaboration avec le Museum of Modern Art, New York: Musée du Jeu de Paume, Paris, 1938 Mai-Juillet.* Paris: Editions des Musées Nationaux; 1938: (xv–xvii), 18–31. [Note: AHB's piece also printed as "La peinture et la sculpture aux États-Unis," 1–17.]

52. "Preface" [and dust jacket]. In: Bayer, Herbert; Gropius, Walter; Gropius, lse, eds. *Bauhaus 1919–28.* New York: The Museum of Modern Art; c. 1938: 7–9; paperbound edition, 1975: 5–7. Second printing, Boston: Branford; 1952: 5–7. New York: Arno Reprint; 1972: 7–9.

53. A.H.B, Jr., co-ed. *Art in America: a complete survey.* With Holger Cahill. New York: Halcyon House; 1939 [c. 1934].

54. "'Art in Our Time': the plan of the exhibition." In: *Art in Our Time: an exhibition to celebrate the Tenth Anniversary of the Museum of Modern Art and the Opening of its new building held at the time of the New York World's Fair.* New York: The Museum of Modern Art; c. 1939: 13–15. New York: Arno Reprint; 1972.

55. *Picasso: Forty Years of his Art.* New York: Museum of Modern Art; c. 1939 (November). [In collaboration with The Art Institute of Chicago.] Second edition, revised; c. 1939 (December). Third edition, revised; c. 1939 (printed 1940 March). Fourth edition, revised; 1941.

56. "Preface" [and catalog notes and charts]. In: *Italian Masters lent by the Royal Italian Government.* New York: The Museum of Modern Art; c. 1940: 6–7 (passim). [Note: AHB "turned out this catalog in six days."]

57. "Report of the Director." In: *The Year's Work: Annual Report to the Board of Trustees and the Corporation Members of the Museum of Modern Art for the year June 30, 1939–July 1, 1940.* New York: The Museum of Modern Art; 1941: 9–11.

58. "Introduction." In: Klee, Paul; Barr, Alfred H., Jr.; Feininger, Julia and Lyonel; Sweeney, James Johnson. *Paul Klee.* New York: The Museum of Modern Art; c. 1941: 4–6. Second edition; Miller, Margaret, ed., revised and enlarged; c. 1945: 4–7. Third edition; c. 1946: 4–7. New York: Arno Reprint; 1968 (In: *Paul Klee: three exhibitions*). [Note: Second edition reprinted by Arno; see also Bibliography #10.]

59. [A.H.B., Jr.] *Paintings, Drawings, Prints by George Grosz.* New York: The Museum of Modern Art, Department of Circulating Exhibitions; [1941]: unpaginated.

60. "Report of the Director." In: *The Year's Work: Annual Report to the Board of Trustees and Members of the Museum of Modern Art for the year July 1, 1940–June 30, 1941.* New York: The Museum of Modern Art; 1941: [5–20].

61. "Foreword." In: Janis, Sidney. *They Taught Themselves: American Primitive Painters of the 20th Century.* New York: The Dial Press; c. 1942: xix–xx.

62. "Introduction" [and notes]. In: *Painting and Sculpture in the Museum of Modern Art.* New York: The Museum of Modern Art; c. 1942: 9–11 (passim).

63. A.H.B., Jr., co-ed. *American Realists and Magic Realists.* With Miller, Dorothy C. New York: The Museum of Modern Art; c. 1943. New York: Arno Reprint; 1969.

64. "Foreword." In: Kirstein, Lincoln. *The Latin-American Collection of the Museum of Modern Art.* New York: The Museum of Modern Art; 1943: 3–4.

65. "Preface." In: Soby, James Thrall; Miller, Dorothy C. *Romantic Painting in America.* New York: The Museum of Modern Art; c. 1943: 5–6.

66. *What Is Modern Painting?* New York: The Museum of Modern Art; c. 1943. [Introductory Series to the Modern Arts 2.] Second edition, 1945. Third edition, c. 1946. Fourth edition, 1949. Fifth edition, revised, c. 1952. Sixth edition, revised, 1956. Seventh edition, revised, 1959. Eighth edition, revised, 1963. Ninth edition, revised, 1966. Reprint edition, 1968, 1975, 1980. Foreign language editions: Japanese, 1953; Portuguese, 1953; Spanish, 1953. [Note: partially reprinted in Blair & Gerber. *Better Reading 1: Factual Prose: introduction to explanatory and persuasive writing.* Chicago: Scott, Foresman; fifth edition, c. 1963: 422–31.]

67. "Lyonel Feininger—American Artist." In: Miller, Dorothy C., ed. *Lyonel Feininger/Marsden Hartley.* New York: The Museum of Modern Art; c. 1944: 7–13. New York: Arno Reprint; 1966.

68. *George[s] Pierre Seurat: Fishing Fleet at Port-en-Bessin.* New York: Twin Editions; [n.d.]:[3] (The Nation's Great Paintings series.) [Note: pamphlet written in 1945 for distribution with a reproduction of the Museum's painting.]

69. [statement.] In: Bel Ami International Competition. *The Temptation of St. Anthony: . . . painting competition for the . . . Loewe-Lewin motion picture . . . Bel Ami.* Washington, DC: AFA: 1946; 3. [Note: AHB with Marcel Duchamp and Sidney Janis judged the competition; see also, *Arts and Architecture.* 63(4):31; 1946 April. Reprinted in German, Glozer, Laszlo. *Westkunst: Zeitgenössische Kunst seit 1939.* Cologne: Dumont; 1981: 109–110.]

70. *Picasso: Fifty years of his Art.* New York: The Museum of Modern Art; c. 1946. Second edition; 1955; first paperbound edition, 1974. New York: Arno Reprint; 1966. [Note: "Based on *Picasso: Forty Years* with new and greatly amplified text."]

71. "Introduction." In: Larrea, Juan. *Guernica/Pablo Picasso.* New York: Curt Valentin; c. 1947: 11–12.

72. A.H.B., Jr., American editor. Soby, James Thrall. *Ben Shahn.* West Drayton: Penguin; New York: Museum of Modern Art; 1947 (Penguin Modern Painters Series).

73. [tribute.] In: Norman, Dorothy, ed. *Stieglitz, Memorial Portfolio 1864–1946; 19 Reproductions of Photographs; Tribute—in Memoriam.* New York: Twice a Year Press; c. 1947: 19.

74. A.H.B., Jr., ed. "Introduction" and "Arrangement of the illustrations." In: *Painting and Sculpture in the Museum of Modern Art.* New York: The Museum of Modern Art; c. 1948: 7–12.

75. "Foreword." In: Hitchcock, Henry-Russell. *Painting Toward Architecture.* New York: Duell, Sloan & Pearce; c. 1948: 8–10.

76. A.H.B., Jr., American editor. Goodrich, Lloyd. *Edward Hopper.* West Drayton: Penguin; 1949 (Penguin Modern Painters Series).

77. "Moderna Kubanska Målare." In: *7 Kubanska Målare: 29 October–27 November 1949.* Stockholm: Liljevalchs Konsthall; 1949: 3–6. (Katalog NR 182). [Note: this is reprint in Swedish of Bibliography #164.]

78. [statement.] In: *Tenth Anniversary Exhibition: April 13–May 10, 1949.* Cincinnati, OH: The Cincinnati Modern Art Society; [1949]: [2].

79. "Problems of Research and Documentation in Contemporary Latin American Art." In: Wilder, Elizabeth, ed. *Studies in Latin American Art.* Proceedings of a conference held in The Museum of Modern Art, New York, 28–31 May 1945. Under the auspices of the Joint

Committee on Latin American Studies of the American Council of Learned Societies, the National Research Council and the Social Science Research Council. Washington, DC: American Council of Learned Societies; 1949: 37–43.

80. "Foreword," "Acknowledgements," "Early Futurism." In: Barr, Alfred H., Jr.; Soby, James Thrall. *Twentieth Century Italian Art.* New York: The Museum of Modern Art; c. 1949: 5, 6, 7–16. New York: Arno Reprint; 1972.

81. *A Statement on Modern Art.* Boston: ICA; NY: MoMA; NY: Whitney; 1950 March. [Note: Museum's Library includes annotated copy signed "AHB's paragraphs marked."]

82. [catalog notes.] "Umberto Boccioni," "Paul Gauguin," "Kasimir Malevich." In: *Collection of the Société Anonyme.* New Haven: Yale; 1950: 10, 37–38, 180.

83. "The Museum of Modern Art, New York." In: *The Museum of Modern Art, New York, Painting and Sculpture Collection.* Paris: Braun; 1950: unpaginated (Collection "Les Maîtres").

84. "Gorky, Pollock, de Kooning." In: *XXV Biennale di Venezia Catalogo.* Venice: Alfieri; 1950: 383–385. [Note: see also Bibliography #272 and #313.]

85. [catalog notes.] *Sheeler/Dove.* Houston, TX: Contemporary Arts Museum; [1951]: [verso of front cover]. [Note: AHB's remarks quoted in Dove catalogs of Andrew Dickson White Museum (Ithaca, NY), 1954, and Paul Kantor Gallery (Los Angeles, CA), 1956.]

86. *Matisse: His Art and His Public.* New York: The Museum of Modern Art; c. 1951 (regular and deluxe editions); paperbound edition (with additional plates); 1974. New York: Arno Reprint; 1966.

87. "Introduction" and "Chronology." In *Henri Matisse.* New York: The Museum of Modern Art; c. 1951; 3–8. [Note: chronology based on Bibliography #86.]

88. [statement.] "Artists' Sessions at Studio 35 (1950): the second day, April 22, 1950." In: *Modern Artists in America. First series.* New York: Wittenborn; [1951]: 14, 15, 16. [Note: AHB moderated this discussion.]

89. [letter.] In: Gallup, Donald, ed. *The Flowers of Friendship: letters written to Gertrude Stein.* New York: Alfred A. Knopf; c. 1953: 340. [Note: AHB tries to persuade Gertrude Stein to lend her portrait to 1939 MoMA Picasso exhibition.]

90. [foreword.] In: *Young Collectors: an exhibition of paintings lent by members of the Junior Council of the Museum of Modern Art at the Guest House of Mrs. John D. Rockefeller, 3rd, 242 East 52 Street, New York.* [New York: The Museum of Modern Art; 1954: unpaginated.]

91. "Introduction" and "Painting, Sculpture, Drawings, Print Collections." With Lieberman, William S. In: *Masters of Modern Art.* New York: The Museum of Modern Art; 1954: 9–10, 11–182. Second edition; 1955: 9–10, 11–182. Foreign language editions: French, c. 1955; German, c. 1956; Spanish, c. 1955; Swedish, 1956.

92. "Preface." In: Sachs, Paul J. *Modern Prints and Drawings: a guide to a better understanding of modern draughtsmanship.* New York: Alfred A. Knopf; c. 1954: unpaginated. [Note: correspondence in AHB Papers, MoMA Archives indicates AHB also served as editor of this publication although this is nowhere mentioned in text itself.]

93. "Foreword." In: Bernier, Georges and Rosamond, eds. *The Selective Eye: an anthology of the best from L'Oeil, the European art magazine.* New York: Random House; 1955: [5].

94. "Introduction." In: *Paintings from Private Collections: a twenty-fifth anniversary exhibition of The Museum of Modern Art, New York.* New York: The Museum of Modern Art; c. 1955: 3–5.

95. "Introduction." In: *Paintings from the Museum of Modern Art.* New York: The Metropolitan Museum of Art; c. 1956: [5]. *(The Metropolitan Museum of Art Miniatures. Series I: Cubism, Abstraction, Realism.)*

96. "Prefazione." In: Guggenheim, Peggy. *Una Collezionista Ricorda.* Venice: Cavallino; 1956: 9–13. [Note: originally entitled: *A Collection [sic] Remembers;* translation by Flavia Paulon.]

97. "Preface." In: Penrose, Roland. *Portrait of Picasso.* London: Lund Humphries for the Institute of Contemporary Arts; [1956]: 5–6. Second edition, revised and enlarged, 1971: 8–9. New York: The Museum of Modern Art; 1957: 6–7.

98. [statement.] In: *Masterpieces Recalled. A Loan Exhibition of 19th and 20th Century French Paintings for the benefit of the League for Emotionally Disturbed Children, Inc.* New York: Rosenberg; [1957]: unpaginated. (cat. no. 103). [Note: AHB's tribute to Paul Rosenberg on the occasion of his 75th birthday.]

99. [introduction.] In: *Catálogo general: IV Bienal do Museu de Arte Moderna de S. Paulo.* São Paulo: Museu de Arte Moderna; 1957: 193–194.

100. [preface.] *IV Bienal do Museu de Arte Moderna de São Paulo.* New York: The Museum of Modern Art; c. 1957: unpaginated. [Note: text identical to Bibliography #99 with addition of English translation.]

101. A.H.B., Jr., ed. *Picasso: 75th Anniversary Exhibition.* New York: The Museum of Modern Art; c. 1957.

102. "Inleiding." In: *Jong Amerika Schildert georganiseerd door het Museum of Modern Art, New York, onder auspicien van de International Council at the Museum. . . .* Amsterdam: Stedelijk Museum; [1958]: unpaginated (cat. no. 194).

103. [statement.] In: Cauman, Samuel. *The Living Museum: experiences of an art historian and museum director—Alexander Dorner.* New York: NYU; 1958: 108.

104. "Foreword." In: *Painting and Sculpture in the Museum of Modern Art: A Catalog.* New York: The Museum of Modern Art; 1958: 5–7.

105. "Introduction." In: *The New American Painting as shown in eight European countries 1958–1959.* New York: The Museum of Modern Art; 1959: 15–19. New York: Arno Reprint; 1972.

106. "Introduction." In: Guggenheim, Peggy. *Confessions of an Art Addict.* New York: Macmillan; London: Deutsch; 1960: 11–14. [Note: reprinted in Bibliography #138; see also Bibliography #137; translated as "Einführung." In: Guggenheim, Peggy. *Von Kunst besessen.* Munich: Kindler; c. 1962: 5–10.]

107. [introduction.] *Thompson Pittsburgh: Aus einer amerikanischen Privatsammlung.* Zurich: Kunsthaus; [1960]: unpaginated. [Note: text is in English.]

108. "Tinguely ex machina." In: *Homage to New York: a self-constructing and self-destroying work of art conceived and built by Jean Tinguely.* New York: The Museum of Modern Art; [1960].

109. [preface.] In: *La Collezione Peggy Guggenheim.* Florence: Il Cenacolo; [1960]: 7.

110. *De Stijl 1917–1928.* With Johnson, Philip C. New York: The Museum of Modern Art; 1961: 4, 6–15. [Note: this booklet is revised edition of Bibliography #171; text originally appeared in Bibliography #43.]

111. "Inleiding." In: *Collectie Thompson uit Pittsburgh.* The Hague: Haags Gemeentemuseum; [1961]: unpaginated. [Note: text is Dutch translation of Bibliography #107.]

112. "James Thrall Soby and his Collection." In: *The James Thrall Soby Collection of works of art pledged or given to The Museum of Modern Art: exhibited for the benefit of the Library of the Museum . . . as a contribution to the Museum's 30th Anniversary Fund [at] M. Knoedler . . . New York.* New York: The Museum of Modern Art; 1961: 15–20.

113. "Adele R. Levy and the Collection of the Museum of Modern Art." In: *The Mrs. Adele R. Levy Collection: A Memorial Exhibition.* New York: The Museum of Modern Art; [1961]: 7–8.

114. "Preface." In: *The Collection of Mr. and Mrs. Ben Heller.* New York: The Museum of Modern Art; c. 1961: unpaginated. [Note: exhibition organized by the Museum's Department of Circulating Exhibitions.]

115. "Comments." In: *Recent Acquisitions of Painting and Sculpture.* New York: The Museum of Modern Art; [1961]. [Note: AHB's remarks printed on verso of this broadside.]

116. [tribute.] In: *De collectie Sandberg.* Amsterdam: Meulenhoff; c. 1962: [5].

117. "Introduction." In: *Recent Painting USA: The Figure.* New York: The Museum of Modern Art; c. 1962: unpaginated.

118. [statement.] In: *Proceedings of the First International Congress of African Culture: 1–11 August 1962.* The National Gallery: Salisbury, Rhodesia: 15–16. [Note: the formally printed 145-page text is available in the Museum Library; final publication by The National Gallery of Zimbabwe is pending.]

119. [statements.] In: *Architecture 1918–1928: from the Novembergruppe to the C.I.A.M. (Functionalism and Expressionism).* Proceedings: Modern Architecture Symposium, Columbia University, 1962 May 4 and 5. New York: Columbia University; 1963: 24–25, 29, 30.

120. [statement.] In: "Foreword." *Modern Paintings Drawings and Sculptures from the Larry Aldrich Collection.* New York: Parke-Bernet Galleries; 1963: unpaginated (Sale number 2220).

121. [essay.] In: *Otto Dix: Ölgemälde 1913–1963, Aquarelle, Das graphische Werk.* Kongresshalle Berlin. Berlin: Bezirksamt Tiergarten, Abr. Volksbildung, Amt für Kunst; [1963]: unpaginated. [Note: this is German translation of Bibliography #209.]

122. "Introduction." In: *Paintings from the Museum of Modern Art, New York.* Washington, DC: H. K. Press; 1963: 7–8.

123. [statement.] In: *Artist and Maecenas: Inaugural Exhibition.* New York: Marlborough-Gerson Gallery; [1963]: 15. [Note: AHB's tribute to Curt Valentin.]

124. *Oelze.* Hanover: Kestner-Gesellschaft; c. 1964: unpaginated. (Katalog 1 Ausstellungsjahr 1964/65.)

125. "Witness." In: Millstein, Gilbert, editor. *New York: True North.* New York: Doubleday; 1964: 179–182.

126. "Preface." In: Barr, Alfred H., Jr.; Soby, James Thrall; Lippard, Lucy. *The School of Paris: Paintings from the Florene May Schoenborn and Samuel A. Marx Collection.* New York: The Museum of Modern Art; c. 1965: [4–5].

127. "Foreword." In: *The Collection of twentieth century paintings and sculptures formed by the late G. David Thompson of Pittsburgh, Pennsylvania.* New York: Parke-Bernet Galleries, Inc.; 1966: unpaginated (Sale number 2420). [Note: text adapted from Bibliography #107.]

128. [statement.] In: *A Tribute.* New York: The Museum of Modern Art; [1968]: unpaginated. [Note: brochure published on the occasion of memorial ceremony for René d'Harnoncourt in Museum's Sculpture Garden, 8 October 1968.]

129. *The Sidney and Harriet Janis Collection: A Gift to the Museum of Modern Art.* New York: The Museum of Modern Art; 1968: 1–5.

130. [introduction.] In: *Sidney and Harriet Janis Collection; an exhibition circulated under the auspices of the International Council of the Museum of Modern Art, New York.* Basel: Kunsthalle; Berlin: Akademie der Künste; Nuremberg: Kunsthalle; [1970]: unpaginated. [Note: text is German translation of Bibliography #129.]

131. [introduction.] In: *Vom surrealismus bis zur Pop-Art: 100 Werke aus dem Museum of Modern Art New York (Sidney and Harriet Janis Collection); an exhibition circulated under the auspices of the International Council of the Museum of Modern Art, New York.* Cologne: Kunsthalle; Stuttgart: Württembergischer Kunstverein; [1970]: unpaginated. [Note: text is German translation of Bibliography #129.]

132. "Foreword." In: *Three Generations of Twentieth-Century Art: the Sidney and Harriet Janis Collection.* New York: The Museum of Modern Art; 1972: ix–xi. [Note: text reprinted from Bibliography #129.]

133. "In Remembrance of Feininger (1956)." In: Ness, June L., ed. *Lyonel Feininger.* New York: Praeger; c. 1974: 252–255. (Documentary Monographs in Modern Art.)

134. [quotations from *Cubism and Abstract Art, Masters of Modern Art, Matisse: His Art and His Public, Picasso: Fifty years of his art.*] In: Lieberman, William S., ed. *Modern Masters: Monet*

to Matisse. New York: The Museum of Modern Art; [1975]: 66, 86, 90, 98, 100, 102, 172, 242.

135. [statement.] In: Lipman, Jean. *Calder's Universe.* New York: Viking; c. 1976: 26.

136. *Painting and Sculpture in the Museum of Modern Art: 1929–1967.* New York: The Museum of Modern Art; c. 1977.

137. "Introduction." In: Guggenheim, Peggy. *Out of this Century: Confessions of an art addict.* New York: Universe; 1979: xv–xviii. [Note: this was reprinted from Bibliography #106.]

138. [preface.] In: *The Peggy Guggenheim Collection: Venice.* Publisher unknown; [printed 1979]: unpaginated. [Note: AHB's piece was adapted from Bibliography #106.]

139. [quotations from *Collection of the Société Anonyme* (catalog notes), *Masters of Modern Art, Matisse: His Art and His Public, MoMA Bulletin* 24(4), 1957 Summer and "Unpublished notes."] In: Lieberman, William S., ed. *Modern Masters: European Paintings from The Museum of Modern Art.* New York: The Metropolitan Museum of Art; c. 1980: 13–14, 25–27, 28, 33–34, 36–38, 40, 47, 54–55, 56, 57–58, 60, 71–72, 74, 80.

140. "On Nelson Rockefeller and modern art." In: Miller, Dorothy C., ed. *The Nelson A. Rockefeller Collection: Masterpieces of Modern Art.* New York: Hudson Hills; c. 1981: 20–26. [Note: written ca. 1970–71; typescript in AHB Papers, MoMA Archives.]

II. THE BULLETIN OF THE MUSEUM OF MODERN ART

[The following can also be found in *The Bulletin of the Museum of Modern Art.* New York: Arno Reprint; 1959: I–VIII.]

141. "Cablegram" from Stuttgart, May 28, 1933. *The Bulletin of the Museum of Modern Art.* 1(1): [1]; 1933 June.

142. "Summer Show." *The Bulletin of the Museum of Modern Art.* 1(2): [1–2, 4]; 1933 October.

143. "Book Comment." (Review of *Vincent van Gogh* by Julius Meier-Graefe.) *The Bulletin of the Museum of Modern Art.* 1(4): [4]; 1933 December.

144. "Book Comment." (Review of *Art Now* by Herbert Read.) *The Bulletin of the Museum of Modern Art.* 1(7): [3]; 1934 March 1.

145. "Comments on the Bliss Collection . . . Alfred H. Barr, Jr." *The Bulletin of the Museum of Modern Art.* 1(8): [4]; 1934 April 1.

146. "Modern and 'Modern.' " *The Bulletin of the Museum of Modern Art.* 1(9): 2, 4; 1934 May. [Note: reprinted elsewhere, see Bibliography #226, #227, and #228.]

147. "Resignation of Mr. Blackburn and Mr. Johnson." With A. Conger Goodyear. *The Bulletin of the Museum of Modern Art.* 2(4): [2]; 1935 January.

148. "Book Notes." (Reviews of *America and Alfred Stieglitz*, collective authors, and *Expressionism in Art* by Sheldon Cheney.) *The Bulletin of the Museum of Modern Art.* 2(5): [2]; 1935 February.

149. "Antiquity of African Sculpture." *The Bulletin of the Museum of Modern Art.* 2(6/7): [3]; 1935 March/April.

150. "Book Notes." (Reviews of *Arts of West Africa*, Michael E. Sadler, ed.; *Handbuch der Afrikanischen Plastik*, Vol. 1, by Eckhart von Sydow; *Kunst der Naturvölker; Sammlung Eduard von der Heydt* by Eckhart von Sydow.) *The Bulletin of the Museum of Modern Art.* 2(6/7): [6]; 1935 March/April.

151. [introduction.] "Dada and Surrealism: Essays by Georges Hugnet." *The Bulletin of the Museum of Modern Art.* 4(2/3): 2; 1936 November/December.

152. [footnote.] "Gifts of the Advisory Committee" by George L. K. Morris. *The Bulletin of the Museum of Modern Art.* 4(6): 5; 1937 July.

153. [statement.] "The Mirror, by Picasso." *The Bulletin of the Museum of Modern Art.* 5(2): 8; 1938 February.

154. "Foreword" to "Exhibition of American Art in Paris." *The Bulletin of the Museum of Modern Art.* 5(4/5): 2–3; 1938 April/May.

155. [A.H.B., Jr.] "American Art and the Museum." *Bulletin of the Museum of Modern Art.* 8(1): 3–4, (passim) 1940 November.

156. "The New Department of Photography." *The Bulletin of the Museum of Modern Art.* 8(2): 3; 1940 December/1941 January. [Note: distributed as the catalog for MoMA exhibition no. 121, *Sixty Photographs: A Survey of Camera Esthetics.*]

157. "A Gift of Paintings from a Trustee." *The Bulletin of the Museum of Modern Art.* 8(4): 3; 1941 April/May.

158. "New Acquisitions: Exhibition Notes." *The Bulletin of the Museum of Modern Art.* 9(2): 2–8; 1941 November. [Note: this entry comprises Bibliography #159, #160, and #161.]

159. "Ensor's 'St. Anthony' and other Recent Acquisitions." *The Bulletin of the Museum of Modern Art.* 9(2): 4–5; 1941 November.

160. "The Museum Collection, Gallery I—Modern Primitives, artists of the people." *The Bulletin of the Museum of Modern Art.* 9(2): 6–8; 1941 November.

161. "Van Gogh's 'Starry Night.' " *The Bulletin of the Museum of Modern Art.* 9(2): 2–3; 1941 November.

162. [A.H.B., Jr.] "The Museum Collection. . . ." *The Bulletin of the Museum of Modern Art.* 10(1): unpaginated; 1942 October/November.

163. [introduction.] "Museum of Modern Art Annex: Photography Center." *Bulletin of the Museum of Modern Art.* 11(2): 2–4; 1943 October/November.

164. "Modern Cuban Painters." *Museum of Modern Art Bulletin.* 11(5): 2–14; 1944 April. [Note: reprinted elsewhere, see Bibliography #77, #245, and #246.]

165. "Picasso 1940–1944: a digest with notes." *The Museum of Modern Art Bulletin.* 12(3): 2–9; 1945 January.

166. [introduction.] Groth, John. "Picasso at work, August 1944." *The Museum of Modern Art Bulletin.* 12(3): 10; 1945 January.

167. "Postscripts to 'Picasso 1940–44.' " *The Museum of Modern Art Bulletin.* 12(4): 15; 1945 Spring.

168. "What is happening to Modern Architecture? A Symposium at the Museum of Modern Art." *The Museum of Modern Art Bulletin.* 15(3): 5–8, 21; 1948 Spring.

169. "Modern Prints and the Museum." *The Museum of Modern Art Bulletin.* 16(4): 4–8; 1949. [Note: distributed as the catalog for MoMA exhibition no. 410, *Master Prints from the Museum Collection.*]

170. "Painting and Sculpture Acquisitions from January 1, 1948 to July 1, 1949: a supplement to the catalog *Painting and Sculpture in the Museum of Modern Art,* New York, 1948." *The Museum of Modern Art Bulletin.* 17(2/3): 3 (passim); 1950.

171. "De Stijl." *The Museum of Modern Art Bulletin.* 20(2): 4, 7–13; 1952–1953 Winter. [Note: issued on the occasion of MoMA exhibition no. 527; text adapted from Bibliography #43; see also Bibliography #110.]

172. "Painting and Sculpture Collections, July 1, 1951 to May 31, 1953: An Important change of Policy." *The Museum of Modern Art Bulletin.* 20(3/4): 3–5 (passim); 1953 Summer.

173. "Introduction" [to] "Paintings from Private Collections: Six Important Gifts." *The Museum of Modern Art Bulletin.* 22(4): 3–4; 1955 Summer.

174. "Painting and Sculpture Acquisitions, June 1, 1953 through June 30, 1955." *Museum of Modern Art Bulletin.* 23(3): 3–4; 1956.

175. "Painting and Sculpture Collection, July 1, 1955 to December 31, 1956." *Museum of Modern Art Bulletin.* 24(4): 3–5; 1957 Summer.

176. "The Philip L. Goodwin Collection." *The Museum of Modern Art Bulletin.* 26(1): 4; 1958 Fall.

177. "Works of Art: Given or Promised." *The Museum of Modern Art Bulletin.* 26(1): 12 (passim); 1958 Fall.

178. "Painting and Sculpture Acquisitions, 1960." *The Museum of Modern Art Bulletin.* 28(2/3/4): 3–7; [1961].

179. "Painting and Sculpture Acquisitions, January 1, 1961 through December 31, 1961." *The Museum of Modern Art Bulletin.* 29(2/3): 3–8; 1962.

180. "Painting and Sculpture Collection, 1962." *The Museum of Modern Art Bulletin.* 30(2/3): 3–6; 1963.

III. PERIODICALS: MAGAZINES, JOURNALS, NEWSPAPERS

180a. "Java Head." (Review of *Java Head* by Joseph Hergesheimer.) *The Nassau Literary Magazine.* 75(1): 54–55; 1919 June (Princeton, NJ).

180b. "The Junior Mansfield Trip." *The Shadfly.* 15(3): 1, 4; 1921 August 13 (Kamp Kill Kare, St. Albans Bay, VT).

181. "Plastic Values." (Review of *The Art in Painting* by Albert C. Barnes.) *The Saturday Review of Literature.* 2(52): 948; 1926 July 24.

182. [A.H.B., Jr.] "The New Books." (Review of *Artist's Life in London and Paris 1870–1924* by A. Ludovici.) *The Saturday Review of Literature.* 3(2): 211; 1926 October 16.

183. "Boston is Modern Art Pauper." *The Harvard Crimson.* 80(32): 1; 1926 October 30 (Cambridge, MA). [Note: partially reprinted in *Boston Evening Globe* (1926 October 30; Sect. 1: 3) and *Boston Evening Transcript* (1926 November 3; Sect. 2: 10); referred to in *Boston Daily Globe* (1926 November 4; Sect. 1: 20), *The Art News* (1926 November 27), *Arts* (1926 December) editorials; cited in *Boston Evening Transcript* (1926 November 6; Sect. 6: 8); criticized in *Boston Herald* (1926 November 13; Sect. B: 12); see also Bibliography #186.]

184. "Modern Painting." (Review of *Evolution in Modern Art* by Frank Rutter.) *The Saturday Review of Literature.* 3(14): 252; 1926 October 30.

185. [A.H.B., Jr.] "The New Books." (Review of *Fifty Famous Painters* by Henriette Serwig.) *The Saturday Review of Literature.* 3(17): 319; 1926 November 20.

186. [letter to the editor.] *The Art News.* 25(11): 8; 1926 December 18. [Note: AHB refers to Bibliography #183 in this letter.]

187. "The Exhibition of Modern Art." *Wellesley College News.* 35(24): 5; 1927 April 21. [Note: AHB comments on exhibition he organized; see Bibliography #2.]

188. [A.H.B., Jr.] "Wellesley and Modernism." *Boston Evening Transcript.* 1927 April 27; Sect. 1: 10. [Note: unsigned but attributed to AHB by one of his colleagues who was also one of his students at the time.]

189. "A Modern Art Questionnaire." *Vanity Fair.* 28(6): 85, 96, 98; 1927 August.

190. "American Painting." (Review of *A Collection in the Making* by Duncan Phillips.) *The Saturday Review of Literature.* 4(7): 99; 1927 September 10.

191. "Dutch letter." *The Arts.* 13(1): 48–49; 1928 January.

192. "Za grantsei: Ruki." (Abroad: Hands). *Sovetskoe Kino.* (1): 26–27; 1928. (Moscow). [Note: this article referred to in Bibliography #335, p. 54, footnote.]

———. [Note: Bibliography #335 also written at this date.]

193. "The Necco Factory." *The Arts.* 13(5): 292–295; 1928 May.

194. "The Researches of Eisenstein." *Drawing and Design.* 4(24): 155–156; 1928 June.

195. "Modern Art in London Museums." *The Arts.* 14(4): 187–194; 1928 October.

196. "The 'LEF' and Soviet Art." *Transition.* 13/14(14): 267–270. 1928 Fall. (Paris). New York: Kraus Reprint; 1967.

197. "Sergei Michailovitch Eisenstein." *The Arts.* 14(6): 316–321; 1928 December.

198. "Notes on Russian Architecture." *The Arts.* 15(2): 103–106, 144, 146; 1929 February.

199. "Contemporary Art at Harvard." *The Arts.* 15(4): 265–268; 1929 April.

200. "Understanding Modern Art." *Wellesley Alumnae Magazine.* 13(5): 304–305; 1929 June. [Note: AHB referred to this, in 1933 correspondence, as a "bibliography."]

201. "Disputed Points on Dutch Art." (Review of *An Introduction to Dutch Art* by R. H. Wilenski.) *International Studio.* 94(388): 71–72; 1929 September.

202. "A New Museum which will devote itself to the Masters of Modern Art." *Vogue.* 74(9): 85, 108; 1929 October 26.

203. "An American Museum of Modern Art." *Vanity Fair.* 33(3): 79, 136; 1929 November.

204. "Museum." *Charm: the magazine of New Jersey home interests.* 12(4): 15–17, 79, 84–85; 1929 November (Newark, NJ: Bamberger & Co.).

205. "The Museum of Modern Art." *The Art News.* 28(14): 13; 1930 January 4.

206. [letter to the editor.] "We stand corrected." *The New Yorker.* 5(46): 76; 1930 January 4. [Note: AHB corrects erroneous statements about MoMA which appeared in 1929 November 30 *The New Yorker.*]

207. "Modern Art." *The Wellesley College Literary Review.* 4(3): 5–6; 1930 February. (Wellesley, MA). [Note: AHB discusses four paintings from MoMA's 1930 *Painting in Paris* exhibition.]

208. "Modern Architecture." (Review of *Modern Architecture* by Henry-Russell Hitchcock, Jr.) *The Hound & Horn.* 30(3): 431–435; 1930 April/June.

209. "Otto Dix." *The Arts.* 17(4): 234–251; 1931 January. [Note: written in June 1929; reprinted in German, see Bibliography #121.]

210. "Russian Icons." *The Arts.* 17(5): 296–313, 355–362; 1931 February. (Reprint edition: American Russian Institute [1931].) [Note: in letter of 1934 AHB referred to this article as a "popular essay" as opposed to "a scholarly endeavor."]

211. [letter to the editor.] "The Pros and Cons: Alfred H. Barr, Jr., The Museum of Modern Art's Director, Replies to Robert Macbeth." *The New York Times.* 1931 March 29; Sect. 8: 12.

212. "Postwar Painting in Europe." *Parnassus.* 3(5): 20–22; 1931 May. [Note: paper read at 20th annual meeting of College Art Association.]

213. "Deutsche Kunst in New York: Ein Rückblick." *Museum der Gegenwart.* 2(1): 1–6; 1931 Zweites Vierteljahr (Berlin).

214. "Die Wirkung der Deutschen Ausstellung in New York." *Museum der Gegenwart.* 2(2): 58–75; 1931 Drittes Vierteljahr (Berlin).

215. [letter to the editor.] "Contemporary Art." *The Harvard Crimson.* 100(36): 2; 1931 December 11 (Cambridge, MA). [Note: AHB encourages support of the Harvard Society for Contemporary Art.]

216. "Paul Klee." *Omnibus.* 1931: 206–209. (Berlin). [Note: reprint of Bibliography #10.]

217. "Notes: The Museum of Modern Art." *Bulletin of the Garden Club of America.* Number 19: 125–126; 1932 January (Fourth series). [Note: AHB provided notes for this article, many of which were used verbatim.]

218. "German Sculpture." *Omnibus.* 1932: 38–52. (Berlin). [Note: reprints parts of Bibliography #16.]

219. "A Brief Survey of Modern Painting." *The Carnegie Magazine.* 6(10): 308–313; 1933 March. (Pittsburgh, PA). [Note: reprint of Bibliography #23, "Preface".]

220. "Who's Crazy Now?" *Park Avenue Social Review.* 9(11): 10–11, 34; 1933 November.

221. "Painter, Mystic (van Gogh)." *Wings.* 7(12): 13–15, 26; 1933 December.

222. [letter to the editor.] *The New Republic.* 77(992): 104–105; 1933 December 6. [Note: AHB defends works of Edward Hopper and criticizes Ralph Pearson's definition of "modern."]

223. "Notes on the Film: Nationalism in German Films." *The Hound & Horn.* 7(2): 278–283; 1934 January/March. [Note: written at same time as Bibliography #253.]

224. ["... letter to Farley," 9 May 1934.] "Museum protests 'Whistler' Stamp." *The New York Times.* 1934 May 10; Sect. 1: 19.

225. "Alumnus narrates old life at 'Dunham': Reminiscences." *The Ink Well.* 18(8): 12, 22; 1934 June. (Boys' Latin School, Baltimore, MD).

226. "Moderno y 'moderno.'" *Gaceta de Arte.* 3(27): 1; 1934 junio. (Tenerife, Canary Islands). [Note: Spanish translation of Bibliography #146.]

227. "Modern & 'Modern.'" *Art Digest.* 8(19): 6; 1934 August. [Note: reprint of Bibliography #146.]

228. "Modern and 'Modern.'" *Design.* 36(8): 26; 1935 February (Columbus, OH). [Note: reprint of Bibliography #146.]

229. "Surrealists and Neo-Romantics." (Review of *After Picasso* by James Thrall Soby). *The Saturday Review of Literature.* 12(20): 6; 1935 September 14.

230. "Vincent van Gogh: Why the sudden popularity of his paintings." *The World Today: Encyclopaedia Britannica.* 3(4): 7–8; 1936 April.
————. [Note: Bibliography #337 also written at this date.]

231. AHB, Jr., ed. "Cézanne d'après les lettres de Marion à Morstatt 1865–1868." *Gazette des Beaux-Arts.* 17: 37–58; 1937 January (79 année, 6 période—Tome 17). [Note: see Bibliography #234.]

232. [letter to the editor, 16 February 1937.] "What is Modern Art?" *The Carnegie Magazine.* 10(10): 290, 306; 1937 March. (Pittsburgh, PA).

233. "Surrealism: What it is in literature and art; its origin and its future." *The World Today: Encyclopaedia Britannica.* 4(4): 3–5; 1937 April.

234. AHB, Jr., ed. "Cézanne in the letters of Marion to Morstatt, 1865–1868." Translated by Margaret Scolari with notes by Alfred H. Barr, Jr. *Magazine of Art.* 31(2): 84–89; 1938 February; (4): 220–225; 1938 April; (5): 288–290; 1938 May. [Note: see Bibliography #231.]

235. "The Museum of Modern Art." *Fortune.* 18(6): 73–[76], 127–128, 131–134; 1938 December.

236. "Popular Appreciation of Art." *Think: a survey of new things and thoughts in the world of affairs.* 6(5): 16–17, 33; 1940 May. [Note: discussion of MoMA's 1940 exhibition, *Italian Masters* (1400–1800).]

237. "Modern Art makes History, too." *College Art Journal.* 1(1): 3–6; 1941 November. [Note: excerpts from this reprinted in *The Art Digest.* 16(6): 14; 1941 December 15.]

238. "What we are fighting for: what have the arts to do with the war effort?" *PM Daily.* 1942 June 10; Sect. 1: 12.

239. [letter to the editor.] "Miró is an Artist." *The Miami Daily News.* 47(198): 4; 1942 June 27. [Note: AHB's response to uninformed criticism of MoMA's exhibition and book.]

240. "Mexican Painting Today: a portfolio of pictures from the exhibition at the Philadelphia Museum of Art, March 27–May 9, 1943." *Magazine of Art.* 36(5): 168–171; 1943 May. [Note: AHB selected this portfolio and is quoted in the introduction.]

241. [letter to the editor.] "The Master of the Two Left Feet Steps on Sundry Aesthetic Toes: the Museum Explains." *The Art Digest.* 17(19): 16; 1943 August 1. [Note: AHB's response to criticism of MoMA's Morris Hirshfield exhibition.]

242. "Foreword." O'Gorman, Juan: "Velazco: Painter of our Time and Space." *Magazine of Art.* 36(6): 202; 1943 October.

243. "Memorial Service." *Knickerbocker Weekly.* 3(51): 23; 1944 February 14. [Note: excerpts from eulogy delivered by AHB at Mondrian's funeral, 1944 February 3.]

244. "A Statement on the Place of the History of Art in the Liberal Arts Curriculum." *College Art Journal.* 3(3): 82–87; 1944 March. [Note: statement jointly signed by a Committee of the College Art Association which included Millard Meiss, Chairman, Walter W. S. Cook, Sirarpie Der Nersessian, George Kubler, Rensselaer W. Lee, Ulrich Middeldorf, C. R.

Morey, Erwin Panofsky, Stephen Pepper, Chandler R. Post, Agnes Rindge, Paul J. Sachs, Meyer Schapiro, and Clarence H. Ward.]

245. "La Pintura cubana." *Ultra: cultura contemporánea.* 15(93): 250; 1944 mayo (Havana). [Note: translation of Bibliography #164.]

246. "Pintura cubana en Nueva York." *Norte.* 4(9): 24–25, 44–45; 1944 julio. (NY). [Note: translation of Bibliography #164.]

247. [letter to the editor.] *Gaceta del Caribe.* 1944 agosto. (Havana). [Note: AHB comments on Cuban painting.]

248. "The American Art Research Council and the Colleges." *College Art Journal.* 4(1): 39–43; 1944 November.

249. "Drie eeuwen van schilderkunst in de Vereenigde Staten." *'t Venster.* 1(4): 63–70; 1945 1e Jaargang. [Note: this is Dutch version of Bibliography #250 and #256; all were written for the U.S. Office of War Information (OWI).]

250. "La Peinture aux États-Unis." *Choix.* 8: 63–68; [1945]. (OWI: Washington, DC). [Note: see Bibliography #249.]

251. "Foreword." Russell, John: "John Piper." *Magazine of Art.* 38(4): 144; 1945 April.

252. "The Study of American Art in Colleges: A Preface." *College Art Journal.* 4(4): 179–181; 1945 May.

253. "Art in the Third Reich—Preview, 1933." *Magazine of Art.* 38(6): 212–222; 1945 October. [Note: this was "written at Ascona, Switzerland, May 1933, after four months in Stuttgart"; see also Bibliography #223.]

254. "Research and Publication in Art Museums." *The Museum News.* 23(13): 6–8; 1946 January 1.

255. [letter to the editor.] "Free Speech." *The Wheaton News.* 24(15): 2; 1946 February 2. (Norton, MA). [Note: AHB discusses the "Wheaton Competition" held to encourage architectural excellence on college campuses.]

256. "Tre Aarhundredens Malerkunst: U.S.A." *I·Dag og I Morgen.* 5: 61–66; [1946] (OWI: Washington, DC). [Note: see Bibliography #249.]

257. "The Bull by Picasso." *Magazine of Art.* 40(4): 154–155; 1947 April.

258. [letter to the editor.] "The Gentle Art. . . ." *The Calendar of the Art Council of New Jersey.* 1(1): 2; 1947 April 1. (Newark, NJ). [Note: concerns Malevich's *Suprematist Composition: White on White.*]

259. "What is Modern Painting?" *The Agnes Scott Alumnae Quarterly.* 25(2): 6–14; 1947 April. (Decatur, GA). [Note: this piece was adapted from Bibliography #66, third edition.]

260. [letter to the editor.] *Art News.* 46(7): 6; 1947 September. [Note: AHB comments on pied-billed grebe.]

261. "Modern Drawings." *Art News.* 46(7): 24–25; 1947 September.

262. [letter to the editor.] "Psychoanalysis and Picasso." *College Art Journal.* 7(3): 220; 1948 Spring. [Note: AHB questions usefulness of Dr. Daniel E. Schneider's interpretation, "The Painting of Pablo Picasso: A Psychoanalytic Study" (*CAJ* 7(2): 81–95; 1947–48 Winter).]

263. [letter to the editor.] "Picasso and Poetry." *The Atlantic Monthly.* 181(5): (22); 1948 May.

264. [letter to the editor.] "Catlin as Artist." *New York Herald Tribune Book Review.* 1949 January 2; Sect. 7: 14. [Note: in addition to AHB this letter was signed by John I. H. Baur, Holger Cahill, Lloyd Goodrich, and Dorothy C. Miller.]

265. [statement.] "A Symposium: The State of American Art." *Magazine of Art.* 42(3): 85; 1949 March.

266. "It Can Happen Here." *The Art Digest.* 23(19): 3, 23; 1949 August 1. [Note: AHB's "message" about the Dondero controversy; contents partially reprinted in *American Artist* 13(8): 38, 64–67; 1949 October.]

267. [letter to the editor.] *Art News.* 48(6): 6; 1949 September. [Note: AHB praises *Art News* for its editorial criticism of Congressman Dondero.]

268. [letter to the editor.] "In Defense of Kokoschka." *The Art Digest.* 24(1): 4, 22; 1949 October 1.

269. [statement.] "A Symposium on the Statue Project: sponsored by the Liturgical Arts Society; held at the Demotte Gallery, New York City, February 8, 1949." *Liturgical Arts.* 18(1): 21, 22; 1949 November. [Note: AHB on modern religious art.]

270. "Scambio di lettere." *Domus.* 6(237): XIII; 1949. (Milan). [Note: an exchange of letters between AHB and Gio Ponti, publisher of *Domus,* concerning Bibliography #80 with special emphasis on the Museum's collection of Italian painting.]

271. [letter to the editor.] "A Lighthouse for the Literary." *The Saturday Review of Literature.* 33(23): 24; 1950 August 19. [Note: AHB questions the validity of psychoanalytical interpretations of art works, assails *Saturday Review*'s practice of cropping illustrations, and praises the Soby art columns.]

272. "7 Americans open in Venice: Gorky, De Kooning, Pollock." *Art News.* 49(4): 22–23, 60; 1950 Summer. [Note: this text is identical to Bibliography #84 "Preface."]

273. "Modernism and Impressionism." *Richmond Times Dispatch.* 100(329): 6; 1950 November 25. (Richmond, VA).
———. [Note: Bibliography #336 also written at this date.]

274. "Letter to the editor." *College Art Journal.* 10(1): 57–59; 1950 Fall. [Note: AHB discusses the history of the aesthetic revaluation of primitive art, citing the active participation of the Museum and others in this area.]

275. "Notes on the Ames demonstrations/art and perception." *trans/formation: arts, communication, environment; a world review.* 1(1): 8–9; c. 1950. [Note: "from a report to a committee of the Museum . . . on the laboratory demonstrations of the Hanover Institute Division of the Institute for Associated Research (formerly known as the Dartmouth Eye Institute)."]

276. [letter to the editor.] " 'The Miracle'; Catholic layman protests ban on film." *New York Herald Tribune.* 1951 January 30; Sect. I: 18. [Note: AHB refers to an article on film censorship by Otto L. Spaeth.]

277. [letter to the editor.] "Classic Column." *New York Post.* 1951 February 6; [Sect. 2]: 27. [Note: AHB praises *NY Post* for initiating an art column in its weekend edition.]

278. [letter to the editor.] "The Loyalty Oath." *Princeton Alumni Weekly.* 51(22): 3; 1951 April 13. [Note: AHB denounces suggestion that Princeton impose loyalty oath on its faculty.]

279. "Masters in the World of Line." (Review of *The Pocketbook of Great Drawings* by Paul J. Sachs). *New York Herald Tribune Book Review.* 1951 April 15; Sect. 6: 12.

280. [letter to the editor.] *College Art Journal.* 10(3): 272; 1951 Spring. [Note: AHB identifies an early (1920) exhibition of "primitive art."]

281. [letter to the editor.] *Magazine of Art.* 44(5): 194; 1951 May. [Note: AHB denounces censorship of films in general and Rossellini's *Miracle* in particular.]

282. "Matisse, Picasso, and the Crisis of 1907." *Magazine of Art.* 44(5): 163–170; 1951 May. ["Note: this article based on two chapters from forthcoming book on Matisse. . . ."]

283. [letter to the editor.] *Art News.* 51(1): 6; 1952 March. [Note: AHB thanks Thomas B. Hess for kind words about Guggenheim Fund purchases, but modestly insists he is not the only one responsible for acquisitions chosen by this means.]

284. [poem.] "Kiesler's *Galaxy.*" *Harper's Bazaar.* Issue no. 2885: 142–143; 1952 April. [Note: tape of AHB reading this poem given to MoMA by Maryette Charlton.]

285. [letter to the editor.] *Art News.* 51(4): 6; 1952 Summer. (June/July/August). [Note: AHB briefly reviews his relationship with Dr. Albert Barnes and the Barnes Foundation.]

286. [letter to the editor.] "Britain at the Biennale." *The Manchester Guardian.* 1952 September 3; 4. (Reprinted in *The Manchester Guardian Weekly.* 67[11]: 13; 1952 September 11). [Note: AHB praises British sculpture entry in Biennale.]

287. "Is Modern Art Communistic?" *The New York Times Magazine.* 1952 December 14; Sect. 6: 22–23, 28–30.

288. [letter to the editor.] "And Picasso." *National Sculpture Review.* 2(1): 5; 1952 Christmas. [Note: AHB comments on Papini's "spurious" Picasso "confession"; see also Bibliography #325, #328, and #334.]

289. "¿Es el arte moderno comunista?" *Noticias de Arte.* 1(6): 6–7, 15, illus.; 1953 febrero. (Havana). [Note: reprint, in Spanish, of Bibliography #287.]

290. [letter to the editor.] "Russia and the arts: abstraction declared the bane of Communists." *New York Herald Tribune.* 1953 March 5; Sect. 1: 22.

291. [letter to the editor.] "City's resort for wild fowl: Central Park reservoir is host to many varieties." *New York Herald Tribune.* 1953 March 26; Sect. 1: 22.

292. [statement.] *Retailing Daily: the Home Furnishings Newspaper.* 1953 April 13; Sect. 1: 9. [Note: AHB criticizes "preposterous" idea, expressed in 1953 April *House Beautiful,* that "foreign influence" on our architecture and furniture constitutes a threat to America's future.]

293. [letter to the editor.] "Threat or Mare's-nest?" *Progressive Architecture.* 34(6): 9–10; 1953 June. [Note: reprint of Bibliography #292.]

294. [letter to the editor.] "Let's include everybody in." *House and Home.* 4(3): 66; 1953 September. [Note: AHB states that evaluating modern architecture need not involve political or social considerations.]

295. [letter to the editor.] "Age of Mammals." *Life.* 35(19): 12; 1953 November 9. [Note: AHB questions color of mammoth that appeared on a *Life* cover.]

296. [letter to the editor.] "Points to flaws in editor's art test." *The Hunterdon County Democrat.* 127(40): 5; 1954 March 11. (Flemington, NJ).

297. "Mrs. Cresson Draws Fire." *American Artist.* 19(1): 13, 55–56; 1955 January. [Note: AHB strongly refutes Mrs. Cresson's notion (*American Artist.* 18[9]: 16; 1954 November) that modern art is a Communist "weapon" or "instrument of subversion."]

298. [letter to the editor.] *Art News.* 53(9): 6; 1955 January. [Note: AHB replies to articles by Henry McBride and Thomas B. Hess on the occasion of the Museum's twenty-fifth anniversary.]

299. [letter to the editor.] "Izaak Walton." *New York Herald Tribune Book Review.* 1955 July 31; Sect. 6: 8. [Note: inquiry as to whereabouts of a Walton portrait; reprinted in *Art in America.* 43(3): 67; 1955 October.]

300. "When Matisse died. . . . " *The Yale Literary Magazine.* 123: (38); 1955 Fall.

301. "Unto you is born this day a Savior: Paintings of the Nativity." *Presbyterian Life.* 8(25): 3–9; 1955 December 24. [Note: AHB selected the illustrations and wrote the accompanying texts.]

302. [letter to the editor.] "Artistic Freedom." *College Art Journal.* 15(3): 184–188; 1956 Spring. [Note: AHB details incidents which illustrate censorship tactics employed by State Department and USIA in their attitudes toward artists' "political associations" and "the style" of their art; referred to by AHB as "an article in the form of a letter."]

303. [letter to the editor.] *College Art Journal.* 15(4): 360; 1956 Summer. [Note: AHB notes the varied pronunciations of the word "Byzantine."]

304. [letter to the editor.] "Mr. Moses and the Ramble." *New York Herald Tribune.* 1957 February 2; Sect. 1: 8. [Note: this piece is unsigned for AHB did not wish to associate MoMA with a letter criticizing Robert Moses's proposed alterations to the Ramble, an area of Central Park known as a stopping place for migratory birds.]

305. [letter to the editor.] "Changes made in the Ramble." *The New York Times.* 1957 February 11; Sect. 1: 28. [Note: AHB signed with the pseudonym C. Marie Alexander, his secretary's name; see Bibliography #304.]

306. [letter to the editor.] *Arts.* 31(6): 6–7; 1957 March. [Note: AHB discusses Museum's Recent Acquisitions Exhibition and policy.]

307. [letter to the editor.] *Arts.* 31(7): 5, 7; 1957 April. [Note: AHB defends the artistic taste

of James Thrall Soby against Hilton Kramer's criticisms of the Balthus exhibition, which Soby directed.]

308. "Portraits by Picasso." *The New York Times Magazine.* 1957 May 19; Sect. 6: 28–29. [Note: AHB replies to criticism of this piece in "Letters." *NY Times Magazine.* 1957 June 30; Sect. 6: 2.]

309. [letter to the editor.] *Art News.* 56(5): 6, 56–57; 1957 September. [Note: AHB details and defends Museum's record prior to 1952 of acquisitions and exhibition of postwar American abstract painting.]

310. [letter to the editor.] *The Times.* 1957 September 3; Sect. 1: 11 (London). [Note: AHB comments on review of exhibition of Picasso drawings at Arles.]

311. "Will this art endure?" *The New York Times Magazine.* 1957 December 1; Sect. 6: 48. [Note: AHB describes Theodore Roszak's *Spectre of Kitty Hawk.*]

312. "Interpreting 'America.' " *Art in America.* 47(4): 10–11; 1959 Winter. [Note: AHB praises the magazine's editorial decision to define American art in terms of the entire western hemisphere.]

313. "American Abroad: 1950." *The Baltimore Museum of Art News.* 21(3): 8–9; 1959 February. [Note: this article adapted from Bibliography #272; see also Bibliography #84.]

314. [letter to the editor.] "Art Show rated best in modern field." *Pittsburgh Post-Gazette.* 1959 February 5; Sect. 1: 18. [Note: AHB comments on Pittsburgh International Exhibition.]

315. "Malarstwo—od Gauguina do Pollocka z cyklu Mekka Sztucki Nowoczesnej." *Ameryka.* Number 8: 25–35; [1959]. (Washington, DC). [Note: published by USIA for distribution in Poland.]

316. [letter to the editor.] *Arts.* 34(4): 7; 1960 January. [Note: AHB corrects impression that he introduced German art to America or that he organized the Museum's 1957 German exhibition.]

317. [letter to the editor.] "Dam the Concrete Tide!" *New York Herald Tribune.* 1960 July 14; Sect. 1: 16. [Note: AHB urges New Yorkers to "keep Central Park green" by opposing Huntington Hartford's proposed café.]

318. [letter to the editor.] "Tastemaking." *The New York Times.* 1960 September 25; Sect. 2: 13. [Note: Barr v. Canaday.]

319. "Skul'ptura—geometria i Dvizhenie." *Amerika.* 47: 56–61; [1960]. (Washington, DC). [Note: written at request of USIA for distribution in the USSR.]

320. "Reply to 'Mr. Barr's "abstract souvenir" ' by A. Romanov." *Art News.* 60(9): 31–32, 57–58; 1962 January. [Note: AHB's answer to A. Romanov's party-line diatribe, which originally appeared in *Literaturnaya Gazeta* and is here reprinted; "abstract souvenir" refers to *WIMP,* Bibliography #66.]

321. "For fifteen dollars. A shelf of art." *New York Herald Tribune Book Review—Paperback Books.* 1962 January 14; Sect. 12: 6.

322. "A Remarkable City is this Salisbury. . . ." *The Evening Standard.* 1962 August 9; Sect. 1: 8. (Salisbury, Rhodesia, now Zimbabwe).

323. [letter to the editor.] *Canadian Art.* 20(1): 63; 1963 January/February (issue no. 83). [Note: AHB discusses Museum's collection of Canadian art; reprinted in *ArtsCanada.* 38(244–247): 102; 1982 March.]

324. [letter to the editor.] "Issues in Alabama: conduct of officials toward Negroes protested." *The New York Times.* 1963 May 12; Sect. 4: 10. [Note: in addition to AHB this letter was signed by Dorothy Norman, Marian Willard, Robert Lowell, Andrew E. Norman, and Mark Rothko.]

325. [letter to the editor.] "Museum director tells of art world hoax." *The Bulletin: Fairleigh Dickinson University.* 3(11): 7; 1963 February 12. (Rutherford, NJ). [Note: AHB refutes veracity of Picasso's so-called "confession" in Papini's work of fiction, *Il Libro Nero;* see also Bibliography #288, #328, and #334.]

326. [letter to the editor.] *Art in America.* 51(5): 143; 1963 October. [Note: Messrs. Barr and Soby defend the integrity of Ad Reinhardt's painting; written in reply to article by Ralph F. Colin who accused the artist of being a "fake."]

327. [letter to the editor.] "American Conformity." *The Hartford Courant.* 1964 December 23; Sect. 1: 14. [Note: AHB defends high-school student's right to determine his own hair style.]

328. [letter to the editor.] "Picasso by Papini." *Saturday Review.* 48(9): 28; 1965 February 27. [Note: see also Bibliography #288, #325, and #334.]

329. "Zere capodopere." *Contemporanul.* 1966 februarie 18; [10]. (Bucharest).

330. [written responses.] Kuh, Katharine. "Modern Art's Durable Crusader." *Saturday Review.* 50(38): 52–53; 1967 September 30. [Note: these replies to Kuh's written questions were subsequently published in Kuh: *The Open Eye.* New York: Harper & Row; c. 1971: 42–46.]

331. [letter to the editor.] "The Tastemakers." *Newsweek.* 70(9): 6; 1967 August 28. [Note: AHB refutes *Newsweek*'s contention that he is "the most powerful tastemaker in America today."]

332. [letter to the editor.] "The Janis Collection." *Art in America.* 56(2): 123; 1968 March/April. [Note: AHB discusses importance of Janises' gift to MoMA's collection.]

333. [letter to the editor.] "Rectification." *Art in America.* 56(6): 123; 1968 November/December. [Note: AHB comments briefly on Picasso's *Dancer* in Chrysler collection.]

334. [letter to the editor.] "Picasso." *Life.* 66(3): 16A; 1969 January 24. [Note: AHB praises *Life* for exposing Papini's Picasso hoax; see also Bibliography #288, #325, and #328.]

335. "Russian Diary 1927–28." *October.* 7: 10–50; 1978 Winter. (Cambridge, MA). [Note: excerpts published in Seton, Marie. *Sergei M. Eisenstein.* London: Bodley Head; 1952: 101–102.]

336. "A continued story: Alfred H. Barr, Jr., Princeton University and William C. Seitz." *Archives of American Art Journal.* 21(3): 8–11; 1981. [Note: AHB's letters of 1950 in defense of Seitz's thesis on Abstract Expressionism.]

337. "1936: The Museum selects an Architect." *Archives of American Art Journal.* 23(1): 22–30; 1983. [Note: AHB's letters of 1936–37 reprinted with comments by Rona Roob.]

Index

Identifications of artists, film directors, and architects cited in the texts will be found below.

Seurat, Georges (1859–91), French painter, 9, 14, 15, 52, 73–76, 116, 177; as innovator, 26, 54, 67, 90, 92; in museums and collections, 59, 71, 72, 75, 76, 209

Severini, Gino (1883–1966), Italian Futurist painter, 12, 148, 180, 183–90

Shadr, Ivan (1887–1941), Russian sculptor, 215

Shahn, Ben (1898–1969), American painter, 222–25, 227, 229, 233

Shaw, George Bernard, 115

Shchukin, Sergei, 197, 201; collection of, 109, 110, 116, 127, 217

Sheeler, Charles (1883–1965), American painter, photographer, 12, 148

Sheriapin, Russian naval officer, 119

Shklovsky, Viktor, 138, 140

Shlovsky, *see* Shklovsky

Shostakovich, Dmitri, 217

Shterenberg, David (1881–1948), Russian painter, critic, administrator, 123–26, 134

Signac, Paul (1863–1935), French painter, 53, 186

Signorelli, Luca (1441–1523), Italian painter, 177

Simon, Louis, 123, 125

Simon, Stella, 113

Simonson, Lee, 113

Sironi, Mario (1885–1961), Italian painter, 190

Sisley, Alfred (1839–99), French painter, 116

Sitwell, Edith, 57, 59

Sitwell, Osbert, 57, 59

Sitwell, Sacheverell, 57, 59

Smirnov, Byzantine scholar, 135

Smith, David (1906–65), American sculptor, 27, 234

Smith, Peter, 128

Soby, James Thrall, 17, 34, 147, 178, 190, 228

Socrates, 87

Soffici, Ardengo, 179, 183, 185, 186, 188–90

Solinger, David, 39

Sophocles, 126

Spaeth, Otto L., 239, 240, 241

Spaulding, John, 74

Speicher, Eugene (1883–1962), American painter, 124, 222

Spellman, Francis Cardinal, 239–40

Spencer, Stanley (1891–1959), English painter, 151

Spengler, Oswald, 57, 59

Stalin, Joseph, 217, 218, 219

Stamos, Theodoros (1922–), American painter, 228, 230, 234

Stanislavsky, Constantin, 60

Stein, Gertrude, 60, 192, 194–98, 201

Stein, Leo, 192, 194–98, 201

Stein, Michael, 194, 195

Stein, Sarah, 194, 195, 201

Stella, Frank (1936–), American painter, 41–42

Stella, Joseph (1877–1946), American painter, 190

Stepanova, Varvara (1894–1958), Russian artist, 9, 10, 68, 113, 125, 138, 140, 143

Stephanova, *see* Stepanova

Sterenberg, *see* Shterenberg

Sterl, Robert (1867–1932), German painter, 149

Stern, Robert A. M., 19

Sterne, Maurice (1877–1957), American artist, 194

Stewart, George R., 239

Stieglitz, Alfred (1864–1946), American photographer, art dealer, publisher, 57, 58, 190

Still, Clyfford (1904–81), American painter, 39, 230, 233, 234

Stone, Edward Durell (1902–78), American architect, 20, 21

Strauss, Johann, 55, 122, 123

Stravinsky, Igor, 55, 59, 60, 110, 114, 122, 129, 186

Stuck, Franz von (1863–1928), German painter, 154

Sudeikin, Sergei (1882–1946), Russian theatrical designer, 109

Sullivan, Mrs. Cornelius J., 7, 72, 73

Sullivan, Louis (1856–1924), American architect, 77, 78

Surikov, Vasilii (1848–1916), Russian painter, 217

Suvarov, *see* Suvorov

Suvorov, Aleksandr, 216

Swarzenski, Georg, 206

Sweeney, James Johnson, 147

Tagore, Rabindranath, son of, 113

Tailleferre, Germaine, 59

Tairov, Aleksandr (1885–1950), Russian film director, 115

Tallone, Cesare (1853–1919), Italian painter, 180

Tanguy, Yves (1900–55), French-American painter, 95

Tatlin, Vladimir (1885–1953), Russian artist, designer, 89, 124, 128, 190–91, 215, 217; mentioned, 112, 125, 128, 136

Taylor, Francis Henry, 32, 34, 208, 209–10, 228

Tchaikovsky, Peter, 116, 122

Ternowetz, Boris, 116, 128, 129

Theophanos (c. 1330–after 1405), Greco-Russian painter, 133

Thomason, John William, Jr. (1893–1944), American artist, 151

Thorak, Josef (1889–1952), Austrian sculptor, 219

Tiepolo, Giambattista (1696–1770), Italian painter, 74

Tinguely, Jean (1925–), Swiss sculptor, 25–26

Tintoretto (1518–94), Venetian painter, 177

Tischler, Aleksandr (1898–1980), Russian painter, 128, 129

Titian (c. 1488–1576), Venetian painter, 12, 74, 135, 149, 177, 178, 207

Tito, Ettore (1859–1941), Italian painter, 181

Tobey, Mark (1890–1976), American painter, 228, 229, 231, 233

Toller, Ernst, 98

Tolstoy, Leo, 140

Tolstoya (granddaughter of Leo Tolstoy), 114, 116

Tomlin, Bradley Walker (1899–1953), American painter, 39, 227, 228, 230, 234

Toulouse-Lautrec, Henri de (1864–1901), French artist, 75, 218

Trencker, Louis, 160

Tretyakov, Sergei, 10, 114, 131, 138–40; Barr's personal relationship with, 107–108, 111, 120–21, 124, 131, 133–34, 143; as LEF member, 68, 138, 143

Acknowledgments

The editors wish to thank Margaret Scolari Barr for suggesting the idea of this volume and for generously providing us with information about her husband; Ruth Berenson, who brought Mrs. Barr and us together; and Rona Roob for guiding us through the Alfred Barr Archives.

Among the many people who have contributed to this volume, we are particularly grateful to Paul Gottlieb and Margaret Kaplan of Harry N. Abrams, Inc.; Richard Oldenburg of The Museum of Modern Art; Philip Johnson, Dorothy Miller, Henry-Russell Hitchcock, Meyer Schapiro, Edward M. M. Warburg, and Arthur Drexler, who generously gave their time in interviews; Jay Leyda, John Bowlt, and Annette Michelson, who permitted us to use their footnotes to the "Russian Diary."

For various favors in locating and acquiring photographs, we are indebted to Irving Penn, Andrew Barr, Sarah d'Harnoncourt, David Whitney, Elizabeth Shaw, Mosette Broderick, Mildred Pou, and Diana Edkins.

We want to thank Jane Edelson, who helped to edit the introduction, and Phyllis Freeman for her multifarious help in shaping the book.

At The Museum of Modern Art, we want to thank the librarians: Clive Phillpot, Janis Ekdahl, Daniel Starr, Paula Baxter, Daniel Pearl, Daniel Fermon, David Monroe, Keith DuQuette, and Kemala Karmen; the members of the Department of Public Information, especially Matthew Bulluck; and Richard Tooke and Mikki Carpenter in Rights and Reproductions. At the Archives of American Art, we want to thank William McNaught and Jemison Hammond.

The editors want to thank each other. Irving Sandler wishes to thank Amy Newman, who painstakingly weighed each of Barr's writings to arrive at a selection that would best reveal his character, thought, and achievement; who wrote the introductions, headnotes, and footnotes; who compiled the biographical index; who gathered the photographs; who helped edit his introduction and scrutinize the paraphernalia of scholarship. Amy Newman wishes to express her gratitude to Irving Sandler for his professional example, his insights, experience, and learned guidance in sifting through the material, and his immense patience, equilibrium, and good humor throughout the ordinary, and extraordinary, tribulations of the project.

To our friends and family—Gilbert Edelson, Sheldon N. Grebstein, Nathaniel Siegel, Lucy Freeman Sandler, Pearl Newman, Stuart Newman, Manfred Epstein, and Bud Shulman —we extend heartfelt thanks for their support and encouragement.

And finally, we are indebted to Alfred Barr, whom Thomas Hess once compared to a Chinese puzzle. His unique blend of vision and obsessions made our work on this anthology always fascinating.

LIST OF ILLUSTRATIONS AND
PHOTOGRAPH CREDITS